Pocket Guide
to Digital
Prepress

Frank J. Romano

Melbert B. Cary Jr. Professor of Graphic Arts
College of Imaging Arts & Sciences
Rochester Institute of Technology

I(T)P™ **Delmar Publishers™**

An International Thomson Publishing Company

Albany • Bonn • Boston • Cincinnati • Detroit
London • Madrid • Melbourne • Mexico City
New York • Pacific Grove • Paris • San Francisco
Singapore • Tokyo • Toronto • Washington

Cover Illustration: John MacDonald

Delmar Staff
Publisher: Michael McDermott
Senior Administrative Editor: John E. Anderson
Developmental Editor: Barbara A. Riedell
Production Manager: Larry Main
Art & Design Coordinator: Nicole Reamer

COPYRIGHT © 1996
By Delmar Publishers
a division of International Thomson Publishing Inc.

The ITP logo is a trademark under license

Printed in the United States of America

For more information, contact:

Delmar Publishers
3 Columbia Circle
Box 15015
Albany, New York
12212-5015

International Thomson Editores
Campos Eliseos 385, Piso 7
Col Polanco
11560 Mexico D F Mexico

International Thomson Publishing Europe
Berkshire House 168-173
High Holborn
London, WC1V7AA
England

International Thomson Publishing GmbH
Königswinterer Strasse 418
53227 Bonn, Germany

Thomas Nelson Australia
102 Dodds Street
South Melbourne, 3205
Victoria, Australia

International Thomson Publishing Asia
221 Henderson Road
#05 -10 Henderson Building
Singapore 0315

Nelson Canada
1120 Birchmont Road
Scarborough, Ontario
Canada M1K 5G4

International Thomson Publishing - Japan
Hirakawacho Kyowa Building, 3F
2-2-1 Hirakawacho
Chiyoda-ku, Tokyo 102
Japan

3 4 5 6 7 8 9 10 XXX 01 00 99 98

Library of Congress Cataloging-in-Publication Data

Romano, Frank J.
 Pocket guide to digital prepress / Frank J. Romano.
 p. cm.
 Includes bibliographical references.
 ISBN: 0-8273-7198-5
 1. Printing, Practical--United States--Data proceessing.
2. Printing plates--United States--Data processing. I. Title.
Z249.3.R66 1995 95-20087
686.2'2544--dc20 CIP

FOREWORD

About 40 years after the invention of printing, a monk named Johannes Trithernius, who also served as abbot for a large scriptorium in Sponheim, Germany, argued that monks should continue to copy manuscripts despite the advent of printing, because of the need for diligence and devotion exercised in the process of being a scribe. He also said that hand-copied words on parchment would last centuries beyond the printed words on paper.

His work was called "In Praise of Scribes" and was widely disseminated—**in print**. The good abbot did not have time to get the work copied in quantity so he had it printed. In fact, the print shop that produced it was located in Mainz, not far from the place where printing was invented by Johannes Gutenberg.

The abbot used new technology to promote the idea of old technology. It's like the postmasters of America communicating with e-mail and fax, or the printing press maker that releases its parts manual on CD-ROM. They are caught in the paradox of transitioning technologies.

So are you, dear reader. We are moving beyond desktop publishing to the place and time where the desktop meets the printing press, and other technologies for reproduction or dissemination of information.

The abbot of Sponheim was tied to the past but forced into the future. The world he knew was changing and he had to either adapt to new technology or forever live in the past.

Frank J. Romano
Rochester, New York

TABLE OF CONTENTS

Introduction ... 17

SECTION 1 INK ON PAPER................ 15

CHAPTER 1—REPRODUCTION PROCESSES
Speed .. 18
Color ... 18
Input .. 18
Technology ... 19
Inappropriate applications 20
Cost factors 20
The continuum 21
DIRECT DIGITAL LINKS 21
Page processing 22
Centralized or decentralized 22
Reproduction 23
THE PRINTING PRESS 24
Page or signature 24
Sides ... 24
Sheet size .. 25
Colors .. 25
PRINTING PROCESSES 25
LITHOGRAPHY 26
WATERLESS OFFSET 28
Exposure and development 29
Processed plate 30
Waterless presses 30
Paper and ink 30
Color proofing for waterless systems 31
Waterless printing system limitations 31
RELIEF PRINTING 32
LETTERPRESS PRINTING 32
Photopolymer plates 33
FLEXOGRAPHIC PRINTING 33
GRAVURE .. 34

SCREEN PRINTING . 35
 Electrostatic plates were the beginning 36
INK JET PRINTING . 37
ELECTRONIC PRINTING . 37
 Electrophotographic printing . 38
 Desktop publishing . 38
DIGITAL PRINTING . 39
 Copier duplicators versus offset . 39
 Comparison . 41
 Copier versus offset cut-off points . 42
 Multiple-page copier versus offset cut-off points 43
REMEMBER THE PRESS . 45
TIPS ON MAKING PAGES WORK ON PRESS 46
 Diagnostic tools . 46
 Color printing standards . 47
 Printing variables . 47

CHAPTER 2—PREPARATION PROCESS ELEMENTS
MECHANICALS . 55
 Camera processes . 56
 Camera-ready art . 56
 Computer-ready art . 56
 Graphics . 57
 Electronic art . 58
RASTER IMAGE PROCESSING . 61

CHAPTER 3—COLOR REPRODUCTION
 Color space . 66
 Maxwell's triangle . 66
 Enter Munsell . 67
 CIE is born . 68
 The CIE system . 69
 RGB . 72
 HLS . 72
 Tektronix HVC . 72
 Device-dependent . 74
 Color in bits and bytes . 75
 A need for real standards . 77
COLOR MODELS . 80
 The reproduction of color . 81

ADDITIVE AND SUBTRACTIVE COLOR 83
 Color balance ... 84
 Color printing .. 85
 Paper and ink .. 85
 Densitometry and colorimetry 86
 Compression .. 86
 Compression solutions 88
COLOR MANAGEMENT 92
CALIBRATION ... 95
 Characterization 97
 Color conversion 98
 Portable color 99
 Quality control 100
 Scanner calibration 100
 Monitors ... 101
 Proofing .. 103
 Soft proofing 105
 Compatibility proofs 107
 Proofs for quality control 108
 Press proofs .. 108
 Off-press proofs 109
 Overlay systems 110
 Internal (single-sheet) systems 111

CHAPTER 4—DIGITAL PREPRESS EVOLUTION
 Enter technology, ad nauseum 117
 A little more history 118
 Hardcopy terms that count 119
PRINTOUT ... 124
 The future .. 127
 Typesetting ... 128
IMAGESETTING 133
 Drum versus capstan 135
 Quality ... 136
COMPUTER-TO-PLATE 137
 System placement 140
 Proofing for CTP 140
 Automation ... 141
 Processing .. 142
 A rose by any other name 142

CHAPTER 5—DESKTOP COMPUTING

Platforms .. 143
Operating systems and graphical user interfaces 144
Peripherals .. 146
Storage media 146
Modems ... 147
Input devices 147
Printers ... 147
Monitors .. 147
SCSI and GPIB 148
SCSI disadvantages 150
GPIB ... 151
NETWORKING ... 153
Configuration of LANs 154
Installing a local area network 154
Circuit cards and cabling 154
Server approaches 154
Installing the LAN software 155
Developing a network profile 155
The log-in process 155
Ethernet LANs 155
AppleTalk Protocol 156
NetWare by Novell 156
Information highway issues 156
The transportation medium 157
The switching system 157
ATM hurdles 159
Wireless .. 159

CHAPTER 6—GRAPHIC FORMATS

FILE FORMATS .. 161
The bit map 162
The vector .. 163
Other formats 164
TIFF .. 165
Aldus started it 166
Compression 168
Bit maps versus object formats 171
PostScript ... 171
EPS ... 173

OPI .. 174
DCS .. 174
FILE EXTENSIONS 175

CHAPTER 7—IMAGE ACQUISITION
CCDs ... 179
Scanners ... 180
Dynamic range 181
Accuracy of focusing 181
Black-and-white points 182
Determining file size 183
Resampling images 184
Use all available tools 184
Scanning quality 185
Printing inks are not pure 188
More numbers 189
Middle tones 191
The resolution solution 192
Your last set of rules 193

SECTION 2 PREPRESS CONCEPTS197

CHAPTER 8—PREPUBLISHING
APPLICATIONS 202
THE NEW AGE OF DOCUMENTS 204

CHAPTER 9—ADVANCED DIGITAL PREPRESS
TECHNOLOGY
The printing connection 208
Recent extensions to Photo CD 208
Open licensing strategy 209
Software utility 210
Flexible application strategy 210
Applications to write Photo CD Portfolio II disks 211
HALFTONE SCREENING 212
Output ... 214
Banding .. 216
SCREEN ANGLES 218
STOCHASTIC OR FM SCREENING 222
Definition of FM screening and "stochastic" 222

Pros and cons of frequency modulation screening 223
Eliminating screen angles 225
Gray levels in FM screening 226
Input sampling 226
FM and HiFi color 227
FM and waterless printing 227
Describing dot area 228
Line screen equivalents in FM 228
Dot etching FM films 228
FM screens versus AM screens 228
Error diffusion and thresholding 229
"Grain" in quartertones 230
Dot gain 231
Transfer curves 231
Scanning issues 232
Subject moiré 232
Dot gain compensation 233
Unsharp masking 233
Image detail 233
Smaller file sizes 234
Scanner resolution 234
Dot growth 236
Dot size 236
Output time 236
FM, conventional screens, and type on the same page .. 236
Scanning resolution and imagesetter addressability 237
Film characteristics 237
Changes to current proofing techniques 237
Conventional versus electronic proofs 238
Conventional process controls 238
Dot representation in electronic proofs 238
Plate resolution 239
Press requirements 239
Press registration 240
Makeready 240
Dot gain on press 240
Dot gain versus conventional screens 240
Ink consumption 241
Ink density 241
Computer-to-plate 241

TRAPPING . 242
 Trapping—what's in a name? . 243
 Issues affecting registration . 245
 Misregistration—Why it happens 245
 Spreads and chokes . 247

CHAPTER 10—DRAWING AND PAINTING SOFTWARE

 Drawing/editing . 253
 Import/export . 253
 Output quality . 254
 Documentation . 254
WHAT TO LOOK FOR IN A DRAW PROGRAM 254
PAINT . 257
 WHAT TO LOOK FOR IN A PAINT PROGRAM 258
 Tools for copying images . 258
 Tools for adding text . 258
 Tools for adding significant areas of color 259
 Tools for rotating images . 259
 Tools for slanting (tilting) images 259
 Tools for flipping images . 259
 Tools for resizing images . 259
 Tools for setting light sources . 259
 Tools for tracing an image . 260
 Tools for cutting or erasing . 260
 Tools for creating 3D shapes . 260
 Tools for measurement . 260
 Tools for cropping images . 260
 Tools for linking items . 260
 Tools for controlling image density 260
 Document or page tools . 261
 Other paint tools . 261
HOW TO DESIGN SOMETHING THAT CANNOT BE PRINTED . . 262
 Pantone versus CMYK . 262
 Blends (vignettes, degradés) . 262
 Prepress system . 263
 The 10 errors of prepublishing 263
 Color publishing . 264
WYSIMOLWYG . 265
 Fonts . 265

Cropping and scaling . 266
Scanning . 266
Other . 266

SECTION 3 THE BUSINESS SIDE OF DIGITAL PREPRESS267

CHAPTER 11—BUDGETED HOURLY COSTS
Budgets . 268
Assigning budget costs . 268
Production centers . 272
Personnel assignments . 273
Hours available for work . 273
Fringes . 275
Depreciation . 275
Repairs and Maintenance (R&M) 276
Rent . 277
Power allocations . 277
General factory allocations . 278
Supervision . 278
Staff allocations . 278
Staff costs . 278
Reconciling the data . 279
Chargeable hours . 279

SECTION 4 THE FUTURE OF DIGITAL PREPRESS281

CHAPTER 12—ON-DEMAND PRINTING
Electrophotography . 284
Color printing . 285
Printing technologies . 288
Electronic printers . 290
Color copiers . 291
Variable information printing . 291
On-demand printing . 291
Short-run process color printing 292
Economics of the process . 294

CHAPTER 13—NEW MEDIA TECHNOLOGY

Form versus content297
Flexible user interfaces298
Tables ...299
Enter PostScript300
Libraries of the future301
Electronic information delivery299
Bitmapped databases302
Fax publishing302
How it works303
Fax On Demand304
Broadcast fax304
Service bureaus306
Fax today ...306
ELECTRONIC PUBLISHING307
The problem and the solution308
The good, the bad, and the digital disaster309
Remote typesetting310
Compression and viewing311
Too many standards ...again311
How printers work with portable documents311
THE INTERNET313
CD-ROM ...317
MULTIMEDIA ...319
Presentation319
Simulation320
Promotion320
Education ...320
Entertainment320
Technical ...320
Instructional321

EPILOG ...323

GLOSSARY ...325

SOURCES ..336

INTRODUCTION

Digital prepress involves the preparation of pages for reproduction on any kind of press or printing system. It has resulted from the broad evolution of five technological tracks in the world we call graphic communications.

Follow each column from top to bottom, left to right, in the chart below. The first column moves from handwriting to electronic publishing, integrating word processing and desktop publishing approaches as we evolved from the typewriter to typographic systems.

HANDWRITING	CALLIGRAPHY	TYPEWRITER	HAND INDEXING	DRAWING
TYPEWRITER	MOVEABLE TYPE	TYPEWRITER PRINTER	INDEX CARDS	PAINTING
TAPE TYPEWRITING	LETTERPRESS PRINTING	LINE PRINTER	PUNCH CARD SORTING	LIGHT LENS PHOTOGRAPHY
WORD PROCESSING	LITHOGRAPHIC PRINTING	DOT MATRIX PRINTER	MAINFRAME COMPUTERS	LIGHT LENS COLOR SEP
VIDEO WORD PROCESSING	FILM STRIPPING TO PLATE	300 - 600 DPI LASER PRINTER	MINI COMPUTERS	DIGITAL SCANNING
NETWORKED WORD PROCESSING	STEP & REPEAT CAMERA	DUPLEXED LASER PRINTING	PERSONAL COMPUTERS	COLOR PRINTING
TYPOGRAPHIC WORD PROCESSING	ELECTRONIC PREPRESS	VERY HIGH RES LASER PRINTING	MAGNETIC DISK STORAGE	DIGITAL PHOTOGRAPHY
DESKTOP PUBLISHING	IMPOSETTING	HIGH-SPEED PRINTING	ULTRA DENSITY STORAGE	COMPUTER ART & DESIGN
ELECTRONIC DISSEMINATION	ON-PRESS PLATEMAKING	INTEGRATED PRINTING BINDERY	HIGH-SPEED NETWORKS	ON-DEMAND COLOR PRINTING
ELECTRONIC PUBLISHING	TRADITIONAL PRINTING	ON-DEMAND PRINT/PUBLISH	DATABASE PUBLISHING	COLOR PUBLISHING

New digital technology for information dissemination is continually being introduced. In this first column, we are seeing increased activity in the area of electronic dissemination of information. This would cover CD-ROM, on-line services, portable documents, and other nonprint alternatives for delivering information. Initially this will include textual information that is reference-oriented, but is predicted to expand to cover magazines, journals, some kinds of books, and and other forms of information.

Rather than considering these new approaches as competitors to print, we see them as partners with print. Electronic approaches will not replace every facet of information delivery—and the data that is used to prepare pages for a press will be the same data that is used to prepare pages for these new delivery systems.

This is the very heart of digital prepress and printing. The pages or documents that are created with digital elements—text, art, photos—become a new form of digital original. In this form they can be converted to virtually any other form of replication or distribution format. These include:

- Digital file to page film for later imposition
- Digital file to imposed film
- Digital file to plate for later mounting on press—whether for lithographic, flexographic, gravure, or screen printing
- Digital file to plate mounted on press
- Digital file to digital press with rewritable plate for customized on-demand documents
- Digital file to portable document format
- Digital file to fax publishing
- Digital file to CD-ROM
- Digital file to on-line service
- Digital file to specialty printers for large format color
- Digital file to vinyl cutting device
- Digital file to new form of digital file.

Thus, digital prepress technology and application are essential if we are to reap the rewards of new approaches to information dissemination.

CALLIGRAPHY

MOVEABLE TYPE

LETTERPRESS PRINTING

LITHOGRAPHIC PRINTING

FILM STRIPPING TO PLATE

STEP & REPEAT CAMERA

ELECTRONIC PREPRESS

IMPOSETTING

ON-PRESS PLATEMAKING

TRADITIONAL PRINTING

The second column shows the evolution from calligraphy to traditional printing. Over a few hundred years we have essentially mechanized and then automated handwriting. We expect new developments in three related areas as electronic (now digital) prepress evolves. Traditional prepress became electronic prepress with the advent of color electronic prepress systems (CEPS) and then became desktop prepress with the application of personal computers and off-the-shelf software and now becomes digital prepress as all pages become totally electronic to interface with advanced printing systems.

Our output devices are now evolving into imposetters that position multiple pages on large sheets of film or plate material. This will change or even eliminate traditional camera and stripping operations. Once we handle imposed units routinely, the film will be supplemented with a plate, and computer-to-plate production will finally arrive. We will need to see more activity in digital proofing and digital advertising standards for magazines and especially in data transmission.

We must be able to move gigabytes or terabytes of information from RIP to platesetter first. From there it is a quick hop, skip, and jump to onpress platemaking. We expect additional developments in this area beyond the seminal Heidelberg GTO-DI.

The next column advances from the typewriter to on demand printing and publishing. There is an interrelationship between these columns, and we must credit word processing with being the pivotal technology in demand printing. Once pages could be input, edited, and stored in electronic form, whether they were in offices or in printing plants, our printout technology had to keep up. Today, the average desktop printer has the speed and capability to go

beyond printout of the occasional memo or letter to be an on-demand printing system, in either black or color.

TYPEWRITER
TYPEWRITER PRINTER
LINE PRINTER
DOT MATRIX PRINTER
300 - 600 DPI LASER PRINTER
DUPLEXED LASER PRINTING
VERY HIGH RES LASER PRINTING
HIGH-SPEED PRINTING
INTEGRATED PRINTING BINDERY
ON-DEMAND PRINT/PUBLISH

RANGE OF LASER PRINTERS

The laser printer was a natural adjunct to page production. It became a de facto copier as users printed out the number of pages needed for their audience, rather than printing out one master page and then using reproduction technology. Resolution levels, which have steadily increased, are now hovering around 600 dpi and heading upward. Speed levels have increased for different user needs. Duplexing ability has increased. Networking functionality has increased. These enabling technologies are important functional components of the overall systems capability that will be required.

A natural progression has led to color. From personal and desktop color printers to digital color presses, as they are called, we are applying new technology to the printing process. The object is eventually to provide the quality and capability to compete head-on against traditional ink-on-paper printing.

The next natural step in the printer process will be the integration of bindery capabilities. These include collating, folding, stapling, strip binding, and so on. They combine to produce a finished document.

The Eastman Kodak Lionheart and the Xerox Docutech have pioneered this area, but mid-range systems are coming to the industry to bring high-speed digital printing and document production—in color—to medium-sized organizations.

On-demand printing is part of a manufacturing philosophy called "just in time" delivery, which eschews inventory and warehousing and replaces it with the immediacy of almost instantaneous production. Because of the nature of the printing process, we had to make (repro-

duce) more products than we may have needed in order to reap any economic benefit. Often the product became outdated and had to be discarded. Today, we can apply a number of technological approaches in the production of printed matter on demand—and update the information with each iteration of production.

HAND INDEXING

INDEX CARDS

PUNCH CARD
SORTING

MAINFRAME
COMPUTERS

MINI
COMPUTERS

PERSONAL
COMPUTERS

MAGNETIC DISK
STORAGE

ULTRA DENSITY
STORAGE

HIGH-SPEED
NETWORKS

DATABASE
PUBLISHING

The next column in our chart shows a path from the lowly index card to database publishing. This latter term covers a lot of ground. It mostly describes the extraction of data from computer files and inclusion of that data in documents, where data can become information.

Data represents numbers, and numbers have no meaning unless they are placed in some contextual environment. A database is also the storage place for vast amounts of information, textual or visual, in a format that allows search and retrieval.

Desktop computers also provide a fertile ground for the development and maintenance of databases. Often, the information in these databases becomes part of a sales catalog, price list, or other material. Utility programs are available to link the data from the database to the document pages. These links also allow you to establish tags that define the typography and other formatting of the information.

Image databases contain large collections of pictures and other graphical objects that are stored for retrieval. For each object, a text-based entry must provide sorting and searching information so that images can be retrieved in an efficient manner. High storage volumes are required for the maintenance of any kind of database.

The last column starts with drawing and painting and ends with color publishing. Artists are only now exploring the boundaries of digital technology for creative purposes, and this area will grow rapidly as they master these tools.

In digital scanning, we expect more desktop scanners at lower prices with competitive specifications. This will bring quality scanning within the reach of most users. Even with the gradual introduction of digital photography, the scanner will still be a necessity.

Color printing continues to evolve. Look for more activity in plain-paper color printing with ink jet or toner or dry ink approaches. Proofing is a part of this area, and there is a lot of activity in it. The advent of stochastic screening may change the way we reproduce and approve color. The traditional rosette will be gone and frequency-modulated dots will take its place. This may make some existing color printing technologies more applicable for color proofing.

DRAWING

PAINTING

LIGHT LENS PHOTOGRAPHY

LIGHT LENS COLOR SEP

DIGITAL SCANNING

COLOR PRINTING

DIGITAL PHOTOGRAPHY

COMPUTER ART & DESIGN

ON-DEMAND COLOR PRINTING

COLOR PUBLISHING

Digital photography will accelerate. This includes the transitional technology called Kodak Photo CD, which is a hybrid bridge between the color negative and the digital world.

Computer art and design will advance as most artists and designers adopt electronic tools. More schools are routinely teaching these new approaches, and artists who enter the workplace will be adept at producing computer-ready art.

Lastly, on-demand color printing will reach a crescendo. We expect high-speed, acceptable-quality printers that output process color from PostScript files. This technology will be applied by commercial printers and related graphic arts firms to develop new markets for short-run reproduction.

All of the technological areas we have discussed are related in that they provide more productive approaches to preparing pages and documents—with type and art and photos and color—for reproduction, or for presentation on a video monitor, or for output to a personal or professional printer, faster and more effectively.

THE DIGITAL PRINTSHOP
The printing industry is changing . . . again. It is applying a host of new technologies to aid in the creation and production of pages for reproduction, by print or nonprint methods.

Each of the technological areas is unique in and of itself, but in total they combine to form new kinds of systems for digital prepress that have usurped a major part of the market from proprietary and specialized systems.

Text and image input
Begin with the input or import of text and graphics and pictures—the essential ingredients of page design and production. Usually text starts in some word processing program and artwork starts in a drawing program or scanner.

Digital scanning
The electronic scanner has been with us for more than 30 years. It was the technology that transformed the color separation business and led the way into color prepress systems. The price dropped rapidly in the last decade from half a megabuck to less than $20,000 for a high-quality drum scanner, now small enough to fit on a desktop along with all those other desktop machines that all together do not fit on a desktop.

In 1994 the worldwide population of desktop drum scanners exceeded the installed base of high-end drum scanners, putting both commercial services and their customers within an arm's length of reflection and transmission scanning. Eventually, scanners will be standard peripherals on every desktop.

Digital photography
Scanners will become obsolete, we are warned, as photography goes digital. The Kodak Photo CD, a winner with professional users, is a transitional technology that buys time until electronic cameras catch up with their promise. Even if they do, there will still be a large base of material that still has to be scanned, so don't sell the scanner just yet.

Digital data and image conversion

Some volume of text and graphics and pictures already exists in electronic form, but probably the wrong electronic form. New utility programs routinely convert one form (like GIF) to another form (like TIFF). These graphic format conversion programs are an essential part of the changing world of graphics standards.

Digital data and image storage

Without low-cost and high-density data storage, it would not be possible to handle the voluminous files that result from the documents and publications produced with digital color technology. You can be assured that storage disks will get much smaller, store more and more gigabytes (rather than megabytes) of data, and cost less.

Digital character recognition

OCR just will not die, no matter how much electronic text is handled. Converting the typed or printed word into coded data is still a requirement for material that has no ASCII file. As the number of typewriters goes down, the number of files in electronic form will go up, as more pages are initiated in word processing programs.

Design and preparation

If there is one area that had the most profound effect on the printing and publishing industries, it must be that of computer-aided art and design. It has changed the relationship between the page creator and the page producer.

Digital art and illustration

In the past, much of what an artist did was really done by the commercial printer. The rubylith overlays, tissue instructions, and margin notes allowed the creative professional to communicate with the commercial producer. In fact, it was only after the printer had worked the magic of film that the creators actually saw what they had created, in the form of a preliminary preview—a proof.

No more! The art and design professional creates and produces with new electronic tools. Commercial printers

now receive more than half of their work in digital form—but there is no consistency. The creative professional now takes responsibility for typography, color, and production. Some files are ready to run; others require extensive re-work. There is no longer a clear demarcation between creative and production worlds. Where does creativity end and production begin? Now there is the problem of responsibility.

Digital image manipulation

Production systems still handle image manipulation productively, but much of this capability is also moving backward to the creative person, as the personal computer—and the imaging program—acquire more and more power, and the creative persons themselves become more adept at handling photographic images.

Digital page and graphic design

Design is a creative process that plays "what if" games with page elements. Design programs and the powerful desktop computers that run them are the perfect tools to accomplish this. Creative professionals who do not use computers will be rare indeed.

Digital color creation

The printable color revolution wrought by Trumatch and others is now at everyone's fingertips. Mixed-ink colors often cannot print in traditional CMYK process printing. Users can select from multiple color systems with relative ease, with feedback as to what can print and what cannot print. "Can print" is better. Blends and gradations are common because they are easy to produce.

Digital type and color intelligence

The concept of artificial intelligence says computer programs can make decisions that humans make. In type, we are already seeing automatic pair kerning, tracking by point size, automatic ligatures and quotation marks, intelligent hyphenation and justification, and other automated typographic functions.

In color, we are starting to see automation in trapping, color calibration, and color management. And do not forget about automated imposition, which is an important capability if we are going to output pages to imposed 4-up, 8-up, or more-up film or plate materials. Little by little we are programming our systems to make decisions that skilled people used to make.

Digital color management

The color that the scanner sees, that the monitor shows, that the computer calculates, that the proofer proofs, that the imagesetter images, and that the press finally prints may all be different. Color management is advancing rapidly to control and "manage" the color between various devices and programs— artificial color intelligence, if you will.

PRODUCTION OUTPUT

Creative pages are useless until they are output for reproduction. This might involve output to paper (to make a pasteup), to film (to make a plate), directly to plate (to go on press), directly to a plate premounted on the press, or directly to a digital printing press. In fact, almost every reproduction process now accepts digital files.

Digital rasterization

Converting the page that you create on screen into data that a printout device can handle is the raster (image) process—placing each dot precisely where it is supposed to go. RIPs are finally catching up with the page production process, incorporating sophisticated graphics and picture functionality to drive high-tech printout systems.

Digital page and color proofing

No one in their right mind would commit to a high-quality print run without a proof—today. One level of proof checks the page elements and imposition and the other checks the color. Both areas are under attack by new technology . . . and new thinking. What if the monitor could be calibrated to display the color properly? What if

the color intelligence could be trusted to make the right decisions? What if we could accept a proof without halftone dots? In any case, there will still be digital color proofing.

Digital page filmsetting
Most imagesetters output film or photo paper as a single page or a two-page spread. Resolutions have gone well beyond the 2,400/2,540 dots per inch of earlier devices, but the advent of new halftone screen technology using frequency modulation of laser dots allows high quality at lower resolutions.

Digital signature filmsetting
The 4-up, 8-up, and more-up film flat is a reality. Called "imposetters" to distinguish them, these behemoths reduce manual stripping—but only if every page and every page element is in electronic form. Magazine advertising has yet to make that conversion, but it will. Manual stripping will continue to exist for certain classes of work, especially where minor changes are required for reprinting.

Digital page platesetting
The 1-up plate is fine for duplicator presses and their ilk, but it is being challenged by electronic printers that increase in speed and quality with each passing model year. Most imagesetters have had the ability to run polyester plates for years, but few users have seen the economy in the 1-up plate. The direct platemaker photographs artwork onto a polyester or paper plates, and quick printers have known of their advantages for years.

Digital signature platesetting
The imposed plate is the most important plate, and the 8-up plate may be more important than the 4-up. More than six metal 8-up computer-to-plate systems were introduced in the space of two months in the fall of 1993, and the number of suppliers is now more than ten. Each platesetter has the ability to take digital data and produce a set of metal signature plates for color reproduction. There are

still issues to overcome, but it appears that larger printing organizations will adopt this new technology.

REPRODUCTION AND DISTRIBUTION

The object of communication is to disseminate infor-
mation. The film and the plate are the enablers for the tra-
ditional printing process, but short-run on-demand
approaches are applying digital printing technologies, by-
passing film and plate altogether. In most cases there is
still an image carrier and a replication process. TV and
radio systems broadcast information; paper communica-
tion requires reproduction.

Digital b&w page printing

Call it a printer and you get the idea. In fact, many
copiers are scanners on the top and digital printers on the
bottom. The trouble with the word "printer" is that it does
not distinguish between the lowly printer on your desk and
the high-performance production printer in the printshop.

Digital color page printing

Call it a digital color printer or digital color press and
you have one of the futuristic reproduction devices of the
21st century—an electronic competitor to the traditional
ink-on-paper printing system.

Digital color and b&w signature printing

The advent of the imposetter that outputs to film and
even to plate directly supplements the large-format print-
ing press. Signature printing is still the most cost-effective
reproduction technology of today and of the predictable
tomorrow for documents with high page count and run
length characteristics, and challengers will have to work
hard to change this inescapable fact. On-demand printers
have the advantage in the production of complete docu-
ments, but only in short runs at present.

Digital press and bindery control

The programs that create your pages know the ink
patterns based on the color coverage on the paper and can

set ink controls accordingly. It may also be possible to place bar codes in nonprint areas so that higher levels of postpress signature selection and assembly could create new classes of custom products by sorting printed signatures into publications.

Digital personalization
Traditional printing has adapted ink jet and other techniques to selectively address and personalize signatures either during or after printing. This capability goes beyond mere name and address imprinting. It is possible that the bar code could also be imprinted with information about who you are as well. With new electronic presses, the entire page is variable, and text and images can be customized to specific people.

Digital document distribution
More than half the effort of reproducing a page has very little to do with the reproduction approach. Thus, the digital data that results from the creative, preparation, and production stages could also be used for electronic dissemination. Digital prepress goes beyond the press, but that is where we must start.

You can see that we have also gone beyond desktop publishing. Digital prepress is the confluence of diverse technologies, applications, and processes whose ultimate goal is the reproduction and/or distribution of documents.

ACROSS THE DIGITAL DIVIDE
The digital revolution is upon us. From art and design to printing and publishing, the graphic arts world has been reduced to bits and bytes. We now live and work in or near cyberspace. Today, the creative originator makes digital files as a byproduct of the creative process; the printer receives digital files as input for the reproduction process. What should unite these two groups often divides them.

Commercial printers receive more than half of their work in digital form, but there is no consistency. We have to reeducate the entire creative community about proper preparation.

RESPONSIBLE PAGES

Why do some jobs run effortlessly and others do not? The ability of the art professional is a big part of it. Those who know the secrets to QuarkXPress and PageMaker, Photoshop and Illustrator, among other programs, can create what are called "responsible" pages. An irresponsible page mixes Pantone and CMYK colors in a gradient blend, specifies 212 line screen halftones, has 39 typefaces with missing EPS files, and traps all colors indeterminate.

One must prepare pages and documents based on meaningful standards of quality but also on pragmatic standards of reproducibility. Can the pages be output by the replicating system successfully?

PREFLIGHTING

Another element in successful output is the preflight and analysis ability of the commercial printer or prepress service. Their attention to detail in resetting all dialog boxes to the proper printout device and making certain all files are present and accounted for assures that the document will actually print. Printers are also offering newsletters, seminars, training sessions, and consulting for their customers in order to increase communication between creator and manufacturer.

Creative pages are useless until they are output to film (to make a plate), directly to plate (to go on press), directly to plate on press, or directly to digital press—or even to digital file on disk or on-line service. Newer reprographic technologies will only accept digital files, so both creative professionals and print professionals will have to work more closely. We need to bridge the digital divide by communicating with each other and making technology work for us. The goal of this small book is to help you understand the various elements that make up pages and documents and how they are used to disseminate information in the brave new digital world.

SECTION 1

INK
ON
PAPER

CHAPTER 1

REPRODUCTION PROCESSES

The word "printing" has long implied ink on paper, even though many of the newer electronic reproduction systems use toner instead of ink. Thus, the manufacturers of toner call toner "ink" and we have even more confusion.

The terms "printing" and "duplicating" are used synonymously because they both deal with the replication of pages or documents. Yet, the distinction must be made between conventional *ink-on-paper* printing, which requires a one-time-use image carrier (plate) that can only carry one image and replicate it forever, and *toner-on-paper* printing, which applies a reusable image carrier (drum or electronic plate) that can be reimaged continuously to produce a complete document.

"Duplicating," as a term, was initially applied to utility-level printing presses that produced moderate quality, black-and-white printing. Today, duplicating applies primarily to copier and electronic printer replication technology, although vestiges of the older offset relationship remain. When used in combination with "copier" or "printer," it implies higher speed and greater performance. Here are some typical replicating systems:

	Speed	Quality	Page Size	Input	Carrier	Color
(Office) Printer	Low	Moderate	Standard	Data	None	Low - Mod
(Color Office) Printer	Low	Mod - High	To 11x17	Digital	None	Low - High
Printer/Duplicator	Mod - High	Mod - High	To 11x17	Data/Digital	Drum	Low - Mod
Copier	Moderate	Moderate	To 11x17	Analog	Drum	Low - Mod
Copier/Duplicator	High	Moderate	To 11x17	Analog	Drum	Low
Digital Color Press	Moderate	Mod - High	To 11x17	Data/Digital	Drum	Mod - High
Color Proofer	Low	High	To 11x17	Digital	Drum	High
(Offset) Duplicator	High	Moderate	To 11x17	Analog	Plate	Low - Mod
(Offset) Press	Very High	High	Signature	Analog	Plate	High
Direct to plate on press	Very High	High	Signature	Digital	Plate	Mod - High

Speed

Reproduction or printout devices usually measure speed in *pages per minute* and *pages per hour*. However, signature-oriented printing presses use *impressions per hour* because they are running a large single sheet of paper with multiple pages on it. For comparison purposes:

Low: 10 standard (a standard page is 8½ x 11 inches) pages per minute or less, single-sided or duplexed.

Moderate: 60–90 standard pages per minute, single-sided or duplexed.

High: 120+ pages per minute or more, single-sided or duplexed.

A printing press could operate at 10,000 impressions (sheets) an hour and each sheet could have 16 pages. That equates to 160,000 pages per hour or 2,666 pages per minute.

Document printers produce a finished document with automatic binding. We are still trying to measure cost and productivity when a complete publication is produced on demand rather than a number of publications produced with traditional approaches.

Color

Color capability is also described with general terms:

Low: Black plus one color, or low-quality "process" color.

Moderate: Black plus highlight colors, or moderate "process" color.

High: High-quality "process" color, primary colors plus black.

Input

Analog: A physical sheet of paper or some other substrate, with images thereon, serves as a master image for reproduction. It could be photographed through a lens (traditional copier), digitally scanned, or plated directly or via film for conventional printing.

Digital: Electronic information consisting of rasterized text and images in page form.

Data: Text-oriented, usually not divided into pages.

Technology

Three primary technologies are used for digital reproduction today:

1. Offset lithography—at the duplicator (11" x 17" and below) level, and signature level (17" x 22" and above) with film-to-plate, computer-to-plate (both off-press and on-press).

2. Waterless offset or dry offset—same as offset but without the need for fountain solution (ink/water balance).

3. Electrophotography—creating an electronic (charged) version of the page image on a rechargeable surface, attracting toner particles and then transferring the page image to paper. The charged page image can be created either with light reflected from the original page image through a lens or digitally mastered by laser light.

The first two lithographic offset processes are used for high-quality reproduction, especially where color is concerned. However, a major advantage of the printing process is the ability to print a signature consisting of 8 to 16 or more pages at one time.

Combined with automated bindery equipment, this is the most efficient approach to the production of publications with large page counts (100 pages or more), reproduced in high numbers (1,000 copies or more). A quick comparison:

	Best for	OK for	Worst for
Offset lithography	High page count, high copy count docs	Moderate page count, moderate copy count docs	Very short runs of most work
	Color reproduction		
	Special or heavier paper stocks		
Waterless offset	Very high quality halftones, color		
Electrophotography	Very short run reproduction	Limited run docs of moderate page count	High quality color
	Most black & white flat forms	Moderate quality color	Long runs

Inappropriate applications

The preceding overly simplified chart shows that conventional printing is best for longer run, higher page count applications and electrophotography is best for shorter run, lower page count applications of moderate quality. Most commercial printers still apply conventional printing which makes the previous statement true, especially for those who buy printing. Over time, you will learn the kinds of jobs that run best on certain types of presses or with certain technologies. The three approaches listed are the most typical, but a lot of digital prepress has to do with the size, shape, and other features of the press.

It is not only printing technology that must be considered. Most electronic systems have integrated sorting and some level of binding (if only stapling). If the final result is a number of completed sets or units, then the integrated approach may turn out to be more cost-effective, since conventional printing systems require an entirely separate step for almost all postpress operations.

Cost factors

One-color printing traditionally means black and white, although it can also mean the use of any single color of ink. On a per-page basis, an interesting phenomenon relates to conventional versus electronic printing/copying:

	Conventional	Electronic
The higher the page count	Cost drops per page	Cost per page stays the same
The shorter the page count	Cost increases per page	Cost per page stays the same
The longer the run	Cost drops per page	Cost per page stays the same
The shorter the run	Cost increases per page	Cost per page stays the same

However, these statements are not true all the time for all jobs. Integrated sorting and stapling, as well as integrated saddle stitching and perfect binding, give a cost and time advantage to many documents and publications produced on integrated digital systems in very short runs. Run length, page count, bindery requirements, and time factors all play a role in selecting the optimum process.

The continuum

There is no clear demarcation between reproduced work on conventional or electrophotographic approaches. The user of a small-format signature press who tries to produce 100 books with 200 pages each could do the job but would be at a disadvantage compared with a 135-page-per-minute electronic printer with on-line binding. If the quantity was 10,000, they would both be at a disadvantage compared to web printing and traditional bindery. In other words, there is a level of optimum applicability for each kind of reproduction technology.

Conventional printing is advancing primarily in the area of color control (on-press densitometry, registration, ink settings, etc.). Automatic plate loading is becoming a reality and, when linked with direct-to-plate production from digital files, could result in the more effective production of single-and multiple-color work; so far, though, this has not been demonstrated.

There is much more activity in the area of digital printing. Newer devices are now routinely incorporating 4-color printing with on-line sorting and finishing. The Xerox Docutech and the Kodak Lionheart are the continuation of a technology that began with the Xerox 9200 copier and will erode the use of black-and-white offset at the duplicator level. They have integrated bindery with production speeds that compete with offset duplicators.

Most of all, the trend is toward digital creation of page files. Reproduction technology must link with page creation technology. Then we will go from page file right to reproduction device and to bindery.

DIRECT DIGITAL LINKS

Most pages today are being created at the desktop level, with word processing or advanced page publishing programs. In the past, we had to incur significant cost to print these pages out on photographic paper as "art" for the prepress stage of the reproduction process. We can now go directly to paper, film, plate, or digital press.

In the past we have provided raw data to a production service, which performed certain functions and then

formatted the data into pages. That file was proprietary in that it could only be used to generate those pages on that company's output device. The original file also had to be free of any special functions so it could be converted to pages by the outside service.

Today, we can maintain independent files in standardized form and take advantage of the significant opportunities for communicating them in any way we want.

Page processing
Most files are essentially stored in micro, mini, or mainframe computers as text databases. This means that they are unpaged. Desktop publishing files are stored in microcomputers as pages and or as documents. Most organizations maintain the integrity of their databases but take the data into desktop programs for paging. This information is then used for final output. The organization has the benefit of controlling its own database, its own format and its own output, whether that output is produced through an internal or an external service.

Centralized or decentralized
The advent of the desktop computer has changed the way in which organizations handle their data and their pages. It is now possible to download the data from the central computer, process it at the desktop level, and then put it into page form. The users can then decide how they want to disseminate the resulting document.

There is increasing decentralization as users take responsibility for some of their pages. The reason we say *some* is that organizations need professional assistance in producing pages, so it may be that there are production departments to assist them. It may be that all pages pass through a centralized production department or outside service.

The advent of new technology for reproduction, the decentralization of page production, and the balance between procured and internally produced work will require better management of the publishing function in order to control and direct costs, schedules, and standards.

To meet the demands of publishing in the next decade, organizations must understand the nature of their work and match it to the diverse equipment, systems, and techniques that are available or will be available.

Reproduction

All printing techniques use mechanical and electronic systems to apply colorants to substrates such as paper, cardboard, or plastic in order to make multiple copies of original images for mass distribution. Each unit of a printing system is usually a different ink color: The more units, the more colors that can be applied to the paper in one pass through the press.

With multiple ink units, multiple colors can be printed in one pass through the press. Spot color printing uses any color or premixed ink for reproduction. Process color printing uses four transparent inks—cyan, magenta, yellow, and black (CMYK)—printed one on top of another in varying amounts or densities. Color photographs and other artwork are reproduced by this method.

Most modern printing presses transfer ink from a cylindrical printing surface, on which is mounted an image carrier, to moving sheets or webs of paper. Presses that print webs can achieve speeds of 2,000–3,000 feet per minute. Presses that print on sheets are generally slower than continuous web presses, but can print on thicker substrates, such as bristol board and even plastic.

Advances in photography and electronics have had a profound effect on the manufacture of printing image carriers (plates). Light-sensitive materials such as diazonium resins and photopolymers make it possible to produce durable printing surfaces photographically and digitally rather than mechanically. Digital prepress systems allow rapid production of the films used to transfer images to image carriers. Some image carriers are prepared directly by lasers or diamond styli.

THE PRINTING PRESS

The major characteristic of a printing press is the plate or image carrier.

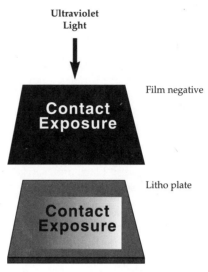

Ultraviolet
Light

Film negative

Litho plate

Traditionally, the plate is created by exposing high-intensity light through a film negative to the plate material. No matter what the printing technology, presses must have an image carrier (plate) which reproduces the same page or pages over and over again. Even electronic printers have an image carrier, but it is one that can be reimaged for each page passing through the system.

There are three basic levels of printing press. Each has different characteristics and quality levels.

Page or signature
Page/Sheet (Duplicator): Single sheets for 1–4 pages.
Signature: A sheet of paper with 4–16+ pages on it.
Web: A continuous roll of paper, printing signatures.

Sides
Presses can print on only one side at a time, or both sides at a time.

Perfecting: Print both sides of sheet with a single pass through the press. Also called duplexing.

Non-perfecting: Print on one side only with pass through press.

Sheet size
The size of the sheet of paper is a primary characteristic. It determines the number of pages that can be printed at one time and the amount of paper waste:

Sheet size: From page size up to 40" x 60" signatures.

Cut-off (on web): The final page size the cutter/folder produces.

Colors
The press can print black and white only, two or three colors, or process color, or six to eight colors:

Single color

Multiple (or spot) color

Process color

Process color plus additional spot colors

PRINTING PROCESSES
There are many reproduction processes. Each has advantages and disadvantages.

Process	Major Advantage	Major Disadvantage
Letterpress	Fast makeready on press	Lower quality photos
Offset Lithography	Major process	Moderate makeready
Dry Lithography	Special press	Higher quality
Flexography	Varied substrates	Heavier substrates
Gravure	Long runs	Long makeready
Intaglio	Fine line detail	Only fine line detail
Screen	Varied substrates	Lower quality photos
Stencil	Inexpensive	Lower quality photos
Electrophotography	Short runs	Long runs
Ink jet	Varied substrates	Speed
Bubble jet	Inexpensive	Very slow
Thermography	Business cards	Expense
Thermal transfer	High quality	Consumables cost
Dye sublimation	High quality	Relatively slow

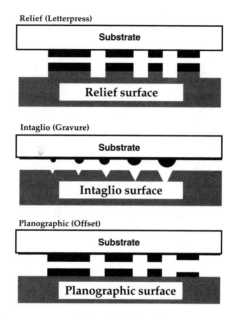

Ink-on-paper printing falls into three main categories:

Relief: The image to be printed rises above the surface. Letterpress and flexography use this approach. This is a three-dimensional image.

Intaglio: The image to be printed is recessed into the surface. Gravure and intaglio printing use this approach.

Planographic: The image and nonimage areas are on the same plane. Lithography, water or waterless, uses this approach.

LITHOGRAPHY

The most prevalent printing process today is offset lithography. Its underlying principles were established by a Bavarian composer, Alois Senefelder (1771–1834), who found that a wet limestone surface would repel an oil-based ink, and that an image drawn on the surface with the equivalent of a grease pencil would repel water and attract ink. The image on the stone surface could be reproduced by bringing a sheet of paper into contact with the

inked image with even pressure over the paper to make the image transfer to it

The image on the stone was backwards:

Wrong reading

The image on the stone was wrong reading (backwards) so it could become right reading when transferred to the paper—like a rubber stamp. Eventually it was discovered that the stone image could be right reading and then transferred to another surface which then transferred the image to the paper, making it right reading.

Right reading

At the turn of the 20th century, limestone (the *lithos* in lithography) was replaced with metal plates and the ink was transferred from the plate surface (right reading) to an intermediate rubber surface (wrong reading) and then to the paper (right reading). The rubber intermediate, called a "blanket," transfers ink to paper and other substrates.

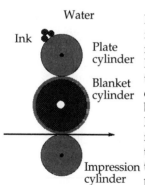

Lithographic plates are the least expensive printing surfaces available today. These aluminum plates have a light-sensitive surface coating that undergoes a solubility change when exposed to intense blue and ultraviolet (UV) light. Images are exposed on the surface by exposing the plate through a film positive or negative. Some plates can be exposed directly, as in a graphic arts camera, by exposure from a film negative, or by a computer-to-plate laser system. The objective today is to go directly from computer to plate.

Modern offset lithographic presses range in size from small sheet-fed duplicators with a maximum of sheet size of 11" x 17" to massive web presses capable of printing millions of copies of magazines or catalogs, in full color.

WATERLESS OFFSET

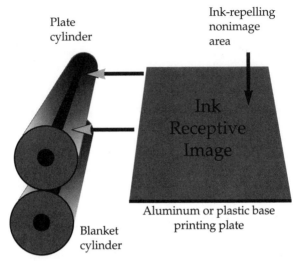

Plate
cylinder

Ink-repelling
nonimage
area

Ink Receptive Image

Aluminum or plastic base
printing plate

Blanket
cylinder

Ink and water don't mix—that's the basic premise of lithography. In conventional planographic (flat image carrier) printing, an exposed and processed printing plate has oleophilic (oil-loving) and hydrophilic (water-loving) areas on the same plane. In the waterless printing system, the image area is recessed. There is no water in the printing process, so the problems that water causes, such as paper expansion, wrinkling and buckling, misregistration, ink adhesion, and drying are virtually eliminated.

The absence of dampening transforms the fundamental dynamic of waterless lithography from ink/water balance to ink/temperature control. Waterless offset printing plates were developed by 3M in the late 1960s as *driography*; however, it gave up marketing of the plate because of the poor scratch resistance and durability.

In 1973, Toray Industries Inc. of Japan developed a positive-type waterless plate which featured better scratch resistance, better reproduction, and better ink repellence, with longer life, than the driography plate. Toray started marketing the plates in 1978 and developed the negative-type waterless plates in 1985.

Waterless plates, the platemaking system, and special waterless inks have been regularly improved, and the press temperature control system developed to provide an optimal waterless printing system.

Waterless plates are based on laminate design, and have a straight-grain aluminum base that, unlike conventional offset plates, has not been anodized. A light-sensitive photopolymer material is bonded to aluminum, then covered by an ultra-thin coating (two microns) of silicone. The plate surface is protected by a transport cover film so thin—seven microns—that it need not be removed during exposure because it yields no appreciable dot gain or undercut. Plate thickness varies from 0.15 to 0.40 mm.

Exposure and development

A positive (or negative) film is placed on the plate to expose it to UV light in the vacuum frame or a step and repeat machine. Exposure times are comparable to those for conventional presensitized plates; however, vacuum time may be 10% to 15% longer. UV exposure activates the photopolymer, causing a break in the bond between the photopolymer and the silicone layers. The plate supports a dot range from 0.5% to 99.5% at a screen ruling of 150 lines.

In the developing process, the silicone layers in the image areas are brushed off the plate. The image areas are made of a photopolymer and are slightly recessed so that the ink in the image areas does not spread out in the printing process—less dot gain. The plate processing chemistry consists of a tap-water solution for lubrication, and a glycol-based solution for treatment with a dye solution, which recirculates and is not discharged from the processor. Total processing time for a 40-inch plate is about 2.5 minutes.

In the finishing stage, a blue dye solution is applied to the plate to provide a visual contrast between image and nonimage areas; a slight etch is added to the photopolymer image area, thus making it more ink-receptive; and the nonimage areas of the plate (which had been softened during pretreatment) are hardened. The unwanted images are deleted by applying a special stop-out solution over the area with special silicone.

Processed plate

On the finished plate, the nonimage area is composed of a two-micron coating of ink-repelling silicone. The image area, slightly recessed, consists of the ink-receptive photopolymer material. The silicone to resist ink, the photopolymer to attract ink—this allows the plate to print without the use of water, etches, or alcohol. Its intaglio-type surface provides supporting walls around each portion of the image area. Because individual dots are supported, the screened film image can be transferred to the plate with exceptionally low dot gain or growth. Midtone dot gain is reduced by up to 30% compared to wet offset processes.

The recessed image area allows the plate to carry a greater charge of ink, allowing for reproduction of higher ink densities. Resolution of 200 to 300 lpi can be achieved with negative working plates, and 400 to 600 lpi with positive plates. Waterless printing plates must be handled with reasonable care to avoid scratching and can be reused.

Waterless presses

The waterless system does not require dampening. Offset presses without dampening systems may be used for waterless printing if the press room is well air-conditioned. The optimum temperature range for the inks/ink rollers is 80° to 88° Fahrenheit. With a properly configured press, an operator can run waterless, conventional, or both processes. Each color (cyan, magenta, yellow, and black) of the process inks runs at a different temperature. (Black is said to require a hotter temperature than yellow or magenta; cyan is between.)

Besides water-cooled ink rollers, another design cools the plate surface with an air-blowing device, which is located at the plate loading position of the printing unit on a swing-away mounting. Pressroom temperature must also be maintained by air conditioning, as the temperature of the press changes with the ambient temperature.

Paper and ink

Quality papers yield excellent results running waterless, with less picking and better acceptance. Because the

nonprinting areas of the waterless plate are silicone rubber, spray powder buildup may result in abrasion. The abrasiveness of paper fibers from stocks that give off fiber can have an adverse effect on the plate.

Waterless offset inks have high viscosity, low tack, and good stability, as well as being quick-setting and high-gloss. The background (nonimage area) starts showing the toning results due to heat buildup during long-run printing unless an effective cooling system is available.

The temperature of the plate surface at which toning starts is called "Critical Toning Temperature." It is affected by factors such as roller settings, contamination of inks by remaining roller wash, and plate wash on the press. To avoid toning, the most effective approach is to cool the vibrator roller in the inking system with chilled water.

Color proofing for waterless systems

The waterless system prints clearly, sharply and with minimal dot gain, and it is important to match the proofing system. Waterless offset handles 300+ line screen color, but no color proofing system exists that is ideally suited for waterless printing. The features of the waterless process that challenge analog color proofing systems—fine line image resolution and minimal dot spread from film separations to the printed image—are ideal for digital proofing systems.

To fully capitalize on high-quality characteristics of waterless printing, a tactic called "sharpening up the film" uses finer screens to produce dots that are closer together, which could also lead to an increase in optical dot gain. To compensate, midtones should be fuller on the film to ensure sharper results on the printed sheet.

Waterless printing system limitations

Like other printing systems, waterless lithography has its limitations:

Substrate limitations: The waterless process is more compatible with stocks that have a high degree of paper strength. Although waterless inks have an initial tack that is comparable to or lower than conventional offset inks,

their running tacks are higher. To overcome the higher re-
lease factor of waterless inks, substrates with high surface
strength or pick resistance are recommended. Because ink
tacks are affected by temperature, it is recommended that
waterless inks be run below the critical toning level.

Plate durability/sensitivity: The nonimage area of the
waterless plate ia a two-micron coating of a silicone rubber
material. This surface is not as resistant to scratching or
abrasion as anodized aluminum. Waterless plates require
careful handling in delivery to press and in mounting on
press. Plate life will be shortened when running more
abrasive stocks. Because the nonimage area of the plate is
softer than the polymer in the image area, the plate will
tend to wear or become ink-sensitive in the nonimage area.
The more durable positive plate is recommended for use
with more abrasive stocks.

Paper dust concerns: The waterless process requires ad-
ditional attention to dust control. With conventional litho-
graphy, the dampening solution tends to lubricate the
plate, removing foreign particles. With waterless plates,
the paper dust sticks to the plate, resulting in hickeys,
which are costly in terms of both productivity and quality
control. The solution is to keep the pressroom as clean as
possible (which is a challenge) and use varieties of stock
that produce a minimal amount of dust.

RELIEF PRINTING

Relief printing processes work on the same principle
as a rubber stamp. Ink is applied to the raised portions of
the printing image carrier, and is then transferred by pres-
sure to paper or some other substrate. Letterpress and flex-
ography are relief printing processes. Letterpress printing
uses a rigid metal or plastic printing surface and a highly
viscous ink. Flexography uses a soft rubber or plastic
printing surface and a fluid ink.

LETTERPRESS PRINTING

Letterpress originated with the invention of movable
metal type in the middle of the 15th century and was the
primary mass printing process for five centuries. In the

mid-20th century, letterpress printing lost its popularity to lithography. Letterpress "plates" were originally prepared by assembling thousands of pieces of metal type plus raised metal engravings of pictures, artwork, and other relief images. Ink was applied to the raised areas of the metal and then transferred under pressure to paper.

After the 19th century, one did not print directly from the composed metal pages. Duplicate letterpress printing plates were made from a plaster or papier-mâché mold of a page form, and a metal duplicate called a stereotype was cast. Stereotyping provided a one-piece printing surface that could be used instead of the original metal relief elements. Curved relief stereotypes are still used on rotary letterpresses for newspapers.

Photopolymer plates

In the early 1960s, a new way of making relief printing plates appeared. A thick coating of photopolymer on a metal or plastic support was exposed to ultraviolet light through negative film that allowed the light to pass through to only those areas that transferred ink. The photopolymer hardened, or polymerized, in these areas, and the remaining unexposed coating was washed away with water or some other solvent. The result was a plastic relief printing plate.

FLEXOGRAPHIC PRINTING

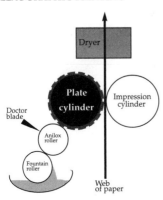

Flexography is ideal for printing on materials such as metallic foils and plastics. This process uses plates (originally made of molded rubber) that were impressions of the original relief surfaces, such as composite type forms and engravings. Rubber plates are then mounted on a single cylinder; each plate must be registered

in relation to the others. Photopolymer plate materials were introduced in the 1970s. With water-based inks used in flexography, toxic solvents are eliminated. Flexographic printing presses are simple in design because the fluid ink is easily distributed to the printing surface without a complicated inking system. Printing is usually done on rolls or webs of paper, plastic, or foil rather than on cut sheets, and the printed rolls are then converted into finished products, such as wrapping paper and packaging.

GRAVURE

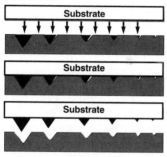

Gravure (also called rotogravure) uses an image carrier that is a smooth metal cylinder with an array of tiny recesses, or cells (more than 50,000 per square inch). The cylinder, which can be in excess of eight feet wide, is partially immersed in a reservoir of solvent-based fluid ink. As the cylinder rotates, it is completely covered in ink. A doctor blade running the entire length of the cylinder wipes the ink from the surface so that ink remains only in the cells. The ink is transferred to a moving web of paper forced against the cylinder under great pressure.

Gravure cylinders are usually made of steel with a thin surface layer of electroplated copper. The copper can be chemically etched or mechanically engraved to form the cells that will transfer ink. Once the cells have been created, the cylinder is electroplated with a layer of chromium to produce a hard surface for the doctor blade. Each cell transfers a tiny spot of ink to the paper and each varies in depth from each other, causing the density of the resulting ink spots to vary. This enables gravure to print a wide range of gray tones and render excellent color reproductions of photographic originals, even with lower than average resolution (about 300 dots per inch).

Color printing is accomplished, as with other processes, by using separate printing cylinders for the cyan, magenta, yellow, and black inks. The web is transported by rollers from unit to unit and can print at speeds of about 3,000 feet per minute. After each color is printed, the web passes through a dryer, where the solvent base of the ink is evaporated. The solvent is either reclaimed or burned to produce energy. Gravure printers have now also begun to use water-based inks.

The cost of a set of gravure cylinders has restricted the use of gravure printing to long-run jobs (millions of reproductions) such as mass-circulation periodicals, mail-order catalogs, and packaging (and even wallpaper and floor tiles). The manufacture of gravure cylinders using computer-controlled electronic engraving machines has reduced the time required to prepare a set of cylinders, but they are still far more expensive than lithographic image carriers.

Intaglio printing is related to gravure in that it employs engraved flat or rotary printing surfaces of steel to print currency, bonds, stock certificates, and high-quality business stationery. Ink is transferred from engraved recesses on the printing surface directly to paper. Intaglio printing reproduces artwork with fine lines and small solid areas, but cannot be used to reproduce photographic images or large unbroken solids.

SCREEN PRINTING

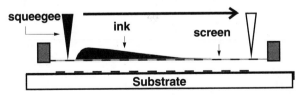

Originally called silk screen printing because of its stencils, screen printing is used for signage, printed circuit boards, plastic containers, and printed garments. Stencils had been produced photomechanically, but now digital techniques are being used. A fine fabric or metal mesh is

stretched over a rectangular frame, and a photopolymer coating is applied. Exposure of the photopolymer through a film positive causes it to harden in the areas that will not print. The unexposed material is washed away to create the open areas of the stencil. This screen is pressed against the substrate to be printed, and ink is forced through the open areas of the stencil with a squeegee. Screen can print on practically any surface, including paper, plastic, metal, and three-dimensional surfaces.

Electrostatic plates were the beginning

These plates are used for short-run printing on duplicator offset presses—the platemaker is essentially a fancy copying machine. The original or master copy is placed on a copyboard and exposed through a lens to the paper or plastic material. The exposed plate material is automatically advanced, processed, and ejected from the device, ready to load on a duplicator printing press.

This technology, which was introduced in the 1960s, helped to create the quick printing business (also aided by the high-speed copier).

Platemaking became electrophotographic. As with copiers, a photoconductive layer is charged electrostatically (like static electricity), either positively or negatively. The polarity of the charge depends on the type of photoconductive insulating layer. When exposed, the areas of the coating subjected to light lose a portion of the charge, depending upon the intensity of the light illumination. The variation of the amount of charge retained on the coated plastic, paper, or metal plate creates an electrical pattern of the image.

The image is made visible by spraying the image area with charged particles (toner), which carry an opposite charge to the initial charge applied to the plate and insulating layer. The toner adheres to the areas that have retained the charge. The toner image is then fused onto the sheet by heat and pressure.

The result is a plate made in minutes with good quality levels; run length is moderate. These plates were used on Multigraphic, A.B. Dick, and Davidson presses.

INK JET PRINTING

Continuous

A computer-controlled array of ink nozzles produces images on a moving sheet or web of paper. There are various methods for controlling the stream of ink droplets. In the *continuous* approach, electronic deflectors position the drops. Another method spits out the ink only as it is needed. Ink jet spits the ink at the paper; bubble jet technology sort of drools it onto the paper.

Drop on demand

Simple ink jet printers are used routinely to print variable information such as mailing labels, and are sometimes installed on the end of a conventional printing press or bindery line. Sophisticated color ink jet printers are also used to produce high-quality proofs.

ELECTRONIC PRINTING

Traditional printing processes employ a fixed image carrier (plate) that transfers the same image of ink to the substrate during each rotational cycle of the press cylinder. Mechanical ink transfer allows these processes to operate at high speed. Because of the cost of making a set of plates, mounting them on the press, and running the press until the printing is in register and colors are correct, these processes had required fairly long press runs to be economically feasible, although printing systems have become more capable of shorter runs. For very short-run printing (less than 3,000 copies)—especially of highly variable information—electronic printing processes are the most applicable.

Electrophotographic printing

Electrostatic copiers have an image carrier surface that is coated with a photoconductive material such as selenium or cadmium sulfide. A photoconductor acts as an insulator, retaining a charge of static electricity. Areas of the surface illuminated by reflected light or by a laser become conductive and lose their charge. The remaining areas retain their charge, attracting oppositely charged particles of colored toner, which is then transferred to a piece of paper or plastic using electrostatic forces rather than pressure. Some color electrophotographic printers can reproduce color originals with image quality approaching that of offset lithography.

Desktop publishing

In the late 1980s, a virtual revolution occurred in typographic communication with the advent of desktop publishing (DTP) technology. Driven by the plummeting costs and miniaturization of semiconductor electronics, affordable personal computers originally developed for word processing became capable of preparing publications from very basic to very sophisticated. When prepared with appropriate layout software, a graphic designer could create sophisticated layouts, choose from thousands of typefaces, arrange the pages according to predefined formats, or change them interactively on the screen of a low-cost personal computer.

Once prepared to their satisfaction, the page or document file could be output from laser printers for low-cost proofs or electronically transmitted to a commercial printer which would set its imagesetter to lay down raster lines. This electronic preparation is carried out by a Page Description Language (PDL). A PDL provides exact instructions to the laser on where to apply the dots on output that build up a series of type characters, line art, and pictures.

The laser printers were generally low-resolution 300 dpi devices, not adequate for professional requirements. The PDLs also linked the computer to high-resolution photo imagesetters so that high-quality film for high-quality printing could be done.

DIGITAL PRINTING

The relationship between traditional printing and electronic printing is complementary and competitive. Digital color printing processes are increasingly used to predict the appearance of images before they are processed into films and plates for lithography, gravure, or relief printing, thus reducing the likelihood that changes will be necessary after the job has reached the press. In addition to this proofing function, they are also used for the reproduction itself.

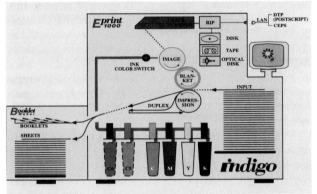

Copier duplicators versus offset

Offset duplicators will normally print on 8½" x 11" and 11" x 17" and related size sheets, as do copiers. There is strong competition between the two processes regarding speed, quality, and economics. There are also offset *presses* in that size range. There are technical differences such as the number of form rollers, registration system, and so on. Except for offset printing personnel, most people only need to know that the press is capable of printing much higher quality on complex work. This is brought out because the author believes that a press is also capable of producing higher quality than any copier-duplicator, including digital. The following comparisons are between offset duplicators and high-volume copiers, including those called copier-duplicators or duplicators.

1. Quality should be checked for true solids, halftone (photograph converted to dot patterns to produce details) reproductions (including maximum screen ranges), fine line detail, ability to hold faint images, and general overall quality. Ideally, this comparison should be made several weeks after the last maintenance. Both options may be excellent at the time of maintenance, but what are their relative qualities after that?

• Either process will do an excellent job on general linework (type, graphs, etc.) with the exception of letterhead, where the offset process is more professional.

• Digital copiers, particularly 600 dpi, will be superior to average offset duplicator work. However, if the offset duplicator operator is highly skilled, then we prefer offset duplicator work. Analog copiers are third.

• Copiers can print solid coverage over a much larger area because they are not limited by the ink roller constraints of the offset process. Appearance over smaller solid areas is a matter of preference.

• Copiers are the clear preference on many combination jobs, such as a heavy solid adjacent to a fine line. To the copier, it doesn't matter. Offset duplicators have problems balancing the two.

2. Operator skill requirements are greatest with an offset duplicator, but the high-end digital copiers with their many capabilities also require considerable skills.

3. Paper variety is clearly in the offset duplicator's domain, because they can run both lighter and heavier stocks.

4. Machine costs depend on quantity and number of pages. Specifically, the offset process has higher initial costs, but lower per-copy costs. Eventually, at a certain quantity, printing becomes more economical.

5. Operator costs strongly favor the copier because the lesser skill requirements usually mean lower wages. Perhaps of greater importance is that it is common for one copier operator to run two copiers. We have seen one operator run three machines, but productivity will be lost unless two of the machines don't require much operator intervention and the copiers are laid out properly. Most offset duplicators need one person for one machine (al-

OFFSET
DUPLICATION (ON PLATE)
VS
DIGITAL COPYING

though we have seen one operator run two machines), but
at least one must be running quantities of 5,000 or more
where the operator has an hour or so between printing
plate changes. Otherwise there will be too much idle time
for one of the offset duplicators.

6. Speed in terms of first copy time will always favor
the copier, because no printing plate has to be made; there-
fore, the copier can have the first copy reproduced in sec-
onds. Some of the automated in-line paper master-to-offset
duplicators are not too far behind, but when making a
printing plate which requires a negative, then even a per-
son dedicated to the task will require close to 30 minutes to
produce the first copy. Likely more important is that the
high-volume copiers have an *interrupt* feature which re-
quires minimum time and bother to produce another job,
even if a different paper is involved. Under the same situa-
tion, the offset duplicator will encounter considerable
problems, including putting the original job's printing
plate back on the offset duplicator.

Comparison
If both are running 8½" x 11" sheets with copy on only
one side, then it is speed versus speed. The fastest offset
duplicator, which is *not* a best seller, is faster than the
fastest copier. The fastest common high-speed copiers nor-
mally will outproduce the commonly found offset duplica-
tors *as long as both are running 8½" x 11" sheets*. If any
deviations occur and the offset duplicator has the capabili-
ties, then the offset duplicator will outproduce the copier.
The reason is that any deviation from an 8½" x 11" sheet has
a major impact on copier speed, but minimal or none on
the offset duplicator. For example, a very high-speed copier
may have a rated speed of 8,100 copies of 8½" x 11" one-
sided sheets per hour, but if you change that to 11" x 17"
copied two sides, the rated speed drops to 1,740 sheets per
hour. A duplicator with 11" x 17" duplexing (printing two
sides in one pass) capabilities will produce at the same
speed and likely average more than 6,000+ 11" x 17" sheets
per hour. Speed then must be calculated on quantity plus
sheet size and number of copies.

Copier versus offset cut-off points

The offset process requires the making of a printing plate, which can vary in costs, including labor:

1. From less than 25¢ when making a *paper master plate* in a process similar to making a copy. Some copiers can make paper masters. Some copiers can also be used to make a paper master plate for subsequent printing.

2. Through several dollars for a direct-image plastic plate.

3. To possibly more than $10 for a negative and a metal plate.

Copiers do *not* need an intermediate step to produce copies. At this point, copiers have a decisive cost advantage. Once running, though, printing ink and chemistry will cost less than 10% of copier ink and chemistry (toner), and offset has no meter click charges, as most copier plans do. Simply put, offset duplicators cost considerably more to get the first copy, but each additional copy has a lower *unit* cost than the copier. The basic formula for one sheet (one or two pages) is:

$$\frac{\text{(Offset Pre-Run Costs – Copier Pre-Run Costs)}}{\text{(Copier Running Costs – Offset Duplicator Running Costs)}} = \text{Breakeven Point}$$

It follows, then, that the breakeven point would be directly related to the platemaking processes. For example:

1. Offset duplicator pre-running costs are $0.24, including paper master cost, transfer of the master to the plate cylinder, and an average of three sheets of paper before the the first good copy is achieved.

2. Copier scans in the copy when the copier is running, which is no pre-running cost.

3. Offset duplicator has ink and chemistry costs of $0.0002.

4. Copier has chemistry and meter click total charges of $0.0062.

The cut-off point calculation is:

$$\frac{(\$0.24 - \$0.00)}{(\$0.0062 - \$0.0002)} = \frac{\$0.24}{\$0.0060} = 40 \text{ copies}$$

Thus, 40 copies is the breakeven point. More than 40 are more economically produced on the offset duplicator. Less than 40 copies belong on the copier. Exactly 40 copies is a *wash*. This, of course, is provided that either option can meet the quality and service requirements without any overtime.

Interestingly, if only the metal plate option exists, the formula is *not* necessarily applicable. For example, suppose the metal plate option costs $10. Using the formula per se with the same running cost differences produces:

$10/$0.006 = 1,667 copies

Conceptually, then, printing becomes more economical at 1,667 copies. In reality, if the film and metal plate cost $3 and no overtime is involved, then the thinking may (and likely should) be in terms of *real dollars leaving the organization.* This would equate to:

$3/$0.006 = 500 copies

If it is 1,667 copies, then $10 leaves the organization and goes to an outside copier vendor. If the offset duplication option is employed, then $3 (actually $3.33) goes to outside vendors, with the remaining $7 staying within the organization.

Is 500 copies or 1,667 copies the correct breakeven point? Most copier vendors will tell you that 1,667 copies is correct, because they treat *internal* and *external* money the same. The author believes that they are quite different and would lower the breakeven point according to workload circumstances at the time.

If the operation typically produces 50 or more copies of a single sheet, it is worthwhile to investigate copiers that use intermediate masters. In essence, the machines have an initial master cost, but the per-copy costs should be lower than any copier option. The machines employ digital technology and are PostScript compatible. They fit into the office environment, where printing presses clearly do not, with speeds comparable to the fastest copiers and monthly ratings of 500,000+ copies. Duplexing is manual.

Multiple-page copier versus offset cut-off points

When the economics of multiple-page work are considered, formulas still apply, but they must be coupled

with common sense. In the previous section, the example paper master cut-off point equated to 40 copies for single-sheet work. Once multiple pages are involved, then the types of binding and the available equipment must be considered. For example, if the job:

1. Delivers 8½" x 11", flat, collated sets, such as loose-leaf or comb binding, and the printing option is coupled with sufficient sorter bins, then the primary difference is pulling out of many bins versus one copier location. The printing option has a minimal time and inconvenience increase over the copier. The cut-off point may increase to 50 copies. If stapling is involved, this must be done off-line with the printing operation, but on-line with the copier option. Dependent upon plant layout, the additional time may increase the cut-off point to 75 or 100 copies.

2. Were the same as above, but all collating were done off-line, then the decision is one of collating capabilities. On many collators, the job can gather more than one set per cycle, depending on the number of pages and pockets available. For example, if the collator has 50 pockets and the job has 14 sheets, it may be able to gather three sets (50/14) with each cycle.

3. Is saddle-stitched, some copiers can do the job on-line, whereas others require an off-line operation. The key considerations are number of pages and quantity. A press which perfects 11" x 17" sheets will require 20 to 30 minutes for each four-page form, depending on camera size, platemaking capabilities, and operator skills. Material costs must be added to this time. Once running, the press is producing approximately four times as many sheets-per-hour as the high-speed copier and at a lower per-copy cost, even though copier companies generally treat 11" x 17" sheets as one meter click (same price as 8½" x 11" images). The other consideration is that the copier will saddle-stitch at full machine speed, so it makes no difference to the copier whether it is binding 8-page or 40-page booklets. The off-line saddle-stitcher may produce 50% more 8-page booklets per hour than 40-page booklets, but in terms of total pages, it is much faster with 40-page booklets, perhaps three or four times faster. Of course, if the booklet has

a separate cover and the copier has no practical means of feeding the cover, then the copier option is likely out unless the quantity is quite small—then manually inserting the covers may be a viable option.

Copiers generate heat. This will cause problems if inks such as rubber base are used, because the ink will melt. Unlike the relative simplicity in determining the single-sheet cut-off point, multipage cut-off determinations require visualizing the procedures and costs of various alternatives.

REMEMBER THE PRESS

Most color reproduction problems must be solved before they get to the press. It makes no sense to keep a million-dollar piece of equipment idle because the job was not reviewed or produced properly. These problems result because page files are produced electronically without regard to the limitations of the printing process.

A page image may look beautiful on screen and even proof from a thermal printer with ease, but neither of these steps will assure proper reproduction with ink and paper. Only the knowledge of the originator or the service that works with them can produce jobs that can run effectively.

The first step is for the originator/designer/computer artist to consult with the printer and/or prepress service to make sure that problems are not being designed into the job. Rough sketches and dummies allow feedback about any potential layout problems—perhaps certain spreads or bleeds could be handled differently.

Because press sizes and capabilities vary, it is usually a good idea to know the printer and its equipment before you start. Designing and producing for a theoretical printing press is dangerous.

Always be sure to review the printer's imposition to see how the job will run on the press. Be especially aware of which pages follow each other through the press. Whatever ink density is needed by the first page in line will influence the ink on the pages following. If a page with a heavy cyan area is followed by a page with virtually no ink, there may be a bluish ghosting effect, or streaks on pages down the line.

TIPS ON MAKING PAGES WORK ON PRESS

1. Design the printed piece to take advantage of standard press and paper sizes—special-sized paper will cost more and is more likely to encounter problems on press. Allow space for the "gripper" that grabs the paper and pulls it through the press, as well as an area for crop and registration marks, color bars, and other test images.

2. The printer will specify which prepress proofs are acceptable. There will usually be a primary selection and some alternatives. If you or your prepress service are planning to use a proofing system that is not on the printer's list, make sure to review it. Proofs from office printers are not adequate.

3. Try not to have photos running across the page gutter of a spread, except in the center spread—it is difficult to align the different parts of an image and maintain consistent color when each side has been printed on a different page, and even more so when the two sides fall on different signatures.

4. Watch reverse type. It should be sans serif and large—at least 10 points, although this varies with the press and paper, to say nothing of the font. Thin fonts fill in easily or get lost in the background.

5. Avoid designs that demand perfect trim. No press is perfect, and trim sizes cannot be held exactly.

6. Be especially careful when overprinting type on a four-color or tint image. Avoid busy areas in photos. The white or color of the type could get lost in white or color areas of the image.

7. Reproduce all thin lines, boxes, very small type, and rules in *one* solid color only. Keeping these lines registered in two, three, or four colors can cause problems. Remember, if registration is off a few mils on a mechanical device, it is not a pretty sight.

Diagnostic tools

Color bars are best. This standard test image has star targets, slur targets, and doubling targets, which show the

REPRODUCTION PROCESSES 47

condition of the printing dots. There is also a numerical indication for reviewing dot gain printing across the sheet. The other printer's tool is the densitometer, a device for measuring the ink density on the printing sheet. Many of these devices are computerized and highly sophisticated. Although the color bar is the testing device, the densitometer is the means to measure the results of the test. These tools work in conjunction with each other.

Color printing standards
The standards movement was initiated by magazine printers and publishers because they work with film from various advertisers and their agencies, combine that film with editorial film, and then print the entire job. The extremely wide variety of film sources and manufacturers led to a correspondingly wide variety of film formats and quality levels, making the printer's job nearly impossible.

Publication printers, advertising agencies, color separators, and publications developed and began to meet SWOP standards. SWOP stands for Specifications for Web Offset Publications. Commercial web printers and high-quality sheetfed printers produce their own spec sheets, which detail how they want the film prepared. We are only now developing such standards for digital files.

Printing variables
You must know how you are going to finish the printed piece before you start it. Pages must be imposed on larger sheets with proper margins, gutters, and alignment marks. You must know the printing process.

Here is a list of many of the variables that affect the offset printing process:

Quality of input material
- Type of film used for original
- Sharpness and detail of images
- Quality of scanning process and resultant image
- Limitations of scanner
- Scanner adjustments
- File structure of digital file

Screen angles used
- Undercolor removal applied
- Screen ruling level applied
- Grayscale
- Middle tone shift

Paper
Opacity
Color
Porosity
Absorbency and uniformity of absorption
- Moisture content
Smoothness
Roughness (texture)
Gloss
First surface and internal reflections
Elasticity
Impression tolerance
- Paper compressibility
Thickness/caliper
Surface
- Chemistry of coating /sizing
Paper size and trim
Waste

Chemistry
pH
- Alkali
- Neutral
Purity of water
- Acidity
Amount of water in ink
Amount of ink in water
Amount of water on plate
Balance and adjustment
Physical attributes
- Perceive line tones, hues
- Judge accurate register and alignment
- Make detailed adjustment
Disposal approaches

Ink
Opacity
Transparency
Ink fountain solution balance (except for waterless)
Ink emulsification
Gloss
Ink dryer composition
Tack
Viscosity
Dynamic viscoelasticity
Elasticity
Color sequence (wet ink trapping)
Ink formulation "properties"
Composition of the vehicle
Pigment and particle size
Ink level
Drying time
Setting time
- Single color
- Overprinted layers
Shift ink amount
- Volume of ink feeding
Balanced inks
- Grayness, hue, error, etc.
Temperature
Cohesion and adhesion

Paper
Grain
- Highlight
- Shadow
Image surface
Dot gain or loss
Variation in sensitivity
Ink holding and transferability
Paper dust levels

Press
Mechanical nature of press
- Adjustments

Packing of blankets
- Impression

- Squeeze out

Printing speed
- Impressions per hour
- Impression intervals
- Printing intervals

Machine construction
- Paper path
- Paper supply
- Double sheet detection
- Jam sensors

Composition of rollers
- Cylinder diameter
- Gears (degree of wear)
- Bearer to bearer settings
- Ink, train, cooling system

Printed dot gain

Deformation
- Slurring
- Doubling
- Offsetting

Printing units
- Number of color units
- Convertible
- Reset time

Perfecting
- Color capability

Printing sequences

Humidity and moisture effects

Static electricity

Water composition
- For fountain solution
- Water effects on halftone dots/trapping

Drying temperature
- Pressroom temperature
- Machine temperature
- Inking system temperature

Printing process
- Mechanical condition

Here is a general list of areas to check before and during your page creation:

1. Will the trim size of the finished document allow the best use of the signature sheet? A minor change in only one dimension could eliminate lots of paper waste.

With paper pricing at record levels and shortages of many grades of paper, it now more vital than ever before that you design and plan the job for optimum use of the paper sheet. Remember, paper comes in weird sheet sizes and your design should try to use as much of the paper acreage as possible.

2. What printing process and paper will be used? Set your halftone screen and dot gain accordingly for printed photographs.

How much dot gain is there on-press for a given paper stock? How much dot gain is expected on-press from the film stage to press sheet in the midtones? Printers might tell you the amount of dot gain expected from the proof stage to the press sheet, but this is an incorrect value to use. Coated stock registers a dot gain of 18% to 25% in the midtones. Dot gain for uncoated stock and newsprint varies from 30% to 40%. Because midtones register the greatest amount of gain on-press, Photoshop uses the gain in the midtones as a good indication of the gain that occurs over the rest of the image. If your printer is unsure of the dot gain value, use the default values provided for each type of paper stock in the Printing Inks Setup dialog box.

3. Will ink trapping be a concern? Older presses may not position colors as accurately as newer presses. This will affect your trapping values.

4. How many ink units are on the press? This will affect your ability to print process color (4-color printing) or to have unique spot colors. An eight-unit press would allow you to print process color, three spot colors, and a varnish, for instance. A two-unit press would require four passes of the paper through the press to do the same.
5. Will the paper you selected run through the press? Certain light-weight and very heavy stocks could be a problem. Work with the printer in paper selection so that it is

matched to the printing system. Some papers only come in certain sheet sizes, and this will affect your waste.

6. Will your film actually make plates the printer can print? Sometimes we output film at a service bureau and then bring it to a commercial printer. Are there registration marks? Color bars? Is the halftone screen one that can be handled? Are the tints at the right percentage? Do not get in the middle of a finger-pointing war as everyone tries to blame everyone else. Get all the facts and make sure all parties know about them.

7. Is your color optimized for the printing process? Each printing approach has different characteristics. You must set your color at the scanner or in an image manipulation program to match the gamut and other limitations of the printing process in use.

To generate a black separation plate, use either Undercolor Removal (UCR) or Gray Component Replacement (GCR). GCR generates black throughout the image (colors and neutrals), beginning in the highlights. UCR generates black mainly in the dark, neutral shadow area, thus holding shadow detail better. Choose the one the printer recommends.

The total ink limit the press can support is a vital piece of information. There are recommendations in these areas from SWOP, SNAP, and others. Use this information in your Separation Setup dialog box.

8. Did you make a simple dummy to make certain about the number of pages? We print in increments of 4, 8, or 16 pages in most cases. Is your page count a multiple of the one that will be used? Are you one page over?

Always remember to set your page size in the page layout program to the *actual* page size, so that trim marks will be accurate. Do not position your smaller pages on an 8½ x 11 page, for example.

9. How will the document be bound? If it is going to be saddle stitched, you must make allowance for the margins as the number of pages increases. Margins must be consis-

tent so that the paper cutter will not cut through live copy when the pieces are trimmed.

Did you plan your margins properly? You may have different formats for left-and-right hand pages. Are you sure that the pages will output so that the proper format falls on the proper page?

10. Double-check your page order to reflect the printing approach. If you are outputting to a digital printer, it may only handle two-page spreads. Make certain you have selected the spreads function for output. If you use "tiling" to output a larger sheet, make sure you turn tiling off for output to the imagesetter.

11. Halftone line screen is affected by paper type and printing process. You can achieve a 400-line screen with waterless printing on coated stock. With offset lithography, it may vary by press and printer.

Determine the screen frequency potential of the press. The screen frequency may also vary depending on the plates. A higher screen frequency may be more expensive and directly affects the resolution of the scanned image. In general, the image resolution must be 1.5 to 2 times the screen frequency at which the image is printed—but watch the reproduction ratio. Many images are reproduced at a size larger than the scanned size; in that case, higher scanning resolution is imperative. For example, if the press can support a 150-line screen, you won't need an image resolution greater than 300 pixels per inch (ppi)—assuming same size reproduction. A higher image resolution does not provide better results and generates a much larger file size. A lower resolution for your image may create pixelated images.

12. Did you discuss retention of the film by the printer? Under trade customs, the printer owns the film and plates if the printer produced them as a part of the job. You may wish to have the printer store the negatives for a possible reprint. Is there an additional charge? Because negs are specific to a sheet size and press, they may not be usable

by a different printer with a different press. Trade customs are usually printed on the back of the printer's estimate or proposal form.

13. Experience is the best teacher. Ask lots of questions and try to get many demonstrations of how jobs flow through a printing plant.

Do not hesitate to ask your printers about every aspect of the job. They can guide you in selecting and modifying images that print well.

CHAPTER 2

PREPARATION PROCESS ELEMENTS

It all started with the mechanical. Art and design professionals assembled the various page elements on a paste-up board. They had the type set, by whatever means, and printed out on photo paper as black type on a white background. This allowed them to paste the type on the paste-up sheet in the proper position for each page.

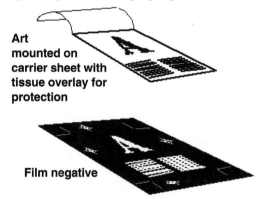

Art mounted on carrier sheet with tissue overlay for protection

Film negative

MECHANICALS

Line art was reduced or enlarged to the proper size via a *stat*—a photographic print—that was also pasted in position. Black-and-white photographs were marked up with either tissue overlays or margin guides for cropping. A black (or red) box was pasted on the mechanical so that the entire entity could be photographed to a film negative, where the box would eventually become a clear window for the picture, which was shot separately and screened.

Color images were sent to a color separator, where they were separated into four or more films from which a proof was produced. This was indicated on the mechanical. Areas of the artwork with tints or spot color were indicated with a tissue overlay, or by means of a black (or red)

mask cut to the size and shape required and assembled into position.

Camera processes

This entire entity, consisting of the mechanical (or pasteup or keyline) and the accompanying artwork, pictures, and films/proofs, was provided to the printer. Each element was photographed with a graphic arts camera to produce negative film. The resultant films were stripped into position on a sheet, merged with separated films or supplied films, and exposed to proofing material that had a blue cast to it and was called a *proof* or "blue line."

At this point, the artist, designer, and customer saw, for the first time, the piece as it would finally appear.

Camera-ready art

All of the preceding materials were referred to as "camera- ready art" because it was prepared to be photographed to film—and film was the basic building block of the printing process.

Computer-ready art

"Computer-ready art" is an all-inclusive term which describes the creation, integration, and revision of art, graphics, and page design for inclusion in promotional, presentational, document, and publication materials. The growth of electronic pagination as a part of word/page processing and electronic/desktop publishing has increased the integration of text and graphics. Most of these technologies have concentrated on text solutions (with the merging of art) and most are now addressing the art and graphics solution (the creation, revision, and integration of art).

All print-oriented materials must be graphically designed—that is a layout is made indicating the position of text and art elements. This function has traditionally been performed by creative professionals, called graphic designers, art directors, or illustrators, who applied minimal technology. Design and art instructions were then "translated" and implemented by production specialists for prepress operations and reproduction.

There are still users who cannot realize the full bene-
fits of electronic publishing because art and graphics are
not fully computerized. It is essential that art and design
professionals create and produce digital art if we are to
have the digital pages needed for new digital prepress
and printing technology.

Computer-ready art represents the merging of exist-
ing technologies coupled with specialized software at the
applications level. Electronic publishing deals with the
production of pages and electronic art deals with the pro-
duction of art, graphics, and design. Although there is sig-
nificant overlap in functionality, creative professionals
should not consider their tasks production-oriented.

Graphics

The advent of the personal computer, and especially
higher resolution approaches to affordable color, linked to
high-performance printout technology, makes it possible
to provide new tools for the almost one million art and
page professionals in the United States. As technology ad-
vances, electronic art capability will be brought to an in-
creasingly larger base of users.

Graphics is, unfortunately, an all-inclusive term for
many levels of nontext elements. Let us explore the entire
range to put the subject in perspective.

Text: Let us remember that there are two aspects to
text: the characters or symbols that you see and the codes
or commands that determine the typographic aspects of
the way you see them. Desktop programs let you see your
type as type, style sheets, and palettes; and other tools
(menus, dialog boxes, keyboard codes, etc.) allow you to
define the typography you desire.

Text is produced in word processing programs and
flowed into page templates and designs. Style sheets and
other approaches let you format the text typographically.

Tabular: Part of text, but not easily done when work-
ing with proportionally designed characters. You just can-
not use blank spaces to align items as you did on a
typewriter. Some systems have more trouble with tabular
material than they do with "graphics."

Equations: Multiple-level equations are as difficult as the formulae they present. Usually programs must be designed to handle equations, and character sets must have superior/inferior, Greek, mathematical, and special symbols. One could include chemical composition here as well, although it overlaps the category called line art.

Rule lines: Horizontal, vertical, and diagonal. Horizontal rules were easy, since they were produced as a dash repeated along the line, but vertical rules were more sophisticated. Today there are line tools in virtually every program for any kind of line.

Boxes: These are horizontal and vertical rule lines that meet at the corners. You can change line weight, color, shade, and even the shape of the box. Of course, these entities can be round or square or even polygons, and the outline rules can be sophisticated borders.

Shapes: These include circles, polygons, and freeform shapes. Polygon capability is expanding to allow outlining of images.

Electronic art

Bitmapped graphics: Paint programs produce slightly blocky, dot matrix kinds of images. The techniques used in creating the images are more like painting than drawing. Seurat's pointillism, the form of impressionist art in which pictures are constructed of dots of paint, helps to illustrate this approach to graphics. Your computer screen builds images the same way that dot matrix and bitmapped graphics printers build them. Every image is actually made of collections of picture elements, or *pixels.*

Business graphics: Include visual representations of quantifiable data. The capability to create these elements may be integrated in the program, or interfaced from other programs that only produce business graphics, or from numeric data in spreadsheet programs which is translated into the chart or graph. Business graphics programs create charts and graphs. Some can use spreadsheet, database, or project-planning programs to generate the information presented in the charts. These programs display numeric values in different visual forms.

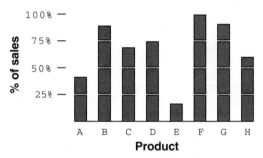

Typically, these are pie charts, bar charts, x-y-axis charts, or specialized presentations. They are generally used for presenting financial or marketing information. Their primary importance is in the way they illustrate business information. Charts and graphs can often tell a story much faster than text.

Line art (raster): Another general term that includes drawings made up of pixel elements, either created on the system or brought into the system via a digitizing scanner. Bitmapped data is not as modifiable as vector data.

Line art (vector): Usually associated with drawing program data. It refers to drawings produced on a system directly or scanned into a system and converted to vector form so as to allow sizing or other changes. Vectors are like little electronic rubber bands that connect the edges of an image as dots that make up a drawing. They can be changed in size or orientation.

Art systems use either bitmapped and/or vector images. Most digitized printers and imagesetters store font

information in vector form. Vector images contain less information about the objects they represent, and storing vector data is a lot simpler than the pixel-for-pixel approach of bitmapped images. Draw programs create graphics that are more like pen-and-ink drawings and use drawing techniques similar to those of traditional illustration. Because of the flexibility of vector images, all type is now vector-based. This allows the creation of typographic variations based on weight, width, and optical size, as shown in the following sample dialog box.

Design and illustration programs include features specifically designed for high-quality line-art production. CAD/CAM programs are different from draw programs, although they have all the features of draw programs. They deal with automatic dimensioning, object rotation, hidden-line removal, and movement the viewpoint through layers of an image. CAD/CAM software can take images already created in an engineering image library and convert them.

Vector data takes up much less space for simple images like type letters; only the boundaries between black and white are needed. Photographs cannot be vectorized because they contain grayscale data at every point. In fact, for very complicated line art, it is more efficient to scan the raster image than to digitize every possible vector point.

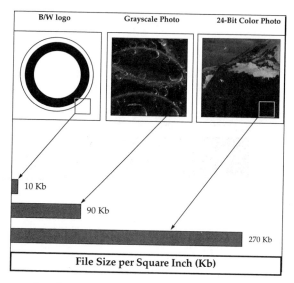

| B/W logo | Grayscale Photo | 24-Bit Color Photo |

10 Kb

90 Kb

270 Kb

File Size per Square Inch (Kb)

As shown here, the type of image determines the amount of storage required. A logo is usually a vector file and relatively small. Grayscale images require data for each pixel, and color images require three or four times as much data as grayscale.

RASTER IMAGE PROCESSING

A raster image processor or RIP is a computer subsystem that takes raster data, vector data, and text data and "maps" it to a block of computer memory that, bit-for-bit, represents each pixel element on the output device—one bit of memory per pixel. A memory bit set to "1" means print the corresponding output pixel as black (ON); a "0" means to leave it white (OFF). A bit map is like a large sheet of electronic grid paper.

A RIP maps the halftone bits for pictures into memory. It also takes vector information and converts it to raster by plotting each bit that should contain an image. Sophisticated RIPs take text data, process it through a font engine to get the properly sized and positioned letterform vectors, and convert those vectors to rasters as well. The result in

computer memory is a dot-for-dot representation of the page image ready to be printed, with type, line art, and pictures in place—a bit map.

Tints are treated here as a separate category, even though many of the preceding levels include the capability. Many systems now routinely handle blends or gradations between colors.

Photographs are handled by the conversion, via a digitizer, from continuous tone to digital form (or someday from an electronic camera). This category is sometimes called "image" to separate it from "graphics," which some consider to be line art only. There are limitations on both ends that affect the halftone screen resolution. Back ends (output devices) can be categorized with the 10% rule of thumb: take the resolution of the output device and divide by 10—this will give you the maximum halftone screen that can be output. A 300 dot per inch printer can output a 30-line screen, for instance. To output a 133-line screen, one needs about 1,330 dots to the inch.

The process of digitizing an image into raster format is called *image scanning*. In most image scanners, a beam of light moves across the copy in small steps. At each step, a photosensitive device called a photomultiplier registers the amount of light that is reflected from the copy. Simple scanners register a "1" if no light is reflected (meaning the image area is black) and a "0" if all the light is reflected. For higher quality applications, 24 bits of data representing the intensity of the light for each color are sent to the computer for every single point read by the scanning beam.

In scanning type characters or line art, the computer converts the intensity reading to all black or all white. In scanning photographs, the intensity readings represent the gray scale for each pixel scanned. Color photographs are scanned by filtering the light and assigning tone values to

the individual intensity readings to compute the color properties of each pixel.

Editing pictures electronically via image processing is maturing, a lot like word processing evolved, except that the computer handles images instead of words. In the process of digitizing copy for a computer system, some slight degree of image degradation usually occurs. This relates to problems caused by the digitizing process itself. If the resolution of your scanner is too low, for example, you won't pick up all the pixels needed to exactly reproduce a piece of art. Or if the image you're digitizing has an edge that's 53½ pixels wide, that edge must be shortened to 53 pixels or lengthened to 54 pixels, because a pixel is the smallest unit the machine can process.

In addition to cleaning up bad scans and fixing vector distortions, image processing systems make it possible to use the computer creatively, to alter the scanned image or to create entirely new variations on a stored piece of artwork. Some of these systems are quite complex, and their use as creative tools will expand as their cost comes down.

Emphasis color is the ability to define elements that will be printed in solid or tinted colors, called "spot" color in the printing world. Many copiers are now providing a second color capability, and we expect laser printers to do likewise.

Process color is the mixing of certain primary colors to create the illusion of full color. Formerly reserved for very expensive systems that digitized photos or transparencies for makeup and manipulation of color images on a video display, personal computers are evolving to increasingly higher levels of color quality.

Because image processing capability is designed to be used primarily by artists, system designers have developed very sophisticated techniques for the user interface, the range of techniques that an individual uses to command the computer system. The latest image processing systems make very little use of the computer keyboard. Instead, they use light pens, pucks, or mouse pointers to pick commands from menus appearing on the screen.

Many systems incorporate the image acquisition process with on-line scanners. Sometimes an on-line interface to other computers is included, making it easier to transfer image files between systems. We make the mistake of thinking that we must always use the most advanced technology to solve our problems. We suggest that you use that part of advanced technology that does the best job—if doing so results in a hybrid system combined with traditional approaches, so be it. We see many potential users getting hung up on the subject of graphics and forgetting the original goal: getting the job done effectively.

Sizing is an elemental feature of image processors. Artwork can be made larger or smaller, either proportionally or in one dimension only. By adding to the pixels along the x axis while maintaining the number of pixels on the y axis, an extended image is created. Conversely, decreasing the x pixels while maintaining the y pixels creates a condensed image. This is *anamorphic distortion.*

In sizing photographs, it's easier to reduce than enlarge. You can always throw away pixels, but you can't add them if they haven't been scanned. For example, if a photo scanned at 500 pixels per inch is doubled in size, the resolution of the new image drops to 250 pixels per inch. In enlargements of more than 125% or so, rescanning of the artwork at the new size is necessary to maintain the reproduction quality.

More importantly, you can merge multiple scanned images and rotate the perspective of the copy. The software can often define the edge of an image to create outlines or masks, and you can drag images around the screen for positioning. Rotation uses a large amount of computer resources; for each degree of rotation, all the pixels for an image must be recalculated and remapped.

One can see that the term "graphics" may mean different things to different people. A clear definition of what is meant and what is required is mandatory.

CHAPTER 3

COLOR REPRODUCTION

Mapping the world of visible color has been as difficult as mapping the geographic world. Recall your early grade school class that taught the various methods for displaying the earth and its continents. Displaying the oblate spheroid of the earth as a flat map distorts the world. So too, the color world is multidimensional and subject to distortion.

In the world of color we deal with fundamental variants that define a color:

Hue (also called the tone, tint, or tonality)—The qualitative variation of the color; how yellow, green, or cyan, for example, is the color. How green was *your* valley?

Lightness (also called value)—the relation of the color to white or black; that is, levels of gray or the intensity of the color (also called chroma). The dark at the top of the stairs.

Saturation—The purity of the color; the extent to which it differs from gray of the same value; how much hue is present.

Brightness—The visual sensation of an area emitting, transmitting, or reflecting more or less light.

The human eye sees reflected light radiation at each spot perceived through the human optical system and interpreted by the brain as color. The physics of the situation are simply that we can see a visible range between about 380 nanometers and 700 nanometers—wedged between the ultraviolet and the infrared.

Color is what the human eye sees, the result of interpretation by the brain of the stimuli received by the eye, depending on the nature of the light source and the object. Change any one of the three and the color is changed.

The visible spectrum contains trillions of colors. A color monitor can display millions of colors and a printing press can print only thousands of colors. The human eye

sees something in between. There is no universal standard for color. There isn't even a defined white.

Color space

A color space is a scheme for representing color as data. For flat colors, one familiar scheme is the proprietary Pantone Matching System, which gives unique numbers to hundreds of distinct hues. The Pantone system is not useful for describing scanned images, however, because the majority of colors in the image do not match any Pantone color exactly, but rather lie between them. Pantone has no mechanism for quantifying these "in-between" colors.

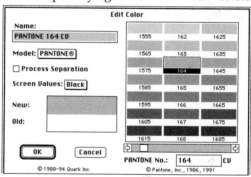

Thus, a color space defines color in three dimensions. Most are built with three coordinates, which explains the preponderance of three-letter acronyms: RGB, HSV, XYZ, and so on.

Maxwell's triangle

James Maxwell, a Scottish physicist, brought mathematical order to the search for a color model. In 1872, he developed a chart in the form of an equilateral triangle and suggested that all known colors could be located within this triangle. The Maxwell triangle identifies red, green, and blue as the three primary components of light, the primary colors at the corners of the triangle. These are the same colors that are the basis of television and computer color monitors. They are the primary colors of light, rather than of pigment.

In the center of the chart is white—the color produced by the combination of all components of the spectrum. All colors can be arranged within the triangle. As one moves along its edges, transitions are experienced: red changes to orange, then to yellow, and finally to green; green changes to blue; blue changes to violet, to purple, and back to red. Moving from the edge to the center of the triangle, the brilliance of each primary color is lost in a transition from full saturation at the edge to white at the center.

Maxwell superimposed grid lines, drawn parallel to each edge of the triangle, to establish a system of color notation. Any point within the triangle identifies a specific color sample, and was assumed by Maxwell to be definable by the quantities of the primary color it contains. This quantity can be measured by the distance from each primary color. In Maxwell's triangle, any point—any color—is defined by only two dimensions, the distance from point 1 and point 2.

Enter Munsell

The Munsell color system was developed in 1905 by Alfred Munsell as a means of expressing relationships between colors. Munsell was looking for a way to move from one color to another through a path of orderly, progressive steps.

The Munsell chart was developed through experiments in which subjects were asked to arrange color chip samples under conditions of constant illumination and surroundings. It consists of a color "tree" of these chips separated into "leaves" according to hue. Within each hue leaf, chips are arranged in a grid, with discernible progressions of chroma (saturation) along the horizontal x axis and discernible progressions of value (lightness) along the vertical y axis. Unlike the mathematically symmetrical grids of the typical lookup table, the resulting color space more closely captures the geometric irregularities of human visual perception. Each leaf is different because with in different hues, the number of discernible colors varies with degrees of value and chroma.

The Munsell system provides a straight-line progression of steps in equal increments along both chroma and value dimensions. This characteristic provides a natural foundation for color navigation.

Hue was defined by Munsell as a circle of hues. He chose to designate as primary colors red, yellow, green, and purple. These colors, together with their complements (yellow-red, green-yellow, blue-green, purple-blue, and red-purple), provide a 10-part division that reminds one of a decimal system. The hues are spaced equally around the hue circuit. By colorimetric measurement, they represent consistent steps of hue change in equal gradations.

Value—as Munsell called the second color dimension—is similar to lightness, though related to pigment, not light. Black and white form the vertical axis of the color model. This axis extends from absolutely pure white (the presence of all color) on the top to ideal black (the absence of all color) on the bottom. Although neither of these ideal poles is attainable in pigment, the steps between them are highly definable as grays. They are numbered from 1 to 10.

Chroma, Munsell's term for the third dimension of color, is similar to saturation, though to Munsell it related more to the amount of colorant present. It is in this definition of chroma that Munsell's color model differs substantially from previous proposals. Although the circle of hues includes all conceivable hues, and although the value axis is all-inclusive, Munsell realized that new colorants are constantly devised and that chroma is therefore open-ended.

CIE is born

In 1931, the Commission Internationale de l'Eclairage assembled in Cambridge, England, to establish a world standard for the measurement of color. By that time, modern instrumentation had made it possible to measure with fair accuracy the wavelength of any particular colored light. The commission took as its model the principles established 60 years earlier by Maxwell; it selected three standard colors, a particular red, green, and blue, with which to generate a version of the Maxwell triangle. The result was what is known as the CIE chromaticity chart,

which became a standard in the lighting industry for measuring the color of light. In 1976, the CIE chart was revised to create a more even distribution of colors. The revised chart, now indicating colors in "uniform color space," is the current standard for measuring the color of light.

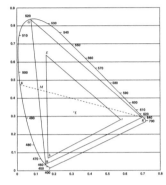

The diagram never defines white. Somewhere in the center of the diagram is the "white spot," that point where light from the three sources blends to form white light. Sunlight is one spot on the diagram and incandescent light another. This point is not fixed, as it is in the Munsell model, and is useful in describing the color of light from various light sources without implying a deviation from some established norm. The absolute white in the Munsell model is also theoretical.

The CIE chromaticity diagram, as a two-dimensional plot of hue and saturation characteristics, is a logical point for beginning computer color mixture. Values can be added to the chart by gradually reducing the intensity (brightness) of the light source until all light is removed and absolute black is achieved. The chromaticity chart becomes a three-dimensional color model: the CIE uniform color space.

The CIE system

The CIE system starts with the premise that the stimulus for color is provided by the proper combination of a light source, an object, and an observer. In 1931, the CIE introduced the element of standardization of source and observer, and the methodology to derive numbers that provide a measure of a color seen under a standard source of illumination by a standard observer.

In 1931, the CIE recommended the use of standard sources a, b, and c, which were soon defined at standard illuminants when their spectral power distributions were

measured. These sources and illuminants served the purposes of color technology well until the increased use of fluorescent whitening agents made it necessary to specify illuminants in the ultraviolet region more nearly representative of that in natural daylight.

The data representing the CIE standard observer forms is one of the most difficult concepts in the CIE system to understand. In an old experiment, light from a test lamp shines on a white screen and is viewed by an observer. A nearby part of the screen is illuminated by light from one or more of three lamps, equipped to give light of three widely different colors, such as red, green, and blue. These primary lights are arbitrarily selected but closely controlled. By adjusting the intensities of these lights, the observer can make their combined color on the screen match that of the test lamp. The amounts of the three primaries yield three numbers describing the test color, called the tristimulus values of that color.

Thus R, G, and B are the tristimulus values of the spectrum colors for this particular set of red, green, and blue primaries. In its 1931 recommendation, the CIE adopted the average R, G, and B data for a small number of observers as the experimental definition of the CIE 1931 standard observer. It was considered important to eliminate negative numbers among the tristimulus values. Therefore, a mathematical transformation of the standard observer data was made, representing a change from the original red, green, and blue primaries to a new set, which cannot be produced by any real lamps, called the X, Y, and Z primaries. The tristimulus values of the equal-power spectrum colors in the CIE X, Y, Z system provide the definition of the 1931 CIE standard observer in its most used form.

In 1976, a linear adaptation of the color space was performed to try to scale color numerical differences to correspond more closely to the visual color differences. The result was the CIE Uniform Color Space.

You have seen this chart that follows many times. It plots the available color gamut of what you can actually see and what machines can actually produce.

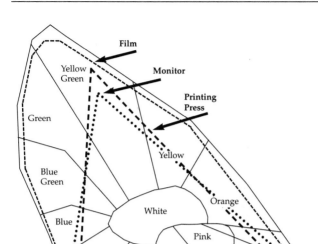

The CIE Uniform Color Space is associated with CIE-LUV colorimetrics. CIE-LUV is based on the theory that the eye and brain code colors into mutually exclusive opponent signals: light-dark, red-green, and yellow-blue. Red-green is plotted along the horizontal U axis, where positive values denote red and negative values denote green. Yellow-blue values are plotted along the vertical V axis. Light-dark values are plotted along the L axis, located perpendicularly to the U, V plane.

Although CIE uniform color spaces still present visual nonuniformities—a color that has the same coordinates may still not look like the same color—they are considered to be the best compromises available. They have been adopted by vendors as the basis for desktop color systems and for approaches to device-independent calibration.

Remember, the color gamut of scanners, monitors, printers, imagesetters, and presses is different enough that certain colors cannot reproduce.

RGB

The most elementary means of controlling color on a computer monitor is by rgb—specifying the percentage of red, of green, and of blue light required for each color. There is an inherent simplicity and logic to this. It corresponds directly to the internal arrangement of the computer; however, human logic and machine logic are two different things. It is extremely difficult to picture most colors based on a percentage of these three components.

With Munsell, the divisions of saturation (chroma) are arranged in visually constant steps. On other models, they are expressed as percentages of change from zero to total saturation. At the midpoint vertically, a uniform gray value is seen.

HLS

With HLS, each horizontal line is a percentage of saturation, a simple way of identifying colors to the computer, but a cause of distortion of the model; each step in the top and bottom rows represents a much smaller change in saturation than is to be found in the critical center row. For a designer, the HLS color model is an improvement over RGB. Seen on another computer, this model might look very different, illustrating a different color capability. Yet, because of the common reference, a given color would appear the same on each computer. Each would be referenced to CIE space. Using this principle, any computer monitor and printing device can be calibrated to the CIE standard.

Tektronix HVC

The HVC color solid is a proposal by Tektronix, Inc., based on the CIE diagram. The model is based on hue, value, and chroma, all familiar terms arranged in a familiar manner. The edge of the model is random, as it must be, for constant values are maintained at a uniform level; the maximum chroma of each of the six primary-secondary hues seeks its own value level. Values are constant on any horizontal line and saturations are constant on any vertical line. In reference to standard Munsell numbering, a standard red has been assigned to zero on the hue circuit.

The complication comes when the user adds a color printer to produce a hard copy of what is on the display. The user desires the color seen on the screen to be the color seen on the printed output. Although the video screen operates with RGB, most printers operate with cyan, magenta, and yellow (CMY) inks. (For simplicity we do not consider that printers often print a fourth, black colorant.) This is an example of the difference between illuminated, or additive, systems such as the video display and reflective, or subtractive, systems such as print.

Suppose that an area on the video display is illuminated at full intensity of red and no intensity of green and blue, represented by (1,0,0) in an (R,G,B) coordinate system or color space. (1 represents "full on," 0 to represents "off," and fractions in between represent "partial on," proportional to the fractional value.) Full red can be printed on the printer by overlaying yellow and magenta inks (yellow subtracts blue and magenta subtracts green, leaving red). However, red is not red, is not red. The red on the video display is determined by the phosphor coating on the inside of the glass display surface. The red on the printer is determined by the pigments in the yellow and magenta inks and by their effect when overprinted on one another. Also, there are many distinctly different colors which we would all agree are "red."

By varying the amounts of cyan, yellow, and magenta inks used on the printed paper, it is possible to obtain a red that much more closely matches the red of the display than can be obtained by doing "color arithmetic." Note that on a printer, like a thermal ink color printer, the inks are either present or not at each individual device pixel (no fractional amounts of ink). However, the halftoning mechanisms simulate, to the human eye, the effect of having fractional values of ink of each color.

In theory, for every color (R,G,B) that the monitor is able to produce, one could associate a color (C,M,Y) for the printer that gives the closest possible match. A monitor may be able to produce hundreds of thousands of visibly distinct colors, so a table of such values would be unmanageably large and practically impossible to generate by

any trial-and-error methods. This is an area where applications distinguish themselves from one another by inventing different approaches to converting the RGB values of the display to the CMY values of the printer, using smaller tables and interpolation techniques or by using computational formulas.

We classify the technique of developing a conversion method that maps colors from a particular display or class of displays to a particular printer or class of printers as a *pair-wise* calibration method. Getting a "match" between a video display screen image and a printed page can be extremely complicated. Variants in the halftoning technique will cause variations in the colors produced, so if the halftoning parameters are changed, then the color calibration must be redone in order to maintain color accuracy. The apparent colors on a video display are affected by the room lighting; even more so, the apparent colors on a printed page have as their initial light source room lighting reflected off paper and ink.

Device-dependent

When yellow is used on a CMY device, for example, the output is the yellow colorant provided by the device and its technology. Yellows will differ from each other because they are produced dependent on the device used.

Color monitors can generate an extremely wide range of colors involving different brightness and different saturation. This can be done by using only variable amounts of red, green, and blue. Color printing can generate an extremely wide range of colors involving different brightness and different saturation. This can be done by using variable amounts or variable spacing of three or four basic inks or colorants that appear, when printed individually, as cyan, magenta, yellow, and black.

The human eye detects color using three kinds of color-sensing cones (roughly red, green, and blue) not unlike a common RGB scanner in use with computer systems. It enables computer systems to represent colors by three (or sometimes four) simple intensity values. If we determined color by using the instruments of physicists, we

would have to have much more complex schemes. Color is and always will be an issue of human perception.

A color space is a particular system for measuring colors. The term "space" comes from mathematics, because the numbers can be thought of as forming a three-dimensional space. The RGB values used to produce colors on a particular monitor form a color space. The CIE 1931 XYZ system is based on what might be considered a virtual RGB scanner that acts like the human eye. It is defined by three color-matching functions which provide the definitions of the three color filters used. Nearly all color standards rely on this XYZ system.

Color in bits and bytes

One color space may be related to another color space by defining the conversion factors needed to compute one from the other. Because color spaces typically are based on triples, the conversions are not as simple to specify as for distance measuring, where one constant multiplier and its inverse are usually sufficient.

Suppose we have a particular RGB color space with values (R,G,B). A second color space, say YGB, with values (Y,G,B) could be defined based on the RGB space by defining y+r+g and leaving the other two components the same. We might call this a YGB (yellow, green, blue) system because the sum of red and green in the y component measures yellow. Any value in the YGB system can easily be converted back to the original RGB system by using the formula r = y − g. That is, because the YGB space has both yellow and green, the red can be recomputed by subtracting out the green from the yellow. Simple arithmetic can be used to convert from RGB to YGB and from YGB to RGB, so for most purposes, which space is used really does not matter.

Different color spaces are more or less suitable to different technical requirements, thus discouraging standardization. In spite of the fact that most color spaces proposed or used can be related by equations, there are reasons that prohibit simple conversion to or from all color spaces. Though in theory there are equations relating one color space to another, the practical aspect of doing the compu-

tations can introduce errors. It is unusual to be able to convert a picture in one color space to another color space and back again and end up with the original values.

The basic computer byte also plays an interesting role in color spaces. Computer systems process data in multiples of bytes, or eight binary digits. Most numbers are processed fastest if they are 8, 16, or 32 binary digits long. A 10-digit binary number usually takes as long or longer to process than a 16-digit binary number.

If we use one byte to represent each of R, G, and B in an RGB sampled image (24-bit color), each color component can range over 256 values of intensity. The number 256 is generally considered to be larger than the number of levels of intensity that the human eye and brain can distinguish. However, most physical measures of intensity do not have a linear relationship with the intensity registered by the eye/brain. That is, if the average person feels that one intensity is twice as "bright" as another, it does not follow that it took twice as much energy to produce it, or that there is twice as much light reaching the eye.

If we associate the 256 numbers of a byte evenly with 256 settings of a physical device, they do not look evenly spaced. Most of the numbers seem to bunch up on one end of the perceptual intensity scale. Even if we were hoping to have numbers for 128 levels on the other end of the scale, we might end up with 80, and that may not be enough.

The human system is much more sensitive to the intensity of the light reaching the eye than it is to color. This is especially true with respect to resolution. Intensity differences across a small area are more readily detected than differences in color within the same area. This has led to the design of color systems that try to separate the color and luminance into separate dimensions of the color space. For example, the first component, l, of the CIE l*a*b* color space represents luminance; the other two components, a and b, represent a two-dimensional color subspace. Because the human visual system is more sensitive to the l component, more binary digits can be allocated to it than to the color components, allowing even more effi-

cient coding of the color values. You can also provide more luminance samples than color samples per given area.

The simplest sets of color spaces are those that can be converted into the XYZ space using one 3x3 matrix. Each different 3x3 matrix defines a different color space. This set of color spaces contains those used by most RGB desktop scanners. Additional color spaces can be defined, such as the NTSC color television transmission standards and l*a*b, by repeating this decode and matrix structure a second time.

The original XYZ space doesn't map easily into the red, green, and blue values required to drive a color CRT. A lot of computational horsepower would get used converting into and out of RGB if the XYZ values were used for storage and interchange. Also, the XYZ space is not visually uniform—that is, a change of one unit in certain parts of the color space can make a much more conspicuous change than a one-unit change somewhere else.

A need for real standards

A variety of color spaces that are easier on humans (and, in some cases, computers) than the original XYZ have been developed. They are equivalent in terms of their ability to describe colors. The only problem is choosing one.

We need a standard way to tell the receiving computer which of the possible color spaces has been used. It can then convert the data to its internal space.

Conversions from one color space to another involve complex formulas and require lots of computational power. To a large extent, formulas can be replaced by lookup tables. The nearest values to the color being converted are looked up in the table, and values are refined by interpolation. This process is routinely used with CRTs. To use it with hardcopy devices can require much larger tables than those used for monitors. Getting acceptable results with a thermal printer, for example, might require a table of 4,000 entries. Tables far larger than that are implementable with today's computer processing, memory, and storage.

Relating these numeric schemes to actual devices—monitors, printers, and scanners—requires two steps. Each device has a gamut, which is the range of colors it can produce. Characterization defines what color ought to be produced by (or, when scanning, ought to produce) a given set of numbers. Calibration is a procedure to keep a device within the parameters specified by its characterization. Characterization is what a person writing a device driver or testing machines at the factory would do. Calibration is what the end-user must do periodically to compensate for the tendency of machines to drift out of adjustment. With proper software working with the correct characterization, and a machine that is properly calibrated, consistent and predictable color results are possible.

Process calibration means controlling the entire process from beginning to end.

Printing standards such as those of FOGRA, PIRA, and SWOP mean that a given set of CMYK separations can be produced that will give the same results in several different printing plants. In converting from RGB to CMYK in the color separation process, errors can show up as banding in the individual separations. But the banding is mild, and because the locations of the bands are different in the four separations, they are not visible in the printed output.

The eye does not always see what the colorimetric measurements say. Color perception takes the surroundings into account. If we want a color standard that truly describes what the eye sees, it will have to account for this.

Cyan:	0%	◁▱▱▱▱▱▷
Magenta:	0%	◁▱▱▱▱▱▷
Yellow:	0%	◁▱▱▱▱▱▷
Black:	0%	◁▱▱▱▱▱▷

Anyone who has had to specify flat tints using process colors is familiar with CMYK percentages. Any color that is printable with process inks can be specified by stating the screen percent of each ink required to represent the color. Data contained in scanned images can also be stored as CMYK. For each pixel, there are four bytes of data (one byte each for C, M, Y, and K). Indeed, this is the way that traditional systems store image data. It has several advantages, particularly the fact

that the separation into four films is straightforward.

But the CMYK scheme has some serious limitations. It cannot be directly displayed on a monitor and the data must be converted into RGB whenever it is to be displayed.

As a medium for exchange among systems, CMYK lacks standardization. The color specified by a given set of CMYK percentages is not absolute: it will print differently depending on the paper stock and the inks in use. Black ink can be traded off for combinations of cyan, magenta, and yellow ink; the fact that one color can be represented in different ways complicates data interchange.

RGB is the other major contender for a color space to be used to store images. Its major advantage is that it can be displayed on a color monitor without conversion. But it also suffers from ambiguities: the same RGB values displayed using different monitors, phosphors, or video boards may look very different.

Monitor calibration cannot solve the problem of file exchange among software packages or among systems. What is lacking is a standard that specifies the visual effect to be produced by a given set of RGB values. Such a standard would make it possible to produce the same visual result with a variety of phosphors or ink/toner pigments. For any set of devices, some colors at the edges of the range would not be reproducible with a given phosphor set or ink set.

Our problem is that each device in the system has a different physical and electronic approach to color. What the scanner sees, the monitor shows, the proofer proofs, the film images, and the press prints are essentially different. So we use numbers to make conversions by trying to find one standard set of color numbers to reference. Because CIE-LAB attempts to be a linear color space (equal changes to color values produce roughly equal changes in the perceived result) and RGB is quite nonlinear, converting color information from CIE-LAB to RGB (or vice versa) is very computer-intensive. Unless you have an incredibly fast computer, you would prefer not to have to convert a million CIE-LAB values to a million computer screen RGB values on-the-fly whenever you want to display a gigabyte-pixel image on your computer screen.

Kodak wanted a device-independent means of specifying color values that would work with minimum overhead for video images and video display and that would be well suited for data compression and decompression. It came up with an extension of the video color space that it calls YCC. Because YCC is essentially a variant of the normalized RGB color space in which the axes have been rotated, it should be relatively simple to convert YCC color into normalized RGB, and vice versa.

Software that displays an image on a monitor and also produces separations must perform color-space conversions. If the image is held on disk as RGB data (typical of desktop systems), it can be displayed without conversion but must be converted to CMYK for separation. If it is held as CMYK data, it must be converted to RGB for display. Thus, conversions are an essential part of color application at the desktop, or any, level.

PIONEER MAPPERS OF THREE-DIMENSIONAL COLOR SPACE

Johann Heinrich Lambert:	This Swiss mathematician and physicist saw a pyramid.
Philip Otto Runge:	This German painter saw a sphere.
Alfred Henry Munsell:	This American artist saw a wheel.
Harald Küppers:	This German engineer and physicist saw a rhombohedron.
James Clerk Maxwell:	This Scottish physicist used a triangle to describe color space.

CIE—Commission Internationale de l'Eclairage (International Commission on Illumination) (1931), an international standards organization uses a theory based on the stimulus of color provided by a light source, an object, and an observer.

COLOR MODELS

With the advent of Trumatch and Focoltone, and new work by Pantone, we will have the proper samples for colors that can actually reproduce on a press. The original Pantone system had difficulty with the impurities of printing inks and could not reproduce all of its colors under CMYK. Today, that is changing. Many color programs, such

as Pagemaker and QuarkXPress, provide virtually all color models so that users will have the ability to select colors intelligently—colors that can actually be printed on a press. The pop-up list in the dialog box shown lists the color models available.

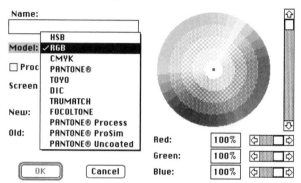

The reproduction of color

A printed color photograph is an optical illusion. What appears to the eye to be hundreds of subtly shaded hues are actually greater or lesser concentrations of microscopic dots of colored inks. The eye merges these dots into a coherent image that—when all turns out well—reproduces the colors of the original accurately.

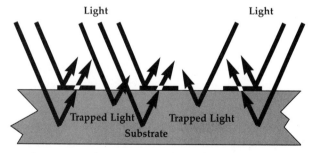

On its way from the eye of the originator to the final appearance on the page and the eye of the reader, the image is subjected to a series of electronic, photographic, chemical, and mechanical process steps in which computer

imaging systems play an increasing role. Each process is subject to its own set of physical laws and has its own set of limitations. The intelligent coordination of these processes determines the quality of the printed result.

Subtractive Color Mixture

Cyan, magenta, yellow primaries—when mixed produce black.

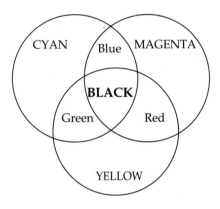

Additive Color Mixture

Red, green, blue light primaries—when mixed produce white light.

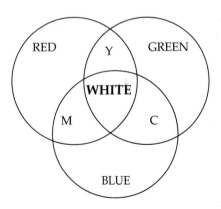

ADDITIVE AND SUBTRACTIVE COLOR

In *additive* methods of color reproduction, all the colors are produced by the adding or blending together in different proportions of three primary colors: red, green, and blue. *Subtractive* color reproduction, at first sight, seems to be quite different, because all the colors are produced by different proportions of three entirely different colors—cyan, magenta, and yellow. The subtractive and additive methods differ only in manner, not in principle.

When light waves in the visual spectrum (between 400 and 700 nanometers) are combined in equal proportions, the sensation of white light is produced. When combinations of these waves are combined unequally, we perceive colors. This is the basis for additive color theory. The primary colors of additive theory are red, green, and blue light, and different intensities of these primaries can produce secondary and tertiary colored light. Thus, virtually any color in the spectrum can be created.

Additive color starts with black and adds the primaries of red, blue, and green to produce white light. This is how a television or color monitor works. The monitor utilizes the light in a mosaic pattern of small dots; when viewed from a distance, these points of light merge to produce an image.

A special camera converts light into electronic signals. The lens focuses light beams passing through it onto mirrors or prisms, which then pass through red, green, and blue filters. The resulting light beams are converted into electrical signals by photoconductive tubes, and these signals are processed and transmitted. Three cathodes receive the red, green, and blue signals and then emit electron streams corresponding to those signals. These streams align themselves to phosphors on the inside of the monitor screen, causing them to glow and produce a color image.

The subtractive principle is used in photography and also in the printing industry. The process of subtractive color theory compensates for the limitations of the additive process. In contrast, the subtractive process starts with white (such as white paper illuminated by white light) and subtracts red, green, and blue light to produce black (in a

perfect environment). This process produces black by combining colorants that are opposites of red, green, and blue—cyan, magenta, and yellow, respectively.

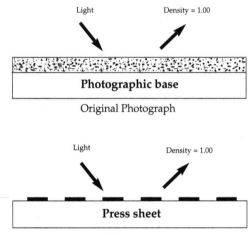

Original Photograph

Printed Reproduction

By subtracting light away from the paper (which reflects equal proportions of red, green, and blue light), color is produced. Yellow ink absorbs blue light, magenta absorbs green light, and cyan absorbs red light. Pairs of these inks, combined in equal proportions, produce secondary colors, which in effect are the primary additive colors. From these colors the full spectrum of visual colors is reproduced.

Color balance
Colorimetrically correct results are not necessary for acceptable color reproduction. Reproduction of some "memory" colors, such as skin tones, is achieved when a definite difference exists between the original and the reproduction colors. There is one property of the appearance of original scenes which remains constant and that is the color of grays. A gray scale, seen in a very wide range of conditions, looks approximately gray. Because of the physiological adaptation of the eye to the illuminant, this effect

is partial, and the gray appearance is also caused by the ability of observers subconsciously to discount the color of an illuminant when looking at objects in its light. Gray balance is a viable measurement of process color printing, and it is often used to help adjust inking on press.

Color printing

By electronic means or by manual retouching, images can be altered more or less ad nauseum, depending on the time, money, and patience available. An image must be divided spectrally into the four CMYK colors—color separation.

Each of the separated images is further fragmented into a pattern of dots. This process is called halftoning or screening because the effect used to be produced by exposing the image through an actual screen. Most dots are now generated by computer.

Up to this point, users can operate entirely in the realm of digital information—that is, once the original analog image is digitized by scanning or captured by a digital camera, it can be manipulated, color-corrected, sized, cropped, and separated with a computer program. After separation, however, other sciences go to work.

The four separated collections of halftone dots must usually be recorded onto four pieces of film or four plates. The images and their halftone dots are transferred from film to photosensitized printing plates. Through a series of steps, the plates accept ink where there are dots, reject it where there are none, and transfer the resulting pattern to paper on a press. When all four separated dot patterns are precisely superimposed with ink, the image reappears, looking more or less like its original. The "more or less" is the real problem.

There are many processes involved in printing a color image. When the job is on press, it is too late to have problems with separations.

Paper and ink

Paper and ink also affect the color printing process. The properties that govern the reproduction process are absorbency, gloss, color, brightness, and smoothness of a

substrate (paper) in relation to the color, pigment, concentration, transparency, gloss, viscosity, and tack of the ink. A paper with a high absorbency, like newsprint, tends to have a loss of ink density, whereas a gloss-coated paper has a significantly greater ink density. This is due to the dispersion of pigments within an agent and the vehicle that binds the ink to the paper. In the case of newsprint, the loss of reflectance and the high absorbency result in a reproduction that lacks density; colors tend to be "dirtier" due to the off-white background color of newsprint.

Gloss white paper printed with the same density of ink tends to be more vibrant because of the low absorption and high reflectance properties of the substrate.

Densitometry and colorimetry

Color perception is a complex function, affected by the human eye, the visual display technology, and the ambient environment. Colors that appear identical under one type of lighting can look quite different under another type of lighting.

• The same colors could be printed on different substrates and viewed under the same light and look different.

• The same colors, on the same substrate, in the same lighting conditions can still look different if viewed from different angles.

• The same colors viewed in the same conditions, at the same angle, but viewed by different people might also appear different.

Colorimetry involves the measurement of colors under controlled conditions. Ink density is measured by densitometry and colorimetry governs the variables of color standards.

Compression

Images are an integral part of color pages in the decade of the color document—where images can be freely integrated, revised, and exchanged. Data complexity and storage requirements have restrained color images. Because of system memory limitations and storage requirements, focus is on the challenge of compression.

Image compression is the process of condensing, compacting, or shrinking a digital image. By eliminating data redundancies, image compression significantly reduces the size of image data. This allows users to manipulate data more easily, use less storage space, and send data across networks at faster speeds.

Data compression maintains data integrity and compresses the data in real time—transparently. It removes redundancy from a data block without loss of information. It records more data in a smaller space. Compression ratio is the length of compressed output relative to the length of uncompressed input. The key is that data stored in a compressed form must be reliably retrievable.

Image compression algorithms attempt to reduce file size as much as possible while maintaining image quality. There is a trade-off between file size and image quality: the more the file is compressed, the more information the algorithm eliminates. A low-quality setting may result in perceivable image loss, but could very easily result in a compression ratio of 50:1. Conversely, higher quality settings—those that keep data loss in the visually imperceptible range—will generate files that are compressed at ratios of 8:1.

Every image varies in the amount of image data that can be eliminated during the compression without detracting from the file's visible quality. One must experiment with the quality settings and determine the maximum amount of compression one can apply without perceptibly altering the appearance of the image.

You could increase a peripheral's capacity by the factor of the compression ratio and increase the peripheral's internal continuous-transfer rate. A 2-to-1 compression factor could double the sustained data rate. Different companies, using the same compression algorithm, may offer unique implementations of it. Multiple compression algorithms on top of multiple formats could create problems.

Vendors of prepress color publishing systems and peripherals consider image compression to be a technology enabler. A standard technique for compressing images will allow color on the desktop to be a viable application. Al-

though compression technology has been used for many years in high-end systems, recent advances have made cost-effective image compression possible for desktop users. A major goal of JPEG image compression algorithms is to maintain the appearance of an image rather than the actual data that constituted the original image.

The production and manipulation of color and grayscale images have encountered significant hurdles. The first of these obstacles concerns the memory and speed requirements needed to process digitized color image information, as well as the storage space required to hold the information (e.g., a 24-bit, full-color page, scanned at 300 dots per inch, requires 24 megabytes of disk space). Consider the process of transferring images between computing devices. Ethernet can transfer approximately 1 Mb of color image data every 10 seconds. That's six minutes for a full-page image to be transferred. Appletalk would require 40 minutes to transfer the same image, and a 9600-baud modem would take more than nine hours to transfer the image over the telephone.

Compression solutions

By deleting redundant data that the human eye won't notice, high compression ratios can be achieved. Image compression solves many of the problems of working with color images. In the area of disk storage, a 10-fold compression of a full-page image will require only 3.2 Mb of disk space instead of 32 Mb. A compressed image could reduce transfer speeds across Ethernet from 6 minutes to 32 seconds. A variety of well-known techniques exist for compressing images. Most center around lossless compression methods and have been designed to maintain image information.

Without data reduction, compression ratios could not be produced. Quantization is a filtering process that determines the amount and selection of data to be eliminated in order to encode the data with fewer bits. Delta Pulse Code Modulation (DPCM) is another compression method that measures one set of bits and then measures differences from that set. The differences can be encoded into fewer

bits. Run Length Encoding is a method of representing the same number in a sequence numerous times (i.e., encodes that zero occurs 20 times (4 bytes), rather than 20 zeroes (20 bytes). Huffman Encoding, the simplest compression scheme, replaces contiguous bits with codes of varying lengths. The most frequently used patterns are represented by the least number of bits.

A standardization effort known as JPEG, for Joint Photographic Experts Group, has been working toward the first international digital image compression standard for continuous-tone still images, both grayscale and color. The "Joint" in JPEG refers to a collaboration between the Consultative Committee for International Telegraphy & Telephony (CCITT) and the International Standards Organization (ISO). The JPEG committee consists of more than a dozen companies as well as potential users such as IBM, NEC, Digital, Kodak, and Polaroid. JPEG is an international, open-system standard and is intended for use across a variety of computers and peripherals. The JPEG algorithm is symmetrical; it requires the same computational effort to compress or decompress an image.

The standard takes advantage of output limitations and exploits the fact that humans cannot distinguish minor changes in high-frequency color. This method of image compression means that some of the image information is lost, but the image should remain visually complete when expanded.

The JPEG scheme compresses an image by applying three different mathematical algorithms to individual 8x8 pixel blocks. The first step, Discrete Cosine Transform (DCT), analyzes each 8x8 block, identifies color frequencies, and removes data redundancy. A quantization algorithm is then performed to further remove frequency information. Quantization causes many of the higher color frequencies to become zeroes, but has little effect on how the image is seen, because as humans are less sensitive to higher frequencies.

The amount of information discarded is determined by the level of compression. Using the Huffman Encoding method, a final step encodes the data by tracking only the

differences from one block to the next. JPEG software implementations will allow users to select from a variety of quality levels. With a low-quality level, you could achieve as much as a 60:1 ratio, but if you choose exceptional quality, you may receive only an 8:1 compression. For acceptable print quality, a range of ratios anywhere from 20:1 to 30:1 compression is recommended.

The interchangeability of the images due to different file formats and approaches is an issue. Because JPEG defines merely how a stream of bytes constituting an image is compressed and recovered, and not how the stream should be stored, there are many different types of files. Most vendors expect the standard to be targeted for a wide spectrum of applications, spanning prepress, image editing, office applications, facsimile, desktop publishing, and storage.

Because JPEG is intended for continuous-tone color and grayscale images, images that have a great deal of high-contrast edges (line art or text) may not compress well. In these cases, compressing the entire image enough to reduce the file size significantly may adversely affect the portion containing the text. But a new technique called selective compression solves this problem and provides even finer control over image quality. Selective compression enables users to specify different compression levels for different elements within a single image. One can preserve the quality of key areas that might not compress well by applying a low compression ratio in those areas, and then use a higher compression ratio on the rest of the image to reduce the file size significantly. Selective compression, also called JPEG++, is a useful extension that affects only the compression side, yielding a JPEG file that can be decompressed by any other JPEG-compatible application.

Color image files in electronic publishing and page-layout applications are generally very large. Saving images in encapsulated PostScript file format results in even larger files than the original RGB or CMYK images. To make working with color images more manageable, Storm Technology's PicturePress software enables users to easily incorporate JPEG-compressed images directly into QuarkX-

Press, PageMaker, and other applications by creating EPS-JPEG files. These files are treated like the regular EPS files, yet contain JPEG-compressed image data. The resulting EPS-JPEG file sizes are significantly smaller than pure EPS files.

As high-resolution digital images become more prevalent, image compression technology plays a vital role. The advantages are:

1. Improve quality: By scanning at a higher pixel density and then using compression to keep the file size under control, you can improve image quality. The size of the compressed file will be smaller than that of the uncompressed file that was scanned at a lower resolution. For example, a 600-dpi image that is compressed occupies less disk space and yields a better quality image than a 200-dpi uncompressed image.

2. Save time: Compressed images often load and display faster than their uncompressed counterparts because less data is read from the disk.

3. Save storage: With compression, you can keep more images on line and readily accessible.

4. Save money: After compressing images, you can transmit them more quickly and more easily. An image that once took more than 45 minutes to send by modem transmits in less than a minute when compressed, resulting in much lower transmission costs or phone bills.

5. Reduce network traffic: Compression decreases the amount of time required to send the image files to output devices. By sending documents with compressed images to PostScript Level 2 output devices, the host computer and network are freed up quickly, because the printer decompresses and prints the image.

Compression products differ significantly. When selecting a JPEG compression product, be sure that it provides the flexibility to select a compression setting that preserves the degree of quality required. Also, consider the need for advanced features such as selective compression and image-management tools like thumbnail previews and captions. Finally, take into account the product's speed and ability to automate image compression and format conversions. Regardless of the manner in which digital im-

ages are used or the pursuit of different applications, the recommendation is to employ JPEG compression and decompression to stretch the imaging dollar and give new and exciting ways to use digital pictures.

COLOR MANAGEMENT

Color management on the desktop evolved as a result of a basic need for the customer to approve the final printed product before there *is* a final product. A problem began to surface when the color off the press failed to match the color approved on the monitor or digital proof. Color management systems have evolved in an attempt to correct this problem.

The desktop system has four major components: scanners, monitors, application programs, and output devices. Each of these elements must be calibrated to one another and then matched to the specific characteristics of the device. Although these elements are consistent, the way any one of these elements defines color can vary greatly.

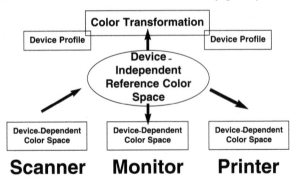

The way in which a specific device defines color is called a device-independent reference color space, defined on a numerical system, usually three-dimensional, resulting in a graphical representation with three axes. Color spaces also have limits to what colors they can or cannot represent. This is called a device's color gamut. The system chosen to represent color in a device is based on the

method best suited to the operation of that device. This type of color space is called device-dependent.

Monitors that use red, green and blue phosphors to generate colored pixels on the screen must use red, green, and blue axes to define their particular color space. These color spaces are also referred to as device-dependent because the inherent variation in the way any device displays, prints, or senses color. The color displayed on a monitor not only depends on the RGB value in the color space, but on the type of phosphors used to produce the color on the screen. The same color value can produce different results on two identical monitors,

Another type of color space is called device-*in*dependent. These color spaces are used as a measurement tool in comparing different device-dependent color spaces during color translation. Most device-independent spaces used for this purpose are based on the CIE XYZ standard. This standard represents a mathematical model of human color perception. These color spaces assist in color matching during translation of device-dependent color spaces.

To achieve consistent visual representation of color through every step of the desktop process, we must accurately translate between color spaces. The actual transformation from one color space coordinate system to another is not in itself difficult to accomplish. Transformation can be done through either linear or nonlinear mathematical operations.

Linear operations, RGB to XYZ for example, are usually performed in a 3x3 matrix, meaning three coordinates of one color space are transformed into three coordinates of another color space. Nonlinear transformations such as RGB to CMYK use lookup tables. These tables define a specific relationship of corresponding color values between two different color spaces to translate individual color space values.

Color gamut is the range of colors that can be represented. Problems arise when colors in the original cannot be detected by the scanner, displayed by the monitor, or output by the printer.

Color separations that match or improve upon the original photograph have been sought by color separators since the invention of process color printing in the 1860s. The first generation of color separators worked with photographic process cameras and used color filters, contone masks, halftone screens, flash, and bump exposures to make a set of magenta, cyan, yellow, and black separations. Second-generation separators used electronic scanners, which became commercially available in the early 1970s. Enhanced accuracy, control, and turnaround time made it easier to adjust separations to the color reproduction characteristics of specific paper, ink, and press combinations. Color management programs incorporate the expertise of camera and scanners operators within an easy-to-use software program.

High-end color scanners scan the original and record the separation data to film or disk. On desktop systems, the original may be acquired from a number of devices, including flatbed scanner, slide scanner, desktop drum scanner, Photo CD scanner, digital cameras, or imported electronic files. The resulting digital color file may be viewed and adjusted on color monitors. Once saved to disk, the color file may be output to a digital color proofer, color printer, networked color copier, imagesetter, platesetter, or digital color press. Multiple system components necessitate predictable, consistent color. This requires:

• Adjustment of scanners, Photo CD, digital cameras, and other input devices, so that scans from any device will produce similar separations.

• Matching of colors of different output devices.

• Matching printed output with the image on the monitor so that the monitor can be used for video proofing.

Some users may not be concerned with multiple device matching; they just want to get the most pleasing reproduction of color photos from scanner to printed sheet.

Many people view "calibration" as meaning all steps necessary to assure accurate color throughout the production process. Color management is a more meaningful term for matching color on different input and output devices and on different substrates.

CALIBRATION

Calibration ensures that all devices in the imaging process perform to a known specification. Characterization quantifies the color space, color gamut, or color behavior of the particular device under known conditions. It determines how an input device captures the color and how an output device produces color. Conversion is the translation from the color space of one device to that of another under known conditions. This can be achieved by either correcting the image manually or using color management software. To achieve the goals of color management, calibration, characterization, and conversion must be performed in this order. The calibration of a device serves as the foundation, and the device must be characterized before color data can be accurately rendered.

Color management assures that all devices in the system are performing to specification. Calibration alone does not guarantee color matching, but it does eliminate some variables by ensuring that scanners in the printing system are performing to specifications.

• Scanner calibration means that a particular density on the test target used for calibration will consistently record as a particular digital value. Most color scanners are manufactured to a known specification. However, small manufacturing variables, including temperature, humidity, and aging, can all affect the accuracy of built-in calibration. Calibration variables include brightness, contrast (gamma), and white point (RGB balance).

• Monitor calibration means that the display card consistently displays the corresponding pixel for a specific digital value. Color monitors are manufactured to known specifications but are subject to many variables. Monitor calibration variables include brightness, white point, and contrast (gamma).

White point measured in color temperature, or degrees Kelvin, determines the warmness or coolness of the white areas of the image. The concept of color temperature, developed in 1900, is based on the fact that a theoretical black body, when heated, will produce corresponding appearance of white light. Lower temperatures appear yel-

lowish, whereas a higher temperature presents a bluish cast. A color's appearance is affected not only by filters or pigments but also by the viewing light. The monitor's color temperature will also affect the accuracy of color rendition. The color temperature should match the lighting conditions under which the input and output are viewed.

Gamma describes the relationship between input value and monitor output luminance. It affects the distribution of tones between highlight and shadow areas of the original. Without color management, the user can set the monitor gamma to simulate viewing conditions by comparing contrast of the image on the monitor and the original. When using color matching software, the system typically specifies the monitor gamma.

• Color printer/proofer direct color output devices may also have to be calibrated. These devices—thermal wax, dye sublimation, and xerographic printers—are typically designed with built-in linearity, but may also be prone to variability from manufacturing variations, aging, and environmental conditions. Effective color management accounts for these variations in order to meet the manufacturer's specification. Some have built-in calibration systems; others can use calibration software.

• Imagesetter calibration: Before the imagesetter can be used, the operator must ensure that the imagesetter is calibrated. Imagesetter software is used to set the maximum density of the film (approximately 4.0) and the halftone tints within 2%.

• Press and off-press proof calibration: Specifications for Web Offset Publications (SWOP) is a calibration system commonly used in lithographic processes that takes into account ink, paper color, solid ink densities, and dot gain tolerances. Setting up film-based or digital off-press proofing involves selecting substrates, colorants, and finishing layers to simulate press conditions.

There is no such thing as device-independent color, but there is device-independent color definition. Color is very device-dependent and you cannot obtain a virtual one-for-one match between an original color and a resulting color. The very nature of lithographic printing will not

allow exact reproduction. With paper and ink variables, you cannot get an exact match. Prepress vendors have developed systems that let you get a realistic picture on the monitor, generate a proof, generate film, or burn a plate, but what you see is not always what you will get.

Characterization

Characterization accounts for the variability in the color representation of a device. This step defines how a specific color space relates to a device-independent color space. Using device profiles and actual testing, characterization can describe what color an output device will produce when given a color value, and what color value will be assigned by an input device when it detects a specific color. This process can also define the color gamut of a device, which can alert the user to "out-of-range" colors with a gamut alarm.

The characterizations are usually created and provided as profiles—digital files describing the color gamut of a device:

• Color models—A number of models can be used to characterize input and output devices.

• RGB—Color space is based on additive color theory and is measured on a scale of 0–255 color values in 24-bit color.

• CMYK—Color space is based on the subtractive theory consisting of cyan, magenta, yellow, and black pigments measured on a scale of 0–100% dot area.

• CIE—Includes two models based on the dimensions of hue, chroma, and value. The CIE models are derived from the characterizations of human color vision known as the CIE 1931 and 1964 Standard observers.

Scanner characterization: Eastman Kodak developed the Q60 series of photographic film and paper test images for characterizing the gamut of input devices. The Q60 has become the basis of the international standard IT/8 input target developed by the IT/8 subcommittee of the Committee for Graphic Arts Technologies standard. Scanners are characterized by software that measures the values in a scanned target, such as the IT/8, and compares them to corresponding lookup tables (LUT).

Printer characterization: Research institutes, including GATF RIT, UGRA, and FOGRA, as well as company vendors, have developed test images for characterization and control of printing presses. Output targets are measured with spectrophotometers in CIE xyz and/or CIE Lab color spaces to characterize the color gamut of a output device.

Monitor characterization: Profiles for commonly available monitors are also offered by developers of color management software. However, these profiles are valid only when the monitor is performing to the manufacturer's specifications. If the operator adjusts the brightness and contrast, the characterization may no longer be accurate.

Understanding each device's limitation of color gamut is the key to understanding the complete system. CIE-LAB values must be measured, calculated, and plotted on the Chromaticity Diagram. Hue is represented at all points around the perimeter of the chromaticity diagram. Saturation is represented by moving outward toward the perimeter, from center representing white. Value is the intensity or brightness of a color.

The color gamut from a scanned color negative or transparency will give a color gamut different from that of a printed halftone. The transparency has a far greater color saturation and dynamic range, therefore producing a much larger color gamut. The color halftone is limited by the density range between the substrate and solid ink density.

Monitor color gamut can be measured and charted on the chromaticity diagram. It has limitations also in that the size and shape are quite different from the printed page. Black is represented by a reduced intensity of light. Therefore, density is not as saturated as ink density; however, monitor color saturation and brilliance are much greater.

Color conversion
Color conversion refers to the translation of color image data from the color space of one device to the color space of another device. Conversion is necessary so that a scanned image reproduces as a believable representation of the original on both the screen and the printer. Because

output devices typically have color gamuts smaller than that of the original, the colors in the original must be fit into the gamut of the device, a process known as gamut compression.

Three methods of color conversion are used:

• Photographic rendering (also known as perceptual rendering), used for continuous tone photographs, maintains a relative range of colors in a photograph. It causes the white portion of an image to have no ink on the paper, and the black portion to have the darkest color printable.

• Solid color rendering is most effective for spot colors, and maintains an absolute color match. It renders colors that are within the device's gamut identically, and brings colors outside the gamut to the closest printable color.

• Presentation graphics rendering is appropriate for bright saturated illustrations and graphs used in business presentations. This rendering style produces pure, saturated colors according to the printing device's limitations.

Translating from one color gamut to another color gamut will require gamut compression. Gamut compression will give the illusion that all color chroma, saturation, and value are present relative to the substrate base and output capability but, in reality, there is a loss in color gamut.

Portable color

Device-independent color refers to a method for encoding the data to be rendered in the correct color by any device receiving it. RGB phosphors differ from monitor to monitor and CMYK pigments differ from press to press, and the same halftone dot percentages will appear different on various paper stock or with various ink sets. There is no universal standard for RGB or CMYK, and there is no defined monitor white or paper white. There is also no agreed-upon method for converting RGB into CMYK.

The best way to do an accurate conversion is to use a consistent reference that is not dependent on phosphors or pigments. The Commission International de l'Eclairage (CIE) developed standards based on the premise that you cannot measure the color of an object without knowing

something about the observer and the light source. The 1931 CIE XYZ color space, the basis for all subsequent CIE color spaces, is based on a standard light source and a standard observer under specific illuminant and angles for perceptual evaluation.

The CIE system was designed to compare colors on similar media. Today's technology compares colors on different media, and device-independent color says that any image stored in a system should look the same when rendered on different devices. The CIE system was not created for this.

Quality control

Quality control is really knowledge. Having key people who are trained in colorimetry and printing technology is essential. Spectrophotometers, colorimeters, and color densitometers are the tools most commonly used. spectrophotometer measures points on the electromagnetic spectrum. A colorimeter measures light in a way not unlike how the human eye views, and a color densitometer is designed to measure materials such as inks and dyes.

Color management is based on the assurance that all devices in the system are performing to specifications. Although calibration alone cannot guarantee color matching, it does eliminate some variables by ensuring that all devices used, from input to output, are performing to some set of standards. Specification Web Offset Publications (SWOP) is a calibration system used in lithographic printing that takes into account ink, paper color, substrate, coated or uncoated, solid ink densities, and dot gain tolerances for offset presses. The entire production staff will use these specifications to minimize the variables that exist in the final printed product.

Scanner calibration

Scanners define color by detecting the intensity and color of light reflected off or transmitted through an original. By separating the light into three components—red, green, and blue—a light-sensitive device, such as a photo-

multiplier tube (PMT) or charge coupled devices (CCD), translates the amount of light detected into digital format.

The color values of any given scanner will vary greatly when scanning the same original. This is due to the variability of any of the following: the spectral reflectance/transmittance of the original, the light source of the scanner, the spectral transmittance of the color filters, the spectral sensitivity of the CCD/PMT, and the spectral response of other optical components.

Scanner characterization focuses on defining the relationship between the colors of the original and the RGB values the scanner assigns to them. This is usually accomplished by scanning a test target and comparing the known color values of the target to resulting values given by the scanner to define the relationship.

The color space transformation between RGB coordinates and CIE-XYZ is done through the calculation of a matrix or the creation of rendering tables. In creation of a matrix, coefficients must be calculated to minimize the amount of error in transformation. However, this is rarely possible and rendering tables must be created instead. In a rendering table, known relationships between the two color spaces are used as reference points to interpolate or estimate all other necessary translations.

Scanner calibration is accomplished by scanning neutral density step targets and adjusting the linearity lookup tables that control the gray balance of the color-sensitive scanner components.

Monitors

Cathode ray tube (CRT) monitors contain three electron beams which sweep across the screen, exciting red, green, or blue phosphors contained in the CRT's face. The phosphors are grouped extremely close together, in triads, to combine the RGB light and produce the appropriate color. These colors can be affected by the following: possible color casts inherent in the monitor (white point), differences in perceived brightness compared to actual voltage values (gamma), the color gamut of the monitor, and the light the monitor is viewed under.

Monitor characterization is accomplished by measuring: the chromaticities of the red, green, and blue phosphors; the gamma; and the white point. This is usually done by the manufacturer of the monitor.

Transforming color spaces from the monitor to CIE-XYZ requires linear correction, color space transformation, and gamut compression. Linear correction involves creating lookup tables for the three light channels to make adjustments in perceived brightness when RGB signal values change. Color space conversion is done the same as for the scanner, but tables and matrixes must be done to transform color to both input and output, as the monitor can be chosen to supply information either way. Gamut compression is done with the same or similar rendering table used for color space transformation.

Calibration of monitors is done with devices that first measure various spots on the monitor, by using a suction-cup device that determines the monitor's white point and gamma, then adjust the monitor's linearity correction accordingly.

Printers and proofing devices use a multitude of methods to produce color output. The main consistency of these devices lies in their use of subtractive color theory, in which red, green, and blue light combinations are obtained by placing cyan, magenta, and yellow transparent pigments onto white paper. The pigments act as filters that, in theory, each allow a different primary color of light to reflect off the white paper. Of course, many factors can affect the perceived color on the printing sheet, including: the spectral properties of the paper, the spectral properties of the viewing light, the gamut of the printer, and the density range of the printer.

Printer characterization measures printer linearity and chromatic characteristics. Linearity refers to consistent changes in print value among the four process colors. The chromatic characteristics determine the color space the output device is capable of reproducing. Both measurements are done by printing test targets and comparing the resulting output to known values of the original.

The transformation process in a printer is done by creat-

ing two tables from the data obtained during characterization. The linearity correction of the printer is determined by calculating lookup tables which represent a tone reproduction curve. The chromatic component of the printer is transformed through the creation of a rendering table, also determined from the data gathered in characterization.

Calibration of the printer can be done by taking density readings off a test target and correcting the tables that control linearity during transformation.

Desktop color reproduction systems have created an essential need for color management systems that can provide accurate and consistent color representation. An ideal system will translate color throughout the desktop process flawlessly and transparently. The system should be able to work at the operating system level of the workstation, providing various standard interfaces to allow vendors of application programs, devices, and specialized approaches to communicate through a compatible color infrastructure.

Files will contain tagged color space information. Application programs will communicate color translation through the application program interface (API). Devices will be characterized through a device profile, which contains the information relating to the color space and color rendering of each device in the system. Color matching methods will contain the transformation software that usually translates in and out of a standard CIE-XYZ device-independent color space. Common features found on current color matching systems are user interfaces, calibration tools, gamut alarms, and output simulations. User interfaces let the user access color matching functions from within certain publishing application programs. Calibration tools are sometimes provided, allowing end users to calibrate their devices. Gamut alarms can alert the user to colors that fall out of the gamut of the devices in use. Output simulation enables the user to preview the hardcopy, providing a type of soft proof on screen.

Proofing

Proofing is vital to practically all printing. It shows the printer and customer what the job will look like after print-

ing, so changes can be made, if necessary, before the job goes to press, where it can waste expensive press time, paper, and ink if it is not right. Color proofing is a very important step in the process of color reproduction, as color proofs are made at different stages and for many diverse uses in the process. There are proofs for customer approval, compatibility proofs, proofs for quality control, and proofs for other uses.

The color proof, which is usually made before the production run for customer approval, is expected to be a reasonable representation of the printed job so the customer can determine what modifications, if any, are needed before printing. When approved, it becomes the guide for pressfolk to use during makeready to derive the OK sheet used for checking the printing during the run. If the proof does not reproduce the printing characteristics of the process, there may be difficulty in getting the printed job to match the proof, which can result in long, tedious, expensive corrections on the press, plate remakes, a dissatisfied customer, and possible job rejection.

Proofs were once made on a proofing press with paper and ink. That approach is still used and is still the best way to verify what is really going to happen when you print from a set of films. Press proofing is slow, expensive, and happens late in the cycle. It also requires the color separator to own a press.

Thus, "off-press" proofs found a ready market. The traditional off-press proof process involves making a contact exposure of each of the separation films and developing the exposure with a toner in the appropriate process color. The principal types of off-press proofs are overlay proofs, in which the four colors can be viewed separately, and one-piece proofs, in which the four colors are laminated onto a background sheet. Some variants also exist, such as electrostatic or digital systems.

Color separation services use off-press proofs extensively to check work in progress. The final proof also serves as a de facto contract between the separation service or printer and the customer. This proof, the service is stating, is what the printed piece will look like; this proof, says

the customer, is what I will accept when it comes off press.

A number of other proofing methods which work from digital data are continuous tone: therefore, they do not show the dot structure. Prepress color correction can be performed only by changing the concentration of one or more of four colors, and it is the size and shape of the halftone dots that affect those concentrations. The function of a color proof is to convey accurate information about how a certain set of films will perform on press. A proof that does not facilitate that function proves utterly useless, no matter how attractive or elegant it is.

Soft proofing

The method of "soft" proofing—proofing directly from a color monitor—is cheap, quick, and uses no chemicals or consumables. Every digital color system includes a high-resolution color monitor, and many scanner systems now offer a "preview" feature that allows the operator to check color before finalization. Soft proofing depends on the calibration of color monitors, though, and that is the problem.

You must adjust a monitor so that it gives an accurate approximation of final color. As desktop systems improve, such adjustments will become more automatic. However, no set of look-up tables is yet accurate enough to permit critical color judgment on-screen, without reference to a hardcopy proof.

The graphic arts industry arrived at a standard for viewing color materials that calls for comparisons to be made against a neutral background in an environment illuminated by light at a temperature of 5,000 degrees Kelvin. To the human eye, light at that temperature appears as a neutral, color-balanced white.

You cannot remember color. If you have both samples in front of you, you can compare. But you cannot look at color in one place and then carry the memory of it to another place. What is really needed is a reliable method of making a hardcopy proof from an electronic system without having to expose a set of films—a technique known as direct digital color proofing (DDCP).

Computers deal with color in a way that makes sense to the computer, but not to the human eye. Color displays generate color by illuminating combinations of phosphors in the common additive primaries: red, green, and blue (RGB) and varying the intensity of the electron beams exciting the phosphor. The number of possible colors is a direct result of the number of bits available per pixel. In a 24-bit system, 8 bits control each of the 3 primaries, making it possible to direct the electron gun at 256 levels of intensity for each of the three primaries—which comes out to some 16 million. These combinations are usually stored as a lookup table, which is accessed by the screen driver.

Most prepress systems are based on the subtractive primaries CMYK (cyan, yellow, and magenta, plus black, which is the basis for printing processes). Multiple lookup tables are used to translate CMYK percentages into RGB percentages for the screen display. Basing color on lookup tables of uniformly quantized increments has little relation to color as the human eye perceives it. Perceptual differences between colors are not constant as one moves from one part of the color spectrum to another. Under constant illumination and at high (lighter) values, we see more blues than yellows. Because the increments in the lookup table are constant, it may take a movement of a dozen units in the high-value blues to produce a color that we perceive as different. In high-value yellows, a movement of a single unit may be perceived as an abrupt color shift.

The user interface that provides us with access to potential colors may be a palette, a color wheel, or a color bar. It may provide menus for specifying percentages of RGB, CMYK, or other color components. Many systems provide a choice or combination of several of these features. But, because of the lack of correspondence between the underlying computer architecture and visual perception, users are often disoriented when they work with color.

Working with color is even more unpredictable because color dimensions, such as RGB and CMYK, cannot be manipulated independently. In an RGB system, a change in value (lightness) automatically effects a change in chroma (brightness). To get a brighter, more saturated red, you

must adjust the percentages of red, green, and blue in a way that is not visually obvious. You couldn't simply increase the percentage of red, because that would increase lightness as well.

In a CMYK system, color changes are effected by adjusting percentages of these primaries and black. To achieve a brighter red, for instance, you would have to reduce the cyan and black and increase the yellow and magenta.

Compatibility proofs

Magazine and other periodical printers have another very important requirement for proofs. They receive advertisements from many different sources, including advertising agencies and advertising departments of manufacturers. These ads contain subjects prepared by many different photographers and commercial artists and can consist of color transparencies of different sizes and types, color photographic prints, dye transfers, and even artwork on board, paper, or canvas in oils, water colors, or other media. Many of them are finished ads that have been used in other publications. Also, films supplied for reproduction may already have been color separated, using different colors, inks, and papers for making the proofs.

The printer is faced with the task of combining a number of these elements, prepared by different sources and with different materials, on the same plate. Proofs of the supplied films in the printer's colors and materials are absolutely necessary to make sure that all the color is compatible, as they must all print from the same plate on the same press and with the same paper and inks.

This is called compatible proofing. If some of the elements do not look right, it is less expensive to correct or remake them before they go to press than to stop the press, remake the plates, and struggle to reach a compromise in printing that often unbalances the other subjects and results not only in missed deadlines and higher costs, but also in dissatisfied clients. Efforts to avoid such disappointments have been made by establishing standards like SWOP for proofing web offset publication subjects, and the GTA Group I and Group V standards. These were devel-

oped so that all subjects made from supplied films would be compatible when printed together on any press.

Proofs for quality control

The printer also uses color proofs at many stages in the preparation of the materials for printing to evaluate the efficiency of its manufacturing processes and how the subjects will reproduce. This is so it can avoid surprises at the press and be sure the product it produces meets the customer's requirements and expectations. Color proofs are used at these stages in the hierarchy of the reproduction process:

• Scanner: Determine color balance, overall color correction, overall quality, size, screen angles, and register.

• Image assembly (stripping): Check sizing, cropping, color breaks, crossovers, reversals, "fats" and "skinnies" (overlaps), screen angles, overprints, and register.

• Platemaking: Check dot quality (gain or sharpening), position, register, color, and other specifications of all elements on the plate or signature.

• Press: Use a customer-approved proof as a guide for print quality, ink strengths, color balance, register, and progressive color guides if job is on a single or two-color press. The customer-approved proof(s) replaces the original(s) for producing the OK sheet for the press run.

• Bindery: Check for layout, size, trimming, folding, imprinting, bleeds, margins, crossovers, and so on.

Press proofs

For many years, the only way to make proofs was to print them on a press. This involved making plates, mounting them on the press, making ready to run, and then running a few prints. Proofs of this type are very expensive because they involve labor-intensive operations, expensive materials (plates), and cost-intensive equipment (press). Special proof presses have been built to eliminate the high costs of using production presses, but manpower costs are still high, as it takes a long time to make press proofs.

Press proofs have three important advantages:

• They are printed on a press using printing pressure and the actual inks and paper to be used for the job.
• Multiple proofs can be produced at reasonable cost.
• Progressive proofs and proof books can be easily made. Press proofs are used extensively by advertising agencies requiring quantities of proofs for distribution to a number of customer representatives and printers. Progressive proofs are useful when 4-color jobs are to be printed on single or two-color presses.

Many buyers of printing have the mistaken notion that a press proof will look exactly like the printed job, regardless of how or where it is printed. This unfortunately is far from the truth. All presses are different, not only in design, but also in performance. Even presses of the same design differ in ink transfer due to numerous variables, including pressfolk, paper, ink, roller and blanket composition and conditions, ink-water balance (in lithography), and roller and cylinder pressures. In fact, it is usually not even possible to put a set of plates that have been printed on a press back on the same press, print them with the same inks and paper, and get the same result.

A press proof, therefore, is no guarantee that the printed job will look like the proof, even if it is printed on the same press with the same materials and pressperson. Compensations must usually be made to relate the proof to the actual printed result. The situation is somewhat different in gravure printing. Practically all gravure printing is proofed on a press. In most instances, the actual printing cylinders are proofed, usually on production-type presses. The introduction of halftone gravure could possibly cause some changes in this practice.

Off-press proofs

Because of the limited correlation between press proofs and press prints and the time and expense to make them, there have been many attempts to develop and use less expensive and faster alternatives to press proofs, especially for processes other than gravure. These are usually made by photochemical or photomechanical means and are referred to as prepress, or off-press, color proofs.

Overlay systems

The success of photomechanical color proofing processes in mapping encouraged the development of a number of other systems for color proofing for commercial printing which, unlike mapping that used line images and special colors, used halftone images and process colors. The first successful products were the Ozachrome overlay films. These consisted of diazo coatings on individual films which, when exposed and processed by ammonia vapor, produced dyed images in colors similar to process inks. For a 4-color proof, a photographic print on paper was made of the black separation; the other three colors were on films (sometimes called foils) that were mounted in register on the black print.

The main advantage of the system was the ability to review the individual images and use them to assemble progressive proofs. The limitations were:

• Only one set of process colors was available, and they were not good matches for the great variety of yellow, magenta, and cyan process inks in use.

• The plastic films used were not completely clear and colorless, so the white paper and highlight areas of the proofs were dirtied and darkened.

• Although they were useful for checking loose fit and whether copy elements were in the right color or missing, the films were not dimensionally stable, so register was not certain and proofs were not good matches for the printed job. They were seldom accepted by the customer in place of a press proof. They were useful mainly for internal checking and quality control in the plant.

3M Color Key was the first overlay system to be introduced that was on a stable base and replaced the dyes with pigments. This system used polyester film and diazo sensitizers covered with pigmented coatings similar to subtractive type lithographic plates so that, on development, a pigmented image was produced. At first, these systems suffered from the same limitation as the diazo films, namely, grayed whites and highlights. Gradual improvements in color and clarity of the film have minimized this problem, although whites are still grayer than desired.

Overlay systems are used extensively by the industry, even though they are not normally considered good matches for the press print and are not generally accepted by many customers in place of the press proof. The problems have been grayed highlights and whites and the difficulty in handling and registering the four films. In addition, the advantage of ease of preparing progressive proofs for the pressperson to use in printing has practically disappeared with the almost exclusive use of 4-color presses for process color printing.

Overlay systems, in contrast, are less expensive and easier to make than most integral systems and are used extensively for most internal quality control operations (which represent more than 60% of the uses for off-press color proofs).

Internal (single-sheet) systems

A number of attempts have been made to develop proofing systems with integral images on a single sheet or base to overcome the limitations and problems encountered with the overlay systems. The first color proofing system, introduced after the end of World War II, was the single-sheet, integral system by Direct Reproduction Corporation, called Watercote.

In the early 1960s, several attempts were made to develop electrophotographic proofing processes based on the electrofax principle, using paper coated with zinc oxide in a resistive binder as a photoconductor and toners consisting of ink pigments dispersed in liquid Isopar. The electrofax principle was introduced in the United States by RCA, and the use of liquid toners was developed in Australia by Ralph Metcalf and Robert Wright of the Australian government. Other groups worked on similar processes, but none ever got to market.

In 1969, a new color proofing process, the Colex 520 Pre-plate Color Proof System, developed at Batelle Memorial Institute, produced an integral color proof based on the use of photosensitive adhesive polymers and dry powder toners composed essentially of ink pigments. This was the forerunner of other integral color proofing systems

based on the use of dry toners and adhesive polymers including DuPont Cromalin, introduced in the 1970s.

DuPont Cromalin depends on a change in tackiness of the special polymers used due to exposure to light. This can cause problems with variations in the amount of toners accepted, resulting in fluctuations in color strength and scum or toning of the nonprinting area. Staley Colex 520 was discontinued mainly because of these problems. DuPont Cromalin has survived them by introducing many innovations such as controlled exposure and the use of automatic toning devices.

Kodak also introduced the Polytrans Color Proof System in 1969. It used pigmented photosensitive films, which were combined to make the color proof using heat and pressure on a specially modified press. Although the process gave very reproducible proofs, it was discontinued in 1975 because of limited choice of colors, high cost of energy and proof press, and competitive pressures from the Cromalin process.

Other integral (single-sheet) off-press color proofing processes were developed during the late 1960s and the 1970s. Actually, the first of the modern integral color proofing systems was Transfer Key, which 3M introduced in 1968. It is a modification of 3M's Color Key, in which the individual coatings are successively transferred, exposed, and developed on a pigmented white plastic base and subsequently laminated together to produce an integral print on a single base.

3M Matchprint has a spacer layer, which is used between the laminated Transfer Key coatings and the printing paper on which they are mounted to simulate dot spread in the proof and thereby obtain a closer match between the proof and the press-printed result.

As we enter the last 5 years of the 20th century, proofing technology is undergoing a significant change. More color is being accepted with ink jet and dye sublimation proofs and new systems are being introduced daily. The market desires a proofing technology that provides cost and quality advantages and is compatible with digital prepress.

CHAPTER 4

DIGITAL PREPRESS EVOLUTION

The prepress market is made up of typesetters, service bureaus, and color trade shops. The changing role of each—as well as a certain functional overlap—has created confusion as to who they are and what they do.

A little history is helpful. Way back in the halcyon days of handset type, every printer had to set its own type to have the metal from which to print. For illustrations, printers usually hired an engraver to create a metal etching that was integrated with the raised metal type to produce a printable page. After the invention of the linecaster, printers were overwhelmed when the number of typefaces reached 100(!). They divested themselves of the typesetting operation and a new entrepreneurial service was born: the trade typesetter. The "trade" part meant that the service set type for printers or others in the trade. They delivered the chases of metal type pages to the printer.

At the same time, illustrations underwent their own revolution as the photoengraving process developed. Once again, a group of entrepreneurs created a service out of the beginnings of technology: the engraver or trade shop. They handled pictures, artwork, and color separations, each resulting in a form of raised metal mounted on wood blocks. The surface was at the same height as the metal type so all images would print evenly. (For those of you who forgotten this magic number, the height to paper was .918 inches.)

And all was well with the printing world—composed of printers who printed, trade typesetters who set type, and engravers or trade shops who made color separations. Then came offset lithography. It finally came into wide-spread use in the 1950s and it no longer required a raised type or image surface for letterpress printing. What the eye could see could be photographed to negative film, which was needed to make offset plates.

The trade typesetter started doing less and less work for printers and more and more work for ad agencies, art studios, and businesses with art departments. They renamed themselves "typographers" to differentiate themselves. The trade shops converted to film production. A few new firms were started that did camera work for printers and others, and a few more made offset plates for printers. The prepress market was now formed.

Enter technology. The hot metal linecaster initially was used to provide the metal type to the printer. With offset lithography, a proof was "pulled" from the metal and used as "art" for the camera. The linecaster was replaced after 1960 by the phototypesetter. It had the ability to set type directly on film, eliminating the need for camera operations.

The graphic arts camera was also used for color separation of photographs, although it was attacked by the electronic color scanner. It produced film directly. Cameras were still used for art or illustration, giving rise to the term "camera-ready art."

All three kinds of film came together at the stripping stage to produce the flats (signatures) needed to make plates. Printers did stripping, but so did typographers, trade shops, and a few new services that stripped film and/or made plates for printers that did not want to.

And all was well with the printing world—printers printed, typographers set type on film, trade shops were renamed color separators and produced color separations on film, and and they and miscellaneous services did camera work. All was right with the world.

Enter technology, again. In the late 1970s, the raster-based imagesetter was born. "Rasterizing" defined a page by addressing every possible dot position that could be placed on that page with a laser or other imaging system. Those dots did not care whether they created type or illustration or pictures. But this technology needed a method to convert the data from the front-end system that made the page to the imagesetter that exposed the dots. That method was, and still is, called raster image processing, and the device or function that does it is called a RIP.

After 1985, the page description language that became common to laser printers as well as laser imagesetters was PostScript. At its introduction, it demonstrated that the same file could be sent to the laser printer for proofing on plain paper at low resolution and/or to the laser imagesetter for film output at high resolution. The imagesetter was an expensive device and was initially installed by entrepreneurs who saw a new developing market. Art and design professionals who used desktop systems could create and produce pages with type and illustrations and then proof those pages in their offices. When finalized, the pages could be sent to one of the new "service bureaus" that had laser imagesetters. These firms were also called imaging services, or PostScript services, or even output services.

Service bureaus operated on the simple premise that you produced and proofed your pages and just brought them files for output at high resolution. It was a cash-and-carry business. At the beginning, with few services and few files, the page rate was $10 each, for example. As the number of firms and the volume of page files increased, competition brought the price down to $5 or lower.

As more and more page creators applied desktop systems, they set more and more of their own type, negating the need for some of the rekeying done by typographers or typesetting services. Thus, the volume of typesetting as done by prepress services was reduced, and these firms either survived, merged, disappeared, or became service bureaus. The net result was that the number of firms was reduced by more than two-thirds.

Some typesetters installed imagesetters and became service bureaus, but the service bureau part of the business was not as profitable as traditional typesetting. Some typesetters offered value-added services, such as electronic art and design and color proofing.

Nor were the color separators immune from the relentless march of technology. Their expensive color scanners eventually had competitive counterparts on the desktop. The volume of color separations was divided up between the high-end scanners and color systems and the

desktop-level scanners and systems. As the desktop scanners got better, their percentage of work increased.

Color separators are struggling to keep pace with digital photography, which negates the need for a scanner. Kodak's Photo CD makes virtually every color lab a color separator. Although these technologies are not yet in widespread use, because of evolving developments, they could be a threat to the traditional color separator.

Then, service bureaus also started to install desktop scanners to compete for a part of the color separation market. To remain competitive, the color separators added high-end color makeup systems and linked RIPs to the film recorders attached to their scanners, or installed high-quality imagesetters.

Buyers of imaging services or color separation services also installed color printers so that they could proof their pages in color prior to sending them to the service bureau or color separator for output. They were already using drawing and painting programs to create electronic artwork—computer-ready art instead of camera-ready art. They added low-end scanners to do comprehensives and dummies.

Then, to complicate matters even more, the customers of the service bureaus and color separators started to install better scanners and printers and imagesetters. These firms included art and design services, in-house departments, and even printers. These firms acquired the devices and systems to scan their own color and output their own film. Then they started taking files from other companies, effectively competing with the purely prepress services.

Prepress services are now offering art and design services to compete with art and design services that offer prepress services.

To summarize, service bureaus are doing color separation work; color separators are doing service bureau work; printers are doing some of each; prepress services are doing printing; art and design services are doing prepress; and everybody is doing art and design.

Enter technology, yet again. A laser imagesetter that outputs a large sheet of film with all pages imposed in the

correct orientation and order is called an "imposetter." It eliminates the stripping process. The first of these machines were installed by commercial book printers because they were limited to black-and-white work. Newer versions do color.

And even newer versions will output plates. Where will these devices be installed? It is predicted that they will go to the printer, as we go full circle back to prepress and press functions within the same organization. There are still proofing issues to contend with (there is no film to proof) and acquisition factors (these machines are very expensive).

Will there still be prepress services? Of course. Not every printer will get into its own prepress, so there will be some need for services. Perhaps there will be fewer of them, but they will still be there.

Enter technology, ad nauseum

There is the digital printer. It takes PostScript files directly; it images pages of type, pictures, illustrations, and color, puts them all on paper, collates and folds and binds and outputs completed units. It negates the need for film and plates. It is designed for short run, on-demand printing.

Who will use it? Quick printers are printers that have a retail, while-you-wait orientation. They were the first to apply copiers, both black-and-white and color. They would seem to be natural adopters of digital printers, although the first of the breed are expected to be very expensive, perhaps forcing the technology into the larger commercial printing establishments.

But what happens when a prepress service installs a printing press? Is it then a printer? On the flip side, does a printer that installs prepress become a prepress service? This is happening, and it is blurring the lines between traditional definitions of our industry. The digital printer will add to the confusion. It is expected that prepress services—because they control many of the page files—will install these devices, once again blurring the lines between graphic arts services.

As more and more of the creators and producers of pages adopt desktop computers, the pool of pages in standardized electronic form will increase, forcing all services within the printing and publishing industries to deal with those files.

As the technology for scanning brings prices down and quality up, coupled with digital photography and Photo CD, as well as high-definition video, color pictures will be more accessible to more people in electronic form for both print and nonprint requirements.

As new forms of information dissemination in nonprint form evolve, from on-line services to CD-ROM to telephone/cable TV links, to the infamous multimedia, some volume of printing may be affected. Digital printing may have an effect as well.

All of these developments and more will continue to change who we are as an industry and what we do. Eventually, it will come down to the very name for our industry. Are we still going to be printers, or is there a better word or words for what we will do in the future? Prepress, you see, is only the tip of the iceberg called *change*.

A little more history

It was not too long ago that you were virtually chained to your typesetting machine. Because of its use of proprietary fonts and its unique driver program that required extensive setup of letter width values, kern/track values, and even character sets at the front end, you did not easily change output devices. In some cases, you did not even have the option, because the front end and back end were sold as a complete and proprietary system.

In 1985 it all changed. That year saw the introduction of PostScript, both as a font and a printer description language standard. We did not know it was a standard at the time, and it had to prove itself against formidable competitors from Xerox and Hewlett-Packard. Many reasons have been advanced since then as to why this upstart from Adobe Systems won out over stronger competitors. I think there were two reasons. First, it was better because it was universal in its application from low-resolution to high-

resolution devices with a font that could run on all of them at any size or variation. Second, it offered a link to the high end—the imagesetter—and whoever controls the high (resolution) ground controls the market.

Monotype had introduced an imagesetter, a typesetter that could output graphics and photos, in 1978. But it had no user-acceptable front end that could make it output much more than type. Other firms created "kluges" that consisted of old typesetters for text and new systems for pictures. All of these companies had phenomenal output devices, but there was no cohesive way of feeding them complete pages.

Linotype took a major risk in 1985 when it partnered with Apple and Adobe in the introduction of PostScript. History will record that they made the right decision. The press conference in Cupertino early in 1985 showed the same Pagemaker page file going to the plain-paper Apple Laserwriter at 300-dpi and also to the Linotronic at 1270 dpi and 2540 dpi. And that was with the same file and the same font data.

As a result, the first service bureaus came into existence. You could put a page together at your office, proof it on plain paper, and then send it to the service bureau for output on photo paper or film. It was magic. Within two years, there were more than 30 printout devices that had PostScript capability. Adobe routinely published a list of them. There are now more than 200 such devices. In fact, today one would have to make a list of those that do not take PostScript.

Hardcopy terms that count

The six major variables are image quality, resolution, speed, equipment cost, cost per copy/media requirements, and device durability.

Image quality. Most users of color output devices rate image quality as a major attribute for device selection. Unfortunately, image quality is highly subjective and depends on the application. A graphic arts professional cares about the appearance of type and the accuracy and fidelity of color.

Line and edge definition: The sharpness of line drawing edges is an essential attribute. This attribute is also important for shade patterns, type, and bar and pie outlines. Pen plotters generally provided acceptable line quality. For complex line drawings that must be published or photoreduced, line thickness is often an issue.

Line definition from nonimpact devices can equal or surpass a standard desktop plotter if the dot size is small (high resolution) and if the dots can be overlapped to smooth out the raster jaggies. Resolution is tending toward 600 dpi, with all major vendors supporting at least 400 dpi. Color printers that are based on cyan, magenta, yellow, and black inks, and that can produce accurate and uniform colors by perfect alignment of overlapped colored lines, are generally the best.

Dimensional accuracy: Certain applications require that objects measured on the plot area be proportionally accurate. This dimensional accuracy is affected by hardware resolution and software control.

Area fill: Area filling is necessary for bars, pies, shading between lines, and type character fill. Solid areas should be free of streaks and voids, and shaded areas should be uniform. Uniform filling is most important in business graphics, where aesthetics are a major consideration. Background shading is important in colored prints and in 35mm slides made with film recorders for use in presentations.

Backgrounds should be smooth and not show missing lines, unwanted images, or interference patterns. Often the hardcopy device or the rasterizer that drives it can handle the area fill or background fill, but the user or application software overrides this and does a substandard color fill by attempting to fill the areas and backgrounds with vectors in much the same way that a pen plotter does. Newer systems have overcome many of these limitations.

Color gamut and fidelity: Color monitors offer color palettes measured in hundreds of thousands or millions of colors. Color hardcopy devices cannot reproduce all the colors that it is possible to display on a monitor. Conversely, many hard copy devices can produce colors that it

is impossible to display on a monitor. "Color gamut" refers to the range of colors attainable by a printer. Ideally, the gamut of all monitors and printers should be the same. The reality is that while a given monitor and printer may each claim to have 16 million possible colors, their color gamuts will be different.

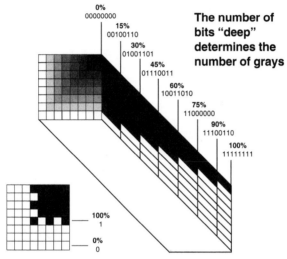

The number of bits "deep" determines the number of grays

Resolution: "Resolution" is defined as the number of discernible line pairs per inch. Terminology such as "dots per inch" and "addressable dots per inch" is more often published, especially for raster technologies, but is not a true measure of resolution. "Dots per inch" is potential resolution and often gives only the measurement of the narrowest line technically possible. If the dots overlap, as is often the case with laser technologies, the visual appeal of the image will be increased with curves and lines looking smooth and not stair-stepped—the dreaded "jaggies." Dot overlap smoothness comes at the cost of resolution. If the dots are wider than their spacing, then closest spaced line pairs will not be discernible. That is, lines are made thicker to smooth them out; therefore, fewer can be placed side by side in a given space and still be recognized as separate lines.

Whereas dot overlap improves visual appeal by intentionally reducing resolution, dot blowup (too much separation between dots) reduces both resolution and visual appeal. Resolution and visual appeal are also affected by stray marks on the paper called "artifacts." Both dot blowup and artifacts can usually be determined by close examination of sample output.

Speed. The primary speed or copy time issues are how long it takes to get the first copy and how long it takes to get multiple copies of the same page. Some other factors, such as graphics processing and whether or not the printing is being done in batch from a queue, muddy the speed issue. Speed measurements can be misleading. For example, a laser printer advertised at 4 pages per minute can take 30 minutes to rip a single page if it contains complex graphics. Four ways to look at speed:

Delivery speed: How fast does the computer deliver the file to the printer? This is a factor of computer processing, networking, and the printer processor.

Offload speed: How quickly does the output device return control to you or become ready for the next job? Is your computer tied up during the entire printing process? Devices with built-in intelligence and large memory buffers can offload your computer quickly. If your computer has an efficient spooler, this may be handled by the computer rather than the output device. Some users are less interested in how fast the actual page comes out than in how long the computer is tied up. If you are more interested in how long it takes from the time you give the command to print until the time you can once again use your computer, then offload speed is what you should determine. We like to call this the time from "click to click," or how long it takes from the "enter" key that initiates printing to the first keystrokes of your next operation. Get a spooler so you can use your computer while the printer is printing or the RIP is ripping.

Processing speed: Raster image processing will be a bigger bottleneck than the actual printing speed of the device. This is particularly true when dealing with color graphics, especially scanned images. For the output of a

roll of 30 slides on a roll of film, the computer spooling time for the files will be less than one minute, and the exposure and film motion times for some of the more expensive film recorders will also total a minute or so. That doesn't mean that you can spool your files and expose a roll of film in only a few minutes. The graphics processing, either in the computer, the rasterizer (RIP), the film recorder, or all three can eat up hours. (The better film recorders process graphics in times measured in minutes.) For large runs or multiple copies needed in a finite time period, the graphics processing times should be carefully understood.

Print speed: This is the most often advertised attribute. How fast can the device produce output after processing is complete? This can be crucial if you wish to produce multiple copies of a document on your output device. When making only one page, this can be referred to as the time from "clunk to clunk," that is, the actual printer hardware time. When spooling large numbers of files, such as the film recorder for example, the clunk-to-clunk time is a good measure of the average time for a page, since between film advances the computer has to offload the file; the computer, rasterizer, or printer has to process the new file; and the printer has to print it.

Cost per copy: The price you pay per page is variable and should include the cost of all consumables, such as paper, cartridges, toner, film, and the like. The actual cost per copy can depend on several factors: device maintenance charges (if any), and the cost of consumables used.

For laser printers and ink jet devices, consumables cost depends on the amount of toner or ink coverage. For example, most monochrome laser printers claim copy costs in the 2-to 5-cent-per-page range. A "page" typically means 5% coverage by toner. But for color graphics, 30% may be a more realistic average for page coverage. "Plain paper" ink jet printers might require special paper to produce adequate quality for your applications.

Durability: "Durability" refers to the number of prints that you can produce in a given time without adversely affecting the device or the copy quality. More technical types

would refer to this as duty cycle, the percentage of time that a device is operated or designed to be operated. For example, a printer that is used an average of 12 minutes per hour could be said to be operating on a 20% duty cycle.

The throughput rate of an 8-page-per-minute laser printer, if operated 24 hours per day for 30 days, would be 345,000 copies per month. At such a continuous rate, or 100% duty cycle, the printer would never survive the month. Rated at 5,000 copies per month, the typical 8-page-per-minute machine is designed for a 1.5% duty cycle over its life and can easily print continuously at its 8 ppm rating for 100 pages, but not for 300,000.

PRINTOUT

Every output device is actually two devices. The first is the imager or imaging or marking engine. It puts marks on paper or film or some substrate. It is the reason that you bought the printer in the first place.

The second is the raster image processor (RIP) that accepts the files from your workstation and processes them into electronic bit maps of zeros and ones that tell the imager where to turn the marking engine marker on or off. In some cases, you do not see the RIP (as with lower end laser printers, where it consists of a logic board), but as the output device gets bigger and the price goes up, the RIP is evident.

The RIP takes input from the computer, most often in the form of a page description language. The PDL describes the page in a standardized way. Because PostScript was the first major page description language for imagesetters, users also installed laser printers with PostScript as well. Pretty soon, page makeup and other application programs output PostScript code, which then provided a larger base of files in this language, which spurred the further growth of printers of all kinds for many markets with PostScript.

Today, PostScript is the de facto standard for page description languages. Virtually all pages that are handled digitally for reproduction on printing presses pass through PostScript.

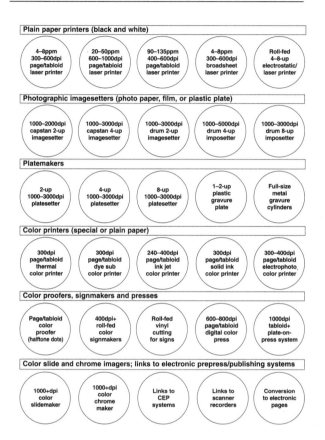

The chart shows the broad range of devices and systems for outputting pages or parts of pages from PostScript files. Laser printers have evolved from low levels of productivity to systems like the Kodak Lionheart and the Xerox Docutech, which are de facto printing presses that produce finished documents. The Docutech speed of 135 pages per minute exceeds that of most offset duplicators (and so does its price). But where it and the Lionheart really shine is in the production of finished documents, something that a duplicator press cannot easily do. In the competitive world of printing, productivity isn't everything; it's the only thing.

Plain paper printers (black and white)

| 4–8ppm 300–600dpi page/tabloid laser printer | 20–50ppm 600–1000dpi page/tabloid laser printer | 90–135ppm 400–600dpi page/tabloid laser printer | 4–8ppm 300–600dpi broadsheet laser printer | Roll-fed 4–8-up electrostatic/ laser printer |

Look for printers in the 20-to 50-page-per-minute range to offer similar capabilities. An important factor in printer selection will involve color. Most of the color output devices are for "pre-proofs," because they do not show halftone dots as the Kodak Approval system does. We must admit that an increasing number of users are applying their thermal, dye sublimation, ink jet (or bubble jet), dry ink, and electrophotographic color printers to get proofs for printing. But even with calibration and color management, there are severe limitations.

But the real action in color printing will come in the area of higher speed and productivity—a Lionheart or Docutech that mixes black-and-white and color pages to produce final documents. The new digital color presses from Indigo and Xeikon are designed to handle color as well as black-and-white, but color is a dominant consideration. There is a need for a demand printer that does both kinds of work effectively.

In both the black-and-white and color printer areas there is also the oversized sheet output device. Dielectric and electrostatic roll-fed printers can now output sheets a few feet wide by several feet long. The black-and-white versions are being used to proof 4-up and 8-up film and plate output devices. The color versions are used for signage. (4-up, for example means four 8½" x 11" pages.)

Photographic imagesetters continue to advance. New capstan and drum versions are still being introduced and prices are as competitive as ever. The trend has been to increase the color capability while maintaining productivity. This has led to renewed focus on the RIP, which now includes new halftone screening functionality. Look for RIPs to become more like print servers (some are now) with automatic queuing and OPI/DCS capability. There will be many suppliers of non-chemically processed film for imagesetters.

Direct-to-plate devices are being introduced on a regular basis, especially the 30 or 40 by 50 or 60-inch versions that expose metal plates. Sony and Ryobi showed a plastic gravure plate and an "office" gravure press in Japan. Output to all kinds of plates, from lithography to gravure to flexographic, will probably evolve as PostScript output.

A unique area of output is that of slides and chromes. Chromes are color transparencies that range from 4" x 5" to 8 x 10". They are sometimes called "digital originals" and are produced as output from computer graphic images. Now one has to ask, "Why go to (color) film only to have to scan the image in order to get to (four) films for color printing?" Art professionals prefer to evaluate the image on film rather than on screen or on a color proof—at least at present.

PostScript files can also be accepted by color electronic prepress systems (via a converter). And do not forget that the back end of older scanners is a photographic recorder. There are RIPs that can drive the recorder as though it were an imagesetter.

There is even PostScript output to machines that cut vinyl for logos and signs and other uses.

Lastly, there is the area of electronic page distribution. Adobe Systems Acrobat is a program that changes the page you created in your page program into a transferable file that can be read, printed, or searched on other workstations.

The future
We cannot think of a single area of output—film, plate, direct-to-paper, electronic file—that will not increase its PostScript output capability. What PostScript has given us is a link between the mind of the image creator and the physical substance of the image carrier for information dissemination. There has never been anything like it. Unless you consider metal type and film negatives to be standards, PostScript is the first standard for the printing and publishing industry. It offers the widest selection of output alternatives ever. But it will have to keep pace with the speed requirements of today's fast-paced business.

Typesetting

Typesetting machines set type. They can also set lines of type, but most were designed with electronic character generators that create characters one at a time.

Electronic publishing or desktop publishing—and all the other terms that we now use to summarize the technologies and the processes of preparation for print communication—began as a craft called typesetting. In the 1950s, photographic methods were applied to replace machine casting of metal lines of type. Phototypesetting, which refers to the output device (or "back end," as we now call it), was strongly affected by computer technology.

The "front end"—whether it was big or small—was where the operator actually worked. It was connected to the back end where the printout (the actual typesetting) took place.

Two printout devices profoundly influenced the way we communicate in print. The first was the typewriter and the second was the typesetter. Both devices mechanized the process of putting decipherable characters on paper. The typewriter mechanized handwriting and the typesetter mechanized hand typesetting. It is interesting to note that the inventor of the typewriter—actually the 52nd person to invent the typewriter but the only one to call it that—was a newspaper publisher who was seeking an alternative to the laborious manual methods used to set type.

One of the investors and users of the typewriter was a court reporter named James Clephane. He saw how the typewriter could replace handwritten communication, but he wanted more. In 1876, he made the prophetic statement, "I want to bridge the gap between the typewriter and the printed page." To accomplish that task, he hired a number of inventors and machinists, ultimately finding, as fate would have it, Ottmar Mergenthaler. After several attempts, the Linotype was born.

The two machines were similar in that they both had keyboards for the selection of characters, although the layout of the keys was different. The Linotype needed to access the more frequently used characters

faster; the typewriter needed to slow them down. Both devices had the equivalent of a return function to end a line. Both machines required that the human operator make all the decisions.

The typewriter was forced to use mono-spaced characters because it had no method for storing different-width characters. The Linotype had no choice but to handle proportional-width characters, and a major problem that had to be solved was that of justification. It was solved with the "variable wedge" or "spaceband" which essentially widened the space between words to force all the characters to the left and right margins—justifying each line to the same length.

As fate would have it, both machines took different paths that would in time converge. The typewriter became the essential tool for office communication, whereas the typesetter became a production tool primarily for the printing and publishing industries, controlled in large part by skilled craftspeople. There were attempts to bring the two worlds together. The Hammond typewriter later became the Varityper. It competed with the Friden Justowriter and the IBM Composer. All of these devices were typewriters with proportional characters. They gave rise to the "cold type" movement in the 1950s and 1960s.

During the 80 years that the Linotype reigned as the dominant typesetting machine, the only significant change in its operation was the addition of paper tape as a peripheral capability. It was responsible for separating the front end from the back end. The tts system, as it was called, let you keyboard copy on a typewriter-like device while keeping track of the accumulated widths of all characters in a line. The operator determined the line end and recorded the data on the paper tape. The tape was then fed into the typesetter which set the type—produced the metal slugs that would be used for printing.

Once it was shown that one did not need the complicated keyboard and apparatus to keyboard copy for typesetting, we were poised for a change. If we could produce a paper tape with encoded data for typesetting on a me-

chanical typesetter, that same tape might be useable on an electronic printout machine. For that and other reasons, we evolved into phototypesetting. At first the typesetter emulated both the typewriter and the Linotype, in that the keyboard (or front end) was physically connected to the printout mechanism. This changed very quickly. As paper tape proliferated, the phototypesetters became "slaves" that could translate the tts codes in order to set type.

This meant that the typesetting operator had to understand the codes—which, by the 1960s, had become a de facto standard. Because the keyboarder made all the end-of-the-line decisions, the typesetting machine did not have to be very smart. That changed too. It was found that the process could be made more productive if the keyboarder did not have to worry about width values or line-end decisions. The typesetting machine then had to have the "intelligence" to add up the widths, determine the end of the line, and automatically hyphenate the last word if necessary—finally spacing all characters and word spaces to justify the line.

This concept of off-line input is not a new one. Tolbert Lanston invented the Monotype in 1890. It had separate devices for input and output. The Friden Justowriter was actually two units, a Recorder which produced paper tape and a Printer which produced the output onto plain paper. The IBM Composer had two modes—the first was used to input the lines and the other to finally print it out. The MT/SC (Magnetic Tape Selectric Composer) let you record on magnetic tape and then play it back for final printout.

As computers proliferated, there was increasing need for faster and faster typewriters to serve as printout devices. Naturally, the keyboard was redundant in many cases. Computer printers evolved as character printers (one character at a time) or line printers (an entire line at a time). To get even more speed and functionality, characters were divided into dots. Multiple pins formed each character as a "dot matrix." Initially the printout was pretty bad, but the matrix kept getting better and better. The advantage over the fully formed character was that one could theoretically, create any character as well as changing font and size.

This concept was challenging phototypesetting as well. Most photographic typesetters used a film, glass, or plastic master set of characters in negative form. After a character was selected, light was exposed through it, and then through a lens to produce the required size. It was then positioned on photosensitive paper or film for later chemical development. Being optical, mechanical, and electronic, these machines were to be challenged by totally electronic approaches. The "digitized" or "digital" photo-typesetter character had about 1,000 dots to the inch—the early dot matrix printer had a character 9 dots by 12 dots.

During the 1970s, typewriter-based printers were oriented to two major markets: data processing (DP) and word processing (WP). The latter area was easier because the device was essentially a "slave" typewriter. The front end of the word processing process was either a typewriter or a keyboard connected to a video terminal and memory and then connected to a printer. As there was only a one operator/one output relationship, the printer did not need much more than the capability of a typewriter.

Data processing, however, needed speed and other functions. These needs led to increasing development of high-speed printout, which culminated, in our opinion, in two devices—the IBM 3800 and the Xerox 9700. Both were printers that employed electrostatic printing technology. Thus, no character was formed by impacting the paper through a ribbon. A laser created the image and it was transferred as toner to the paper. Nonimpact printout was born.

What happened next may seem confusing. Computers got bigger and then smaller; word processing got smaller and then bigger. As desktop publishing evolved toward personal computers, the printers of the word processing world were adequate. As word processing evolved toward bigger systems, the printers of the desktop publishing world were too big and those of the PC world were too small. Thus, laser printers came down in size and capability and, most of all, price.

For many years, formed-character printers were the name of the game for word processing. The best you could

do in the office was letter-quality print from a daisywheel or thimble printer. These printers rotated a molded set of characters in front of an impact hammer, which forced the characters against a ribbon to transfer the images to paper.

What were typesetting machines doing during this period? They got faster, added more font and size capability, increased in quality, and added the ability to expose a film negative—while holding the line on price. However, for many office users, the quality and capability of existing laser printers is adequate for much of the internal documentation and marginally adequate for some of the external material. And there's no chemistry.

But typesetting machines only set type, and they were pretty much replaced by the imagesetter, which set type and also output graphics and pictures.

Each printer has an internal command language that allows the front end to actually get its data printed out. This language lets you print a character, move a space, or advance a line, for example. Although there are some limited standard languages left over from the DP and WP printers (Centronics and Diablo), each printer or typesetter has its own unique control language.

To access the capability or back end, each front end (program or system) must output the result of its processing in the control language of the back end. We call this a "driver." If there are three different output devices on your system, there must be three different drivers.

After you have assembled a page on the screen of your front end workstation, using the commands for changing font and size, for instance, the program converts the page data into the control language of the printer through a driver program. This data is then sent to the printer where it is interpreted and converted to codes to drive the marking engine. In other words, the back end of the front end must relate to the front end of the back end.

There have been competing "standard" page description languages, such as PostScript, DDL, and Interpress, as well as printer-specific languages that have become standards, such as Hewlett-Packard PCL. But today, PostScript is the primary language.

IMAGESETTING

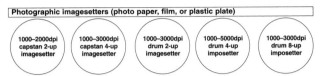

| Photographic imagesetters (photo paper, film, or plastic plate) | | | | |

1000–2000dpi capstan 2-up imagesetter — 1000–3000dpi capstan 4-up imagesetter — 1000–3000dpi drum 2-up imagesetter — 1000–5000dpi drum 4-up imposetter — 1000–3000dpi drum 8-up imposetter

Imagesetters are printout machines designed to output color-separated film in the form of film negatives for printing. Output devices or imagesetters have come a long way since their first introduction. In fact, three generations of machines have evolved. The original issues, such as image area, output speed, resolution, film transport mechanism, and upgradability were addressed in the first two generations of imagesetters. Other issues, such as repeatability, proprietary screen angles, new screening technology, Ethernet connectivity, multiple dot sizes, and roll (capstan) versus drum-based have been addressed in the color imagesetters shipping today. Shown here is a typical capstan recording system.

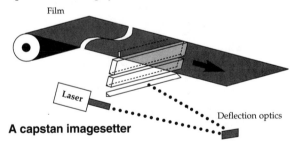

A capstan imagesetter

In 1988, there were only four imagesetter manufacturers to choose from: Linotype (now Linotype-Hell), Birmy Graphics, Compugraphic (now Agfa), and AM Varityper (no longer under that name). The early imagesetters were really typesetting devices, modified slightly with a hardware translator called a raster image processor (RIP). The RIP translates the PostScript language into the native language of the recorder. These devices were called imagesetters because they print "images."

When PostScript imagesetters were first introduced, it became clear that they could output high-quality text with linework graphics and tints in place. This was the impetus for the combination of all the elements of a page electronically, output directly to composite film. Composite film means that all elements are on one piece of film. Conventional typesetter manufacturers demonstrated that their equipment could print composite pages on film, but the systems were not viable.

The new photographic imagesetters that accepted PostScript language files could print on film as a negative. First-generation capstan devices were used. But many had a 4-mil repeatability error over four pages, and that was a problem with registration of colors on press. A 4-mil repeatability error means that when four 8.5" x 11" pages of process color are printed in register, these pages are 4 mils out of register. Process color refers to the CYMK (cyan, yellow, magenta, black) printing model, as opposed to the spot color model in which each color is printed separately. The 4-mil error made working with process color unacceptable.

Repeatability and accuracy are not the same. Accuracy is the ability to place a dot in an exact spot. Repeatability is the ability to place that dot in the same spot on four successive color separations. In working with color separations, repeatability is more important than accuracy—but they are really related. For example, you could live with a color page started at .001" deeper than specified on the film roll, but could not live with .001" variability between the separations. Problems with repeatability interfere with the rosette pattern necessary for 4-color printing as well as the trapping approaches required to overcome misregistration problems on the press.

Another problem is moiré. Moiré problems could be the result of inaccurate screen angles. Conventional printing uses screens rotated 30° or a multiple of 30° to avoid moiré. This allows only three colors to be printed. Because yellow is the lightest color in the 4-color process model, it is usually placed at 15° offset from the two other colors (magenta and cyan). Each of these problems contributes

about 2% error to the screening angle, often resulting in 4% error in each of the four plates. A 4° error on two plates offset by only 15° explains why moiré problems might occur with the yellow plate.

This could all change if frequency modulated or stochastic screening becomes more widespread. It eliminates screen angles. The FM screening capability would be built into the RIP.

Drum versus capstan

Photo imagesetters are either capstan-based film recorders or drum-based film recorders. Capstan printers, also known as roll-based or continuous feed devices, transport the media (either RC paper or film or even polyester plate material) from a continuous roll into the takeup cassette. Repeatability and moiré problems caused most capstan users to work with spot color rather than process color. Imagesetter manufacturers developed second-generation capstan devices with only a 1-2-mil error.

In capstan devices, the film is pushed and/or pulled by rollers, which is the cause of some of the problems. Besides repeatability, start/stop imagesetting could result in banding, where you can actually see inconsistencies in the raster lines across the page. Although manufacturers have used a buffering technique to control the manner in which data is sent to the imaging engine, to eliminate banding resulting from the stop/start mechanism, the problem still occurs from time to time. Rollers must be cleaned and adjusted regularly.

Inexpensive capstan devices have only one set of rollers, whereas more expensive imagesetters have multiple sets of rollers that push and pull in opposite directions. It is difficult for rollers to maintain a uniform tension throughout the entire roll, and there are often variations in tension based on the media remaining on the feed roll, which could make the media stretch differently at the beginning and end of the roll. Present capstan devices have elaborate mechanisms to maintain appropriate tension through the entire roll of film. Newer capstan devices could compete with drum systems.

A drum imagesetter

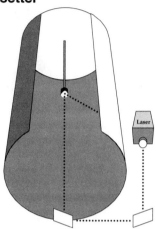

Drum-based imagesetters move the media only during nonimaging periods. Instead of imaging and advancing the media into the cassette, drum machines hold the sheet of film until the imaging is done. Imaging takes place while the media is either standing still, as in an internal drum, or rotating, as in an external drum imagesetter.

Quality
The main advantage of drum-based imagesetting is high-quality output. Drum-based machines are configured with high-performance RIPs to increase productivity. Drum-based imagesetters are much more accurate in placing dots and have few, if any, registration problems. Banding from the start/stop mechanism on most capstan imagesetters is eliminated. Some drum-based imagesetters use lasers that image on blue light-sensitive film which can cost 20% less than other films. Registration holes are punched in some cases. The disadvantages of drum-based machines are price, wastage (film and time), and imaging area. Some imagesetters minimize the wastage.

Quality is generally reflected in resolution levels. The higher the resolution, the more gray levels and tints you can produce. Here are two charts that show available tints at 1,270 and 2,540 dpi.

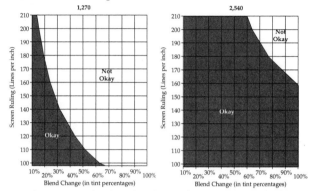

The price is higher for drum devices, typically $20,000 or more when compared to high-end capstan devices. Many work with a sheet-fed technique in which unused portions of the sheet are wasted. Those that are sheet-fed often have to be fed manually, in a darkroom, which wastes time, or may require an expensive automatic loader.

For high-quality output, you need to monitor everything: file setup, imagesetter calibration, media transport, processor rollers, processor speed, developer chemistry, output registration, and more. Operators must have an attention to detail in color, film use, and chemistry, and printing.

COMPUTER-TO-PLATE

Computer-to-plate is not a new concept. Back in the early 1970s, Eastman Kodak had a special material that could be exposed by second-generation photographic typesetters that required a special chemical processor. The plates were used on duplicator presses by telephone companies who produced daily updates for operators on new and changed phone numbers. The technology did not catch on, especially because one of the chemicals used was arsenic.

Platemakers

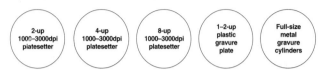

In the early 1980s, the 3M Onyx plate was introduced. It could run in the new breed of photographic imagesetters that composed pages of text, graphics, and pictures all at one time. Up to now, they have not been recommended for process color work, exclusively the province of metal plates.

Laser						
Laser Diode	Argon Ion	Helium Neon	YAG			
Plate Type						
Silver	OPC	Photopolymer	Hybrid	Thermal	Ablation	Ink Jet
Coating						
Precoated	Wipe-on (no longer used)					
Substrate						
Metal	Plastic	Paper				
Printing Process						
Lithography	Waterless Litho	Gravure	Flexo	Stencil	Screen	
Processing						
Toner		Chemistry		Dry Silver	Thermal	
Liquid	Dry	Aqueous	Solvent			
Thickness						
4 – 15 mil						
Repeatability						
1/2 mil						
Minimum Dot						
5 – 20 micron						

What about computer-to-plate in full color? Computer-to-plate to most printers was a dream 10 years ago, but our industry has come a long way since then. Currently, these polyester film and photopolymer plates have long-life activator processing. They are supplied in appropriate versions for invisible and visible red-light sources. More recently, high-end drum imagesetters ensure a much higher degree of precision in the registering of films for

different colors. CMYK film output from these mac
so dependable that the time savings and increased produc-
tivity offered have enabled them to take a share of the
color market, especially on presses like the GTO.

Direct output onto metal plates is the next logical step.
Is this the computer-to-plate dream come true? Although
polyester tended to stretch on the press cylinder, its di-
mensional stability greatly improves with the thickness of
the material. Here are some of the current CTP plates:

	Silver Halide	Photopolymer	Hybrid	Other
Polylester				
Agfa SetPrint (8 mil)	•			
3M Onyx (7 mil)	•			
Mitsubishi Digiplate (5–8 mil)	•			
Aluminum				
Agfa Lithostar	•			
DuPont *Howson* Silverlith	•			
Fuji FNH			•	
Hoescht N90		•		
Horsel (Anitec) Electra		•		
Kodak		•		
3M Viking LaserPlate		•		
Mitsubishi Kasei Diamond (WL)		•		
Polychrome CTX			•	
Presstek				•

Computer-to-plate applications will of course con-
tinue to be of interest mainly for the majority of simple
black-and-white and spot-color offset jobs. But new plates
and the new generation of high-end imagesetters make
short-run 4-color applications less dependent on the skill
of the press operator, so that what used to be technically
hazardous for many printers can now be an old dream
come true.

Computer-to-plate is a technology whose time has al-
most come. In another way, it is competitors reacting to
competitors. Few suppliers want to be locked out of the
technology. It is being fueled by suppliers of new plates,

mostly aluminum, who realize that someday their existing consumables business will change.

The benefits are clearly understood and so are the issues. You can have the benefits of direct-to-plate but you will have to give up something: your present form of proofing or the verification for the press operator and others.

You will probably have to trust the machine and the software to check what people used to check and to make decisions that people used to make. The system will trap and impose. The system will punch and bend the plate. The system will do it all.

System placement

And where will this remarkable system be situated? Users are somewhat split, but there is a rising trend toward placing the platesetter proximate to the press. The press operator will then request plates as they are needed.

Once near the press, the platesetter will have to be impervious to environmental conditions, such as temperature, vibration and oil vapor. New higher speed networking will be needed to get the data from the prep area to the platesetter (and one will have to decide where it is ripped).

In reality, we will also have to develop new methods for getting these jobs in electronic form from the client. A publisher will have 100 megabytes of data or more for a small magazine. Will they use disks? Will data be sent by Federal Express? It may be that they transmit the data, but high-speed lines are not high enough speed for the volume of data.

It has been suggested that this area is a major opportunity for AT&T or MCI or others who will offer a service that lets the publisher place the data in an electronic mailbox at a local phone number, from which the printer can retrieve it with a local phone number. For publishers, this represents a savings in time as well as money.

Proofing for CTP

The proofing issue has two aspects: a substitute for the traditional blueline and a color proof. The blueline was a check for pagination. It may be that the client will trust

the printer's quality control to make certain that all pages are sequential.

The problem with digital proofing is that the proofer and the platesetter may use different RIPs. By their very nature, the ripping and the engine will produce different results. We may have to train a generation of print buyers and print producers to interpret proofs that are not what they used to be when we proofed from film.

The color proof will also be problematic for the reasons cited earlier. Digital proofers like the Kodak Approval system show halftone dots, but it may be that we will not need to look at halftone dots as we know them. Frequency-Modulated screening technology negates the need for traditional dots. See more information on this later.

We think that many cost-conscious print buyers will make concessions and apply low-cost dye sublimation, ink jet, or electrophotographic color printers for their proofing. These printers will not match the print exactly—at least not for some time. Even with color management, there will be differences in color gamut and saturation that will require the user to interpret the proof in terms of what it will look like later, after printing. It may also be that the use of video proofing will find its way back into use and that a version will be used by the press operator to check imposition or registration or other aspects of the job.

Automation

CTP systems are large to accommodate plates, robotics and images.

It is generally agreed that there will not be an operator, except for someone to feed plates to the machine and perform some level of routine maintenance. There are some interesting problems here. All plates come with a sheet of paper in between them to eliminate scratching. The feeding system will have to dispose of that sheet. The robotics feature, plate size, and processor connection make these devices relatively large, like a mid-sized recreational vehicle.

Processing

The platesetter will be faster than the processor. Rather than slow the platesetter down, we will see systems with dual processors and some elaborate conveyor system to move plates to each of them.

The ripped file for a six-color job of 8-up plates could be 8 to 10 gigabytes of data. This data will probably be stored in case a plate must be rerun. Storage will be another important issue in terms of archiving. Film has a fantastic volume of data compared with current storage systems.

Film will be around for a long time. It will take 5 to 10 years to phase the industry over to new approaches. Initial investments for platesetters will be more than $400,000, which means that they will be applied by the top 1,000 printers in North America. The other 49,000 printers will have to wait for the technology to come down in price. They will continue to apply a mix of technologies.

A rose by any other name

We have called this technology "direct-to-plate" and "computer-to-plate" and its shorthand C2P or CTP, and even "platesetting." All are applicable and interchangeable.

CHAPTER 5

DESKTOP COMPUTING

Your computer consists of many parts. The heart and soul is the central processing unit (CPU), the microprocessor that does all the real work. But it is useless without many other components that make it into a useful system.

When you buy a computer, you are usually buying the box under the monitor—the chassis, if you will—which contains the motherboard, the CPU, and accompanying electronics, into which are plugged various logic boards, external connectors, disk drives, keyboards, mouses, and so on.

```
┌─────────────────────────┐
│                         │
│         MONITOR         │
│                         │
└─────────────────────────┘
┌───────────────────────────────┐
│           COMPUTER            │
│   CPU + Motherboard + Disk    │
└───────────────────────────────┘
   ┌───────────────────────────┐
   │         KEYBOARD          │
   └───────────────────────────┘
```

Platforms
Your computer is also called the "platform," a term that really refers to the microprocessor the system uses. This level can be divided into desktop approaches at the lowest end and more professional approaches at the high end. The platform is changing rapidly as the upper end of the PC world overlaps the lower end of the workstation world.

Personal computer: Three computers define this world: the Intel 80486 series and the Pentium, the Motorola 68040

series, and the Motorola Power PC.

INTEL	*Introduced*	*Transistors*
8086	1978	29,000
8088	1979	29,000
80286	1982	130,000
80386	1985	500,000
80486	1989	1.2 million
Versions	*1991–1992*	
Pentium	1993	3 million+

MOTOROLA	*Introduced*	*Transistors*
68000	1979	68,000
68010	1982	69,000
68020	1984	195,000
68030	1987	300,000
68040	1989	1.2 million
Versions	*1991–1992*	
PowerPC	1994	2 million+

This table shows that microprocessors become more powerful by integrating higher and higher numbers of transistors, the building blocks of computer processors.

Workstation: Characterized by reduced instruction set computing (RISC) architecture, faster processing, and more of everything at the PC level. Look for lots of color capability at this level.

Dedicated System: Hardware and software bundled into a turnkey package specifically for prepress processes.

Operating systems and graphical user interfaces

The operating system links all major computer components.

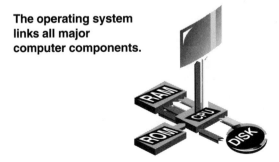

Art by Rawsam Alasmar

The operating system is the glue that unites all the components into a viable system. The operating system controls the flow of information from disk to computer, and back again, to disk and then monitor, from keyboard or other input device to disk, to printer or other output device from disk, to and from other peripherals, and so on. It acts as both the electronic highway and the traffic control system. It is loaded first and then the application software is loaded.

The graphical user interface, or GUI, is the way the information is presented on the monitor. It consists of the icons (little pictures), menus, and functions that make the system easy to use. In the old days, users had to type commands to accomplish tasks; now they click on icons to select files or programs, or point and click at menu items or fill in dialog boxes. Here is a typical user interface, or at least part of one. Functionality is presented with English terms so that you can choose the function you want.

	Operating System	*Graphical User Interface*
INTEL		
IBM PC and clones	MS-DOS	Windows
	OS/2 Warp	Presentation Manager
	WindowsNT	WindowsNT
	Windows95	Windows95
	AIX	Motif
NCR large systems	Xenix	Desqview
Sequent	Dynix	Motif
MOTOROLA		
Apple Macintosh	Mac OS 7.5	QuickDraw
	AUX	Motif
H-P workstations	UNIX V.4	Motif
NeXT	MACH	NextStep
Sun	Sun OS	OpenLook
RISC		
IBM RS/6000	AIX	Presentation Manager
		Motif
MIPS R3000		
DEC	ULTRIX	Windows
		Motif
Silicon Graphics	OSx	Motif
MOTOROLA 88000		
Data General	DG/UX	Motif
Unisys	UNIX V.4	Motif
SUN SPARC		
Sun	Sun OS	OpenLook

Peripherals

Peripherals are just about anything that you hook up to a computer. They include external disk drives, fixed and removable, modems, monitors, printers, and so on.

Storage media

It all started with the lowly punch card. It was the first method for storing information that could be transported easily from one place to another. Its 80 columns of data were adequate for the world of data processing.

The punch card evolved into paper tape, which could hold more information but was less modular.

Modems

"Modem" stands for modulator/demulator. It is the essential device in telecommunications. Speeds are now more than 14,000 bits per second (baud is a shorthand way of saying bits per second).

Input devices

These range from keyboards to pressure-sensitive tablets to various tape readers. Scanners are also considered input devices.

Printers

These can range from personal laser or ink jet printers up to full-blown digital color presses. However, what you connect directly to your computer will usually be a black-and-white or color personal printer.

Monitors

A color monitor displays images with pixels, the smallest picture element that displays color data. Each pixel shows a single color, translated from digital data represented as bits of information. The fineness of detail that can be displayed on a monitor depends on how small the pixels are and how precisely the color data in the pixels represents the color of the original image.

The size of the pixels displayed on monitors is measured in pixels per inch (ppi). Some monitors display 72 pixels per inch. Monitor resolution is frequently referred to in terms of the number of pixels the monitor displays horizontally and vertically, for example, 640x480. Larger monitors must support more pixels across and down. The fineness of the color information displayed on a monitor is measured in the number of bits per pixel. Most commonly, color monitors use 8 or 24 bits of information per pixel, depending on the monitor card. Eight-bit monitors use a palette of 256 colors. Monitors with 24-bit cards can display 16.7 million colors.

If an image is displayed on a monitor with a lower pixel depth than the pixel depth of the image, fewer colors may appear than are in the original file.

Monitor resolution does not influence either file size or output quality—it determines only how the files are displayed on a particular monitor. Monitors that display more pixels per inch than the typical 72 ppi look sharper, with fewer visible "jaggies" with more objects per screen.

Colors displayed on a monitor can look different from those that are printed. You can control certain factors to ensure predictable printed results, but it is important to work in a controlled environment where the ambient light in the room does not change. Any change can affect your perception of colors on the monitor. You should work in an artificially lit room with the same brightness level at all times. Maintain these settings once they are set.

Screen colors can be affected by a monitor's age and temperature. Such factors can create a color cast on the monitor. If your monitor does display a color cast, follow the instructions to be sure that it is adjusted properly. Let the monitor warm up for an hour after it is turned on before making color corrections to an image. Do not leave the monitor running overnight. Most uncalibrated monitors tend to display a bluish cast. Use a monitor calibration program to eliminate the cast. If the color cast remains, and you add yellow and red to an image to compensate for the blue cast, the result is a printed image with a yellow and red color cast.

All monitors tend to display images with a shift in the midtone values, causing an image to look darker or lighter. This varies even between monitors from the same manufacturer. A built-in value is used to compensate for this effect. The default monitor gamma value is 1.8 for both monitor setup and the Gamma Control Panel in Photoshop. Images intended for video and film recorders should have a target gamma of 2.2, which is the typical gamma of most television sets.

SCSI and GPIB
The connection of hardware and peripherals comes down to the Small Computer Systems Interface (SCSI) versus the bi-directional, parallel interfaces like the General Purpose Interface Bus (GPIB). Both buses perform the job of

platform-to-peripheral connection, but there are key differ-
ences which render one interface better for one application
and the other a better choice for a different application.
Interfaces like GPIB and SCSI are the primary interface con-
tenders, although there are a number of different imple-
mentations of SCSI, and GPIB is only one of a few
bi-directional parallel interface implementations.

Both interfaces perform comparably, with the excep-
tion that SCSI is sometimes viewed as slightly faster on the
Macintosh. The transfer rate or speed at which the inter-
faces work is negligible, because the mechanical move-
ment of a scanner, for instance, as well as the speeds of
computer operation, are much slower than the information
transfer rate. Until the mechanical movement of the scan-
ner greatly improves and platform power increases, the in-
terface or transfer rate is not an issue.

The SCSI 8-bit bus (GPIB is also 8 bits) does have a wide
version which GPIB does not have, which enables it to go to
16 or 32 bits. The transfer rate is up to four times faster.
This capability enables a maximum 8-bit transfer rate of
about 10 megabytes per second to increase even more, to
as much as 40 Mb per second on a 32-bit bus, due to "dif-
ferential" versus "nondifferential" technology—which al-
lows a bus to go even faster with the same number of bits.
Although this capability afforded by SCSI is an advantage
over GPIB performance, there are currently few, if any, ac-
tual implementations of this "wide SCSI" capability.

The SCSI interface is virtually free for Mac users, but is
an added expenditure on the PC platform. The GPIB inter-
face is not an automatic offering for Mac users, and ven-
dors cannot include interfaces with their products. GPIB
could run a few hundred dollars for Mac and PC users.

SCSI on a Sun workstation is not the same as SCSI on the
Macintosh or PC. The interface does "care" what platform
it's connected to, and is really not a platform-independent
means of standardizing across different computer plat-
forms at all.

Because DOS and Windows do not recognize SCSI or
GPIB, the software developer has to write a driver into the
software code to connect to that SCSI or GPIB peripheral de-

vice. GPIB is a single standard interface, largely because it has been promoted by National Instruments as a default parallel standard. However, SCSI is more popular.

The strongest touted points of SCSI for the Macintosh are its speed and its capacity to accommodate up to seven peripheral devices via daisy-chaining. SCSI interfaces work well in the Macintosh domain, but many consider it to be weak in the world of PCs. The main reason is Apple's highly controlled implementation of SCSI in the Mac world; the same control was somehow neglected in the PC environment. Because Apple tightened the reins on third-party SCSI vendors and required them to adhere to Apple's standard, the result is a SCSI bus that can connect hard drives, CD-ROM drives, and scanners easily.

PC vendors had visions of Mac-like peripheral connectivity and interface standardization, but there was no standards commitment among vendors and little consistency in using the SCSI interface. Specs often indicate that stringing peripherals together on a single SCSI host adapter should work, but the fact is that it typically does not. This is due to conflicts with device drivers or the hardware itself.

SCSI disadvantages

The disadvantages to SCSI became known when many Mac and PC users connected multiple devices to their computers and were unable to start them. On both fronts, PC and Mac users were disillusioned when SCSI's capacity to handle seven peripherals was frequently limited to three or four devices because of different operating system requirements. Users who experienced difficulties with sequential connections, would reorder the sequence in which their printers, scanners, external hard drives, and other devices were connected to their computers, so that their peripherals would function properly. Other SCSI users experienced difficulties with cables, and some SCSI connections worked with some cables but not others.

SCSI is not a "standard" per se—a single, identical implementation across all platforms. SCSI is full of inconsistencies that vary from platform to platform. In the connectivity domain, users frequently risk corrupting their

hard disks when they turn scsi printers and scanners on and off after startup (or disconnect scsi cables while the power is on), to find out if their Macs or PCs still work with their scanners turned off and maybe save energy in the process, by minimizing power to idle machines.

A scsi hard drive from one vendor and a scsi scanner from another may end up incompatible, with neither device able to work with the other.

A process called termination tells the Mac or PC where the scsi bus begins and ends, so that the bus can handle multiple data transmission signals and ensure transmission of information to a scsi peripheral among multiple connected devices. Connecting more than one scsi device to a Mac or PC requires terminators. GPIB performs the termination function invisible to the user.

scsi-2 is a new version of scsi, which facilities data transfer rates of 10 Mb to 40 Mb per second. This performance is essential for high-end color applications. The two major performance-enhancing aspects of scsi-2 are Fast scsi and Wide scsi. Fast scsi doubles the bus's transfer rate to 10 Mb, whereas wide scsi incorporates additional paths or lanes to the bus "highway," expanding scsi's parallel data path from 8 bits wide to 16 bits and eventually 32 bits.

GPIB

The General Purpose Interface Bus (GPIB) standard was originally called the IEEE-488 standard, and has been around since 1975. Some of the major peripheral vendors opted to use the GPIB interface.

GPIB is platform-independent. A few key advantages of GPIB include connectivity to a number of different programmable peripherals, cabling flexibility, and high speed parallel input/output (I/O). GPIB allows longer connection distances between peripherals and computers, so that users may easily plug in a 25-foot cable with GPIB, and have their scanners, printers, and other devices 20 or more feet away. scsi doesn't typically perform as well at these distances, with 10 or 12 feet as the maximum workable distance without losing data.

Whereas SCSI now limits users to seven peripheral devices that may be connected to one computer, GPIB claims to support up to 14 devices.

An advantage of GPIB concerns the separate bus issue. With SCSI, the scanner is on the same bus as the "brains" of the computer; it the user turns the scanner on or off while the computer is on, the user could crash the hard drive or even corrupt data. With GPIB, there are separate buses, and the interface is intended for people who turn their peripheral devices on and off while using the system. The on-and-off peripheral issue is not a problem with GPIB.

If a user wants to scan to disk in the background and still do other things on the Mac or PC, this process requires asynchronous calls, which free the computer to process on the fly, update the screen, and so on while it scans. GPIB can do asynchronous calls, but SCSI on the Mac cannot. There may be the capability to do asynchronous calls on the PC with SCSI, but there's no single version of SCSI on the PC.

Unlike SCSI, GPIB has the capacity to share a common peripheral device among multiple computers on a network. This is a clear advantage for GPIB. A number of SCSI users who have attempted to share SCSI scanners and other peripherals among multiple hosts have not been successful. GPIB has this capability by default, although this shared capability is hardly transparent to the user. Rather, it is currently the software developer's role to write the GPIB code with the goal of enabling users to share peripherals among several computers.

	Mac SCSI	PC SCSI	Mac GPIB	PC GPIB
Bits	8 (16–32 with wide)	8 (16–32 with wide)	8	8
Speed	10Mb/sec	10Mb/sec	10Mb/sec	10Mb/sec
Cost	Free	Free	$200+	$200+
Devices on bus	7	7	14	14
Termination	Yes	Yes	No	No
Cable length	10–12 feet	10–12 feet	25 feet	25 feet
Share device on network	No	No	Yes	Yes
Drivers needed	No	No	Yes	Yes
Background operation	No	No	Yes	Yes

NETWORKING

Moving information around from workstation to workstation or to and from printers and servers could be done with the traditional "sneakernet" approach to carrying disks from place to place. However, the more prevalent method is to link all users, devices, and systems electronically. A local area network (LAN) is defined as a group of computers, printers, and workstations that are located within a defined area and connected together to share information and functionality. The simplest LAN connects only two computers and a printer. LANs are local, high-speed, private, and structured, and transmit packets of data. Local means that the LAN only links equipment located in the same room or building.

A LAN transmits data at high speed—2 to 10 million bits/second. A LAN is nonbroadcast, so it does not have to be licensed, because it operates outside government regulation. The devices that the LAN connects do not lose the ability to function, as they used to do, just because the LAN is installed. By breaking a long transmission into small parts and reassembling them at the receiving end, LANs transmit data in packet form. And LANs can easily be connected to other networks.

In general, there are two types of networking medium: physical cable and electronic transmission. Physical media include twisted-pair wiring, coaxial cable, and fiber-optic cabling.

Twisted-pair wiring is very common for telephone lines. It is not expensive and it is easy to install. The speed is up to 4 Mb per second, which is not sufficient for high-volume networks. Coaxial cable consists of conducting copper wire located in the center of the cable. The wire is covered by an insulator, usually made from PVC or Teflon. A third layer is a woven mesh of fine copper wire which also acts as a conductor. The outer layer is a protective polyethylene jacket. The speed of the coaxial cable is up to 10 Mb per second; it is commonly used for television cabling. The highest speed cabling is fiber-optic cable, which transmits light pulses through glass or plastic fibers.

Configuration of LANs

The basic configurations of a LAN are ring, star, and bus topology. Each of these topologies can be used alone, or they can be combined. Ring configuration connects all of the terminals with one continuous loop, where data passes from one station to the other in one direction only. Star topology connects all of the terminals to the center computer, where data passes from the sending station through a center point and to the receiving station. Bus topology connects all of the terminals to its backbone cable, which runs the entire length of the network. Data transfer through the backbone is back and forth.

Installing a local area network

In a network, each computer, printer, disk drive, or any device that can send or receive information is known as a node. To install a basic LAN, we need to connect all of the nodes together.

Circuit cards and cabling

Most computers do not come with an integrated network port. The exception is Macintosh, which has a built-in AppleTalk, (and on later models, an Ethernet) port. A network card is needed to connect the nodes to the network. A Christmas-tree-light approach is most common.

Server approaches

A server is needed as a central source of information available for use by workstations on the LAN. There are several types of servers, such as a print server, disk server, file server, and modem server.

The function of a disk server is to read and write information to and from the disk. Software is used to divide a single physical disk into several logical volumes which behave as if they were individual disks. Therefore, a user can have access to a particular file, or several users can, but only one at a time will be able to access the same file.

A file server functions like a disk server, but it also allows users to use the same file simultaneously. The file server manages the shared network resources and main-

tains the network hard disk driver. It can be built into a shared printer or can be provided with keyboard and screen. There are two types of file server: dedicated and distributed. Dedicated servers only run application programs on a powerful computer as a server of the user computers on the network. Peer-to-peer network is an example of a distributed file server that functions as both a server and a user. The computer can share its hard disk and printer with any other computer without going through an intermediary such as a central server.

A modem server is connected to the computer on a network. The disadvantage of a modem server is that only one person at a time can use it. Multiple modems should be purchased for more efficiency.

Installing the LAN software
LANBIOS (Local Area Network Basic Input/Output System) is LAN operating system software used to connect the computer operating system to the network circuit cards in each computer. Then a network name for each computer is established, for network recognition.

Developing a network profile
The purpose of the network profile is to specify what kind of information from the microcomputer is available through the network and who is allowed what access to the network. To protect the access to the network, a specific password can be specified.

The log-in process
In this process, software makes all connections between computers, printers, and users. Log-in processes are not necessary for larger LANs, such as those using Novell network software, because it is done automatically.

Ethernet LANs
Ethernet is a bus topology. The concept of Ethernet was developed at Xerox Corporation's Palo Alto Research Center (PARC) during the late 1970s. Ethernet is a 10 million bits per second carrier sense multiple access/collision detection

(CSMA/CD) baseband technology. CSMA/CD access method detects collision during transmission and holds back the data packets if collision occurs. The data packets are held for random time intervals and are retransmitted after the colliding message disappears. Baseband signals only carry a single transmission at a time, and intermixed signals, such as voice, data, and image, are not allowed.

AppleTalk Protocol

Macintosh computers have an integrated network called AppleTalk, a 230,400 bits per second carrier sense multiple access/collision avoidance system. CSMA/CA uses a three-byte packet to send data throughout the network to tell other computers to wait until the data has been sent by the first computer. If a data collision occurs, which is unlikely with such a traffic control system, it is not between the data packets. Collision avoidance requires that time slots be reserved for each workstation, which lowers performance when a large number of terminals are used— AppleTalk supports no more than 32 terminals.

NetWare by Novell

The Novell network operating system connects DOS operating system computers and the network's operating system located in the server. Novell is the most popular network operating system (NOS). The most prevalent Novell system is NetWare, which allows the integration of different kinds of hardware topologies and interface cards in the same network.

Information highway issues

The so-called information superhighway is putting a combination of technologies together to deliver images, voice, data, video, and movies to computer users. The information, in whatever form, will certainly be transferred digitally because that gives information providers a variety of data transportation options. Whether wired or wireless, digital data is more highly compressible than analog data, so more information can be stuffed onto the communication medium and moved faster and more efficiently. Thus, full-motion, high-resolution video will be possible.

The transportation medium

There are two major components in a digital information highway. One is a switching system to direct traffic on the network and the other is a transport medium for delivering the information. The future vision of the data transmission system is a single network that merges support for audio, video, graphics, and computer data. Judging from the demands of such applications, fiber optics is definitely the favored medium. Fiber optics has hundreds of megabits per second of transmitting capacity, and it is reliable and delivers excellent picture quality. In fact, as it is deployed today, fiber uses less than 1% of its theoretical bandwidth. In theory, a single strand of fiber could carry the entire nation's radio and television traffic and still have room to run all the television sets in the state of Texas. We have a long way to go to see that theory a reality.

Fiber optics has greater potential bandwidth because it transmits signals as pulses of light at a far higher frequency than electric signals in wire or microwave radiation to satellites. Optical transmission has very low error rates, because electromagnetic fields do not disturb it the way they can with signals on conventional wiring. Optical transmission is more secure and much more difficult to eavesdrop on, because electromagnetic radiation is not emitted. A light signal passing through fiber has a low attenuation rate, so point-to-point fiber connections can be much longer than equivalent copper connections without amplification. A drawback of fiber optics is the high cost of providing electrical power to "illuminate" the optical wire.

The switching system

Regardless of the transportation medium, the switching system remains the key technology choice. A few switching technologies that are being discussed right now are Fiber Distributed Data Interface, (FDDI), Asynchronous Transfer Mode, (ATM), and frame relay. Among these systems, ATM is a solution for "bandwidth on demand" in gigabit global networks that support applications such as multimedia. ATM is a group of standards for moving packets of data over a network. It is characterized by several

features: switched-circuit topology, small packets of data, virtual circuits, and negotiable bandwidth.

The connection-oriented packet switching approach employed by ATM simplifies the delivery of time-sensitive transmission such as voice or video over the same circuit that carries data. Each 53-byte ATM packet or cell can carry a header that describes where the cell is supposed to be. This header information does not have to be repeated and processed in each cell of the transmission, as it is in Ethernet and other shared-media networks. Before the cells are transmitted, a pathway through the network is determined to ensure fast delivery of continuous streams of multimedia traffic. ATM also offers the promise of improved network security because each ATM communication sets up a virtual connection, and other nodes on the network do not "see" the transmission as it passes by.

ATM has a lot to recommend it as the network technology of the future for video, data, and voice communications. Compared to Ethernet, which has a top speed of 10 megabits per second and is attempting to move up to the 100 Mbps level that is now the province of FDDI technology, ATM starts at 155 Mbps and scales up to several gigabits per second. This kind of bandwidth is likely to be needed within a few years as multimedia applications become important.

There are few other selling points for ATM to be the data switching system in the future. An important consideration for any new transmission technology is how well it can coexist with older technologies in the years to come. ATM works equally well for local area networks and for phone systems, cable systems, and wide area networks (WANS). No changes to existing applications software are required, except that each computer needs an ATM interface.

Another selling point is the prospect of simplifying the operation and arrangement of computer systems. In an all-ATM network, there would be no need for all the network gear that interprets, routes, sorts, and distributes every message sent over today's networks. If this is realized, both local and wide area messaging would be as

ubiquitous as universal telephone service, and the only network equipment needed would be departmental switches that tie into the huge switches used by long-distance service providers. If an "all-ATM tomorrowland" is achieved, there would be little distinction between the equipment used for work groups and for wide area network connections.

ATM hurdles

ATM still has a long way to go, however. To realize its potential and facilitate an interoperable, multivendor network, ATM must solve and standardize a number of key issues, including congestion control, signaling, traffic management, and network-to-network interfaces. However, it is hoped that ATM will provide the key building blocks for construction of the digital highway. Its system of transmitting small cells of information is flexible enough to work at capacities ranging from megabits to gigabits. This flexibility makes ATM scalable for a variety of environments ranging from LANs to WANs. ATM's switching protocols permit the mixture of different types of traffic, including voice, video, and data. ATM could erase the distinctions between LANs and WANs to provide seamless networking.

Wireless

Transmitting data at speeds of gigabits per second over fiber optics will be a reality in the near future. However, data transmission will eventually move toward wireless nets, with wireless networks implemented as either LANs, MANs, or WANs. By providing coverage for a building, city, region, or even a nation, wireless-network technology makes it possible for users to stay connected while still on the move.

Wireless data networks and services are poised to revolutionize mobile computing. As companies and workers become more mobile, and as routine office tasks are outsourced to offsite locations, the value of wireless communications becomes strikingly apparent. Wireless data transmission uses packet switching, which entails breaking

messages into hundreds of small packets, each containing the intended address of the information. These packets are routed to the addresses based on the availability of open circuits, in tandem with other messages. This scheme results in drastically reduced waiting time.

The biggest limitation of wireless networks is the range and signal strength of transmitters. There are also problems of interference and limited bandwidth. Other complications that current users encounter include the difficulty of telling why transmissions are unsuccessful, and making wireless data transmission work from inside either a parked or moving vehicle. Wireless transmission will require more development than wire-line transmission.

Coverage, error management, and the cost of wireless data distribution will improve over time. This technology allows users to communicate regardless of their location, as a physical transportation medium (cable) is not needed. This is an important feature because in the future, portable computers equipped with receiving software that allows connection to the information highway could be just as common as the telephone.

CHAPTER 6

GRAPHIC FORMATS

Photographs and graphics are stored, translated, and conveyed in a number of formats. You must understand the difference between a file format (PICT, EPS) and the types of graphics (bitmapped and object-oriented) that applications produce and save. A file format is the structure of the data used to record line art and picture images. The same data structure can be used to record more than one type of graphic, and a given type of graphic can be stored in several data structures. The PICT file format can contain both bitmapped and object-oriented graphics, and a bitmapped image can be stored in PICT, TIFF, or EPS format. Every combination of file format and graphic type has advantages and disadvantages.

FILE FORMATS

Format:	✓Photoshop 3.0
	Photoshop 2.0
	Amiga IFF
	BMP
	CompuServe GIF
	EPS
	Filmstrip
	JPEG
	MacPaint
	PCX
	PICT File
	PICT Resource
	Pixar
	PixelPaint
	Raw
	Scitex CT
	Targa
	TIFF

Most imaging applications can import and export images in different formats. Here is the list from Photoshop. Image manipulation and publishing programs accept most file formats and save in an equal number of formats. Some programs also store images in a proprietary format, which contains specialized information that only the creating application can fully inter-

pret. When a program converts an image from a proprietary to a generic format for export to other programs, some of the image's special attributes may be lost.

The bit map

The most basic type of graphic is the bit map. It is essentially a grid of dots—a mosaic made from many tiny black-and-white or colored tiles, or bits. The tiles are called pixels, or picture elements. Lines are built up as rows of adjoining pixels, and all shapes are outlines filled with black-and-white, gray, or colored pixels. You change a bitmapped image by replacing tiles. The optical illusion of nonexistent colors or grays is achieved by dithering, or mixing tiles of nearby colors or shades of gray. Dithering looks at the colors or grays in one row of tiles and the colors or grays in an adjacent row and then averages the two rows to create a third row between them.

Black-and-white bit maps need only one bit to describe each pixel—zero or one. A single bit per pixel doesn't provide enough information to specify a color or shade of gray. Images containing 256 grays or colors require 8 bits per pixel, and photographic-quality full-color images require 24 bits per pixel to specify any of 16.7 million colors. Depending on resolution, color, and grayscale, bit maps require significant volumes of storage.

Bit maps have a fixed, grid-like or mosaic nature and can produce unsightly results when an area of the bit map is moved, enlarged, or even rotated. When you move part of a bit map, you tear up tiles and put them somewhere else, leaving a hole. Moved tiles overlay or replace tiles. If you enlarge a bitmapped graphic, it looks like big dots. If you shrink the bit map some of the tiles overlap others. Any change to a bitmapped image becomes jagged and distorted.

Printing a bit map gives you only the resolution you started with. Low-res bit maps print at low res, even on high-res output devices. If you print a 300 dpi image on a 1,200 dpi printer, you will get 300 dpi. On a 2,540 dpi imagesetter, that 300 dpi image looks awful. Most professional systems use bit maps only for pictures.

Pixel use lets you achieve artistic effects that resemble those of traditional color painting. Image manipulation programs work on bit maps, which are also the graphic format for scanned images.

Bit maps are even more confusing because the term is also used for:

• Type fonts produced as a fixed size and style, which are incapable of resizing. This format is not used very much today for fonts.

• The result of the raster image processing process, whereby every laser dot is placed on a grid for the imaging engine indicating whether that dot is on or off.

The vector
The object-oriented graphics typically produced by drawing programs overcome the limitations of bit maps. The images are composed of mathematically described objects and paths, sometimes called vectors. Object-oriented applications store your strokes as a list of drawing instructions compiled from menu choices and mouse actions. Think of vectors as lots of electronic rubber bands describing the outline of the image. Everything you draw, move, or change updates an internal file that lets the program keep precise track of each item in the drawing.

You can enlarge, reduce, rotate, reshape, and refill objects, and the program will redraw them with no loss of quality. Moreover, you can manage objects as if each item were drawn on a separate transparent sheet. They are freely movable over the surface of a document and can be stacked and partially hidden by other objects without being permanently erased.

The advantages of object-oriented art extend to the printing phase as well. Instead of dictating to the printer where each pixel should be, the program mathematically describes the object and lets the printer render the image at the highest resolution possible. Therefore, unlike bit maps, object-oriented graphics are resolution-independent. An object-oriented image printed on a 2,540 dpi imagesetter looks far superior to the same object printed on a 300 dpi laser printer.

Object-oriented graphics are the natural choice for illustrations, line art, business graphics, and the like. Object-oriented images have smooth curves, grayscale shadings, and tints.

Other formats

MacPaint formats are simple bit maps named after the first graphics program. That format holds only black-and-white bit maps at 72 dots (or pixels) per inch. Mac-Paint graphics lack high resolution, object-oriented flexibility, and some levels of grayscale values.

PICT—not an acronym—is the oldest generic file format on the Macintosh. It is based on QuickDraw, the Mac's native graphics language. PICT objects and bit maps can be white, black, cyan, magenta, yellow, red, green, and blue; they can hold bit maps with resolutions greater than 72 dpi but most are 72 dpi.

PICT2 is an extension of the PICT format, and it has two subtypes: a 16.7-million-color version, commonly called 24-bit PICTT2, and the more prevalent 8-bit PICT2, which holds 256 colors. PICTT2 sets no limit on the resolution of bit maps except that imposed by the application. With 8-bit PICT2, a custom 256-color palette can be saved along with the image data, enabling any PICT2-wise application to recreate the original screen appearance.

Some programs do not save a custom color palette when exporting an image, and some importing applications ignore the custom palette. In these cases, when the image is opened by the new application, its colors will be determined by the current color palette, which can create color-shift and output problems. Color shifts could also occur when a chunk of 8-bit PICT2 from one page is pasted into another 8-bit PICT2 page.

PICTT2 is usually a better choice for presentations in which the final image is viewed on-screen for multimedia, or on a slide, than it is for publishing. It is readily imported but poorly supported by publishing applications. Page layout programs offer contrast and brightness adjustments for grayscale art, but not if it's in PICT2 format.

PICTT2 is used by many screen capture programs to take a snapshot of what is on your monitor.

TIFF

TIFF files are versatile bit maps. The Tagged Image File Format is the most commonly used method for storing bitmapped or picture, images in various resolutions, gray levels, and colors. It does not store object-oriented images. TIFF was created specifically for storing grayscale images, and it's the standard format for scanned images such as photographs. TIFF has different levels based on the number of colors or grays they can contain:

• Monochrome TIFF stores 1-bit images, but the black-and-white pixels can be dithered in a variety of patterns to simulate grays. Dithered patterns limit the degree to which you can edit and scale an image.

• Grayscale TIFF typically holds 256 grays. It's the best choice for graphics used in page layouts, because most page layout programs can adjust the contrast and brightness of grayscale TIFF images.

• Color TIFF handles 16.7 million colors. With EPS, it is in the top two formats for images that will be color separated. Some programs saved TIFF images with subtle variations from the norm, but TIFF/IT has changed that. TIFF is not used for storing text or object-oriented graphics.

Tagged Image File Format for Image Technology (TIFF/IT) is an ANSI standard that builds on the Aldus 6.0 version of TIFF (Aldus came up with the idea) and carries forward the work done on DDES (Digital Data Exchange Standards) and IFEN (Intercompany File Exchange Network). TIFF/IT provides an independent transport mechanism for raster images and integrates high-end and desktop publishing formats. In practice, TIFF/IT should make it easier to exchange data between high-end and desktop environments.

TIFF is a format for storing and interchanging raster (as opposed to vector) images. This usually refers to data that comes from scanners and frame grabbers, as well as paint and photo-retouching programs. TIFF describes images in a number of formats and also supports several compression methods. It is not tied to proprietary products and is intended to be portable. It is designed so that it can evolve as new functions become necessary.

It is the tags from TIFF which made the format attractive to the supporters of DDES. Because TIFF had been designed to evolve, it was possible to create new tags for TIFF/IT to satisfy requirements of high-end systems.

Aldus started it

The TIFF concept began late in 1985 when Aldus Corporation met with a variety of desktop scanner vendors to discuss format standards. The consensus was that none of the existing proprietary formats had the industry clout to become the de facto standard. In addition, page layout programs were likely to be burdened with the task of reading a wide variety of proprietary picture formats. A standard for scanned images would simplify the process of including scanned images in page layout documents.

By August, 1986, the first version of TIFF was approved. Microsoft played a role in the drafting of TIFF and later formally endorsed TIFF for Windows. This helped establish TIFF in both Macintosh and Windows applications. While Aldus was finalizing the 6.0 specification in 1992, the IT8 committee of the American National Standards Institute (ANSI) was working on TIFF/IT, which was approved in 1993.

The TIFF/IT format is made up of three primary components. Only the first component (CT) is actually part of the Aldus TIFF specification:

• Contone image (CT)—Each pixel is described by four bytes, one for each of the four process colors: cyan, magenta, yellow, and black (CMYK). This format is equivalent to TIFF CMYK, previously known as TIFF S (separated TIFF).

• Linework image (LW)—High-resolution, contone, multicolored graphic and text elements described as run length compressed data. LW is superimposed onto CT during color separation. Although LW pixels may be assigned a color, they may also be assigned to be either opaque (to block out the CT below) or transparent (to let the background CT show through).

• High-resolution contone image (HC)—Run length coded format commonly used for masking or trapping. The resolution of this format must be high to avoid stairstepping at the edges of masked images.

Another component is described:

• Final page (FP)—A complete page formed by superimposing CT, LW, and HC information. FP comes directly from work done in IFEN.

LW, HC, and FP have no equivalent formats in Aldus TIFF. These file formats are unique to raster-based file structures of high-end systems. PostScript linework is usually reproduced with vectors. In addition, PostScript has no use for the HC format, because masks are generally described using vector clipping paths. Given that LW and HC formats are not used in PostScript, it would be superfluous to include them, or the FP format, in TIFF.

There are also three monochrome or binary components of TIFF/IT. These come from work done in DDES and "are similar to their color counterparts except that their formats take advantage of the reduced amount of data associated with monochrome and binary images."

• Binary line art (BL)—Binary line art (or run length encoded bitmap) image or file. Each pixel is represented by a single value.

• Binary picture (BP)—Binary picture (or byte packed bitmap) image or file. Each pixel is a single bit.

• Monochrome picture (MP)—Monochrome picture (or continuous tone) image or file. Each pixel is represented by a single byte.

The ISO standard proposes two levels of conformance:

• TIFF/IT is intended to support a transport-independent means for the exchange of various images used in the prepress, printing and graphic arts fields, typically between color electronic prepress systems.

• TIFF/IT P1 is also intended to support a transport-independent means for the exchange of various images, but for prepress, printing, and graphic arts, and additionally DTP and information processing.

TIFF/IT allows the exchange of files with a wide variety of characteristics. P1 removes some of the flexibility of TIFF, but makes those files simple to read. In essence, P1 has more restrictions, which make it simpler for receiving, but more complex for sending. P1 uses the most common desktop defaults within TIFF.

Some data formats are very closely linked to the methods used to compress them. With high-end DDES formats, if some method of compression had not been available, their large file sizes would have made them impossible to use.

Compression

A variety of compression methods are used in TIFF and TIFF/IT:

• Run length (sometimes abbreviated as RLE, run length encoded)—Run length data compression methods decrease file size by encoding sequences of identical symbols. For example, in a bilevel image, the image is composed of only two types, black and white. In some cases, there may be sequences that include long strings of either black or white characters. Instead of encoding a sequence of 20 white pixels as: ####################, this string could be encoded as 20#'s. Two examples of run length compression methods are Pack Bits and CCITT Group 3 1-dimensional Huffman coding. PackBits is a byte-oriented run length compression scheme used with Apple Macintoshes. CCITT Group 3 is a two-pass coding method in which frequently occurring items are given shorter codes than less frequently occurring items. Bilevel images may be compressed with either PackBits or CCITT Group 3. Grayscale can't be compressed using CCITT Group 3.

• LZW—LZW stands for Lempel, Ziv, and Welch (the names of the compression scheme's creators). LZW is designed to be able to compress all kinds of data, including images of a variety of bit depths. LZW is lossless, which means that there is no loss of quality due to compression. LZW works quite well on bilevel images; however, for grayscale and full-color images (particularly images with a lot of detail), LZW may not be able to offer significant amounts of compression.

LZW is an adaptive compression method, which means that the compression technique is dynamically adjusted based on the content of the data being compressed. LZW may also be termed a dictionary method of compression, because it creates dictionaries which are used to compress commonly repeated data.

• JPEG—The Joint Photographic Experts Group (JPEG) was formed to create a standard for color and grayscale image compression. It is effective only on continuous tone color spaces. JPEG describes not one, but a variety of algorithms, each of which is targeted for a particular class of image applications. These algorithms fall into two classes: lossy and lossless.

Lossy—These algorithms are based on discrete cosine transform (DCT). Though they involve the loss of some data, they provide substantial compression without significant image degradation.

Lossless—These algorithms use an algorithm based on a two-dimensional differential pulse code modulation (DPCM) technique. JPEG as used in TIFF also provides for use of the Huffman coding model.

The LW and HC formats are two particularly good examples of data formats that are closely matched to compression methods.

Although high-end systems generally use raster formats alone, in the PostScript world both raster and vector formats are common. Also, LW files are not line art in the PostScript sense. In PostScript documents, line art is created as PostScript code (which describes the lines, curves, and fills of a piece of line art.) This vector PostScript line art is resolution-independent (i.e., it can be output on a variety of PostScript devices and still produce the best quality that the device can achieve).

Historically, traditional high-end systems work with raster data only. This means pixels, and lots of them. Scanned images contain many pixels, each of which can represent a range of colors. These scanned continuous tone images are relatively large in size, but, because they are ultimately halftoned, the scan resolution does not have to be extremely high. Line work (because it includes items with well-defined edges like text, rules, and logos) needs higher resolution to avoid stairstepping. To merge the line work convincingly with the contone data, not only does the spatial (i.e., scan) resolution have to be high, but the tonal resolution (i.e., bit depth) also has to match the continuous tone scan. This results in a large line art file. As an exam-

ple, a 300-dpi, 1-square-inch, CMYK file requires about 350 Kb of storage space. By increasing the resolution to 1,800 pixels per inch (about what a line work file requires), the file size increases by a factor of 36 to 12.4 Mb. (An 8" x 10" image file at that resolution would be a gigabyte in size.)

LW files, because they contain repetitive areas of the same color, are easily compressed using run length encoding methods. The same is true of the HC files used for trapping and masking. They also are of great size, and they benefit greatly from compression. The size of LW and CT files is one obscure technical reason why PostScript has had such great success. For most desktop applications, it just made a lot more sense to create line work with vectors than to create humongous raster files.

TIFF/IT is a collection of formats, some with roots in the high end, some with roots in the PostScript world, and all joined together through a common file structure. Why did the industry think that it was necessary to bring these elements together in a standard? The main reason is ease of interchange. But TIFF/IT also allows powerful high-end formats that take advantage of DDES to break the bonds of magnetic tape. TIFF/IT could also simplify direct-to-plate and direct-to-press operations by providing a stable raster format, which is desirable for a number of reasons:

• In computer-to-plate and computer-to-press environments, it is costly to have a PostScript error occur late in the process. A stable raster file can be passed to a recorder with less chance for error.

• Imposition, trapping, color correction, and adjustments for press conditions can often be handled more easily with a raster file.

• It is generally easier to estimate the output time of a raster file based on its size. When PostScript vectors are ripped, even though the file size may be small, the job still may take a long time to output.

TIFF images can be transferred from the PC to the Macintosh and vice versa. It was designed to travel across any machine architecture. TIFF is a file format capable of representing several kinds of scanned data. Currently, there are two kinds of TIFF data: bilevel—black-and-white—data,

and grayscale data. Grayscale images consist of an array of pixels and each can represent one or more shades of gray. The pixels of a gray image are usually 4, 6, or 8 bits deep, representing 16, 64, or 256 different shades of gray. This makes grayscale images useful for storing photographs.

Bit maps versus object formats
Let's review:

Bit map: A bit map is a mosaic of individual pixels in fixed locations. If it's enlarged, the pixels seem to grow and emphasize the jaggedness. When printed, the image retains its jagged appearance, regardless of the printer's resolution. In other words, a bitmapped image freezes the image with its "tiles" in place.

Object or Vector: The object-oriented graphic is composed of mathematically defined paths and drawing instructions. Paths can be rendered sharp and smooth at any size or orientation, and the image prints at the highest resolution available. These are the electronic rubber bands that can be stretched or shrunk as line segments.

PostScript
In the early 1980s, Adobe Systems, Inc. developed a method to describe typographic images as vectors or outlines, thus allowing type to be infinitely modified and distorted. Previously, most type had been bitmapped, which allowed no change in size or style.

At the same time, they introduced the PostScript language, which described pages in coded form in order to print those pages on raster-based printout devices. The PostScript language consists of more than 300 verbs or commands that instruct the program to move to certain points, draw lines, fill boxes, select type, and so on.

Lastly, they developed the PostScript interpreter, which processes the PostScript page file for printout.

A PostScript file is a purely text-based description of a page. In many applications, you can create a PostScript file from the Print dialog box. You can open this file with any word processor and modify it (if you know the PostScript language).

Here is a typical PostScript file. It begins with the required %!PS:

```
%!PS            1 setlinewidth    1 setlinewidth    1 setlinewidth    1 setlinewidth
newpath         stroke           stroke           stroke           stroke
210 360 moveto  230 360 moveto   250 360 moveto   270 360 moveto   }repeat
%create 1st box %create 2nd box  %create 3rd box  %create 4th box  /Times-Roman
210 407 lineto  230 407 lineto   250 407 lineto   270 407 lineto   findfont
230 407 lineto  250 407 lineto   270 407 lineto   290 407 lineto   24 scalefont
230 360 lineto  250 360 lineto   270 360 lineto   290 360 lineto   setfont
closepath       closepath        closepath        closepath        230 450 moveto
gsave           gsave            gsave            gsave            (My Gray Scale)
   .90 setgray     .80 setgray      .70 setgray      .60 setgray   show
%fill with gray %fill with gray  %fill with gray  %fill with gray  showpage
   fill            fill             fill             fill
grestore        grestore         grestore         grestore
0 setgray       0 setgray        0 setgray        0 setgray
```

Lines that begin with the % are comment lines. Note that the value or variable comes before the command. The result of this little program is:

My Gray Scale

When you click the print command of any job, the page is converted to PostScript code and sent to the printer's RIP. You can save the page or document as a PostScript file—the same one that would have been sent to the printer—for later printing. You don't need the originating program to print a saved PostScript file. The PostScript file can be fed directly to a PostScript printer with a PostScript download utility. Unfortunately, there's no preview image, and the graphic essentially loses its editability, so you should always keep the original version of an image or a page in the native format of its originating application.

A saved PostScript file includes all type and graphic information. If dialog boxes for printing have been properly selected, a PostScript file is best for remote printout.

There are, then, several "flavors" of PostScript format:

1. Click the Print button and your document is converted into a PostScript file and sent to the printer.
2. Select "Save" instead of "Print" and the PostScript file is saved to your disk. You can open it in any text-based program and see it in all its glory.
3. Art, design, and other programs can save the PostScript file to disk and include a view file. This is an EPS or Encapsulated PostScript file.
4. You can convert the saved PostScript file to a portable document format using the Adobe Acrobat Distiller program. This creates a PostScript file with a view version that can be opened on Mac or Windows systems and read with the free Adobe Acrobat Reader.

All of these formats are versions of PostScript.

EPS

Encapsulated PostScript is a PostScript file with a preview. It is used for storing object-oriented and bitmapped artwork. EPS has two subtypes: ASCII (text-based) and binary (hexadecimal). Object-oriented programs (such as Illustrator and Freehand) that offer an EPS Save option often use the ASCII format.

An EPS file in ASCII format usually contains two versions of the graphic. One is a resolution-independent PostScript (text) description for printing on a PostScript device. The second is a low-resolution bitmapped PICT preview that can be displayed on the monitor without PostScript interpretation. This method enables page layout programs to import, crop, and scale EPS graphics while using the PICT image for visual feedback. If an EPS file has no embedded PICT version of the graphic, the importing application displays a gray box as a sort of placeholder.

If an object-oriented image is saved in EPS, it will retain its resolution-independent printing quality, and in most cases cannot be ungrouped, refilled, or recolored. It can be resized, distorted, or cropped. Because EPS files are self-contained, most popular programs that perform color separation accept and color separate EPS files.

Binary EPS is similar to the ASCII version, containing both a PICT preview image and the actual graphic. Instead of being a text-based description, the printable graphic is stored as a stream of numbers that represent the pixel attributes. Binary EPS is voluminous but well suited for outputting bitmapped color images for 4-color separation. A binary EPS color bit map uses about half the disk space of its ASCII EPS counterpart. Many programs have a specific save option for binary EPS.

OPI

The Open Prepress Interface is an extension to Post-Script that automatically replaces low-resolution placeholder images with high-resolution images.

OPI is the solution to a problem. Here is the problem: If you had a high-res picture and brought it into your document, the size of your document would increase to about the size of North Dakota. Because picture files are usually large, just getting them from where they are scanned to your workstation could be a challenge if the place where they are scanned and imageset to film is remote from the place where the pages are produced. Why not scan the picture and save the high-res version at the printing or prepress location and create a low-res version that can be used for page makeup? The method was OPI.

The low-res file was easy to handle and allowed the page to be assembled with all elements in position—with placement, sizing, and cropping of TIFF images. When the final file is sent to printout, the OPI server replaces the low-res image with the high-res image.

DCS

Whereas OPI works with TIFF images, Desktop Color Separation or DCS is a file format that creates 4-color separations by saving images as a set of Encapsulated Post-Script or EPS files. It is used to exchange color data between retouching, separation, and page layout programs.

Unlike TIFF, which originated from the work of committees, DCS was basically the work of Quark, Inc. in response to a request from CyberChrome Inc. of Branford,

Connecticut, which had created a DOS-base
tion system for the desktop. CyberChrome
mat for bringing separated color images
QuarkXPress file.

The basic specification, which Quark, Inc. made freely available to other developers, includes five linked EPS files: CMYK versions of the separated image and a composite master file that allows users to print low-resolution composite files on a color printer. This standard also is called five-file EPS or EPS5.

The advantage of DCS is that it allows an image-editing program to perform color separation and pass the image file through to final output with its integrity maintained. Users can choose which of several image editing programs or systems they want to use to create DCS separations independent of the final creation of the page and the separation of color elements on the page, such as type or line art.

The DCS format was adopted by Adobe Systems as a standard method of output for the first version of Photoshop. DCS provided a convenient way to prepare separations in Photoshop before rasterizing the PostScript file in a page layout program. This division of labor saved processing time, and a combination of Photoshop and QuarkXPress became popular among designers and prepress services for outputting pages with color images.

Users have said they want to see some reduction in DCS file size, because DCS files contain bitmapped data for each file of the CMYK separation, and most also include a complex, 8-bit, 72-dpi, 4-color view file.

FILE EXTENSIONS

You can often identify a graphics file by its descriptor extension. DOS-based systems usually include it as part of the filename automatically; Macintosh systems tell you in the "Get Info" box. You should get in the habit of naming with a period and then the three-letter extension that tells you what the graphics format is. It helps to have an immediate knowledge of what you are dealing with. Here is a list of some of the more common file extensions and the file formats that use them.

Bitmapped file formats

GIF (.GIF): Used for pictures that are transmitted by modem from commercial on-line services.

IMG (.IMG): A bitmapped GEM file. Used by Corel Ventura Publisher.

MacPaint (.MPNT): Bitmap format limited to a resolution of 72 dpi.

PCX (.PCX, .PCC): A bitmapped file developed by ZSoft for PC Paintbrush.

TGA (.TGA, .PIX): Format for images created on TARGA video boards from Truevision. Because of their resolution, files can be very large.

TIFF (.TIF): Tagged Image File Format. Probably the most common bitmapped file type. Now a standard called TIFF/IT.

Object-oriented file formats

CDR (.CDR): CorelDraw format.

MacDraw (.DRWG): Format used by MacDraw.

CGM (.CGM): Computer Graphics Metafile, a standard graphics file format for high-level systems.

DFX (.DFX): A format for CAD files.

EPS (.EPS): Encapsulated PostScript.

GEM (.GEM): Developed by Digital Research as its operating environment.

HPGL (.HPG): Hewlett-Packard Graphics Language. Originally for plotters.

PIC (.PIC): The Lotus format used by Lotus 1-2-3 for graphics and charts.

PICT (.PCT, .PIC): A bitmap format used by the Macintosh.

PICT2 (.PI2): An advanced PICT format that can handle color.

SLD (.SLD): AutoDesk's slide format for AutoCAD.

WMF (.WMF): Windows Metafile Format. Microsoft's common graphics file format for applications that run under Windows.

CHAPTER 7

IMAGE ACQUISITION

A scanner collects image information from an original when light from the scanner's light source reflects off reflective art or passes through a transparency and contacts the scanner's reading head. Data is captured in analog form and digitally stored. The more detail a scanner captures from the original image, the higher the resolution of the scan.

Scanning resolution refers to both pixel depth, or the number of colors available in a file to represent the colors of an original, and to spatial resolution, or the size of the pixels. Together these factors determine how much of the detail from the original will be represented in the digital image.

Scanners classify the colors of the original image into digital values by assigning a value of either "1" or "0" to each bit. The more bits each pixel has available for capturing information, the greater the pixel depth. Greater pixel depth means more available colors and, therefore, more accurate color representation in the digital image.

A pixel that describes only one bit of information from the original can be one of two colors (one bit with a value of either "1" or "0"). Pixels with 8 bits describe one of 256 colors (2 to the 8th—8 bits) and scanners that capture 24 bits of information per pixel (2 to the 24th) have 16.7 million colors from which to choose to translate the color of the original.

A 4" x 4" image scanned at 1 ppi would appear as 16 one-inch square blocks of color—4 down and 4 across. If the same image were scanned at 300 ppi—1,200 down and 1,200 across—1,440,000 minute blocks of color would portray the same 4" x 4" image.

When scanning a line of art or type for output at 2,400 dpi on an imagesetter, the scanning resolution should be 2,400 ppi when the output size of the image is the same as

the input size of the image. If the output size will be 125%, the scanning resolution should be:

Percentage x Resolution = Scanning resolution
125% x 2,400 ppi = 3,000 ppi

Scanners work by reflecting light from or transmitting light through an image or transparency. The reflected or transmitted light is directed to the scanning head, which usually consists of an array of charge-coupled devices (CCDs) or light-sensitive diodes. The array measures the amount of light striking it to generate an intensity value between 0 and 255 for each of the three additive primary colors: red, green, and blue (RGB). The software then combines these RGB samples to produce a (typically) 24-bit, full color image (8 bits for each primary color).

There are slide scanners that are designed to scan 35mm slides or 4" x 5" transparencies; low-end flatbed scanners for reflection copy; and high-end drum scanners, or laser plotters, which are used by high-end color systems (such as Linotype-Hell, Screen, Scitex, and Crosfield) that color separate images as part of the scanning process. Images can also be captured directly from image-capture devices such as still-video cameras or digital cameras.

Slide scanners, like those marketed by Nikon, Pixel-Craft, and Kodak, are designed to scan small-format transparencies such as 35mm slides and 2.25-inch transparencies at resolutions up to 4,000 lines per inch. These scanners use linear arrays of CCDs to capture a single line of image data at a time. Three passes, each using a different color filter, are made over the image to capture RGB information. A three-pass process increases scanning time and the possibility of motion-based scan lines or defocusing.

Flatbed scanners, such as those from Microtek, Sharp, and Howtek, can accommodate reflective art in a variety of sizes and can also handle transparencies (using an optional transparency holder). The effective resolution of flatbed scanners is usually 300 to 400 dpi, although some can reproduce resolutions up to 600 dpi. Some flatbed scanners

make three passes over the image for a full-color scan.

Drum scanners, made by Howtek, Optronics, Screen, Linotype-Hell, and other manufacturers, are considered high-end devices. The operator fixes the original artwork to a transparent cylinder that spins in front of the scanning head, which also focuses a point of light onto the image. These devices generally use photomultiplier tubes (PMTs) to record light intensity. Consistency of the light beam and accuracy of the focusing optics result in high-quality scans.

Digital cameras capture images using CCD arrays and store the data on disk or in semiconductor memory. Video cameras can convert images directly into NTSC (television) format, which systems can convert into RGB data. Video-graphics boards can also digitize individual frames from videotape or from a live video. The resolution of images captured from video is fixed at about 640 pixels by 480 pixels, and color accuracy is limited by broadcast standards.

CCDs

Photomultiplier tubes have been the key to the quality most buyers of color printing have come to expect. New technologies being introduced are delivering commercial-quality color at prices that are a fraction of "conventional" drum scanners. The most popular scanning technology among these is the charged coupled device (CCD).

The first color CCD scanner, the Barneyscanner, was invented by Howard Barney in 1986. It was the first color scanner to attach to a PC or Macintosh. It scanned 35mm color slides. This color CCD technology has now been implemented in a plethora of flatbed and transparency scanners. A new wave of PMT scanning has also been introduced, providing drum scanners for desktop use.

The only measurement of one scanning technology or another can be measured by the expense and the effort required to get quality results from a printing press.

The principle of any scanner is relatively simple: light is reflected from an original image to an electronic sensing area that records the value for each point on the image. The number of points is your resolution; the amount of gray sensed for each point is your bit depth.

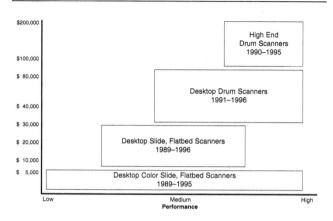

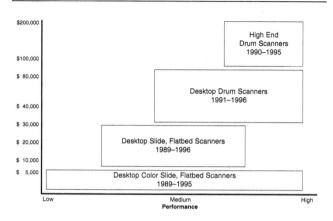

Scanners

Scanners come in all shapes and sizes. They began as high-end drum devices that combined a scanner and a film recorder. The acquired images were converted and separated and later screened and then output to film as four separated images.

In the early 1990s, hardware and software links were developed to capture the result of the scanning operation and convert the data for desktop systems.

These drum scanners sold in the range of $250,000 to $400,000. In 1989, the first desktop drum scanner was introduced to link to desktop prepress systems. The desktop drum scanner now sells in the range of $25,000 to $80,000 based on image size, performance level, and speed. Drum scanners can handle both reflection (print) and transmission (slide or chrome) images.

Flatbed scanners range from less than $1,000 to almost $100,000 depending on image size, resolution, and speed of scanning. Some flatbeds can be adapted to handle transmission material, but may not enlarge the image very well.

Slide and chrome scanners handle only transmission images and range from $1,000 to $20,000. Some require a special holder for the image and some can scan a slide that is still in its mount.

Most of these scanners link with the SCSI or GPIB approaches.

Dynamic range

Several variables determine a scanner's dynamic range—pixel depth (number of bits per pixel per color), sensitivity of the CCD, accuracy of the focusing optics, and precision measurement of the black-and-white points.

There is a range of colors that a scanner can distinguish. Variations in dynamic range impact the quality of the scan more than resolution. High-end scanners are more sensitive to the range of colors in the spectrum and can record minor differences between two visually identical colors, but scanners with a lower dynamic range see the closely matched colors as the same.

Illumination can also affect the quality of a scan. CCD arrays require a consistent light source to illuminate the image evenly. Variations in illumination across the original can produce artifacts in the digital image.

Density range is often mistakenly referred to as "dynamic range" and is measured on a scale from 0.0 to 4.0. Density range is the difference between the highlight point and the shadow point of the image to be scanned. A transparency that measures .2 at the highlight point and 2.8 at the shadow point has a density range of 2.6, as an example.

A conventional PMT scanning system can capture densities on film up to 4.0. Most transparencies, from which a majority of separations are made, have a maximum density of about 3.1. A CCD scanning system has a maximum density range of about 3.5. A factor in the density equation is the traditional printing press. The very best sheet-fed presses have a maximum density range of about 2.2.

Accuracy of focusing

The color information for one pixel in the original image is focused precisely onto one CCD in a scanner with excellent optics. This yields a very crisp scan with distinct colors. In a scanner with less refined optics, the pixel's original color information is diffused slightly across adjacent CCDs. The diffusion tends to soften or muddy the colors and edges in the image. If one of the devices has better optics, two scanners with identical resolution and illumination characteristics can produce different quality scans.

Black-and-white points

A scanner must accurately recognize the darkest point in an image and set that point as black. A similar reduction in tonal range occurs if the scanner incorrectly determines the white point (the lightest point in the image). Because most desktop scanners do not automatically seek an image's black-and-white points, these scanners generally clip the original image's dynamic range. Most high-end scanners automatically and accurately determine white and black points and spread out the range of tones to be scanned.

Here is a schematic of a typical flatbed scanner:

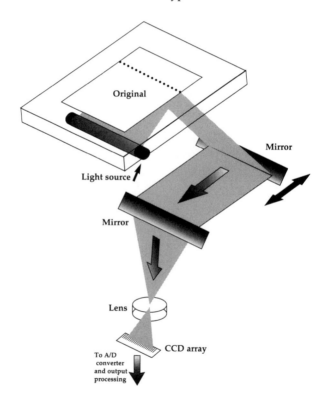

Original

Mirror

Light source

Mirror

Lens

CCD array

To A/D
converter
and output
processing

Scanning at resolutions of more than 2,000 ppi is usually done at service bureaus that work with high-end scanners and can handle large files. To avoid scanning at such high resolution, some black-and-white line images can be scanned in at a lower resolution and traced in a drawing program. This converts the bitmapped image into a resolution-independent PostScript file, and enables output at the highest resolution possible.

Resolution-independent art intended for output at 2,000 dpi can usually be created with file sizes of less than 1 Mb. To create the same resolution in a 4" x 4", 24-bit CMYK paint or imaging program file would require more than 200 Mb.

Determining file size

To determine a file size prior to scanning, the final size of the scanned image must be calculated in pixels and then multiplied by the pixel depth. First multiply the anticipated width of the scanned image by the anticipated length (in inches). Multiply this result by the image resolution squared (ppi):

$$(\text{Width} \times \text{Length}) \times \text{Image resolution}^2 = \text{Total pixels}$$

The next step is to multiply the number of pixels that will make up the scanned image by the pixel depth (in bits).

$$\text{Total pixels} \times \text{Pixel depth} = \text{Total bits}$$

Each color channel in a scanned image has a pixel depth of eight. RGB images, three color channels, have a pixel depth of 24, and CMYK images, with four color channels, have a pixel depth of 32. Most desktop scanners scan RGB.

Custom file sizes are not measured in bits, but in bytes. One byte normally equals 8 bits. The final step in determining file size, then, is to divide the number of bits in the image by eight. 1,000 bytes is approximately 1 Kb; 1,000 Kb is approximately 1 Mb (1.024 Mb).

A rule of thumb is that the file size of a one square-inch, 24-bit image scanned in at 300 dpi is 270 Kb.

Resampling images

Image resolution can be altered through resampling in a photo-imaging program. Resampling means changing the resolution of a scanned image. Sampling up adds pixels, basing their color data on surrounding pixels. This process involves estimates and always yields results of lesser quality than a scan that has captured all color information from the original. Be careful when resampling images that have fine detail.

When resampling through "interpolation" methods, new pixels are created with colors that mathematically average those of surrounding pixels. The compromise colors of the new pixels could soften the image, as opposed to replication methods, which copy the exact colors of neighboring pixels. Use replication methods only when doubling resolution (200%, 400%, 800%, etc.).

Enlarging a scanned image in a page layout program creates larger pixels, thus lowering the image resolution. Resizing images can also cause printing problems.

Use all available tools

Early desktop scanners were only 8 bits per color per pixel, but now they are mostly 24-bit. Some scanners throw away the extra bits to produce the 8 bits per color per pixel and their function is to get the right 8 bits. Adjusting tone and color after the fact in an image program doesn't take advantage of the extra bits the scanner captures, if they are in fact discarded. If you make color adjustments with the scanning software, you will only be using the data the scanner is capable of capturing.

Tools are available to control scanning and provide proper adjustment:

• Histograms are bar charts that graph the number of pixels against the number of gray levels.

• On-screen densitometers show a numeric display of the grayscale, RGB, or CMYK values.

• Levels control is a dialog box that lets you set the white point, black point, and gamma.

• Curves control is a dialog box that lets you set the tone curve of the image by placing points on the curve.

Save settings separately from the image so you can try different combinations on various images and Undo to get back to the basic scan. You can Undo to switch between the original scan and the desired effect, providing an immediate comparison. When you've figured out what should be done to get the effect you want, go back to the scanner software and rescan the image with the settings that duplicate the image software settings.

Scanning quality

The key to producing good-quality color separations is based on the system's ability to compress the tonal range in the original transparency to the 2.0 or less that can be reproduced on the press. Based on the numbers alone, we can easily see that both scanning systems are capable of capturing enough image data. But software, capable of creating a custom tone curve, is the key to getting results in print. This is because every transparency is different and the human eye is more sensitive to tone gradations in highlights than shadows.

An operator examines the transparency under controlled lighting, a highly subjective activity which accounts for much of the training required. Through a prescan, the operator adjusts for cast in the transparency and then the scan, color correction, and film recording take place in one proprietary system.

Most scanners prescan the transparency, and the software assists the user in identifying the highlight and shadow points by differentiating between adjacent lightness and darkness in the image on the computer monitor. In a separate dialog window, the operator may adjust for film cast and maximum print densities, just as the high-end scanner operator operator would.

Based on highlight and shadow point, a tonal range is defined by the software, which then adapts a tone curve customized to the specific transparency to be separated. In both cases, the application of mathematical algorithms determines proper tone compression, so that the press, which has a much more limited density range than either the transparency or the scanners, can reproduce the color and

tone appropriately when ink is applied to paper. Applying a custom tone curve to a given image is handled in much the same manner on both high-and low-end systems, which compensate for the way in which the human eye perceives color and light on paper.

The sensing technology employed in the scanner is much less critical than whether one can depend on that device to provide predictable, printable color separations. Much of the prepress capability needed in the scanner is provided by the software. The performance of any scanner is more reliable when its software is designed in conjunction with the hardware.

Professionals who scan for color separations know that some colors and shades are simply more important than others. If a picture of a sweater is to be reproduced, it may be relatively unimportant that the color of the sweater be reproduced accurately, particularly if the readers don't know, or don't care, about the exact color of the original. It is more important that facial tones be accurate, because we all have a preconceived notion of what facial tones should be. We have preconceived notions of what blue sky should look like. And green grass and yellow bananas. These are called memory colors and they must be reproduced accurately. Neutrals (gray) accuracy is key in good separations.

All color separation begins with an original to be scanned. There are three alternatives for originals

- Reflection copy (photographic prints),
- Photographic transparencies (slides or chromes), and
- Photographic negatives.

The scanning process must produce a good digital representation of the original. Image manipulation (retouching) software should be used to evaluate and modify the image. The algorithm that converts the image from red, green, and blue (RGB) data to the printing plate requirements of cyan, magenta, yellow, and black (CMYK) should be appropriate to the printing conditions. As printing conditions change, so should the separation algorithms.

Before scanning any photographic subject, it is helpful to set up a scanner using some of the same tools that prepress professionals use—gray scales and color patches.

Gray scales may have no color data, but this neutrality is helpful. The Kodak and the Agfa gray scale, both have a number of steps at different density values. Let's scan:

- Place a color original and a gray scale on the scanner platen or drum or in a holder.

- Open the scanner control program, and go to Acquire or Scan, and then to any submenu. You should now have a preview window.

- Set the scanner to color, select the resolution desired, and define the area for the original and the gray scale.

- Activate the preview function. You will then see if you have to make any adjustments in the window size to make sure that both pieces of copy are in the defined area.

- Note the numbers in the areas next to R, G, and B. These will probably be set to 0 if the scanner is new, but might have been changed over time. Positive numbers lighten the respective channel.

- Also note the gamma. This is a measure of contrast. With higher contrast originals, set this number higher than with low-contrast originals. Generally numbers between 1.5 and 2.0 are good starting points for color prints. Now you can activate the real scan.

- Check the "overall exposure" and "neutrality" of the digital image. The monitor is not the place to make this judgment. Do not trust an uncalibrated monitor. Check the digital image in Photoshop. Choose Show Info from the menu. You now have R, G, and B values. Select the eyedropper tool, which acts as both a color light meter and a densitometer. Put the eyedropper over a step of the gray scale. Each of the RGB values should be similar. For typical

printing conditions, values in the 230s or 240s are acceptable. Photoshop, like other PostScript programs, allows for only 256 shades of gray (for each color)—0 to 255.

• In Photoshop, as with most, but not all programs, 0 represents black and 255 represents white. Press operators generally prefer to have a halftone dot everywhere in the image. Numbers in the 250s and higher 240s convert to very small halftone dots, and are generally inappropriate except under very fine printing conditions. Before going on, make a note of these three RGB numbers, even if the values are outside the 230s or low 240s. The Info palette will also produce C, M, Y, and K values.

• Pick a step near the bottom of the scale and record the step number. Click on that step. The R, G, and B numbers will be below 200 and within 5 to 11 points of each other. Repeat for more steps. As the steps get darker, the RGB readings will get lower, but, for each step, they still should be similar to each other. Always record the step number and the R, G, and B value.

• The RGB values in the last grayscale step play a major role in determining your halftone dot sizes in the shadows. Values below 20 could lead to shadow dot sizes above 90%, and press headaches. If two of the three RGB numbers are below 20, raise the gamma value used in scanning by 0.10 to 0.20. Adjust the RGB balance. Rescan if you must and recheck values—scanning by the numbers.

Printing inks are not pure

Even if the RGB values in any step were identical, the C, M, and Y values will not be. It is normal for the cyan (C) separation to print more ink than either magenta (M) or yellow (Y) in neutral areas. Equal amounts of cyan, magenta, and yellow inks make brown, not neutral gray. This is true even for lower screen values. 30% each of normal cyan, magenta, and yellow inks make a shade of yukky tan, not neutral gray.

The reason for this is that the cyan, magenta, and yellow inks are not perfect. Pure cyan ink would absorb all red light and reflect all blue and green light. Cyan ink is a much better reflector of blue than of green, and the ink

looks more like blue than green. In fact, some press operators refer to the ink color as blue, not cyan. Magenta ink should absorb green and be a perfect reflector of blue and red. But it is a much better reflector of red than of blue, and looks more like red than blue. Some press operators call this ink red, not magenta. A perfect yellow ink would absorb all blue light and reflect all green and red light. Although not perfect either, yellow inks are more accurate than cyan or magenta inks.

You could observe that cyan inks are contaminated with some magenta. It's as though some magenta ink was blended in with a purest cyan to make the cyan ink that printers use. Magenta inks are contaminated with some yellow. Magenta ink can be thought of as a perfect magenta, but with some yellow ink added in.

This is known as "hue error." Printers and color separators know that they must print more cyan than either magenta or yellow to make neutral. Process color ink sets have this hue error "error." At certain printing conditions you could have neutral shadows print with 90% cyan, 80% magenta, 80% yellow, and perhaps 50% black. It would not be appropriate to print equal 90% amounts of cyan, magenta, and yellow, along with black, in neutral shadows.

More numbers

Measure each of the steps to get the CMYK values for those steps. The first step is the lightest and might give C (cyan) values of about 6–12%, with M and Y at about 3% less than C. C might read 85–90%, with M and Y about 10% less. The difference between C and C/Y readings gets larger as the steps darken.

CMYK readings are dependent on the RGB readings from the original and the separation algorithm used. These factors are controlled in the Preferences/Separations Setup dialog box. Change these factors and CMYK values produced from a given set of RGB values will also change. In the highlights, the CMYK values produced by the separation process are determined by the RGB values. As the tones get darker, the separation algorithms are instrumental in pro-

ducing the CMYK values.

Review this with the printing firm. Shadow halftone dots of c90%, m80%, y80%, k50% (total 300%) may be appropriate for quality printing conditions, but not for newsprint. Printers refer to these percentages (300% out of a possible total of 400%) as total ink laydown or coverage. For high-quality printing, 300%, or a little more, is acceptable. Where dot gain is greater, total ink coverage of 240–290% may be more appropriate. Newsprint should be less than 240%. The printer may recommend a total ink coverage and appropriate dot values for highlights and shadows for each of the colors.

To review or establish printing conditions, use the Printing Inks Setup dialog box in Photoshop, which defaults to SWOP. Many printers use SWOP inks, but some print at higher ink densities than SWOP specifications. The inks colors list is at left.

Separation approaches: The Separations Setup dialog box is where the RGB to CMYK conversion is controlled, if the scanner has not done the conversion on the fly. The first choice is between GCR (Gray Component Replacement) and UCR (Under Color Removal). These terms refer to the way in which the black printer interacts with the three color printers, particularly in neutral grays areas.

These methods allow for black to substitute for the three color printers. UCR, is the more common method, with GCR as a more recent capability. GCR allows for greater black replacement, but is more difficult to apply and is often avoided. If you toggle between GCR (medium) and UCR, you will see changes in the curves. Although either approach produces similar printing, intermediate films are different. With GCR, the ink saving on long-run jobs is substantial because of the replacement of color with black ink.

Middle tones

It is also important to check on middle tone reproduction, because they are often dark when highlights and shadows are correct. This means that there is not enough detail in the shadows. Many pictures can be improved by some lightening of the midtones (or middle tones).

If the RGB values for highlights and shadows are OK, check a lighter step on the gray scale. If the RGB values are below 140, middle tones might print too dark. Photoshop Levels produces a set of histograms which can be modified. Move the triangle in the middle of the bar. Use the eyedropper over one of the grayscale steps. As you see the RGB values increased and the CMYK values decreased, you can make your decisions. To recap:

• Set *Printing Inks Setup* and *Separations Setup* to the desired values. Check with the printer and/or prepress service.

• Set your scanner so that each grayscale step provides similar readings for each of the RGB values. Use a test target to set this up.

• Adjust your scanner to provide highlight and shadow RGB readings as closely to desired values as possible. Depending on printing conditions, you may want to avoid RGB values greater than 245 or less than 20.

• Adjust middle tones if necessary.

• Do RGB to CMYK conversion (it will probably be automatic).

• Check CMYK values in highlights, midtones, and shadows. Modify histograms to adjust dot sizes if necessary. After the CMYK conversion, the monitor presentation of the image may be less accurate than it was in RGB.

• Use a calibrated imagesetter. Uncalibrated imagesetters may produce films which have middle tones 10% or more off the proper values.

• Check films with a densitometer to verify digital separations.

• Make a color proof from the films.

• Create a form and keep good records. Comparing the printed jobs with job settings, and making adjustments, will help.

The resolution solution

To properly scan an image, you must control:
• Resolution
• Tonal range
• Color balance
• Sharpness

Resolution is the easiest because it depends on the original image size, the reproduction size, and the output method. For halftone output, whether from a laser printer, imagesetter film, or computer-to-plate destined for press and reproduction, the rule of thumb is:

> The number of pixels per inch, at the output size, must be between 1.5 or 2 *times* the line screen frequency used for final output. Scanning for a 133-

line halftone screen, which is used for most printed photographs, requires a resolution between 200 and 266 pixels per inch (ppi).

For scanning resolution, multiply your output resolution (line screen x 2) by the scaling factor you need—the output size divided by the input size. If you want to reproduce a 1"x1.5" 35mm slide at 6" x 9" with a 150-line screen:

Line screen x 2 x (output dimension *divided by* input dimension) = Scanning resolution

150 x 2 x (6/1) = 1,800 (dpi)

When scanning for output on a continuous tone device such as a dye sublimation printer, the output resolution should match the resolution of the scanning device:

(Output dimension *divided by* input dimension) x Output device resolution = Scanning resolution.

Your last set of rules

Always get the tonal range correct before fixing the color balance. When the tone and the color are right, you can sharpen the image.

1. Go as far as you can with the scanner software.

Get the tone and color balance adjustments down pat before scanning. If you make the adjustments after scanning, you will have less data, and each time you readjust the tone/color balance, you will lose data. Plan ahead.

Histograms show you scanner gamma setting and this gives you information at each of the 256 gray levels the 8-bit data represents. Gamma controls will map all input levels to all output levels. A value greater than 1.0 lightens the middletones, and a value less than 1.0 darkens them.

2. Use the histogram to see your image as a chart.

This all-important bar chart tells you a lot about your scans. A histogram that ends in a steep cliff at the left (shadow) end of the scale indicates a scan in which

shadow detail is lost. If it ends in a steep cliff at the right (highlight) end of the scale, the image is overexposed and the highlight detail is lost. A correctly exposed scan produces a histogram with relatively few dots at either the darkest value (0) or the lightest value (255).

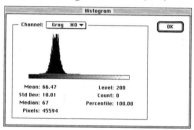

3. For sensitive adjustments, use Curves.

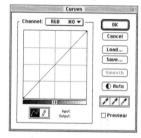

In the Levels dialog box, gamma is the middle value, and you are "curving" the tone curve around a single point in the middle. The Curves command, however, allows you to make finer adjustments to the tonal range—opening up the extreme shadows and spreading the highlight detail across a wider range. Anchor the curve with two points to localize the effect of any change.

4. Use Levels instead of Brightness/Contrast.

Never try to brighten an image with any control called Brightness/Contrast. Ever! This shifts the image up or down the entire brightness range, blowing out highlights or plugging up shadows. If you look at the histogram of a good scan that is dark and then increase the brightness, all the highlight detail will be lost, and you will wind up with a screenful of white pixels.

With the Levels function, you can adjust the brightness of the middle tones without losing detail in the shadows or highlights.

5. Control scanner noise and film grain by sharpening channels.

Unsharp Mask's Threshold setting is effective for controlling noise and film grain, but if you examine the individual channels of the image, you'll find that very often noise or grain is much more prevalent in one (usually the blue channel) than in the others. The green channel contains the most brightness information and also contains the least noise and grain. You can get good results by sharpening the green channel, using the preceding settings; sharpening the red channel, using the same *Radius* and *Threshold* settings but with a lower *Amount* setting; and leaving the blue channel unsharpened. If the blue channel is particularly noisy, try the Despeckle filter. Beware of creating color fringes along the edges, which is more of a problem with high-res images that demand a higher *Radius* setting.

You could despeckle the noisy channel (more than once maybe) and then use a low *Amount* setting and the same *Radius* and *Threshold* settings as the other channels.

6. Use Curves and the Info palette to set the neutral balance.

Get the tonal range right and then adjust the individual curves for the red, green, and blue channels for good gray balance. Balance grays and the rest is easy.

Even with a calibrated monitor, color cast is not easy to discern. The image or scanning Info display or an on-screen densitometer help to identify and correct color casts. Check the RGB values in the Info palette display when you move the pointer over these areas. Values for all three channels should be about equal.

If one channel has a lower or higher value than the others, adjust that channel's setting to bring the neutrals into balance. In the Curves dialog box, click the pointer on the image and adjust the curve so that the output value matches those of the other channels.

7. Sharpen images by using Unsharp Mask.

The Unsharp Mask filter increases the contrast between adjacent pixels in an image, especially where they represent an edge of some kind. The use of this function increases the visual sharpness of the image. The Unsharp Mask filter allows you to set these parameters:

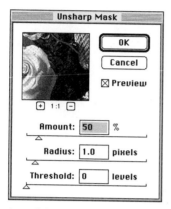

- *Amount* controls the intensity of the filter and the amount of sharpness. The settings for *Amount* will vary depending on the original image. For halftones, set it between 100% and 250%. For continuous tone dye sub printing, try 65%– 85%.
- *Radius* determines how far the filter will look around each pixel as it evaluates its color, and the size of the contrast halo the filter creates around edges. For the *Radius* setting, a useful formula is:

200 *divided by* (output size x output resolution) = Radius

- *Threshold* sets the minimum degree of difference between pixels at which point the filter will operate. It lets you prevent noisy areas from being sharpened.

The setting for *Threshold* depends on the amount of noise the scanner produces and the amount of graininess visible in the scan. The threshold of 5 (out of 5) makes the filter's effect less obvious.

8. Test, test, test.

Start by talking to the prepress service and/or printing service. They will usually have a list of settings that work best with their presses. Then run a few sample images at different settings through the imagesetter and have them proofed. Then pick the one that will provide the best quality. If the project has a large number of images, you and the printing company may wish to actually print some samples. Remember, just looking good on the monitor or on a color proof, is no assurance that the images will print properly on a printing press. Why risk the cost of a rerun, when some pretesting will provide a greater assurance of success?

SECTION 2

PREPRESS
CONCEPTS

CHAPTER 8

PREPUBLISHING

Being a reformed typographer, it seemed like a good idea to include some really basic layout information. Today, the functions of designer, typesetter, photographer, and printer seem to be merging as we use the computer to integrate text, images, graphics, and more to output pages and documents for reproduction.

All pages and documents begin with basic design. No matter what reproduction technology is used, you must create and produce a cohesive layout that meets the needs of the product. Here are some simple rules:

1. Be consistent

Set up your document pages to the trim size of the final product. Use the same margins throughout the publication. Keep a consistent look to heads and subheads. Do not change typeface or size too much. Handle the various elements of graphic design within each page and within a publication consistently, especially in regard to placement of running headers and footers, folios, and rule lines.

2. Avoid dullness

Too much balance and symmetry can lead to boredom. Interrupted eye movement occurs when the reader's eyes are faced with too many equal-sized elements. Asymmetry adds interest to a page. Unequal left/right or top/bottom balance helps provide movement—but don't make every page different.

3. Give each page a dominant visual element

Provide a focal point for the reader's eyes as they travel through the page. This is not possible in book work or directories, but there are many types of publication, like catalogs and magazines that lend themselves to innovative layout.

4. Design facing pages

Concentrate your design efforts on two-page spreads so that pages work together. We view two pages at a time when we read.

5. Create a grid

A grid consists of nonprinting horizontal and vertical lines which define the placement of the graphic elements that make up a page. They form a publication's overall organization and consistency.

6. Standardize margins

Indent copy, headlines, titles, and page numbers the same distance from margins on all pages.

7. Use borders as frames

Frame your pages with appropriate borders. Use simple borders.

8. Organize text into columns

Select column widths appropriate to the size of type. Use wide columns for large type sizes and narrow columns for small type sizes.

9. Organize the page with horizontal or vertical rules

Rule weight should depend on how the rule relates to the copy and white space. Use vertical rules to separate columns. Use horizontal rules sparingly.

10. Post signposts

Headers (running heads) are information contained at the top of each page. Page numbers can be placed in the header or footer (running heads or feet).

11. Use type with personality—sparingly

Each typeface evokes a different feeling, and speaks in a different tone of voice. The typeface you select for headlines, subheads, body copy, and captions affect the way readers experience your ideas. Use only a few, but make them count.

12. Provide a strong flag or identifier
The flag is your publication's title set in a unique way. The flag is usually the dominant visual element on the first page of a publication.

13. Use dominant, descriptive headlines
Headlines determine the overall appearance by strengthening the message you want to communicate. headlines must be large enough, but must not compete with other page elements.

14. Let subheads provide transition
Subheads lead readers into the body copy. Subheads also break up long blocks of copy, making it easy to locate information.

15. Use captions to describe photographs and artwork
Captions should be set in smaller type, so they do not compete with the body copy.

16. Use color to set elements apart
Use color to highlight borders, rules, or headlines. Color gains impact when it is used selectively.

17. Use big type to emphasize big ideas
Type size should reflect importance. Headlines should be larger than subheads. Subheads should be larger than body copy, and body copy should be larger than captions and footnotes.

18. Use type styles for emphasis
Add emphasis to copy by setting headlines, subheads, and body copy with different type styles.

19. Use white space as an element
White space emphasizes whatever it surrounds, so frame pages with white space.

20. Use tints and reverses for attention
Screen tints and reverses can be used to add interest to pages without photographs or illustrations.

21. Focus ideas with graphics

Use photographs, illustrations, charts, and graphs to communicate ideas at a glance and add visual variety. Graphics and images are now easier to use and therefore more common in documents.

22. Check text and layout

Always check your work. Make sure that nothing has been left out. Check names, addresses, and phone numbers. Check any word that begins with a capital letter. Check for graphic consistency and accuracy. And, never, ever, trust the spelling checker.

APPLICATIONS

A distinction must be made between documents, publications, and promotional and utility products:

• Documents—Less than 50 pages typically, with simplistic page elements, primarily text. Moderate color.

• Publications—More than 50 pages, with more complex page elements, especially graphics and some color.

• Promotional—Page count usually very low, but very high levels of quality for text, graphics, and color page elements.

• Presentational—Here a page is essentially a slide, a flip chart, an overhead transparency ("foil") or some other item used for display or projection.

• Utility—Miscellaneous items that do not fit into the other categories, such as business cards, invitations and menus.

There are essentially two main types of pages: structured and unstructured.

Structured pages follow a predefined grid or page format. Unstructured pages do not. There is probably a middle ground where a grid is defined but pages are allowed to deviate from it.

Traditionally, structured pages required batch pagination approaches and unstructured pages required interactive pagination approaches. Today there is a great deal of crossover.

DIFFERENCE BETWEEN PRINT PRODUCTS

	Schedule	Pages	Revision	Typography	Preparation	Graphics	Color
Document	Shorter	Moderate	Moderate	Typescript	Electronic	Less	Black
Publication	Longer	Very high	Low	Typescript or typeset	Electronic	More (Line)	Spot
Promotional	Shorter	Low	High	Typeset	Electronic	More (Photo)	Process
Utility	Varies	Low	High	Typeset	Traditional	Some/none	Spot

Document	Reports, Budgets, Plans, Analyses, Proposals, Price Lists, Legal Materials
Publication	Manuals, Catalogs, Books, Magazines, Newsletters, Directories, Guides
Promotional	Data Sheets, Advertising, Flyers, Direct Mail, Presentations
Utility	Forms, Packaging, Tags, Labels, Stationery

THE NEW AGE OF DOCUMENTS

Computers should not be the center of attention—information should. Computers do not help you read or manage documents—they create more of them. Most applications create paper documents as their final communication medium. If you wish to communicate directly between computers, you most likely use ASCII text, the common denominator of computer-to-computer communication. You don't communicate more complicated information because the receiver may not be able to read it.

The computer world revolves around applications and operating systems. To transmit a document to someone else, the receiver's operating system, application, and resources must be compatible with yours. If the document's form and content depend on several applications, the receiver must have all of them.

Networking enables standards that allow data interchange between platforms. But data interchange is not document interchange. Corporations have mixed computing environments, using mainframes, minicomputers, and personal computers. Diversity may also occur within an operating environment—you have a black-and-white, 13-inch display and a computer with limited memory, but your document recipient has a 21-inch full-color, 24-bit display with lots of memory. The dream was that everyone would move to a common hardware and operating environment. Some feel that Microsoft Windows should be it, whereas others support the Macintosh operating system, and still others choose forms of Unix.

There are just so many problems in trying to pull all the pieces together. Text, graphics, and images have unique requirements for successful interchange. Text interchange deals with font metrics that change according to typeface, position, tabs, line and paragraphs, plus different character sets and encodings. Graphics interchange must accommodate paths, structured graphics, plain art, graphic state modifiers, device-independent color, and vector curves. Image interchange must specify data for images, masks, and parameters (width, depth, color space, and compression). Sound and video exacerbate the problem.

You must emphasize the independence and completeness of the information's structure. When Adobe Illustrator was under development, one of the objectives was to make the intermediate file format the same as the print file format. The PostScript language was used to describe both the appearance of the printed page and the semantics of the editable objects manipulated by the application. The first Illustrator product dealt with simple graphic objects and the ASCII file format was simple. Then Adobe discovered that you could pass the intermediate files that Illustrator created to other applications to insert, scale, and rotate them. Because the graphics were PostScript language fragments, an application didn't have to understand content to print the document. Other applications that primarily deal with illustrations can read the semantics of Illustrator files. As a result, most device-independent clip art is stored in EPS format.

The PostScript language has the potential to abstract the document objects while preserving the exact layout and appearance. The goal is to capture documents from existing applications in a way that is independent of device, operating system, and hardware. Windowing environments provide a good, common, device-independent interface between the applications and the operating system imaging models with interfaces to printer drivers: Graphics Device Interfaces in the Windows environment, QuickDraw interfaces in the Mac environment, and Graphics Programming Interfaces in the OS/2 environment.

One approach is to develop specialized printer drivers for each environment that will capture the output from applications and convert it to a single, uniform document-interchange format. With this format, you can write document viewers and printing utilities for each platform. This collection of drivers, with viewing and printing facilities, will enable the initial communication of documents between diverse platforms without changing existing application programs.

This is the course that Adobe has taken with its portable document technology called Acrobat. Applications create Acrobat documents by sending their output to

a printer driver containing an Acrobat module. In environments that support device-independent printing, any application that prints can create an electronic document. In the DOS environment, you can convert PostScript output files to electronic documents with a utility program. Thus, only DOS applications that support PostScript can create Acrobat documents.

A fundamental concept of electronic publishing is that you should be able to work with electronic documents in the same way that you work with paper and still be able to take advantage of their being computer files.

Documents are really abstractions of information formatted to communicate ideas. It is one form of information that is difficult for personal computers to communicate. Computers know bits and bytes. Format is not their strength.

Publishers are switching to electronic distribution of their documents. CD-ROMs are cheaper than paper for long documents, and they support full-text indexing and hypertext links. SGML markup allows platform-independent access to information, and it can be formatted in alternative ways depending on the application and the output medium. There are different approaches to electronic delivery; which one is appropriate depends on the application and other constraints on the project, such as existing equipment.

To supplement the table of contents, there is full-text retrieval. The search engine is from Fulcrum Technologies with Sun's user interface overlaid; the search features are simple and require no Boolean operators. There is also a content-based retrieval utility, based on freeform querying, that ranks its results by word, phrase, or sentence. Most searches take about four seconds. The search can apply across a network.

CHAPTER 9

ADVANCED DIGITAL PREPRESS TECHNOLOGY

Photo CD is advanced technology from Eastman Kodak that was intended as a consumer product to allow Auntie Em to view family pictures on a television set. That idea didn't work out—Auntie Em went back to prints—but the underlying technology was sound and it found another application—digital prepress.

Photo CD (the CD stands for compact disk) provides very fast image capture of film originals using a CCD-based scanner and storage of the resulting image data on read-only compact optical disks. Some of the images are stored in a color format for color television display. The concept was that color labs would develop your film and then scan the negatives on a special scanner and convert the images into digital form.

It was determined that consumers would probably want hardcopy prints up to 8"x10". This would require 16 times more data than was necessary for the television display format. Kodak faced a problem: to store the image at the highest resolution (for prints) would slow down display of images at lower resolutions (for television). The answer was a file format called the *Photo CD Image Pac* that stored one image in five (later six) different resolutions. The highest resolution handled photographic enlargements and the lowest resolution handled thumbnail views. The middle resolution—the "base resolution" —was used for the television display.

The Photo CD scanning system was designed for 35mm slides and film negatives. Its digital images have a maximum resolution of 2,048 x 3,072 pixels. The "Pro" Photo CD system scans up to 4" x 5" at a maximum resolution of 4,096x6,144 pixels—which is now sufficient for prepress requirements that involve images.

Instead of RGB files, Photo CD converts the scanned images into a device-independent color space called *Photo*

YCC. These files are called "digital originals" because they can be rendered for uses beyond printing; traditional scanning produces color-separated film specifically for CMYK printing.

The printing connection

Photo CD was initially considered an inexpensive approach to color scanning, as publishers and others dreamed of scans for less than a dollar. Even though color labs could have sold Photo CD scans for less than a buck in some cases, quality was not what it should have been. Prepress services charged from $3 to $11 dollars per scan, with lots of effort to reach the required quality level.

The Photo CD process creates digital "interpretations" of the original film images. To print, they must be converted from their YCC color space into CMYK, cropped, rotated, sized, adjusted, and sharpened—at additional time and cost.

Kodak licensed its technology to high-end scanner suppliers to produce an "electronic job jacket" so that color separators could scan images and write them to the Print Photo CD as Photo CD *Image Pacs*. Users could import these images to their page layouts and return the final documents for printout, where they would be converted to CMYK using the layout's placement, cropping, rotation, and sizing information. The write-once nature of compact disks also provides for image and document archiving.

Recent extensions to Photo CD

The Photo CD system has been widely accepted in desktop publishing and prepress applications since its launch in 1992. Dozens of popular software applications and operating systems enable users to work with the scanned film images that have been stored on Photo CD disks. Kodak intends to make these images even more accessible, allowing anyone with a desktop computer to read, write, and use Photo CD images.

• Under a new open licensing policy, any software or platform developer can obtain a royalty-free patent license for encoding and decoding images in the Photo CD Image

Pac format. The policy will enable people to read and write Photo CD images as easily as other common image formats, such as TIFF and JPEG, with the added benefit of cross-platform compatibility.

• A new, more flexible application strategy establishes two categories of Photo CD disks: Photo CD Master disks, which serve as digital negatives for images scanned from film (and include both Photo CD Master and Pro Photo CD Master formats), and Photo CD Portfolio II disks, which contain Photo CD Image Pac files and other digital content. The new Photo CD Portfolio II format provides a single disk type to meet the needs of customers in prepress, presentation, image archiving, and other applications.

Open licensing strategy

Kodak's new licensing policy recognizes the industry's need to have open access to a single, consistent means of representing digital images. Because the Photo CD Image Pac format offers a number of functional advantages, that Pac format is becoming the basis for a universal digital imaging standard.

The Image Pac format ensures that users can access their digital images at multiple levels of resolution (enabling them to select the quality and file size appropriate for their application). The design of the Image Pac format is platform-independent and ensures that users can work with the same image file on any number of computer platforms, with no conversions required. As Kodak's new licensing strategy takes hold, users will be able to handle files in the Image Pac format like any other form of data, writing them to floppy disks, transmitting them over networks, and storing them on CD-recordable disks.

Royalty-free licensing of the Photo CD Image Pac format will enable software developers to build into their applications the ability to read and write Image Pac format data files, and to play back prerecorded Photo CD Master and Photo CD Portfolio II disks. The Photo CD System Description, along with a royalty-free patent license to read and write Image Pac images, will be made available.

Software utility

Kodak also demonstrated prototype software that will let people add color pictures to documents as easily as they cut and paste text. The software utility provides a direct link between the images on a Photo CD disk and any word processing or desktop publishing software that employs the Object Linking and Embedding II (OLE II) interface—such as Microsoft Word, other applications in the Microsoft Works integrated product bundle, and Novell WordPerfect software. Both Macintosh and Windows versions of the utility can be written automatically onto Photo CD Master disks beginning in the summer of 1995. When users insert their Photo CD disk into a CD-ROM drive, the utility will guide them through its use. Users will see a variety of layout templates for compound documents; they can use a supplied template, adjust it, or create their own.

To add pictures to a document, users highlight the area where they want the picture to appear, select an image from the clipboard, and paste it in place with a click of the mouse. The software utility employs OLE II to provide intelligent picture framing, which means it automatically selects the appropriate level of resolution from the Photo CD Image Pac file based on the size of the picture and the usage.

A low-resolution version of the image would be selected for on-screen viewing, minimizing demands on the processor, while a higher-resolution version of the image would be selected for output to a color laser printer. For people who want to keep track of images for future use, the software utility also invites users to create a simple image database by naming their disks, and individual images, with descriptors of up to 64 characters each.

Flexible application strategy

In another move to expand the use of Photo CD images, Kodak is streamlining the number of disk formats it offers to meet the needs of different applications.

• The two Master disk formats contain images that originated on film, scanned at high resolution using a Kodak Photo CD Imaging Workstation. Images on these disks

serve as "digital negatives" that contain virtually all the information from the film original; they serve as a convenient, low-cost way for users to bring their own pictures into any computer imaging application.

• Photo CD Portfolio II disks provide desktop users a medium for the storage and distribution of images in the Photo CD format. Along with Photo CD Image Pac format files, users can write other data to the disks—such as CMYK image files for prepress applications, indexes and retrieval software, or digital audio for a "still image multimedia" presentation. The Image Pac format files on Photo CD Portfolio II disks can differ from Photo CD Master disk images in two key ways:

• They don't necessarily originate on film, but instead can come from any digital source—such as digital cameras and scanners.

• They don't necessarily contain all the resolution of Master or Pro Master disk images; the highest required resolution is 512 x 768 pixels, the "base" level needed for high-quality video display. Like Photo CD Master disks, however, the Image Pac format files on Photo CD Portfolio II disks offer a unique benefit not available on other media: these images can be viewed on television as well as on computers. A number of low-cost consumer players let people view Photo CD images on television.

Application to write Photo CD Portfolio II disks

Kodak Build-It Photo CD Portfolio disk production software enables Macintosh and Windows NT users to author Photo CD Portfolio II disks right at their desktops. Targeting presentation and image archiving applications, Build-It software can be used to create on-disk multimedia programs and image catalogs. The software can convert images from many graphic image formats—such as BMP, TIFF and PICT files—to the Image Pac file format.

Build-It software also will allow users to record data in the ISO 9660 format, the standard for CD-ROM disks. For these applications, Build-It software will write images, software, ASCII text and other data files to a writable CD-ROM disk.

HALFTONE SCREENING

Until 1972, when electronic scanners were equipped with electronic magnification and electronic dot generation, only 10% of color separations were made on scanners and 90% were made on darkroom cameras, enlargers, or by contact. By 1986, after digital scanners were introduced, more than 90% of all color separations were made on electronic scanners.

Most photographic images are composites of varying or gradient tones that absorb and reflect light in a continuous tone pattern. Such patterns cannot be reproduced by a printing process like lithography, as it is a binary process. Lithography can print only a full tone or charge of ink or no ink. It cannot transfer different ink film thicknesses in the same impression, so it cannot print an image consisting of gradient tints and tones. To print such tones, the image must be converted to a pattern of very small dots of varying sizes with equal spacing between dot centers. All the dots print the same density of ink but their varying sizes create the optical appearance of light, medium, or dark tones. This is called a halftone. Here is a digital halftone dot:

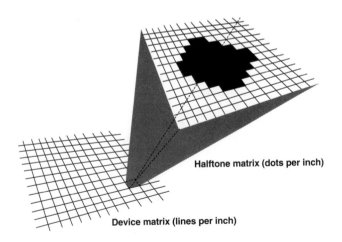

Halftone matrix (dots per inch)

Device matrix (lines per inch)

The halftone principle is an optical illusion. It is based on the limit of visual acuity of the human eye, which cannot distinguish between two points separated by one minute of arc. This is equivalent to 1/250 of an inch (0.004" or 100 micrometers) at a normal reading distance of 12 inches. A halftone tint with a checkerboard (50% tint) pattern with black dots separated by 1/250th of an inch is equivalent to a screen ruling of 125 lines per inch (lpi), as the distance between dot centers is 1/125th inch (0.008" or 200 micormeters). Screen rulings in conventional use are 60–80 lpi, for illustrations in newspapers, 100–120 lpi for general quality quick and in-plant printing, 133–150 lpi for magazine and commercial printing, and 175–400 lpi for high-quality process color printing.

Below are two sets of grids based on the resolution of an output device—the size of the laser dot in most cases. A "cell" is created that is composed of some number of those laser dots. In this example, it is 12x12. The laser spots are then positioned to create an illusion of gray—a halftone cell. The left example shows lower resolution spots—perhaps 20 micron spots or 1,270 dpi; the right shows high-resolution spots—perhaps 10 micron spots for 2,540 dpi. Because the laser spots are so small, you cannot even see them under a magnifier in most cases. The shape of all the laser spots in the cell, shown with the bold outline in the right example, is therefore the halftone dot. Dots can also be overlapped, but this may not yield higher quality because the space between dots is not visible to the naked eye.

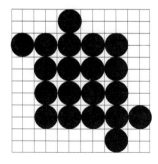
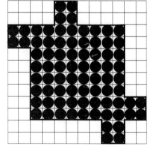

The original halftone screen consisted of a grid of straight lines or bars ruled on two sheets of optically flat glass cemented together at right angles. The lines, or rulings (from whence the term "screen ruling" was derived), were the same width as the spaces. Glass screen photography is obsolete, as it requires precision cameras with means to mount the screens and maintain accurate screen distance over the whole image area.

Glass screens have been replaced by contact screens which are usually made from glass screens. A contact screen consists of a grid of dots on a film base with the number of dots in both directions equal to the screen ruling. Each dot is like a circular gray scale with a gradient of highest density in the center and lowest at the perimeter.

Halftones are produced by photographing the subject through the screen in vacuum contact with the film mounted on the image back of the camera, on the base plane of an enlarger, or between the subject and the film in a vacuum frame. The variable density of the dots in the screen records variations in light reflected from, or transmitted through, the original in different sizes of high-density dots. Each dot forms a matrix, within which the dot can vary in size from 0% to 100% coverage. The number of dot sizes corresponding to the colors that can be reproduced is limited by the intensity of the light reflected from the original, the processing chemistry, and the resolution of the film.

Output
The number of steps in tints or gradient blends should not exceed 256 when outputting to a PostScript device, as they cannot produce more than 256 grays per color.

Most continuous tone proofer output resolution is between 200 and 300 ppi. Because each pixel reproduces its own color and can create more than 16 million colors, this resolution can produce near-photographic quality for images.

When anticipating halftone output, the image resolution should be twice the line screen, multiplied by any enlargement or reduction of the output image relative to its input size. For certain output devices, images, and output

settings, the image resolution could be as low as 1.25 times the line screen. When enlarging an image at 200% that will be output at 133 lpi, the input resolution should be:

$$2 \times 133 \times 200\% = 532$$

For imagesetters, 1,200 (or 1,270) dpi is a low resolution output, 2,400 (or 2,540) dpi is medium-high-and 3,600 dpi is high. However, most work is output at 1,200/1,270 dpi. The optimum line frequency depends on the stock to be used for printing. Typical line frequencies are 85 lpi for newspaper stock, 133 lpi for uncoated/coated stock, and 150 lpi or more for coated stock. If you use too high a screen ruling for the type of paper, dot gain will hamper the quality of the image.

The typical imagesetter setting of 2,400 dpi and 150 lpi when printing on coated stock allows for the creation of 256 grays, the maximum for PostScript. Lowering the line frequency or increasing the dpi output resolution does not increase the number of grays that can be reproduced.

When scanned images and bitmapped paint images are output at a size larger than the original file, the reproduced image will lose detail. A higher image resolution is needed to compensate for enlargements. Always plan for the output size and resolution.

When outputting halftones, image resolution is also determined by the size of the halftone dot cells. This is known as the line frequency, and is measured in lines per inch (lpi). In general, the image resolution should be between 1.25 and 2 times the lpi.

Halftone dots are laid down on film or paper in a grid that is divided into halftone cells. Each halftone dot is in one cell. The size of a halftone cell determines how much detail is reproduced in the output. The more halftone cells located per linear inch, the more detail is reproduced. The number of halftone cells per linear inch is referred to as line frequency, line screen, screen ruling or lines per inch (lpi).

Increasing the output resolution (higher dpi, more laser spots per linear inch) increases the number of available grays. This is also the case when the line screen de-

creases (lower lpi, fewer halftone dot cells per linear inch). The more grays that are available, the smoother the color gradations will be in a printed piece.

Banding

Halftone dots are made up of laser spots. The number of laser spots that are available per halftone cell determines the number of grays of a color that can be reproduced.

The size of a halftone dot determines the "gray" of a color. Gray here does not refer to a shade between black and white, but rather to the density of the color that the dot represents. The size of the halftone dot determines the density of the color the dot represents. A larger dot will create a denser color in a printed piece. The size of laser spots relative to halftone dot cells determines how many laser spots are available to build each halftone dot. More laser spots per halftone dot means smoother edges of the dot and also more different sizes that the dot can be. In PostScript, a maximum of 256 gray levels are reproduced.

Banding is the occurrence of visual steps in a blend. In drawing and page layout programs, blends can be created by using a number of objects that each have a slightly different color. The number of steps is critical to avoid banding. The required number of steps for a particular blend depends on output resolution and line frequency as well as the colors used in the blend. Calculate the greatest percent color change in the blend. If a color blends from 0% to 100% (or from 100% to 0%), the number of steps necessary will be less than the number of available grays.

To avoid banding, you should have enough steps in the blend so that the length of each step is two points or less. Always measure the greatest distance between origin and destination points in a blend.

Line art or type requires higher resolutions when scanned than do continuous tone originals. To avoid jagged edges on the halftone, line art should be scanned at the highest possible resolution—ideally, as high as the dots per inch on halftone output devices or the pixels per inch on RGB output devices.

When the scanning resolution is the same as the out-

put resolution, each pixel in the image is output through one laser spot or pixel and resolution is retained. Both imagesetters (laser spot output) and continuous tone devices (pixel output) require high-resolution scanning for line art—for example, 2,400 ppi for an imagesetter and 1,270 ppi for a continuous tone device.

Conventional versus digital halftone dots are shown:

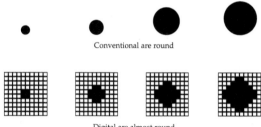

Conventional are round

Digital are almost round

An electronic scanner produces halftones using an electronic dot generation system. This consists of a dot generator and a dot former. The dot generator receives video information from the scanner color computer, along with data on the exact location of the writer exposing head relative to the surface of the output separation film. This information is passed on to the dot former which is electro-optic and draws each individual dot or part of each dot in the exact location on the output film with specially formed beams of laser light. To appreciate the complexity of the operation, a scanner equipped with such an electronic screener computes and draws 20,000 to 30,000 halftone dots per second!

Unlike the single-dot matrix of a photographic halftone, the dot matrix of an electronically generated halftone consists of pixels whose size depends on the spot size of the exposing beam. The number of pixels in the matrix is determined by the dots per inch (dpi) resolution of the imagesetter, which in turn determines the resolution of the image and number of levels of color it can reproduce. These are limited mainly by data storage and the speed of image processing—the more pixels, the longer the processing time.

Eight-bit color, or 256 levels of color for each separation, amounts to 256 pixels in a 16x16 pixel matrix. The number of pixels used to produce the printing dot determines the color level of the pixel matrix. The combination of the three colors, YMC, is 24-bit color—or 16.7 million colors— 6 million or so more than the average eye can see. When 8 bits of black are added to the color mixture, it becomes 32-bit color—more than 429 million colors.

SCREEN ANGLES

When screen patterns like halftones are overprinted, the orientation of the patterns is critical. If they are not oriented properly, interference patterns, called "moiré," result. The patterns change depending on the number of films and the angles between the screen rulings. In single-color halftone printing, the screen pattern is oriented at 45°. At other angles, 0° or 90° especially, the eye can look down rows of dots and see linear patterns, even though the screen ruling is beyond the limit where the eye can resolve the individual dots. Four-color printing has been done with all the colors at 45°, but the waste was very high (almost 50%) because the slightest paper stretch or misregister on the press caused severe color shifts in the printing.

Moiré may occur in any job where more than one halftone (or tint) is superimposed; 2-, 3-, and 4-color work are susceptible to moiré. Even black-and-white work could display a moiré pattern if a previously screened image or textile with patterns like lace or herringbone are the originals.

Because moiré is caused by the poor orientation of overlapping screen patterns, the angles between the screen patterns used as a means of orienting halftones, can also be used to minimize moiré. It has been found that minimum patterns are produced between colors when they are oriented by screen angles of 45°. The moiré patterns formed by screen angles of 30° between colors are not much different from those formed at 45°. These 30° angles, therefore, allow three colors to be printed with minimum moiré. Four-color printing, however, poses serious problems.

Different dot shapes are used in halftones for special effects. There are round, square, elliptical, double-dot, and

triple-dot screens or patterns. The most common are the round and square dots. When screens with these dot patterns are used, rotating them past 90° repeats the angular patterns: 105° is the same as 15°, 0° is the same as 90°, 45° is the same as 135°. Therefore, there are only three 30° angles that can be used to ensure minimum moiré. The darkest color, black (K), is usually printed at 45°, magenta (M) at 15°, and cyan at 75° or 105°. The problem is where to put the yellow. Usually it is printed at 0° or 90°, between the magenta and the cyan. Because it is a light color, the moiré between yellow, magenta, and cyan is not very noticeable. It is very important for quality color reproduction for the screen angles to be as accurate as possible. Errors in screen angles as small as 0.1°, or a slight misregister between colors in printing, can cause serious moiré in areas where three or four colors overprint.

When 30° differences between colors are not possible, the moiré patterns are smaller and less objectionable as the angular differences increase. With yellow at 15° from magenta and cyan, there is a strong possibility of objectionable moirés in orange, red, and green colors. In subjects where orange or brown colors (such as skin tones) are critical, the magenta is usually run at 45° and the black at 15°. In subjects where greens are predominant and reds are less important, the cyan is placed at 45° and the black at 75°. Moiré can also be reduced by using halftones with different screen rulings if the 30° angles cannot be achieved. Magazine printing has been done with 133 lpi halftones for black, magenta, and cyan, and either 120 lpi or 150 lpi screen ruling for yellow.

Traditional screen angles are:

Color	Angle	Screen
Cyan	15.000	133.000
Magenta	75.000	133.000
Yellow	0.000	133.000
Black	45.000	133.000

When PostScript was introduced, there was only one type of halftoning: RT Screening. It is the type of halftoning that has been used since the introduction of the Linotype

RIP 1 in 1985. RT Screening is a patented Linotype-Hell technology that has been licensed to the industry. One of the characteristics of RT Screening is that 15° and 75° angles are impossible to achieve exactly. In addition, the screen rulings in a set of separations may vary from one color to the next. This is unimportant in black-and-white work, but for color work it means that even if you do get the angles as close as possible, moiré problems may still crop up.

The first 4-color electronic screening scanner was produced by PDI, a Time, Inc. subsidiary. It produced the correct screen angles and superior dot quality. It was many years before other manufacturers were able to duplicate the same quality and the correct screen angles by electronic means. The first Hell laser scanner could not achieve 15° and 75° screen angles. The scanner produced angles of 0°, 45°, 18.4°, and 71.6° and different screen rulings from 150 to 200 lpi were used. This was the basis for Hell's RT screening patents.

Although photographic color separation can achieve any desired screen angle, it is a very difficult task in electronic color image processing. The fact is that no digital output device in use can produce exact 15° and 75° angles—they can only be approximated. PostScript interpreters have approximations no better than the original Hell screen angles, so moiré was minimized by changing the screen rulings. This situation improved when PostScript Level 2 became available.

Adobe's "Accurate Screening" approach allows halftone screens to be defined to an angular accuracy of ±.001°, depending upon the exact screen angle and frequency requested, the resolution of the device, and memory for algorithms.

In rational screening, it is only possible to obtain angles based on a rational tangent (RT) value. The amount of computation required to generate each dot to its desired angle requires that screen dots be assembled as cells comprising multiple dots as a pattern element. These cells are repeated to create the overall image. If the angles, which must be laid according to the imaging resolution of the output device, don't align, they can produce a moiré.

The high-end color prepress market has employed irrational tangent screening in which each screen dot position is computed interactively to position the dot in correct alignment with surrounding dots. This is done by special hardware screening computation logic that is used to get angles closer to the conventional photographic angles.

Two other effects can influence the quality of printed color halftones. One is color shifts that can be caused by screen angles (already mentioned), and the other is ink trapping which depends on color sequence in printing. Both are related to the fact that process color inks are imperfect in their light absorption and reflection characteristics and thus make the appearance of the print dependent on how it was printed.

Typical screen angle rules for selected PostScript imagesetters (nominal 150 lpi screen ruling):

Imagesetter	Screen angles	Screen rulings
Optronics ColorSetter	0.00°	150.00 lpi
(Irrational)	18.43°	158.25 lpi
	45.00°	141.00 lpi
	Optional fine/black	212.00 lpi
	71.57°	158.25 lpi
Linotype 330 or 300		
Neptune RIP at 2540 dpi	0.00°	141.11 lpi
(Rational)	18.43°	133.87 lpi
	45.00°	149.67 lpi
	71.57°	133.87 lpi
Agfa SelectSet 5000		
Atlas RIP at 2400 dpi	0.00°	150.00 lpi
(Rational)	18.43°	126.50 lpi
	45.00°	169.71 lpi
	71.57°	126.50 lpi
Agfa SelectSet 5000		
Star RIP at 2400 dpi	0.00°	150.00 lpi
(Irrational)	14.93°	154.60 lpi
	45.00°	154.28 lpi
	75.07°	154.60 lpi

STOCHASTIC OR FM SCREENING

Halftone screening

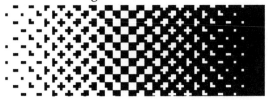

Stochastic screening

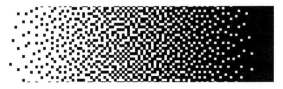

Definition of FM screening and "stochastic"

With frequency modulation (FM) screening, all halftone microdots are the same very small size—as small as a single recorder element, the smallest dot that the imagesetter or printer can produce—but their average number per surface area, or frequency, varies according to the tone value to be reproduced.

Moreover, their spatial distribution is carefully distributed by algorithms (rules) that place dots in accordance with a statistical evaluation of the tone and detail in adjacent parts of the image, so that no clumping or unwanted grouping of microdots is apparent. In effect, the dot placement is based on a scheme of "calculated randomness."

"Stochastic" is from the Greek *stochasticos*—skillful at aiming, from *stochazesthai*—to aim, to guess at; also,

- Random: involving random variables,
- Involving chance or probability.

"Stochastic" is used in mathematics to describe the process used to analyze and predict the motion of particles in a viscous liquid. It is now used in printing to describe the process of precisely placing dots so as to appear random—and to create the illusion of tone levels.

The term "stochastic" in printer's circles has come to mean predictable on average. It is loosely used to mean the same process as frequency modulation screening; however, stochastic could encompass more screening methods than only FM.

Frequency modulation screening makes two major improvements in the conventional lithographic process. It uses smaller printing dots to create higher image detail and allows greater ink densities to improve tonal range and contrast. Frequency modulation screening, also known as "stochastic screening," and generally called "FM screening," has been commercially available to lithographers since the spring of 1993, though the concept as implemented today has been known for many years. Since the first vendors announced their FM products in the spring of 1993, new vendors have added to their ranks.

Currently more than 20 vendors promote some sort of frequency-modulated screening, and perhaps a great many more than 20 are in the wings. Though the benefits of FM screening are claimed, implementation of the technology has been slow to spread. Few printers and separators have made the process a regular part of their production, despite general interest among buyers of print.

Pros and cons of frequency modulation screening
Pros:
- Images look smoother and display greater detail.
- Image file sizes are 25% of conventional file sizes.
- No possibility of screen moiré.
- Faster press makeready on unmodified presses.
- Ink/water balance more easily maintained.
- Heavier ink coverage produces more dynamic range.
- Drying times are reduced.
- More evenly distributed ink in thinner layers.
- Registration not a factor in color balance.
- Touch plates, bump plates, and screened spot colors can overprint process colors without moiré.
- Rapid transition from slightly less than a midtone value to slightly more than a midtone value is eliminated.

Cons:

- Grainy appearance, especially in the highlights and quartertones.
- Reduced tolerances throughout the production process require careful process controls and monitoring far beyond those required for AM screening.
- FM images are currently difficult to proof, difficult to duplicate and difficult to contact. Conventional film assembly is strongly discouraged.
- FM screening is less tolerant of deviation and most changes in film and chemical processing are not noticeable in the final result. Users will have to adopt a new level of precision throughout their production processes. RIP processing is much more intensive, though the effects may be mitigated by RIP accelerators and smaller image files.
- Because increases in the ink film layer do not affect the size of FM dots as dramatically as AM dots, poorly separated images cannot easily be improved on press through ink key adjustments.
- The smallest microdot size is too small for many printers to handle.

Very simply, amplitude modulation (AM) traditional screening varies the size of the dots with equal distance between them. Frequency modulation varies the center-to-center spacing but uses the same size dot according to the lightness or darkness of input pixels.

FM screening has same-size dots with variable spacing

AM screening has variable-size dots with equal spacing

By less overprinting of inks and by spreading ink out over more of the page (leaving smaller gaps between dots), each printed dot is less contaminated by overprinted inks ,and less unprinted substrate shows through to desaturate the purity of each ink. The result is a cleaner, more dynamic image. The advantages are:

- less overprinting
- better distribution of nonink areas
- better diffusion in highlight areas
- more even spreading of different color values
- fewer overprinted colors
- less paper to absorb light

The result is better color reproduction with FM printing.

More ink may be laid down to further increase the printing gamut. Up to 15% more ink can be held on the sheet. Higher ink densities result in minimal dot gain compared to AM screens, which result in more ink laid down within the same dot area of an FM screen.

In transition areas of an image from white to neutral gray, FM screens exhibit less rainbowing or banding than conventional screens.

Larger conventional halftone dots leave a proportionally larger area of white space between dots. This increased area of white space will skew the perceived color and desaturate inks. Higher line screens leave less white space between dots and thus reproduce more accurate color.

Compensation for proportionality failure is built into the conventional process and is not generally considered when performing conventional screening. With FM screening, the ratio of white area to inked area changes and can alter transfer curve calculations if not considered. Any given screened area will give a different appearance according to the distance between the dots. This phenomenon is also known as "flair effect."

Eliminating screen angles

Eliminating the rosette pattern relieves the printer from the possibility of moiré patterns on press and somewhat relaxes the need for critical registration. It is impossible to develop moiré from misaligned or miscalculated FM screens. Theoretically, subject moiré is still a possibility.

Poor registration will not cause color shifts or rainbows in the neutrals, as happens in AM screens due to the moiré effects of an out-of-register rosette pattern. FM screens printed out-of-register will still look out of register, just as in AM screening, but color will not be affected.

Gray levels in FM screening

Traditional calculations to determine the number of gray levels no longer hold with FM screens. In AM screening, the combination of imagesetter addressability and line screen determines the number of laser spots per halftone cell; the number of spots per cell determines the number of grays. FM screens have no halftone cell to limit the number of grays. With FM screening, no matter how high or low the imagesetter addressability, the basic printing dot is a uniform size which will not change until it begins to merge with neighboring dots. The question of gray levels becomes less relevant. The vital question shifts to "How much detail is being reproduced?" The answer is affected by the imagesetter resolution and the scanning resolution.

Input sampling

Comparing the same image file printed using AM and FM screens, the FM image will reliably present better detail. Thus, to achieve the same level of detail, lower sampling can be used with FM screens.

The AM halftone process prints large dots with large spaces between dots. The process of converting a near-continuous tone scanned image to AM screens requires that detail be thrown out and averaged into the halftone dots. Several scan pixels are used to create each single halftone dot. The usual ratio of scan pixels to halftone dots is 4:1.

In FM screening, much more detail transfers to the screen. The ratio of scan pixels to printing dots is much lower than in conventional screening. Vendors have claimed that ratios as low as 1:1 produce acceptable image quality. However, most users report that they use the same scan resolution as for conventional images.

Because FM screening allows the reproduction of much greater detail, for very high-quality jobs, scan resolu-

tions even higher than the usual AM scan resolutions can be used to further enhance detail.

FM and HiFi color

FM screening is ideal for printing with an extended color gamut. Several color spaces have been defined for printing and use more than four process colors. Additional colors are typically orange, green, red, and violet. Usually, two or three of these are used in combination with traditional CMYK. The additional colors create more dynamic images with better range and contrast.

Conventional screens are limited in their use of these extended gamuts in process images, because any fifth or additional overprinted screen will cause moiré with the other colors. Inks angled any closer than 30° will create an objectionable moiré pattern. This limits the number of colors that can be screened in any single area to effectively four. (Only three angles are available at 30° intervals before they begin to repeat themselves. An exception to the rule is the yellow printer. The yellow printer, which is separated by only 15° from the nearest screens. The moiré thus created is not highly visible because yellow is so light.) FM screens have no angles and no possibility to moiré. Any number of colors can be overprinted using FM screens without fear of degradation due to moiré. FM screening also eliminates angled screens. No moiré pattern is possible by any orientation of FM screens. Any number of colors can therefore be overprinted without danger of moiré.

FM and waterless printing

Waterless printing has 5–10% less dot gain than conventional lithography, thus allowing much finer line screens and higher ink densities. Some printers regularly print 600 lpi conventional halftone screens with excellent results. However, waterless presses are very expensive and demanding on their operators. Tolerances are quite small; ink/water balance is hard to maintain. Special, expensive, plates and inks are required.

FM screens are able to produce an equivalent level of detail and brilliance of color using conventional presses, conventional plates, and inks.

FM screening on a waterless press may produce phenomenal results. The excess dot gain inherent with FM screens is offset by the minimal dot gain on waterless presses. Both systems alone produce clear vibrant color and high detail; together, the effects are multiplied.

FM screens achieve the goal of fine image detail without waterless presses and with much less trouble in ink/water balance or press maintenance. It could be considered an alternative to waterless lithography, but actually works in conjunction with waterless printing to produce superb printing quality. In 1995, there was concern over a patent that claimed to cover both areas.

Describing dot area

Terms such as "quartertone," "midtone," and "shadow" all still apply in describing the tones of FM images. In the same respect, percentage evaluations also accurately describe the tones of FM images.

Line screen equivalents in FM

There is no obvious relation between the line screen of conventional dots and the imagesetter resolution of FM dots. When people say that FM dots at 21 microns equal a 150 line screen, they are repeating a subjective evaluation that has gained wide acceptance.

Dot etching FM films

The small size of the dot, the difficulty in accurately contacting dot for dot, and the fragility of the imagesetter soft dot make both dry and wet etching difficult to control.

FM screens versus AM screens

FM screening places small dots in a pattern of calculated and changing randomness. FM screening varies the frequency of printing dots across the page. AM varies the size of dot and maintains the same distance.

The only difference in amplitude modulation screening is that the dots in the bit map are arranged as isolated small dots rather than as a coherent area. If an image were screened according to that simple procedure, the irregu-

larly arranged dots would produce an objectionable pattern. To avoid this disadvantage, the dot arrangement should be varied even for the same gray value.

Error diffusion and thresholding

Error diffusion is part of the process of calculating the randomization of FM spots. When any particular pixel is imaged, it can only be black or white, though the pixel it images is rarely either. Error diffusion is the process of adding the difference between the black-and-white value of a printing dot and the gray values of the image pixel it represents to the next-imaged pixel so that the error of one dot is compensated for when imaging the next. The "error" in error diffusion is the difference between the black-and-white value of a printing dot and the gray value of the image pixel.

For example, the image pixel currently being imaged has a gray value of 113. The threshold is 127. The printing dot will print (on); its value is 0. The error is 113 (113–0). The next imaged pixel has a gray value of 120. The gray value is added to the previous error for a current value of 233. the printing dot will not print (off); its value is 255. The error is 22 (255–233).

Thresholding is the process used to determine whether a printing dot will be on or off, printing or non-printing. Though an image may display a smooth area of midtone, the printing dots representing that tone must be alternately on and off in order to accurately represent that gray. The gray value of the currently image pixel is compared against some threshold value. Whether the gray is higher or lower than the threshold will determine whether the dot is a printing dot. The threshold may be a single value for every imaged pixel, or it may consist of an array of values.

Because image files sizes for FM screens are sometimes undersampled compared to conventional screens, it may not be possible to use an image scanned for FM screening in a conventional separation. Images scanned for conventional separations can easily be sampled down for use in FM screening, or can be used at their full resolution in FM

screening, though little advantage will be gained by the excess resolution, and processing time will increase.

Before ripping, a transfer curve is applied to the image to compensate for the excess dot gain inherent in FM screens. Workflow proceeds as with conventional screens. No special setups or dot gain adjustments are used.

The decision to screen stochastically or conventionally does not have to be made until the image is ready to be sent to the RIP, with the caveat that the amount of unsharp masking (USM) desired may change for maximum image quality based on the type of screen selected.

"Grain" in quartertones

The "grain," or sandpaper look, especially visible in the quartertones of FM screens is the product of the randomization of FM dots. The human eye is capable of filtering, or ignoring, certain types of noise. The noise of an AM screen is easily filtered so that it is unnoticed under normal viewing circumstances. AM screens are filterable because they are regularized. FM screens, however, are random and random noise is not filterable.

Dots joining in the quartertones grow to sizes that begin to be noticeable, producing the grainy look, yet not so large that they merge into each other. This more frequently occurs with spot sizes larger than 20 microns and in very smooth image areas.

The effect can be muted by using a smaller microdot and a softer stock. Some vendors are now trying AM screens within FM screened images to reduce this problem. The AM screens are used where an FM screen would exhibit grain or other unwanted artifacts.

Part of the problem seems to be with the algorithms that determine the way microdots link up. More precisely calculated transfer curves may smooth this transition by stretching out the contrast in the critical areas around the quartertone-to-midtone transition. Because this entire area is based on software, suppliers are constantly tinkering with various algorithms to find the optimum approach for a majority of situations.

A combination of AM and FM screens within an image may provide the best solution to reduction of grain in the future. FM images AM dots are best used in smooth tonal areas to maintain a smooth appearance in the screens. FM dots are best used in areas of tonal transition to reproduce as much detail as possible.

Dot gain

Dot gain occurs around the perimeter of dots. When a large dot is broken into smaller dots, the ratio of circumference to area increases. More perimeter will create more dot gain. For any given dot density, there will be more perimeter in a FM screen than in a conventional screen. The extra dot gain is an inherent feature of smaller dots.

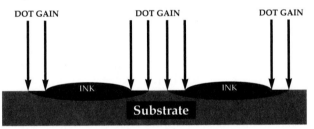

The midtone dot has greater perimeter than the quartertone and therefore grows more. A gain of 1 micron in a 40% dot at 200 line screen gives an increase of 1% in the dot size.

Transfer curves

A transfer curve is a mathematical conversion factor that adjusts the ratio of input values to output values. The transfer curve is applied before ripping the image—but after all color corrections have been made. When applying a transfer curve to adjust for dot gain on press, every dot percentage in the file is reduced by an amount specified by the curve. For example, the curve shows that for an input value of 50%, the output value should be 32%. When the file is ripped, those areas that should print as a 50% dot will be reproduced on film as a 32% dot. On press, dot gain of 18% will increase the 32% dot to the desired 50% dot.

In the creation of a transfer curve, a test target consisting of at least 10 steps is ripped and printed. The resulting densities are measured on the printed substrate and noted for each test target step. Where the image should be 50% but measures 73%, a dot gain of 23% is present and the transfer curve at 50% will be suppressed by 23%. This procedure is performed at every step of the scale.

Proper transfer curves are absolutely vital to successful implementation of FM screens. They must be calculated for specific production processes. To use a transfer curve "out of the box" from a vendor could lead to difficulty.

Scanning issues

The standard scan resolution for conventional screens is two-to-one, meaning a scanner sampling rate of two pixels for every halftone dot linearly and vertically. (Two across and two down make a grid of four scan pixels forming one halftone dot.) If the line screen is 150 lpi, a scanner resolution of 300 ppi gives a two-to-one sampling. One-to-one in AM screening gives a jagged image.

The term "one-to-one," when used to describe scan resolution of an FM screen, refers to the detail of a particular conventional line screen that equals the detail of a particular FM imagesetter resolution. The scan resolution in a one-to-one ratio is the ratio of scanner resolution to the halftone screen that a particular FM screen is said to equal. Thus, if imagesetter resolution of 2,400 dpi equals a 150 line screen, a one-to-one scan resolution for a 2,400 dpi FM screen is 150 pixels per inch.

Because there is no regularly repeating screen in FM images, only imagesetter resolution can be used to describe the resolution of the screened image.

Subject moiré

FM screening does not necessarily eliminate all cases of subject moiré. Theoretically, there remains a potential for moiré to occur between patterns in the subject and the pattern of square scanner grid. Some users of FM technology report jagged diagonal lines similar to jagged diagonals in conventional screening. Higher imagesetter resolution

should smooth any jagged line not perpendicular to the imagesetter grid.

Dot gain compensation

In AM screening, dot gain is usually compensated for in the scanning process. Currently, many users of FM technology are scanning for conventional dot gain and using transfer curves to compensate for the additional dot gain above that inherent in the conventional process. This procedure gives them the flexibility to print with AM or FM screens. It also relieves scanner operators of trying to learn new dot gain curves.

Unsharp masking

The fine detail retained in FM screening makes the need for unsharp masking less acute. In some cases, unsharp masking in an FM image can create additional problems by accentuating noise in the image which would have been lost in a conventional image. The result of over-accentuated detail will be objectionable harshness. In general, less or the same amount of unsharp masking is recommended.

"Unsharp masking (USM), undercolor removal (UCR), and gray component replacement (GCR) are not influenced by FM screening and may all be used in the same manner."

However, adjustments may improve the image even further. In some cases, additional USM may improve an image beyond the best capable with a conventional image by taking advantage of the full range of detail available with FM screens.

Image detail

AM halftone screening is generally unnoticed in casual viewing of printed matter, but its graininess can be detected by the unaided eye. Making printing dots finer renders the image with more detail. This is the effect achieved by printers using high line screens on waterless presses. FM screening will not smooth undersampled blends or sharpen poor scans.

The detail in FM screens is not limited by the constraints AM screens imposed. Additional detail can be reproduced if it is captured in scanning. It is possible that FM screens will benefit from USM even more than AM screens due to higher levels of reproducible detail. "FM screening benefits from high resolution scans because of the greater amount of detail that it can deliver. It is no longer necessary to limit scan resolution based on screen ruling." The amount of unsharp masking applied and the scan resolution required depend upon the image quality desired and individual image characteristics. If scan parameters are properly adjusted, the potential exists to increase the level of image detail beyond any possible in AM screens. The detail gained with FM technology reveals itself best in the reproduction of line work and type within a scanned image.

Smaller file sizes

Image file sizes for FM screens may be smaller than images to be separated conventionally for an equal quality of detail. Because the FM process achieves greater detail with the same size file, a smaller file achieves the same detail as a larger conventional file. FM screen vendors have claimed that a "1:1 ratio is an adequate scanning resolution." In other words, to achieve an FM screen with the level of detail in a 150 line screen scanned with the conventional 2:1 scanning resolution, FM screens only require a scan resolution equal to the line screen of the detail intended to match. However, users do not report satisfactory results with such low ratios. Unless the image is very soft in detail, many users still scan for FM screens at a 2:1 ratio, or even higher, for very finely detailed images.

Scanner resolution

The Nyquist theorem states that increased scan resolutions will not improve any AM screened image beyond twice the line screen. FM screens carry more detail than conventional screens using the same scan resolution. FM screens are thus not limited by the constraints of this theorem. Some FM users report that scan resolutions higher than those for conventional screening increase further the

greater range of detail exhibited in FM screens. Few users would scan at a resolution higher than 3.5:1.

It is possible that lower scanner resolutions could be used with stochastically screened images compared with conventionally screened images. The recommended scanner resolution for AM screens, based on the Nyquist theorem, is two times screen frequency. However, many separators produce quality AM screens with ratios as low as 1.5 times the screen frequency.

FM screened images may require even less resolution to achieve the same perceived results. An easy rule is to use half the resolution used to scan conventional separations of the same detail. This results in file size 25% the size of conventional files, because of the difference in scanning resolution.

Some users of stochastic technology report that they notice degradation in image detail even when slightly reducing scanning resolution from levels used conventionally. With FM screens, there is no screen ruling, so the determination of the scanning resolution becomes solely based on the output quality. Though some observers have claimed that lower scan resolutions may be used with FM screens, it is unlikely that users who are looking to show off high levels of detail will choose to scan at lower resolutions. Images with an abundance of fine detail in them require a greater amount of scanner resolution to maintain image quality.

The benefits of higher resolutions in part depend on the image. An original with high detail may benefit from high scan resolution while soft images will gain nothing. Other users have reported that images scanned at 225 pixels per inch look better than images scanned at 300 pixels per inch when both are printed with a 21-micron screen.

Other users, however, report no noticeable image degradation until dropping below 140 dpi depending on the image sharpness.

Dots are created from imagesetter laser spots, usually grouped into a 2x2 or 3x3 grid. A 3,600 dpi laser spot creates a 7.5-micron spot. To create a 14-micron dot, two spots across and two spots down may be grouped together.

Individual printing dots are tiny spots of the specified laser dpi (resolution). They join to form "worms" in the quartertones and fill in as the tone increases. The worms resemble conventional mezzotints.

Dot growth
As the tonal value increases, more and more dots are printed. Each dot is kept separate from its neighbors until they are forced to connect. Clumping is avoided at densities lower than the middle tones by algorithms which keep all of the printing dots separate. A truly random pattern would create random and objectionable clumping. At higher density levels, the dots join together a few at a time. Tonal transitions smoother than AM screens are created because there is no corner dot link-up at any particular tone.

Dot size
A micron is one thousandth of a millimeter, and designated "µm." An imagesetter spot at 3,600 dpi is 7 µm. At 2,400 dpi, the spot is 10.5 µm. A 2x2 grid is used to create the basic printing spots of 14 and 21 µm, respectively.

A 14-micron spot is about the size of a 1% dot at a 200 lines per inch screen. A 21-micron spot is about the size of a 1% dot at a 133 lines per inch screen. Processing conditions will affect the size of the actual dots on film. Spot sizes up to 70 microns are used by some vendors.

Output time
Though FM screening calculations are more intense than AM calculations, the potential for smaller file sizes may offset increased processing time. Imagesetter resolution could be lower than conventional screens, resulting in faster print times. The concept is that you can get the "equivalent" of higher res images at lower res output. This seems to result in about an even trade-off in time, though results will vary based on specific production practices.

FM, conventional screens, and type on the same page
Many vendors promote the ability to rip both types of images on the same page. This ability to rip conventional

and FM screens on the same page rest, with the implementation by RIP vendors. PostScript Level II allows for multiple screening algorithms on the same page.

Electronically imaged type begins to look very good at resolutions around 1,000 dpi. If pages are imaged using an imagesetter resolution lower than this threshold, the type will look more or less jagged, whether the images are screened conventionally or stochastically.

Scanning resolution and imagesetter addressability

In conventional screening, the general rule of thumb is that the imagesetter resolution should be 10–16 times the line screen to reproduce the full range of 256 shades of color a printing press can print. Stochastically, 8 bits of image data will always yield 256 gray levels, regardless of imagesetter resolution.

Film characteristics

High-contrast films are critical to suppressing the dot gain that is possible from the partially exposed area around the small FM dots. All films exhibit some area of partially exposed transition area around the well-exposed dot, which can lead to a gain in dot size. Slight gains in dots as small as FM dots will have a dramatic effect. High contrast films help to minimize the partially exposed areas and reduce the potential for gain from this step in the process.

Due to the fine tolerances inherent in the FM production process, films with the widest possible exposure latitude will enable the best dot reproduction.

Changes to current proofing techniques

Conventional proofing techniques, using analog materials, are designed to accurately reflect the changes in dot structure and size of AM screens on press. Because FM microdots behave differently, current proofing techniques are not able to reflect the behavior of FM dots on press.

Conventional versus electronic proofs

Accurate FM proofs are hard to obtain. Current proofing techniques are calibrated to accurately predict the behavior of AM dots on press. AM dot behavior radically differs from FM dot behavior. Conventional proofing systems cannot be adjusted by the end user to reflect FM dot behavior.

Some analog systems more accurately predict FM dot behavior than others. The granular toners used in some analog systems are too large to hold the fine printing dots used in FM screening and may be unacceptable as a contract proof. The future of FM proofing lies with electronic proofing, which may produce excellent results because screenless electronic proofs mimic FM screens in the way dots are laid on the substrate.

On-press dot gain behavior is more easily emulated with an electronic proof, because transfer curves developed from densitometer readings are easily entered and adjusted.

Conventional process controls

The minute size of the fundamental printing dot exaggerates every defect in current proofing techniques. Tolerances are generally tightened. Where dust and dirt caused slight problems in the AM screening process, they can create big problems in the FM screening process. The proofing area must be kept clean to avoid reproducing minute particles. When the entire system relies on small-sized dots, small dirt particles will make noticeable defects. Printing microdots in FM screens are as small and smaller than dirt in AM screening that has traditionally been eliminated by overexposing the plates.

Consistent and even vacuum pressure are required for plate-to-plate and across-the-plate consistency. Slight variations in vacuum pressure will allow hot spots to develop, which will be much more noticeable than would the same hot spots created in an AM screen.

Dot representation in electronic proofs

The only need for proofs with exactly reproduced FM microdots is to reveal the existence of subject moiré within

an image. The final product of a printed image is judged by observers at reading distance. If the proof represents the appearance of a final sheet, no dots should be required.

Plate resolution

In order to print high-resolution dots, in the range of 14 to 25 microns, the plate must resolve 4-to 6-micron images. The plates must be exposed to hold a 6-to 8-micron test target in order to hold the smallest dots.

A microline target should be used to determine plate resolution. Plate resolution is determined by finding the specific target whose negative and positive halves look the same. If the lines appear to be the same thickness in the 8-micron target, the plate resolution is 8 microns.

The plate must hold single FM dots in the highlight and shadow. If single dots are lost, potentially all detail in the 0%–20% and 80–100% areas will be lost. (Tone in these areas is entirely reproduced by single microdots spread at appropriate distances.) This may require that the plate be underexposed, according to conventional standards, in order to hold dots at both ends of the spectrum. Reduced exposures may result in shorter plate life and an increase in reproduced dirt.

A post-exposure has been used to harden the dots for longer plate life. Attention to cleanliness is required to prevent the reproduction of dirt on the plate. Good-quality vacuum frames are required to reduce variability in the contacting process. A poor frame will create hot spots and inconsistency in exposure across the plate and from plate to plate. Matte film helps improve draw-down, but may sacrifice resolution.

Press requirements

Two typical sizes for the FM dot in high-quality work are 14 and 21 microns. A press must to be able to hold these dots in order to accurately reproduce the range of tones. A 14-micron dot is approximately the size of a 1% dot at a 200 lines per inch screen. If the press can hold a 1% dot with 250 lines per inch screen, then it will print stochastically at the highest resolution.

Because fine microdots in both the highlight and shadow must be held, plate exposure is usually decreased from that used in conventional screens. If the plates are not fully exposed at lower exposure settings, the microdots will not last as long on press. A post-exposure may be needed.

Press registration

With the elimination of rosettes and moiré, out-of-register FM plates will not rainbow in neutrals or exhibit color shifts. However, an out-of-register image will still look out of register, and trapping is still required to hide slight substrate travel that might result, especially on older or uncalibrated presses.

Makeready

Makeready is generally 25% to 50% as long as conventional makeready due to unexplained behavior of the microdots in the ink/water balance interaction. Among shops successfully implementing FM screens, ink/water balance is universally reported to be easier to achieve and maintain.

Dot gain on press

The secret to good FM screens is a good dot gain compensation curve. No press adjustments should be necessary if the compensation is correctly performed in pre-press. Any press manipulations to compensate for out-of-balance screens will only lead to further out-of-balance color, muddy highlights, discolored neutrals, and plugged shadows. Adjusting color on press is not feasible because dot gain is not easily changed by adjusting ink film densities. (This allows one of the major benefits of FM screens: increased ink densities, and therefore greater tonal range, without the dot gain associated with AM screens.)

Dot gain versus conventional screens

Dot gain is generally found to be around 25% to 35% with FM screening in situations where conventional screens give around 18% (SWOP standard). However, an appropriately adjusted transfer curve will compensate so that the printed page shows no sign of the excess dot gain.

Ink consumption

Ink consumption can be less with FM screens compared to AM screens. However, one of FM's strongest benefits is the ability to lay more ink without a sharp increase in dot gain. Ink consumption will increase whenever higher densities are run. It is not necessary to run more ink to improve the quality of the printed image using FM screens. The decrease of proportionality failure over conventional screening improves the image without any more ink. Some printers report that they can use less ink. The option remains with FM screening to run densities higher than were possible with conventional screening.

Ink density

Whereas AM screens may print with densities in the C, M, Y, K as: 1.30, 1.35, 1.00, and 1.80, respectively; FM screens may print with densities closer to 1.60, 1.65, 1.25, and 2.20 respectively, while retaining image sharpness and contrast. The smaller size of the FM screen limits the height of the ink on the sheet. It is therefore less likely to spread or gain (once initial compensation curves have been applied) when ink densities are run higher.

Conversely, a larger dot on the plate transfers a thicker layer of ink on the blanket, which gains heavily when transferred to the sheet. This phenomenon is compensated for in conventional dot gain curves and in the standards, such as SWOP, for ink densities.

Computer-to-plate

Plate imaging processes will be the same as with conventional screens. The only caveat with computer-to-plate imaging of FM screens is that the plate must meet the strict resolution requirements of any plate used in FM screening. The resolving power of the plate must hold a 4-to 8-microline test target. Problems with run length may be accentuated with the extreme size of FM microdots.

However, computer-to-plate technology offers the greatest opportunity for FM screening applications. By eliminating the film and its resultant dot gain, we eliminate a major problem area.

TRAPPING

Trapping is part of the process of making multiple colors of ink print properly regardless of the press, substrate, or environmental factors. It is the intentional overlapping of colors in a printed piece that prevents unintentional errors in printing from showing. It is compensation—in advance of production—for the human and mechanical errors that result in misregistration of images on a printing press.

In the preceding example, black is a color of ink printed on a sheet of paper. The gray circles are to print over the color. If the color of the circle printed on top of the color of the background, the circle color would not look like it should. Printers knock out the the background color and print the overlay color in the space that results. The circle on the left demonstrates what could happen if an object is not trapped—the underlying paper (usually white) will show. The circle on the right demonstrates how the image should appear if trapped properly.

Trapping what's in a name?

Printers use the word "trapping" for a few different meanings. Trapping is the intentional overlapping of colors along common boundaries to prevent unprinted paper from showing in the event of misregistration in printing.

• "Wet trapping" is a term used to describe how overprinting inks adhere to each other when printed wet ink on top of wet ink. When wet ink is printed on wet ink, it is the ability of each consecutive ink to adhere to the previous ink(s) and produce the proper color.

• "Dry trapping" is a term used to describe how overprinted inks adhere to each other when one coat of ink is overprinted on an already dry ink.

Wet and dry trapping are totally different topics, and are not related to the topic of trapping as discussed here. "Trapping" or "design trapping" has come to mean the intentional overlapping of colors to compensate for register errors on press. Without correct trapping, we cannot produce excellent printing.

A yellow circle over a blue box could not be accomplished by simply overprinting cyan and magenta to produce blue, and then printing yellow on top of the blue to produce a yellow circle. The overprinting of yellow in combination with the other two inks would yield a gray circle.

To accomplish quality color printing, accurate positioning of two or more colors of ink is required. This is referred to as register. There are various types of register that deal with exactly how accurate a job must be:

• Hairline register
• Loose register
• Lap register.

OBJECT	OVERPRINT	KNOCKOUT	SPREAD/CHOKE
Text on Solid	Yes	Yes	Yes
Text on Blend	Yes	Yes	Spread
Text on Graphic	Yes	Yes	Spread
Picture Background	Yes	Yes	Yes
EPS[1]	N/A	N/A	N/A
Line Art PICT	Yes	Yes	N/A
Bitmap PICT	N/A	Always	N/A
1-Bit TIFF	Yes	Yes	N/A
Grayscale TIFF	Yes[2]	Yes	N/A
Color TIFF	N/A	Always	N/A
Frames	Yes	Yes	Algorithmic[3]
Darker Foreground	Yes[4]	Yes	Default: Choke
Darker Background	Yes	Yes	Default: Spread
100% Black Object	Default	Yes	Yes

[1] EPS must be trapped in the application in which it was created.

[2] Only if specified in the Trap Information palette.

[3] Algorithmic Frames are the ones you can't open in Frame Editor.

[4] Of a spot color and not black.

COLOR	OBJECT	BKGRND	AUTO	TRAP
Cyan	70%	30%	1 pt	+0.5 pt
Magenta	30%	50%	1 pt	−0.5 pt
Yellow	70%	80%	1 pt	−0.5 pt
Black	20%	15%	1 pt	+0.5 pt

Note that the trap value is either +1/2 the auto amount or −1/2 the auto amount, depending upon whether the object is darker or the background is darker.

Source: Robin McAllister

In hairline register, colors touch with no trapping, with no unprinted paper showing. Hairline register is the most difficult type of registration to maintain and may be impossible to achieve on older presses.

Loose register is done in such a manner that the colors are spaced apart and registration becomes less of an issue.

Lap register refers to trapping that is built in to maintain register.

Issues affecting registration

Printing quality color requires more than using lap register or trapping. The imagesetter used to produce the color separations must be accurate and repeatable. As a general rule, capstan imagesetters do not produce the highest quality color separation simply because of the way they operate and handle film. Drum imagesetters produce consistent, accurate films that allow for critical fit.

Misregistration—Why it happens

In traditional prepress, factors contributing to misregistration are:

- Errors in film assembly
- Film or stripping material instability
- Errors in platemaking and film handling
- Poorly maintained printing presses
- Paper inaccuracy or instability
- Lack of proper environmental controls.

In a digital prepress system, two factors that contribute to misregistration are:

- Inaccurate imagesetter generating color separation
- No trapping applied to the job.

Trapping is rarely completely automatic; someone with an understanding of the process needs to make decisions and use the trapping software properly.

The need for trapping can be overcome by designing a job that does not require trapping, by either spacing out the colors or by only using colors that can be achieved by overprinting. Page layout programs do not automatically default to overprinting. The overprinting technique, although it eliminates the chance of misregistration, greatly limits the creative and aesthetic choices of the designer.

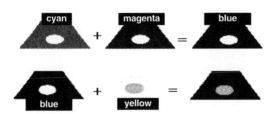

In the above illustration, a "knock-out" of the circle is created in the cyan and magenta separations. The knock-out area is left as visible substrate which the yellow circle can then be printed into. Knockouts are the reason why trapping must be done. If any misregistration occurs, there is a chance some visible substrate could show through. Spreads are when two different colors meet, and one of the two colors spreads into the other. Above, the yellow circle is "spread" into the blue to avoid any trapping problems.

Chokes are a bit more difficult to explain. Instead of spreading the yellow circle, the knockout of the circle in the white could be choked or made smaller. This would also prevent trapping problems. Spreads and Chokes are used in conjunction with each other and are the basis for trapping.

Colors that contain common elements do not have to be trapped. Suppose two objects, one light blue and the other yellow have to be printed next to each other. If pure inks are used to produce these colors, then trapping is necessary. However, if a small amount of yellow is added to the light blue color, no trapping is required. Yellow is now a common element in both colors. There needs to be at least 20% commonality.

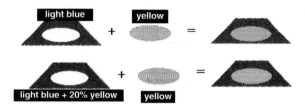

Spreads and chokes

Elements are either enlarged slightly or reduced slightly to allow proper printing to take place. Staying with our circle example, if the circle has a diameter equal to 10mm and the knockout for the circle has a diameter equal to 10mm, then we run the risk of having registration problems and allowing some of the paper base to show through somewhere around the circle

If the knockout diameter of the circle remains the same 10mm, but the yellow circle is slightly enlarged to 11mm, a spread is produced. The yellow circle will spread into the blue slightly, preventing any registration errors from showing. If the yellow circle diameter remains the same 10mm, but the knockout diameter of the circle is slightly decreased to 9mm, a choke is produced.

The background knockout is reduced, thereby allowing the yellow circle to fit easily into the opening with a little bit extra at the edges to cover up any registration problems. This is what trapping is all about. The lighter colors (subordinate colors) should be spread into the darker colors (dominant colors).

Here are some trap amounts by press and substrate:

Printing method	Substrate	Trap
Sheetfed offset	Gloss coated	.25 pt
Sheetfed offset	Uncoated	.25 pt
Web offset	Gloss coated	.30 pt
Web offset	Uncoated commercial	.40 pt
Web offset	Newsprint	.45 pt
Flexography	Coated	.45 pt
Flexography	Newsprint	.60 pt
Flexography	Kraft	.75 pt
Screen printing (wet on wet)	Fabric	0
Screen printing (dry)	Paper, fabric, other	.45 pt
Gravure	Gloss coated	.25pt

There are many causes of press misregistration, including high-speed paper handling, the quality and thickness of the paper, ink characteristics, plate misalignment, dimensional changes of paper as ink is applied, and changes in humidity. Trapping does not eliminate press misregistration, it merely hides it. Spreads and chokes are also called shrinks, grips, or fatties and thinnies. When neighboring colors have an overlap of the proper amount, colors appear to be touching even upon misregistration. This overlapping procedure requires skill and experience, as trapping can affect the look of a printed piece. In general, one should spread the foreground color if it is lighter than the adjacent background color, and choke the foreground color with the color of the background if the background color is the lighter one. Because trapping can create a dark line around a page element, spreading lighter colors into darker ones will minimize any visual effect of trapping. Other methods to avoid misregistration are overprinting one color on top of another or selecting colors that share similar process color components. These colors are referred to as common or bridge colors.

The problem of trapping is illustrative of how two worlds are colliding. On one hand, there is the design world inhabited by designers with art backgrounds. They are now struggling with the trapping tools of their drawing and page layout programs. They have an array of tools available that allow them to set traps, but they may not

fully understand what trapping is, when it needs to be done, and how it can be effectively applied.

Desktop trapping can be done manually and, to a certain extent, automatically. On the Macintosh, manual trapping most often takes place in Freehand, Illustrator, and QuarkXPress. The term trapping might be misleading when referring to the spreading and choking techniques used in Freehand and Illustrator. In these programs, you cannot simply select an object and choose "trapping" from a menu for assigning a certain choke or spread that takes the color of the background objects automatically into account.

One uses a drawing tool, the "stroke" value or keyline thickness, and assigns a printing specification to this tool ("overprinting"). For instance, overprinting a blue stroke around a blue object that touches a red object will compensate for any misregistration that might occur to the blue or the red plates.

A choke is more complicated to accomplish. A background color doesn't recognize the area where the foreground color is knocking out, so one has to simulate a choke. This is done by creating a copy of the foreground object, assigning it an overprinting stroke with the background color, and pasting it between the foreground and background objects. When an illustration is fairly complex and many objects have to be choked, one might be better off having a conventional stripper make separations from black-and-white output and handle the choking in the darkroom.

Manual desktop spreading or choking becomes even more complicated when an object is partly on top of a background object, and partly sticking out on a white background. Because spreads and chokes can only be applied to strokes around the entire objects, there is no direct way to let the program spread or choke the part of the stroke that touches the background color (no clipping paths are possible). A spread or choke through an overprinting stroke around the entire object will visibly change the shape of that object where the background is white. Ideally, an overprinting stroke should be applied only in

the area where the colors touch and not where the foreground color has a white background.

In Freehand and Illustrator, one can work around this by cutting the object in two and assigning an overprinting stroke only on the part that touches the background color. This procedure can be quite cumbersome if one works with a complicated design. In Freehand, one can also make a clone, assign it an overprinting stroke, and paste it inside the background, whereas the original foreground object will still stick out on the white background.

A similar procedure is necessary when one foreground object is on top of one lighter and one darker background object, which requires one part of the foreground to be spread and one part to be choked. Objects should be cut and have different colors assigned to the parts where they touch different background colors, or one can use Freehand's "paste inside" command. An easier but less accurate method is offered with an "indeterminate" trapping value, which will create one uniform spread or choke value. However, this might lead to undesirable visible overprinting areas when a darker color spreads into an area of a lighter one.

One can override these values by typing in a positive ("spread") or negative ("choke") value. One can also choose to overprint or knock out the background. Desktop trapping tools allow the user to trap process separation plates individually when a page contains overlapping process colors. Users select absolute or proportional trapping values and have the option to select an overprinting limit, which will automatically let colors with a certain darkness overprint (such as black).

There is still the need to create traps in imported graphics, because most desktop programs do not trap EPS files. If an imported EPS file is not properly trapped, one has to go back to the original file in Illustrator or Freehand and manually assign overprinting strokes. Last-minute changes—for instance, when one decides to print on a different stock that requires larger traps than anticipated—are difficult to accomplish because one also has to go back to the drawing programs that created the EPS

files. Any resizing of EPS graphics in the desktop program will change the stroke widths.

When touching colors have more than 10% of either cyan, magenta, yellow, or black in common, misregistration won't cause white paper to show through, but the misregistration will be caught by the common color, also called a "bridge" color.

High-end systems share a common workflow strategy. Mac files are imported through a number of different techniques and converted to the native systems file structure. In most cases this involves a raster image processor, or RIP, that rasterizes a PostScript file and creates a large bitmapped image or rows of pixels. This approach allows the high-end system to use its native software functions like pixel editing and trapping. Regardless of where or how the file was created, CEP system operators can work with the file in one program on their workstations, solving the problem of uneditable EPS files on Mac page layout packages.

Users can expect advanced trapping capabilities on high-end systems. In almost all cases, it is better to deliver untrapped Mac files for input, because files trapped on the Mac before input to the high-end system can cause problems. The decision to go to a high-end system should, therefore, be made prior to investing any labor in desktop trapping.

High-end systems have trapping solutions that are similar to desktop software solutions, but differ in some features. High-end systems allow for some level of automatic or semi-automatic trapping. Be aware that each vendor uses the terms automatic or semi-automatic trapping differently. Some systems require the high-end operator to tag color areas to trap or black areas to overprint; others will do this automatically.

As all systems may vary slightly, different jobs may lend themselves to different systems' capabilities, all with varying prices associated. In problem-solving terms, it doesn't really matter if a job is sent to a shop that uses Scitex's automatic trapping features or to a Crosfield shop that semi-automatically traps the file, as long as the quality, turnaround, and price are the same.

High-end systems all handle partial trapping. By selecting only part of a line or object to trap, a partial trap will spread a color only where it is needed. Sometimes this is referred to as a clipped line or path. As we said earlier, this feature is missing in desktop solutions where entire objects are spread or choked, even if the object is partially on a color and partially on white.

On some high-end systems, the software will take the color information of a background photo into account when the photo is knocked out by a tint. It then automatically generates a trap color, based on the color information in the CT. The foreground tint will be trapped depending on the color information of the underlying areas of the photo.

The end result will be a spread color that gets lighter as it enters a highlight area of the photo and gets darker as it touches the shadow or richly colored areas. CEP systems are well-geared to trap into CTs, because they are capable of working with full high-resolution photos and bit-mapped data. A similar way of trapping is applied to foreground tints that knock out vignettes or color gradations, which in CEP systems are described as continuous tones, as opposed to linework-based vignettes on the Mac that consist of multiple polygons, each filled with slightly different colors.

High-end systems vary in how they arrive at the dominant trap color. Some systems require operator specification; others generate this automatically under software control. Some systems can analyze the darkness of the touching colors and create the new trap color. All of the systems choke back color on super blacks (100% blacks with at least 10% cyan, magenta, or yellow) to prevent a color from showing through on misregistration, and most can spread a CT under a tint or rule. Some systems also extend a tint halfway under an overprinted black line even if the black line varies in thickness.

CHAPTER 10

DRAWING AND PAINTING SOFTWARE

Drawing programs can be categorized according to their functionality. As each supplier adds features, we are seeing a redefinition of the market—essentially creating a high end and a low end with very little in between. Typical programs can be categorized based on price and performance. Note that Paint programs and Presentation programs (which we cover separately) can be similarly categorized. Over time, the low end and the high end will probably merge. Perhaps the differentiation will come because the higher level, or professional programs, will require more computer horsepower, thus segmenting the market by the price of the combined program and workstation.

Drawing/editing

All products provide basic drawing tools, fine curve reshaping and object editing capabilities, color separation support, gradiated fills, and alignment of text to a path.

Some add the top text-handling features to their extensive list of drawing tools and charting capabilities, which themselves have long lists of drawing tools and include sophisticated object blending and transformation features.

CAD-like layering and multiple pages are most useful for technical drawing. A separate trace utility offers the most control options, and it converts color bitmap images. Designer had the top trace score. It has a simpler integrated approach than CorelDraw, is more accurate, and can produce color vector objects.

Import/export

Most programs offer many built-in filters. Some PC products rely heavily on add-on conversion modules.

Output quality

These products produce excellent 4-color separations, but vary in how much control you have over the output. Some do not support Pantone colors. All are PostScript oriented.

Documentation

All programs offer high-quality manuals that provide tutorial instruction and technical references. Some also include videotaped instructions.

WHAT TO LOOK FOR IN A DRAW PROGRAM

User interface: Look for efficiency and ease of use. This includes the combination of keystrokes, menus, dialog boxes, and other interface methods. What is easy for one artist may be hard for another. This area is the most subjective.

Drawing/editing mode: Fill editing and drawing in WYSIWYG "Preview" mode. Some programs have one mode for drawing and another for viewing the version that will be output. Eventually, all will combine these two modes into one.

Editing and moving: Select, reshape, move, and transform (scale, rotate, and shear). Because art revision is somewhat standard, strong editing features are a must.

Handle/node editing: Multiple handles can be selected across multiple objects for transformation (move, scale, rotate, mirror, shear, and skew).

Scrolling and zooming: Scroll during drawing, editing and moving. Zoom in and out during all operations including in the middle of a drawing operation.

Selecting objects: Pick up objects by their interiors as well as outlines. Select all (with keyboard shortcut), reverse selection, select by color.

Page size: A page could be a simple letter-sized sheet or a poster-sized sheet 99" x 99" or more.

Layering and organization: Number of layers (user defined names and colors), moved or hidden, lock, hide, group objects.

Drawing tools: Bezier, freehand, splines, rectangles, ellipses, circles, lines, regular polygons, polygons, gratings, circular arcs, elliptical arcs, and registration marks. These shapes and tools make up the heart of any program.

Advanced Bezier tools: Tangent and endpoint control with preview to next segment.

Text handling: On-screen editing, multiple fonts, styles, sizes within text, control tracking and character widths, on curve, import text, rotate text, convert text to graphics. Most pages contain type, and it is only recently that many programs improved their typographic capability.

Font support: Mix True Type, Adobe Type 1, and native fonts without conversion. Some of the Windows products come with a group of typefaces. Handling fonts via Windows is not as simple as handling them via the Macintosh. There are now almost 20,000 fonts in PostScript form.

Paragraph block text: Full control of tracking, line spacing, paragraph spacing, paragraph indents, tab ruler, linked text blocks with automatic reflow, user-defined block shapes, multiple-language automatic hyphenation.

Connection lines: Lines attached to objects for schematics, flowcharts.

Alignment aids: Rulers, grids, guidelines, snap to handles, snap to crosshair.

Replicating objects: Multiple-copy rotate, scale, shear, mirror, grid replicate.

Cut/join: Cut multiple objects or selected objects only.

Color palettes: Palette and color scroll bar for easy selection as well as dialog box, color mixer, palette manager, list colors by name or as palette; Pantone, Trumatch, and Focoltone support. Color support features are essential.

Fountain/graduated fills: Process colors, tints per graduated fill. Linear, accelerating, and decelerating distribution of colors.

Blends: Specification of matching nodes and blend direction.

Extrude: On-screen specification of extrude parameters, solid and shaded (with light source) extrude.

Envelope/distort: Distortion envelope with envelope library.

Pattern fill: Tiled or overlapping patterns.

Color control: Of grayscale, of process colors, adjust contrast and brightness, adjust color balance, posterize, invert.

Masks and holes: Masks and holes are used for color work. They let you crop and change images as related to backgrounds.

Graphing tools: Stored formats for bar, line, and pie charts. Saves having to use a chart program and then bring images into the drawing program for finalization.

Support: On-line help, context-sensitive help feature, and good company backup are important.

Multiple windows: Multiple jobs open.

Bitmap editing: Pixel editing/color control, automatic bitmap tracing.

PAINT

In a drawing program, a shape is a specific outline that is mathematically defined. It has thickness and texture, and it can be filled with a selected pattern, color, or colors, or rotated on an axis.

In a painting program, a shape is made up of individual pixels. You can change the color of each pixel on an individual basis, but if you want to move the image, you must define all the dots and group them. It is the difference between the object-oriented world (drawing) and the bitmapped world (painting).

Most painting programs are based on MacPaint, whose tools were based on tools used by artists—markers, paintbrushes, pencils of different weights, erasers, and paint cans and sprays, plus tools for drawing lines, producing geometric shapes, and selecting areas of an image for activity.

Paint programs involve color, and color is related to the number of bits available by the computer in use. Thirty-two bits can produce 4 trillion colors; the more popular 24 bits can produce 16,777,216 colors. The 16.8 million colors (some folks round to 16.7 and some to 16.8) of a 32-bit painting program are produced by only 24 bits of the 32-bit computer world that's the basis of Apple's 32-bit QuickDraw. The extra bits are reserved for developers.

A 24-bit paint program has access to all 16.8 million colors and can thus create a smooth blend between any two colors, usually at any angle. An 8-bit program has only 256 colors in its arsenal and cannot do as much. It must use dithering to simulate smooth color transitions. Dithering involves trying to find the in-between color or gradation to create transitions where they are not possible.

Painting programs are also different from color image-manipulation programs such as photo retouching applications. Although the principles are the same, the retouching programs are more concerned with changing photographic images than creating new images. In both cases, you manipulate pixels—the pattern of color dots on an electronic canvas represented by your screen—to create artwork that is a dot-by-dot bitmap. Paint, draw, and re-

touching programs overlap more than they admit. But you still need all three.

Painting tools produce artwork and images comprised of pixels. Lines and shapes produced by these tools can only be edited by modifying individual pixels or groups of pixels. In some paint applications, the use of these tools is enhanced by a pen tablet with a pressure-sensitive stylus. Electronic paint tools usually imitate the effects of conventional tools, such as brushes or sprays.

WHAT TO LOOK FOR IN A PAINT PROGRAM
• Carbon pencil, chalk, charcoal tools
• Paintbrush (varying sizes) tool
• Blur/sharpen tool. Also called the waterdrop or blend tool, it softens or blurs an image where it is applied
• Waterdrop tool which often toggles to a sharpen tool
• Finger tool also called the smudge or smear tool, which smudges an image in the same way that running your finger through wet paint would, enabling users to paint by blending or smearing
• Airbrush tool, also called the spray can tool, which creates a feathered or blended effect at the edges of painted images.

Tools for copying images
Tools are available for duplicating or copying (cloning) parts of artwork.

Clone or Rubber-stamp tool. Used for copying part of an image and then placing the copied area, or stamping it, in another part of the image.

Copy brush tool. For copying parts of an image and painting with it.

Duplicate or Copy tool. For duplicating selected items or areas.

Tools for adding text
A text tool is used to input type into a document, usually in a special text area. Double-clicking on the tool icon will sometimes open a type specification dialog box.

Tools for adding significant areas of color

Blend tool. Defines the area to which a blend is applied and, in some cases, specify the blend characteristics.

Paint bucket tool. For filling defined areas with a color or tint.

Tools for rotating images

Pitch, roll, yaw, and view rotate tools. For rotating three-dimensional (3-D) objects.

Rotation tool. Items may be rotated freely, or it may be necessary to specify a value. A dialog box is sometimes called up for input.

Tools for slanting (tilting) images

Skew tool. Sometimes called the shear or slanting tool, this slants an image to the left or right as defined.

Tools for flipping images

Mirror or reflection tool. Sometimes called the mirror tool or flip horizontal tool, it makes a mirror-image transformation of items along a vertical axis, which may also be defined in a dialog box.

Flip vertical tool. Reflects an object electronically along a horizontal axis.

Tools for resizing images

Scale tool. Although the size of an item can usually be altered by entering values in a dialog box, applications provide a tool for size alteration of items visually by dragging the image edge points.

Zoom. A function that lets users define an area of the active canvas to be magnified in a separate screen window.

Tools for setting light sources

Spot light tool. Used to position localized directional light sources in a 3D environment.

Point light tool. Used to position localized, nondirectional light sources in a 3D environment.

Tools for tracing an image

Tracing tool. Sometimes called the autotrace tool, it is used to select an area of an image, the edges of which are to be traced automatically. This function works most effectively with images of a solid color, but the tool is getting better.

Tools for cutting or erasing

Scissors tool. Used to select and cut areas or lines.

Knife tool. Used to cut a line or an area into segments.

Eraser tool. Used to erase parts of an image or the entire image or page.

Also, cut and paste functions as available from the operating system.

Tools for creating 3D shapes

Lathe shape tool. Generates lathed 3D objects.

Extrude shape tool. Generates extruded 3D objects.

Tools for measurement

Angle measure tool. Used for measuring the angle of any image.

Measure tool. Used for establishing the distance, in a predefined scaling system, between two indicated points.

Tools for cropping images

Cropping tool. Used for removing unwanted areas from an image.

Tools for linking items

These link (or unlink) text boxes so text flows from one area to the other.

Freelinking tool. For linking (and unlinking) objects in 3D artwork.

Tools for controlling image density

Brightness tool.

Contrast tool.

Opacity. The density at which paint is applied. Paint that has 100 percent opacity completely covers what is un-

derneath it. Paint of a lesser opacity lets whatever is underneath it show through to some degree. Zero percent opacity paint is transparent. The reverse of opacity is translucency.

Document or page tools
Note tool. For attaching comments to an image or document.

Page tool. Usually used to adjust the page grid area.

Page insertion tool. For inserting new master pages or grids.

Other paint tools
Cloning. The process of painting with a copy of an image onto the same or a different image canvas.

Filter. A graphical conversion that improves, diminishes, or changes the visual quality of a digitized image.

Gradient or Blend. A smooth transition between two or more colors, also known as a ramp or dégradé.

Grayscale. Simply, shades of gray.

Lasso. A tool that lets users define a shape by enclosing one or more objects or colored areas with a drawn loop. The lasso automatically determines which shapes within the lassoed area are different in color from the background and defines them as the current shape.

Anti-aliasing. A function that makes jagged edges appear smooth by softening the colors of pixels at the edges of painted areas to make them appear to blend into the edge or background color. Also referred to as smoothing.

Masking. The process of protecting portions of an image from painting.

Palette. A set of colors provided as a way to select commonly used colors for painting. Users can modify the palette by mixing, adding, or rearranging colors. They can be saved and recalled.

Quad Ramp. A two-way transition among four or more colors. Big blend.

Undo. A function that removes all effects of the most recent operation.

HOW TO DESIGN SOMETHING THAT CANNOT BE PRINTED

As art becomes electronic, it must interface and calibrate to the final reproduction process. The concept of computer-ready art is one of the missing links in the chain leading to electronic prepress and electronic reproduction.

Digital designs reproduced on paper are limited by the printing technique, including variables such as ink and water, plates, resolution levels, and the images themselves. Designers are hampered by trapping, color consistency, font handling, and graphics use. The digital prepress process converts an image into the form needed for reproduction. If this process is not understood, it is possible to design something that cannot be printed.

You must know the printing process and press characteristics so that you can set up your output parameters.

Pantone versus CMYK

A major problem area involves the use of color. Many Pantone colors cannot be simulated with CMYK because they are spot color premixed inks. But there are alternatives. Trumatch and Focoltone have pioneered "printable" color by using only CMYK mixtures. Pantone itself has CMYK versions. That means that every one of its colors will print in a 4-color process. Other ink makers now have process ink swatch systems as well.

Jobs could also be printed on 6-color or 8-color presses where spot color inks can be used on one of the units.

Blends (vignettes, degradés)

Never blend between spot colors Blend between CMYK colors. Also, do not try to blend between a CMYK color and a spot color.

Halftone screen lpi and output resolution dpi interact:
LPI should not exceed resolution (dpi) divided by 16
For example: 2,400 dpi ÷ 16 = 150 lpi.
Bands result when there are too few steps or when the lpi is too high for the imagesetter resolution.

Prepress system

Your prepress systems consists of three main p——

Workstation. Your PC or Mac or whatever. Get lots of memory.

RIP. The raster image processor takes your page data and prepares it for the output device. This is the key device because what you do affects what it does. It must process your files to create the dots the output engine outputs. If you prepare your pages responsibly the RIP will rip faster and more efficiently.

Recording engine. The engine that produces film or plate or whatever.

The 10 errors of prepublishing

Here are the 10 most common errors of prepress preparation:

1. TIFF and EPS files wrong or missing.

Don't forget to put the graphics files in the same folder with the page file and then put all of it on the disk going to the prepress service. Some page programs do not integrate the image—they only create a link to the image. Thus, you think the image is in the file and it is not.

2. Fonts not specified or missing.

The usual suspect. The rules say you cannot have a font in two places at the same time, so make sure the service bureau has the font. Make sure both the screen and printer font are present. Also, don't mix PostScript and Truetype fonts. Use Truetype if you are a masochist.

3. "Tiling" clicked on.

This causes some interesting output of multiple sheets of film. It is used so that large page sizes can be output to page printers, but then we forget to unclick the function and the imagesetter does the same with film.

4. No line screen specified.

This makes printing pictures almost impossible. Or, you left the laser printer setting of 65 line screen and you want 133 line screen on the imagesetter.

5. Pantone and CMYK mixed.
 This is a no-no, as we noted earlier.

6. Blank disks.
 Yes, blank disks. The service will then send you blank film and an invoice.

7. Use of Geneva and New York at high res.
 There are lousy fonts no matter what resolution you use and they have city names in some cases. Unfortunately, they are used by the Mac user interface and thus must be in the font folder. If it has the name of a city, move.

8. Compression program unknown.
 This makes it impossible to decompress. Make sure the service bureau has the same program, or go out and buy a larger capacity disk.

9. Typesetting in drawing program—fonts.
 Don't forget to supply the fonts that are buried in your EPS graphic file. The system needs the font to output it. Otherwise you will get `Courier`.

10. Film emulsion not specified.
 Check with the printer of the job to get the right orientation specs.

Color publishing

• Watch the number of steps in color blends.
 Follow the recommended formulas in the manual.

• Crop and rotate photos to size before importing.
 This results in less data to RIP.

• Leave trapping to someone else?
 Not a bad idea. Or get a professional trapping program or a professional trapper.

• Should *you* set your own screen angles?
 You better know what you are doing.

- Turn color separation on in the print dialog box.

- Remove unneeded colors from the color palette.

WYSIMOLWYG
What You See Is More Or Less What You Get.
- Just because you can see it on the screen does not mean it will print. *Nested files two levels deep are problems.* Here's what happens: you create an illustration in a drawing program and use some type. You save the file as an EPS and import it to your page program. You forget about the font and also forget that EPS does not save font data. The font must be in the system folder of the printer.

- Just because you can't see it on the screen does not mean it isn't there. *Don't cover a mess with a white rectangle.* It's a natural trick to place a white box over some area. Post-Script will still rip the unseen area.

- If the page does not print on the laser printer, it won't print on the imagesetter.

Fonts
Font problems are still with us. Watch Screen fonts and Printer fonts. You need both. If you see it on the screen, the screen font is there. If you see it on the printer, the printer font is there.

- The output service must have the same fonts used by the creator of the page. It is legitimate to send your font to a service bureau to output your pages. It must be returned. It cannot also be in your workstation. Beware the font police.

- Watch out if you make a bold font **bold**. You get wild and crazy spacing.

- Do not use "hairline" for anything.

Cropping and scaling

- Importing a large graphic file and then cropping it in a picture box does not eliminate the unseen parts. *Clip art usually comes this way.* Even the unseen parts of the graphic must be processed.

Scanning

For those of you who do your own scanning

- Most scans are at too high a resolution. Try a few experiments to get the specs that work best for you.

- Clean up and crop scans in a retouching program before placing them. This will cut RIP time substantially.

- White borders do count. They are still data and they must be processed by the RIP. Crop them out with an image manipulation program.

- Rotation in a layout program imposes a large burden on the RIP. Rotate in retouching program and import.

- Shrinking a high-res scan is better than enlarging it.

Other

- Create your page size for the final trim with crop and registration marks. Do not forget to extend color areas and pictures if bleed is required.

It does not take much to design a real award-winner that *cannot* print on a printing press.

SECTION 3

THE BUSINESS
SIDE OF
DIGITAL
PREPRESS

CHAPTER 11

BUDGETED HOURLY COSTS

The need for timely and correct cost information is vital. Developing budgeted hourly costs provides such information and serves three purposes:

1. Recovering all costs. The example includes typical costs. These, of course, will vary because of different equipment and allocation methodologies.

2. Serving as a primer or refresher for nonfinancial managers.

3. Laying out all items on a spreadsheet basis. Each line will be explained, including the math for applying the proper formulas. This allows for current cost updates in a matter of minutes.

The methodology used is called 9H. It is the basis for 90+% of all services that have established budgeted hourly costs. It was selected because it both recovers all costs and can be used for "apples to apples" review. It has been refined by consultant Jack Klasnic and provides the most meaningful approach to cost comparison.

Budgets

The budget provides the basic information for developing the budgeted hourly costs. The key is the proper assignment of all budget costs to ensure that they are recovered and charged back to the customers.

This procedure has proven to be the most reliable:

1. List all assigned budget costs and assign them as either direct, indirect, or outside costs.

2. Establish the production centers.

3. List personnel and assign to areas of responsibility.

4. Assign all direct costs to each center.

5. Allocate all remaining costs.

Assigning budget costs

Remember that the primary objective is to recover all *projected* operational costs; thus, all must be assigned. Bear

in mind that the budgeted hourly costs are being developed for the current or next fiscal period, not the previous one. All pay increases, and like items must be included in the budget.

The steps are as follows:

1. List all budget items.

2. Assign as specifically as possible where each cost item belongs. The classification definitions are as follows:

• Direct costs are those costs which can be allocated to a specific production center, in essence, all costs belonging to that production center. For example, the wages and fringes paid to the workstation operator(s), along with the maintenance contract(s), specifically belong to the prepress production center(s). Some items, such as toner, probably will have to be allocated among several production centers that use that item.

• Indirect costs are those internal operating costs which cannot be allocated to any specific production center. These include costs such as staff (nonchargeable) wages and fringes, common space rent, and any intracompany allocations such as payroll and human resources allocations.

• Outside costs are specific job-related purchases. In essence, they occur because a particular job is in the shop. If the job had not occurred, the costs would not be there. The major problem with some budgets is that they lump all supply and material costs into one budget item and typically call it "Supplies." This is incorrect for budgeted hourly cost purposes.

A supply is any item which either is too small when compared to total job costs or cannot be allocated to a specific job. A material is a relatively major cost item which can be assigned to a specific job. They always appear as separate line items on the estimate sheet.

Supplies and materials must be differentiated to develop accurate budgeted hourly costs, even if it means reviewing invoices for the previous year and checking with vendors to determine current year cost projections.

3. Reconcile all costs by totalling the three columns to ensure that they match the budget.

The following is an example of budget item allocations. Note that some items may be classified as either or both direct and indirect. For example, temporaries who work at production centers are direct because they perform chargeable work. But temporaries who perform staff functions, such as secretarial, are indirect because they do not perform chargeable work.

If utilities are charged as a separate line item (as opposed to being built into the rent or occupancy costs), then they are charged directly to the production center according to consumption. These are direct. The balance is typically charged according to square footage usage because the heavy equipment power usage has been allocated.

Budget Item	Direct	Indirect	Outside
Production Wages	X		
Staff Wages & Salaries		X	
Production Benefits	X		
Staff Benefits		X	
Temporaries	X	X	
Rent	X	X	
Production Equipment R&M	X		
Computers, etc. R&M		X	
Utilities	X	X	
Depreciation	X	X	
Office Supplies		X	
Taxes	X	X	
Subcontracting			X
Paper, Film, Plates			X
Colored Ink			X
Black Ink	X		X
Sales Promotion		X	
Travel, Dues		X	
Professional Fees		X	
Corporate Allocations		X	
Telephones		X	
Office Copier		X	
Production Copier	X		

The manager has considerable control over the direct and indirect costs. Some organizations view these as *cost containment* budget items and hold the manager accountable for these areas. Outside costs are considered *flow-through* budget items.

Production centers

Production centers are any operations that produce work chargeable to the customer. In the commercial sector, they were originally called *cost centers*. However, this has a negative connotation, so the name was changed to production centers. There are a few commercial printers who have changed the name to *profit centers* because that's what they're expected to produce.

Depreciation and rent are fixed cost components which are divided by the hours of usage. For example, a printer that cost $3,000 is depreciated over a five-year period. The depreciation costs are $600 per year ($3,000/5 years) or $50 per month ($600/12 months). Rent is $12 per square foot annually or $1 per month ($12/12 months) per square foot. If the printer area is 10 square feet ($10 per month), this equates to $60 per month ($50 depreciation + $10 rent). If $8 per hour with 30% fringes were the assigned operator cost and other associated hourly costs were included, the hourly costs under several scenarios would be:

Monthly Chargeable Hours	1 Hour	2 Hours	10 Hours
Depreciation	$ 50.00	$ 50.00	$ 50.00
Rent	10.00	10.00	10.00
Wages	8.00	16.00	80.00
Supervision (20% of Wages)	1.60	3.20	16.00
Repairs & Maintenance Contract	10.00	10.00	10.00
Direct Totals	$ 79.60	$ 89.20	$166.00
General Factory Allocations (20%)	15.92	17.84	33.20
Total Factory Costs	$ 95.52	$107.04	$199.20
Staff Allocations (25%)	23.88	26.76	49.80
Total Departmental Costs	$119.40	$133.80	$249.00
Costs Per Hour @ 100% Productivity	119.40	66.90	24.90
Costs Per Hour @ 75% Productivity	159.20	89.20	33.20

This table illustrates the importance of keeping equipment busy. Note how hourly costs drop as the number of chargeable hours increases. The reason is that *fixed costs* are spread over more chargeable hours.

Personnel assignments

Dependent upon company size and variety of work, employees may be assigned to:

1. Staff functions. These are the nonchargeable areas such as secretarial, estimating, and supervision. These costs must be recovered by the production centers.

2. One specific production center. All hours are assigned to one production center, such as camera in a large operation or prep (camera, stripping, and platemaking) in a smaller shop where these are combined into one production center.

3. Several production centers. The hours (or percentages) at each production center should be ascertained and accordingly assigned, along with all related costs. In essence, the employee is split into 40% prep and 60% duplicators.

4. Split staff and production center(s). For example, a working supervisor may spend 40% of his or her time on staff functions (nonchargeable), 25% in prep, and 35% with the duplicators.

5. Primary and coverage operations. In general, a primary goal is to keep the most expensive (highest hourly costs) equipment running. For example, the employee may primarily be assigned to the duplicator, but when the two-color press operator is out, the duplicator operator will run the two-color press.

Hours available for work

Employees are paid for a combination of at-work time, vacations, holidays, and in some cases personal and illness days. This constitutes the base annual wage; however, chargeable hours can only be obtained during the at - work time.

1. Vacations in most United States organizations are usually employee-selected periods to take off, such as a week's vacation. Government agencies often call this annual leave. In some countries, these "vacations" may be called holidays. The missing employee's equipment *may* be operated by a backup person.

2. Holidays in the United States are days when the

entire organization is generally closed for a particular com-
memorative day, such as Christmas and New Years. Most
likely no equipment will be operational.

3. Personal and sick days are days when the em-
ployee is away from work for various reasons. The miss-
ing employee's equipment *may* be operated by a backup
person.

For illustration purposes, the more common United
States terms will be used.

One area works a 40-hour week, with an average of
12 vacation days, 3 illness days, and 10 holidays. The
Available for Production (at-work) Hours are determined
as follows:

Annual Paid Hours (40 hours x 52 weeks)	2,080
Vacations (8 hours x 12 days)	96
Holidays (8 hours x 10 days)	80
Absences (8 hours x 3 days)	24
Total Paid Hours Away from Work	200
Net Available Hours at Work	1,880

All of these hours at work cannot be charged in that
nonchargeable functions will be performed, such as mix-
ing chemistry and maintenance, as well as other delays.
There may also be one or two formal breaks of 10 or 15
minutes' duration. If one desires, these breaks may be cal-
culated at this point, as the following illustrates:

Net Available Hours at Work	1,880.0
Breaks (47 weeks x 5 days per week x 0.5 hours per day)	117.5
Net Available Hours for Work	1,762.5

Because this varies considerably among organizations,
our example will use the 1,880 hours and treat all non-
chargeable work as lowering the percentage of productiv-
ity. For example, if a typical 8-hour day has 2 hours of
nonproductive work and 6 chargeable hours, the percent-
age of productivity is 75% (6 chargeable hours/8 total
hours). On an annual basis, the various percentages of pro-
ductivity equate to chargeable hours as follows:

Net Available Hours for Work	1,880
100% Productivity	1,880
90% Productivity	1,692
85% Productivity	1,598
80% Productivity	1,504
75% Productivity	1,410
70% Productivity	1,316
65% Productivity	1,222

Fringes

Fringes should be based on organization policy. This may be actual cost per employee or an average cost per employee. Fringes are any additional costs which the organization incurs other than the direct *at-work* wages. These include all paid away-from-work days, FICA, workers' compensation, unemployment, medical insurance, retirement, education (when organization paid), and so on.

However, many organizations calculate fringes as a percentage of base annual wages for costing purposes. Others treat it as a percentage of at-work pay. The average is 25% of annual base wages.

Depreciation

Depreciation usually takes one of three basic forms:

1. Organization actual assigned depreciation. This is the most common. When an accelerated depreciation is used for tax purposes, the equipment will carry a higher depreciation during the early years. But it will also carry little or no depreciation as it ages. For example, for a $21,000 color printer, accelerated depreciation over 7 years may appear as follows:

Year	Depreciation	Accumulated	Balance
1	$ 4,200	$ 4,200	$16,800
2	3,360	7,560	13,440
3*	2,688	10,248	10,752
4	2,688	12,936	8,064
5	2,688	15,624	5,376
6	2,688	18,312	2,688
7	2,688	21,000	0

The depreciation was switched from accelerated to straight-line to increase the amount of depreciation. In the United States, this may be done once during the depreciation period. Other countries vary.

2. Straight-line depreciation over a defined period. For example, if depreciation for a $21,000 duplicator were spread over 7 years, this would be $3,000 per year ($21,000/7 years).

3. Replacement cost. This normally applies to older equipment. The goal is to build up a contingency fund for the ultimate replacement. This is far more common in the commercial sector than with in-plant operations.

The organization can use an accelerated depreciation for tax purposes, while using a reasonable life expectancy (which may exceed the government period) and/or use a different method of depreciation for internal costing purposes. There is nothing illegal about this practice.

Repairs and Maintenance (R&M)

Repairs and maintenance costs normally are a combination of maintenance contracts and historical data. The contracts may include total parts and labor or be for labor only. In the former case, the contract is the repairs and maintenance total. In the latter case, a contingency provision for parts should be provided.

When using historical data, care must be employed to reflect reality of costs. For example, a complete overhaul of a major piece of equipment rarely is an annual event unless it's ready for the scrap heap. To base maintenance costs on the previous year is a mistake. It should be a statistical projection based on previous years and discussions with the maintenance people. Those who are independent are more likely to be objective than vendor maintenance personnel, but this is not an absolute rule.

A general rule of thumb with questionable validity is to use an annual 2% per shift over the life of the equipment for repairs and maintenance. A variation is to use 2% for one shift, 3% for two shifts, and 4% for three shifts. The problems with those rules are that:

1. Prepress equipment often costs in the 10–12% range.

2. Cameras and platemakers are less.

3. Computer-aided equipment tends to run higher than equipment which is not.

Rent

Rent (or occupancy) normally is allocated as an annual cost per square foot. Quite often this figure includes heat, air conditioning, water, and power. All rent must be accounted for. This usually is done through a combination of:

1. Equipment direct allocation, which includes the actual equipment space and the effective working area around it. Equipment may share common areas (for instance the four feet between two presses may be allocated as two feet to each).

2. Common areas such as general aisles and storage. Typically they go to General Factory.

3. Staff areas such as offices.

Some organizations also directly allocate such areas as "fair share of the cafeteria." This would be incorporated as additional staff allocation or intracompany allocated expenses.

Power allocations

When electricity is a separate line item, the election may be to treat each piece of equipment as carrying its fair share. In that case, the following formula to determine power cost should be used:

Horsepower x 0.746 x Available Hours x Power Usage % x Cost per Kilowatt Hour

Assume that the following holds true for a piece of equipment:

Horsepower	2.50
Available Hours	2,000
Power Usage	60%
Cost Kilowatt Hour	$0.075

Applying this to the formula would produce:

2.50 x 0.746 x 2,000 x 0.60 x $0.075 = $167.85

Equipment with minimum or no horsepower rating, but which uses costly, high intensity light sources, etc., must have its annual costs projected and captured.

General factory allocations

This is the total of all the general factory costs which cannot be attributed to individual production centers. Traditionally it is allocated as a constant percentage of the direct factory costs, as will subsequently be shown when budgeted hourly costs are determined.

The following costs are based on general costs that cannot be attributed solely to production jobs. They are:

General Factory Costs

Unallocated Factory Rent	$18,000
Factory General Supplies	1,200
Factory General Repairs	1,000
Factory General Depreciation	400
Total General Factory Costs	$20,600

Supervision

This is the salary and/or wages of "on the floor" supervision. Traditionally it is allocated as a constant percentage of production center employee wages, as will be shown when they are allocated. Because supervisors and managers usually do not work on specific jobs, their time must be allocated to jobs in some manner.

Staff allocations

Staff allocations are the total office costs and include all the remaining direct costs of having a production department. Traditionally it is allocated as a constant percentage of the total factory costs. Staff may be secretarial and administrative personnel and the costs associated with them.

Staff costs

A manager and secretary plus the following costs.

Staff Allocations

Manager	$40,000
Secretary	20,000
Total Staff Wages & Salaries	**$60,000**
Fringes on Above (25%)	15,000
Phone	1,500
Dues & Travel Expense	1,200
Postage	1,000
Equipment Rental (Office Copier)	1,500
Recruiting Expense	1,000
Office Supplies	1,200
Taxes	2,000
Depreciation	1,275
Repairs & Maintenance	1,100
Rent	1,600
Total Staff & Unallocated	**$88,375**

Reconciling the data

At this point all budget costs, except for materials and other outside purchases, should have been captured in the previous cost data allocations. A check should be made to ensure this. Any deviations must either be corrected or the reason noted. For example, the $16,100 total supply costs may appear in the budget as part of the $150,000 (or whatever) allocated for "Supplies." This budget "supplies" figure also includes materials.

Chargeable hours

Total departmental costs have been allocated. These costs are recovered by establishing an hourly rate for each production center, which is based on the projected number of chargeable hours. If total costs were $1,000 and chargeable hours were projected to be 100, then $10 per hour ($1,000/100 hours) should be charged in order to recover the $1,000.

Not all personnel hours are productive; there will be cleanup, preventive maintenance, personal times, and other delays. If the actual percentage is unknown, most likely 75% should be used until the actual percentage can be determined. The actual production percentage will probably

fall between 70% and 85% depending on the operation.

Example of chargeable hours at the various percentages of productivity:

Total Hours	100%	85%	80%	75%	70%
3,760	3,760	3,196	3,008	2,820	2,632
7,296	7,296	6,202	5,837	5,472	5,107
1,992	1,992	1,693	1,594	1,494	1,394

The budgeted hourly costs are determined by dividing total departmental costs by the available hours @ 100%, then by the various percentages of productivity.

For example: Total prep departmental costs are $77,008. There are 3,760 available crew hours. At 100% productivity, this would require dividing $77,008 by 3,760 hours to get $20.48 per hour. To determine budgeted hourly Costs @ 80% Productivity, divide $20.48 by 0.80, which is $25.60 per hour. Dividing $77,008 by 3,008 chargeable hours (80% productivity) yields the same $25.60. Either method is acceptable. 75% would be $20.48 divided by 0.75 or $27.31 per hour.

It follows, then, that a primary goal is to attain the highest practical percentage of productivity, which results in lower hourly costs and a more competitive cost position.

SECTION 4

THE FUTURE
OF
DIGITAL
PREPRESS

CHAPTER 12

ON-DEMAND PRINTING

The term "digital printing" means different things to different people. Here is our definition in the form of a chart.

Digital printing involves all aspects of reproduction utilizing rasterization processes to produce image carriers or to replicate directly to substrate from digital document files.

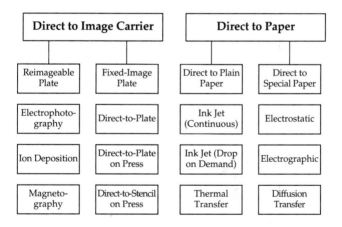

DIGITAL PRINTING	
Direct to Image Carrier	**Direct to Paper**

Reimageable Plate	Fixed-Image Plate	Direct to Plain Paper	Direct to Special Paper
Electrophoto-graphy	Direct-to-Plate	Ink Jet (Continuous)	Electrostatic
Ion Deposition	Direct-to-Plate on Press	Ink Jet (Drop on Demand)	Electrographic
Magneto-graphy	Direct-to-Stencil on Press	Thermal Transfer	Diffusion Transfer

Thus we include direct-to-plate (and stencil) technology in our definition, as well as direct to imposed film (not shown in the chart). Imposed film is one of the steps to a plate.

Any device that replicates pages or images is certainly included in any definition. We have not considered speed or quality or substrate in the decision to include a technology. We recently attended a seminar where a major topic

of discussion was the production of automobile license plates on demand using digital approaches.

Eventually, digital approaches will apply to just about every facet of graphic communication, whether it has to a run of 1,000, 100 or just one. Let us not to make our definition so narrow that it excludes too much.

Computer-to-print systems are based on the same concepts as electrostatic copying machines, in which the image replication must be repeated for each impression. Because of this, these systems are capable of printing variable information from impression to impression. Until Canon and Xerox introduced their color copiers in 1990 and 1991, and Indigo and Xeikon announced their electrophotographic color printing systems in mid-1993 most of the systems in use could print only a single color; some could add a spot color. A number of technologies are used for computer-to-print systems. They are electronic printers, color copiers, and electronic printing systems using electrophotography, magnetography, ionography, field effect imaging, ink jet printing, thermal transfer, and modifications of these technologies.

These systems go directly from the RIP to a press-like device without any intermediate films or plates. They are true digital printing systems, in that all or part of the image area can be changed from impression to impression. Also, because the image recording must be repeated for each impression, the amount of data that must be ripped is so large that machine speeds are limited in most cases to 300 feet per minute (fpm) or lower. The electronic printing systems in use or development use electrophotographic, magnetographic, ion or electron deposition, field effect, ink jet, and thermal transfer technologies.

Electrophotography
Electrophotographic printing systems use imaging and printing devices similar to electrostatic copiers. They use drums or metal plates coated with photoconductors that are charged overall with a corona charge and exposed to an image by light which discharges the charge in the nonimage areas. The image is toned by powder or liquid toners in

the charged areas, transferred to a substrate, and fused or fixed by heat, solvent vapor, or other fixing method.

In 1977, Xerox introduced the 9700 laser printer. It ushered in an age of digital laser printing that eventually found its way to virtually every desktop. It also spawned considerable interest in, and eventual application of, the concept of demand printing and publishing.

In 1989. the Canon Color Laser Copier (actually a scanner and a printer), coupled with various interfaces to electronic page files, held out the promise of on-demand *color* printing. Although it lacked speed and duplexing capability, it did create a de facto demand color market.

In 1992, Heidelberg introduced the GTO-DI, the first printing system to introduce the concept of on-demand color reproduction. In concept, it created printing plates on a traditional printing press, effectively solving the registration problem associated with the 4-color printing process. The plates were created with a spark discharge which then allowed them to print without water, effectively solving the ink and water balance problems associated with offset lithography.

These systems whetted the appetite of the market for instantaneous reproduction of black-and-white and then color pages.

Color printing

Color printing has long been batch-oriented. Large printing presses fed by sophisticated prepress systems produce long runs of ink on paper. Long runs are virtually mandated to absorb the traditional makeready costs of the process. But increasingly, we are seeing a demand for shorter and shorter runs as marketers pinpoint their promotions and publishers define their audiences.

The concept of "just in time" (JIT) delivery is changing the nature of the printed product. Rather than print long runs, to maximize the cost idiosyncrasies of the color printing process, prudent print buyers are acquiring smaller volumes to meet immediate demands. JIT delivery not only mandates short runs, it also mandates very fast turnaround.

Indigo E-Print 1000 (Rehovot, Israel) was announced in 1993 as the "World's First Digital Offset Color Press." It is an electrophotographic system using laser imaging, a special new liquid toner called ElectroInk, and essentially a single color offset press with plate, heated blanket and cold impression cylinders, paper pile infeed, pile delivery system, and means for turning prints over and printing the reverse side (perfecting) or duplex printing, and some finishing options. Printing has 800 dpi resolution. Single-color prints can be produced in 11" x 17"+ at a press speed of 4,000 sheets/hour (67 per minute). Because color printing is done by consecutive impressions of the same sheet on the impression cylinder, the output for 4-color (one-side prints) is 1,000 sheets/hour, 17 sheets/minute, or 34 pages/minute. Duplex printing (2 sides) reduces the output to 500 sheets/hour, 8 sheets/minute, or 32 pages/minute optionally. The system is capable of printing six colors.

The E-Print 1000 accepts digital data in PostScript and other formats. The most unique features of the E-Print 1000 are the ElectroInk and the image transfer system. The ElectroInk consists of micron-size pigment toners dispersed in a thermoplastic resin diluted in a light mineral oil (isopar). It is applied to the image on the photoconductor immediately after exposure by laser. The mineral oil is squeegeed from the surface of the imaging cylinder and returned to the toner reservoir, leaving just the toner/resin mixture on the image transferred to the heated blanket. This heated dispersion of toner pigment and resin sets when it transfers to the cold paper. Adhesion of the ElectroInk to the paper can be critical. Prints made at early shows were erasable. Toyo Ink (Japan), which is the Far East distributor for the E-Print 1000, has produced prints that are not erasable.

The electrophotographic photo conductor plate is claimed to be capable of 30,000 to 40,000 impressions. It must be imaged after each impression. Blanket life is 20,000 to 30,000 impressions. Because of the 100% ink transfer the plate is claimed to be clean and ready for the next image, which can be the same as the last one or a

completely new image. This is typical of digital imaging and printing systems. Although this feature makes possible the printing of variable information on

Printout Alternatives

Documents	Black-and-white	Demand hard copy
		Pen plotter
		Laser printer
		COM recorder
		Electrostatic
	Color Pages	Pen plotter
		Dot matrix printers
		Thermal-wax transfer
		Ink jet
		Color xerography
		Color electrostatic
Presentations	Flip Charts	Pen plotter
		Color electrostatic
	Wall-size charts	Pen plotter
		Electrostatic
		Color electrostatic
	Transparencies	Pen plotter
		Thermal-wax transfer
		Ink jet
		Laser printer
		Film
	Slides	Film recorder
Publications	Black-and-white paper	Pen Plotter
		Ink-jet
		Laser Printer
		COM Recorder
	Color Pages	Thermal-wax Transfer
		Film Color Separation
		Digital Color Press
		Printing Press
High-Volume	Black-and-white paper	Laser printer
	Color paper	Laser printer
		Color electrostatic
		Thermal-wax transfer
		Digital color press
		Printing press

consecutive impressions, it imposes gigantic demands on data storage and data transmission rates. This accounts for the slow output of these systems in comparison with conventional lithographic printing.

Xeikon DCP-1 (Mortsel, Belgium) was announced in 1993. It is an electrophotographic web press in which the printing engine has eight in-line units, with four on each side of the paper so it can print both sides of the paper in one pass. Exposure of the photoconductor plates on each cylinder of the printing units is by LEDs (light emitting diodes) assembled into arrays of 7,400 diodes spaced at a density of 600 per inch corresponding to a spatial resolution of 600 dpi. The system has variable spot intensity, with each spot having 64 gray levels achieved by applying different amounts of toner. The special dry small-particle dual-component toner was developed and is manufactured by Agfa. The image is composed of single line screens with continuously variable widths according to the amount of color needed. Each color is placed at a different screen angle.

Consumables are significant cost items in the use of computer-to-print systems.

Printing technologies

Electrophotographic printing can be subject to three serious deficiencies. (1) Charge voltage decay between the time of charging the photoconductor, exposing, and toning can affect image density and tone reproduction, as the amount of toner transferred to the image is dependent on the exact voltage of the charge on the image at the instant of toner transfer. (2) Toner chemistry is not completely understood, which can cause variations in batches of the same toner and high cost for formulating special toners. (3) In liquid toner systems, the isopar used to disperse the toner is a volatile organic compound which might require venting and is subject to environmental regulations.

Magnetography is a nonimpact print technology like ion deposition (Delphax), except that a magnetic drum is used, a magnetic charge is produced on the drum by an infinitely variable computer-generated image, and a

monocomponent magnetic toner is used. Spot colors can be used, but not process colors, as the toners are dark and opaque. The systems are used for printing business forms, direct mail, lottery tickets, numbering, tags, labels, and bar codes. The Bull engine is used almost exclusively for these systems.

Ionography is also known as ion deposition or electron charge deposition printing. It was developed by Dennison Manufacturing and is called Delphax. The image is produced by negative charges from an electron cartridge transferred onto a heated dielectric surface of aluminum oxide using a special magnetic toner. It is used only for single or spot color printing because the pressure of image transfer and cold fusion fixing of the toner can distort the substrate. Systems are in use for volume and variable printing of invoices, reports, manuals, forms, letters, and proposals and specialty printing of tags, tickets, and checks.

Field Effect Imaging uses three novel materials to produce high-speed, high-quality color printing composed of variable density pixels with resolutions of 500 dpi. The new materials are X_1, a thin-film dielectric, ultra-hard writing surface onto which electrical charges are deposited by an M-Tunnel write-head to generate powerful electrostatic fields across the thin-film insulator. These fields cause the pickup of X_2 "ink bites" whose thickness is proportional to the strength of the fields. The bites of ink, in pixel size, are carried by the X_1 surface to a print position where the ink is transferred totally to the print substrate, which can be either paper, plastic, cloth, or metal.

Ink Jet Printing, a digital printing system, produces images directly on paper from digital data without a press-like imaging machine. These systems use streams of very fine drops of dyes which are controlled by digital signals to produce images on special paper surfaces. There are three types of ink jet printers: continuous-drop, drop-on-demand, and bubble-jet systems. Some have single jets and others use multiple jets. Most ink jet printing is single or spot color printing of variable information like addressing, coding, personalized computer letters, and other di-

rect mail advertising. Ink jet systems are used for color proofing but have been too slow for short-run color printing. However, this will change.

Thermal Transfer Printing uses digital data to drive a thermal printhead to melt spots of dry ink on a donor ribbon and transfer them to a receiver. The technology was introduced in 1970, but printers were not available commercially until the mid 1980s. They are used for word processing, computer output printing, facsimile, graphic and pictorial color printing, labels, and other applications in single or multiple colors. When the solid ink on the donor is replaced by a sublimable dye, the thermal head converts the dye spots to gas spots which condense on the receiver. This configuration of the printer is the thermal transfer dye sublimation engine used for color proofing.

Electronic printers

The first digital printing system was the Xerox 9700 in 1978. It established 300 dpi as the de facto standard for image resolution. It was followed by the IBM 6670 and 3800, and Kodak 100, 150, and 250 electronic printers. Many of these were equipped with automatic collaters and other bindery functions and were used for short-run on-demand, variable information printing of business forms, personalized printing, and customized book publishing. Most of these systems had resolutions of about 300 dpi and low page counts per minute (ppm).

In 1989 Xerox announced its Docutech 600 dpi laser printer, capable of printing 135 pages per minute (8100 pages per hour) in a format size up to 11" x 17". About the same time, Kodak announced its 1392 Lionheart 300 dpi—92 ppm (5520 pph) PostScript-based electronic printer. These electronic printers are used for short run variable information printing and the new on-demand publishing market. Their speed and resolution ushered in a new age of digital printers that competed with offset printing.

Color copiers

Color copiers are essentially a scanner at the top and a digital printer at the bottom. They are designed for making one or several copies of spot or 4-color process subjects. When controlled by computers, they can be used for very short-run color printing (less than 100 to 500). The first color copier used for digital color printing was the Canon CLC. It was also the first copier device to integrate a Post-Script controller. The Canon Color Laser Copier is an ana-log copier with a scanner that color-separates the color original into the four separation colors (CMYK), each with 400 dpi resolution and 256 levels of color.

It produces the four composite toned images on the paper mounted on a drum, after which the images are fused on the paper using a special fusing oil and heat. A special image processing unit (IPU) is used to produce im-ages digitally from PostScript files.

Digital printing is fostering three essentially new printing markets which have been dormant because of the cost of prepress and printing by conventional printing methods. These are variable information printing, on-de-mand printing, and short-run process color printing.

Variable information printing

The ability to print variable information is a unique, exclusive, and important characteristic of digital printing systems. Printing markets are now limited to multiple quantities of images by fixed-image plate printing processes. Digital printing systems provide more cost-ef-fective means of producing printed products with variable information. They will stretch the capabilities of systems now being used for the personalization of documents to enable the production of special editions of magazines, cat-alogs, newsletters, and other publications according to professional, occupational, regional and/or demographic interests, and open other new markets for printers.

On-demand printing

On-demand printing is specialty printing, as the prod-uct is a combination of printing and binding or finishing.

On-demand printing requires both an imaging engine and a means of combining, in consecutive, uninterrupted operations, the printed pages into finished products—college textbooks, out-of-print books, insurance policies, research reports, business proposals, or any other products. Printing with in-line finishing puts very stringent demands on the condition and reliability of the equipment used. When any part of the line is down, the whole system stops. Also, printing and finishing require different skills.

Short-run process color printing
What is short run? Here is a categorization of run length ranges:

1–100 101–250 251–**500**	**Very Short Run** (VSR)
501–1000 1001–1500 1501–**2000**	**Short Run** (SR)
2001–3000 3001–4000 4001–**5000**	**Moderate-Short Run** (MSR)
5001–6500 6501–8000 8001–**10000**	**Moderate Run** (MR)
10001–25000 25001–40000 40001–**50000**	**Average Run** (AR)
50001–70000 70001–100000 100001–**250000**	**Moderate-Long Run** (MLR)
250001–400000 400001–600000 600001–**750000**	**Long Run** (LR)
750001–1000000 **>1,000,000**	**Very-Long Run** (VLR)

Almost 56% of commercial, book, and office printing including duplicating and copying is in the category of run lengths from 500 to 5,000 impressions. Only 2.8% of all this printing is done in 4 or more colors. With the use of digital printing processes, by the year 2000 the amount of 4-color printing in this run-length market will more than quadruple to 11.5%. In fact, color will increase as a percentage of total reproduced pages as it becomes easier to accomplish on new and traditional equipment.

% of Run Lengths	% of Total Market	% of Total Market Run Length in 4-Color	in 4-Color 1994 est.	2000 est.
<100–500	16.6	1.0	0.2	3.5
500–2,000	33.5	3.0	1.0	5.5
2,000–5,000	22.3	10.0	1.8	6.0
5,000–10,000	13.8	16.0	2.2	5.0
10,000–100,000	5.6	25.0	1.4	1.5
>100,000	8.2	41.0	3.4	5.5
%	100.0		10.0	27.0

Markets for long-run printed products will continue for a long time, however. They include:
- Consumer product marketing
- Metropolitan daily newspapers
- Mass market books
- Political and institutional fundraising promotions
- Tax forms
- Telephone books and other directories
- General interest and news magazines
- Consumer catalogs
- Direct mail
- Promotional materials
- Government forms and documents.

Some of these long run market areas may also have short-run requirements. The trend toward elimination of inventories and printing shorter runs has created many new markets for short-run printed products.

It is important to note that there are market niches based on run length and resolution—and reproduction

technology. The chart below shows nine reproduction technologies, most capable of color. There are certain areas, in which each has a production and economic advantage. There are also an increasing number of areas where they overlap. This is indicative of the new world order that is evolving as new and existing technologies adapt to the short-run market demands.

Economics of the process

To prepare and print a page in color at a quantity of 500, for example, requires several steps:

1. Creative development. This is the area that has been most affected by desktop technology. Art and design professionals create their pages with desktop computers. The byproduct of this process is pages that are in electronic form. None of the costs of the creative process are usually calculated in the cost of the page. When creative personnel

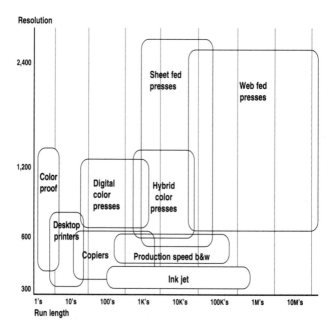

acquired type and art from commercial services, those costs were included, but now that they do these things themselves, such costs are not.

2. Film output. Most page production today is done by the originator and is essentially printed out from a high-resolution imagesetter. The originator creates pages, proofs them on laser printers, and sends them to a service bureau for printout on film. Costs vary significantly, but most printout is at about $7 per page for photo paper and $19 for film (black-and-white). A set of four films for 4-color printing would probably sell for $60.00.

3. Separations and proofing. $60 per image—at the low end, depending on image size. We have assumed the purchase of separations. It is likely that an increasing number of originators will install scanners, and it will be interesting to see how they price the scans.

4. Stripping. $70 per page. This process has several steps: strip the page units onto a special sheet and finally inspect for alignment and quality. Consumables (the special sheet), labor, and equipment are the cost areas. Printing industry cost standards are presently at $60 per hour or about $35 per page. This is usually sold at $70 per page.

5. Platemaking. $70.

6. Makeready/Print. $100. Minimum of one hour.

7. Paper. About $10 for the required stock, including wastage for makeready.

Traditional reproduction:

	Per page	**hours**
Film output	$ 60	1.0
Color seps	60	.5
Stripping	70	1.0
Platemaking	70	.5
Makeready/Print	100	1.0
Paper	10	—
Total	$370	4.0

Color separation and film output could take place at the same time.

These costs may vary from printer to printer, but major industry associations publish cost standards so that all printers may measure their productivity and cost-effectiveness. These costs are based on those standards, which are excellent guides to industry patterns.

The cost of conventional color reproduction carries a high pre press and preparatory cost. This immediately negates the ability to produce short runs cos- effectively. Desktop and electronic systems are attempting to bypass some of the steps and go directly to four film negatives. This will cut some cost and therefore the selling price. Makeready is under attack and will be reduced over time.

Digital reproduction:

	Per page	**hours**
RIP time	$ 20	.5
Color seps	40	.5
Stripping	—	—
Platemaking	—	—
Print	200	.5
Paper	8	—
Total	$268	1.5

Color separation here would be electronic. The picture file would be supplied as digital data for output. The page must still be rasterized.

Where applicable, digital printing results in a savings of about 40+% in dollars and 70+% in time.

CHAPTER 13

NEW MEDIA TECHNOLOGY

The predominant international standards for open document processing are the Standard Generalized Markup Language (SGML), defined by International Standards Organization (ISO) Standard 8879, and the Office Document Architecture (ODA), defined by ISO 8613. Both standards are growing in importance in both publishing and office environments. SGML consists mainly of a character-oriented syntax for the representation and interchange of document structures, whereas ODA provides mechanisms for describing structures, standardized semantics for controlling document layout, and syntax definitions for interchanging information.

Document interchange standards play a significant role in the development of open publishing systems. Standards include the recognized SGML and potential standards such as Editable PostScript and Page Interchange Language (PIL).

Form versus content

SGML is a metalanguage for creating other languages (DTDs) that structure information. It allows formatting instructions to be attached to every element in the document. If the *form* of information is well structured, the *content* is well structured. The intent of SGML is to make documents portable. Embedding specific formatting instructions (specific typography, for example) within documents makes them less portable. Publishing professionals realize that sometimes you want to put processing instructions into a file—even if you are trying to separate form and content. Thus, the standard lets you do it.

SGML is used for describing text-based structures. Languages created from it are not usually thought of as languages; they are known more commonly as document type declarations, also called document type definitions,

or type declarations, also called *document type definitions,* or just DTDs. A DTD is an ASCII text file that describes the structure of a class of documents—what elements they contain and the order and frequency of their occurrence in a document. A DTD is often thought of as a structural outline or skeleton of a document, but it may also be thought of as a language—a set of tags and a set of rules that govern how those aliases may be used together in a document.

Early work in SGML came primarily from the Department of Defense and the Association of American Publishers, who separately developed document definitions and tag sets that fit their publishing applications—technical manuals, journals, and books.

SGML is the notation used to create a contextual infrastructure that describes structured information. SGML is not just a set of tags. Rather, SGML provides a framework for describing the structure of the document—the tags, or generic identifiers, that are used to describe elements in a document are not part of the standard. The tag set is established in the DTD. The document designer can create whatever tags are needed in the DTD.

SGML, formally published as an international standard in 1986, is a set of rules for defining document-processing applications. PIL is a method of describing the page geometry, or layout, of the components that comprise an electronic document. The PIL format can be used to describe entire page layouts and can make reference to the individual components of a page. Adobe Systems Inc.'s Editable PostScript is a more robust and refined version of the editable PostScript format used in Illustrator 3.0 as a means of document interchange.

Flexible user interfaces
SGML can go hand-in-hand with WYSIWYG display. SGML says nothing about the user interface of software written to process documents. There are now several commercial systems that define the user interface and how it may be tailored to the user's preference, whether it be a structural view with tags, an exploded view with all mark-

up or a WYSIWYG display with all markup hidden. The internal data format is marked-up ASCII text files, along with any associated graphics, images, nontextual data, or style sheets. To many users who come from a production background, SGML is verbose markup coding but, it is really about interchange.

Putting textual information into SGML helps prepare that information for other functions that are more than just putting out typographic pages. As publishers begin to build libraries of electronically produced publications, books, journals, or manuals, they are considering alternative products, such as electronic books or on-line services, derived from the same data. Keeping a library of documents in the form of a page-oriented formatter may complicate the development of such new products. Storing the files with generic mark-up imposes an initial burden of conversion, but in the long run it may be the most efficient approach.

Tables

Tables are of two types: typographic tables and database reports. Database reports extract the records of selected fields from a computer database into tabular form. The objective is usually to capture the information in response to the query and and modify the typographic appearance as it is required. Typographic tables may or may not come from a database, but they are defined by their appearance, which is more aesthetic and complex than those generated by database generators with straddle heads, rules, special alignments, and justification within fields.

The general approaches to tabular markup are structural and content. The structural approach produces object classes that identify elements according to their position within the table—column heads and subheads, row heads, and individual cells. The content approach creates object classes that are more like database fields: they identify an element according to its subject matter. In a table comparing the price of chicken feed in different states, one object class is state, another is the price.

Enter PostScript

Some users feel that PostScript, which is nearly universally supported by today's publishing programs and printers, should be applicable as a document modeling language. PostScript is acceptable if you want a document database of page images that may be rendered on a wide variety of display and output devices. It may also evolve into a standard file format for some graphics-based applications. But PostScript is a page imaging model, and not a content data model. It does not lend itself to database applications, and it does not support the kind of content-based mark-up that imposes structure on the database. Saving documents in PostScript also complicates any later decision to deliver documents in alternative formats, such as Hypertext.

SGML publications may still be formatted and represented in PostScript form. The two standards are complementary, in that SGML was designed for representing the document in a *manipulable* form and PostScript was designed for representing the document in a *renderable* form. Users of SGML will most likely still use PostScript printout devices.

Computer technology has matured to the point where publishing complete journals electronically is economically viable. In PostScript, documents are stored as a collection of formatted pages. It is difficult to convert these pages back into a form that lends itself to a different appearance, such as you might want for a particular type of display or an entirely different publication format.

Libraries of the future

The 1980s was the decade of information accumulation, but the 1990s will be the age of information access. Databases will make it easier for individuals to acquire and use information. CD-ROM databases proliferate as users move from print to electronic media. There will be libraries in the year 2001 because the public will want books. However, libraries will change because of information access. The concept of the library as an institution will be changed, as four dimensions of access must be considered:

self-access, assisted access, mediated access, and collabora-
tive access. Librarians will become pointers and retrievers
as well as facilitators and organizers.

CD-ROM applications have been instituted in the library
market with bibliographical data such as abstracts, in-
dexes, card catalog databases, on-line databases, and ma-
chine-readable catalogs becoming familiar tools. Several
key information publishers have put much of their biblio-
graphic material on CD-ROM. ASCII full-text versions of peri-
odicals archived on CD-ROM may be succeeded by SGML
files, and the "digital microfilm" page image approach
may be replaced by page description languages or digital
compound document descriptions used in publishing the
original print versions. Eventually the print version and
the electronic version will be subsets of the same file.

Electronic information delivery

Publishers are now implementing electronic delivery
of publications. Subscribers do not want to read pages on
the screen. They want better ways to find information rele-
vant to their research, and electronic media offer a better
means of indexing and retrieval, which is critical when
searching for information in a base of thousands of docu-
ments. Delivering on-line is faster than print.

Outside of advertising/promotion, there are very few
documents that do not have a logical content structure.
We are accustomed to interpreting this structure typo-
graphically, because culturally we are attuned to print.
But now that electronic devices are becoming prevalent
for viewing documents (meaning that information is pre-
sented in a form meant for reading on a screen), enabling
the computer intelligence to read and apply this logical
structure opens up new possibilities for us and for
machines.

We are too early in the development of electronic-
delivery technology to even predict which technologies
and methods will ultimately prove the most popular
among publishers. There are advantages and drawbacks to
every technology, and these must be weighed against an
organization's requirements and objectives.

Bitmapped databases

Databases containing bitmapped images are not searchable and must be converted to text (ASCII) format first by using optical character recognition (OCR) techniques. Mounting the text file on an on-line retrieval system as a private database and using standard text searching techniques on it is not simple. This has spurred the appearance of an array of text management systems, many of which are specifically equipped to interface with imaging systems and handle OCR output.

In a typical document imaging system, the user interacts with the text management system to do searches instead of interacting directly with the full text database. Text management systems are appearing in the imaging and software marketplace. Some are highly sophisticated and use advanced artificial intelligence and knowledge engineering techniques.

Fax publishing

Publishing companies use fax machines to communicate between editorial offices and regional printing plants. They also use fax machines to distribute information to customers who request it, known as Fax On Demand. (See later in this chapter).

Multiple copies of a newsletter sent to subscribers using a database is broadcast fax. Fax publishing is a niche within the publishing industry that is generating income and exposure for several companies. Most people think the facsimile or fax was invented in the 1970s—actually that is when fax machines became popular. The first concept of the fax was actually created in 1842 by a Scottish inventor named Alexander Bain. He had an electrically controlled pendulum act as a clock timing system that transmitted and converted electrical contacts. The product was called an automatic electrochemical recording telegraph.

The first commercial facsimile system based on Bain's system was used in France in 1865 and developed by Giovanni Caselli, an Italian expatriate. Clement Ader, in 1885, introduced electromagnetic light waves for photographic recording. In 1902, a photoelectrical facsimile system for

photographs was created by a German, Dr. Arthur Korn, and the first photograph was transmitted to America in 1922. America didn't really tinker with fax machines until the 1920s, after noticing Korn's invention. AT&T, RCA, and Western Union developed their own systems for picture transmission, and some products came out in 1924. The first adoption of fax machines in the 1930s was for the transmission of weather data. Eventually, in 1934, Associated Press became the first major news agency to use the fax, calling it "Wirephoto."

A St. Paul, Minnesota radio station, KSTP, was the first to develop the idea of fax publishing in 1937, delivering a special-edition newspaper to homes. About 10,000 homes had fax machines in the late 1930s. Broadcast fax expanded to 40 different stations in the 1940's. Along with radio stations, major newspapers sent special editions such as the Chicago *Tribune*, the *New York Times*, and Miami *Herald*. The Miami *Herald* took fax publishing seriously, transmitting five editions and leasing to hotels in the area. This popularity diminished when World War II ended and television was introduced, but news agencies kept using fax machines. When the telephone networks became a transmission medium for fax machines in the 1960s, fax's popularity rose again.

How it works
A fax machine works when a light source reflects off the original. The amount of light reflected back, according to the level of original density, produces a voltage level. Electrical signals are sent via the phone line. The receiving fax machine then translate the pulses and reproduces an exact copy of the original. The Consultative Committee for International Telephone and Telegraphy (CCITT) created a standard so that different fax machines can "talk" to each other. Each generation of fax machines is distinguished by groups. Group 1 transmitted a single page in six minutes; Group 2 was faster, at three minutes a page. Both groups were used in the 1970s. Group 3 was introduced in 1980 and was able to transmit, in less than a minute, at 200 dots per inch.

Group 4, which is expected to come out this decade, relies solely on a digital network transmitting at even higher speed with higher resolution. This is possible providing that the transmission lines used are digital, not analog. Because analog lines will not become obsolete, the carrier will become responsible for the conversion from digital to analog when transmitting. Today, fax modems enable fax documents to be sent directly to and from computers.

Fax On Demand

One example of fax as a reader service involves requests for information which advertisers use as a marketing tool for leads, or for reprints and/or back issues. Fax On Demand lets readers' choose what they want and when they want it. Readers use a touch-tone phone to call an 800 or 900 number and then request information by punching a code number, their credit card number, and their fax number. Depending on the number of pages, the material is faxed or mailed.

Massachusetts Lawyer Weekly is a national magazine, in conjunction with six state magazines that contains court opinions cases and their numbers. Customers can call and specify which one they want by using a six-digit account number, and have it mailed or faxed to them. Over a four-month period, 29% of the subscribers used this service. Another periodical, *Car & Driver,* offers information on road tests of certain vehicles. *Cruising World* maintains a database of owners who want to sell their boats; readers call to get more information using the voice/fax system. Fax On Demand is projected to generate $1 billion in sales in 1995.

Broadcast fax

Once publishers saw how much revenue was created from Fax On Demand, some decided to regenerate broadcast fax. Broadcast fax involves sending multiple copies of a newsletter to subscribers, using a database. Leading publications send out an adaption of their existing titles, and some publishers are sending more in-depth information to small, specialized markets.

The readers pay the subscription rate, which is considered high, but they are willing to pay the price to receive up-to-date information quickly. Specialized publications with high turnaround time and/or that contain information that normally covered, are broadcast fax to customers. Service bureaus help cover the cost of starting up a fax publishing issue as well as maintaining it.

The *Los Angeles Times* sends a Moscow edition, "News Fax." The *New York Times* has four different editions, transmitted each evening at 10 p.m. to different audiences. For $1,600, Japanese business people can get a six-page English "TimesFax" focusing on business events and containing no advertisements. There is the Caribbean edition, and more recently a Hawaii edition, which are faxed to hotels in those areas targeting vacationers. Another group of vacationers who receive "TimesFax" is cruise ships passengers. About 26,000 people read it daily on 36 different ships. With its weekly turnover, about 1.5 million people see the New York "TimesFax." The vacationers' "TimesFax" has approximately eight pages and contains news, sports, weather, a crossword puzzle, and assorted advertisements. The subscription is paid for by the hotels and ship lines. During the Gulf War, the *New York Times* sent a newsletter to military personnel stationed over seas; the editorial focus was coverage of the war, with regional U.S. news and sports. The *New York Times* fax newsletter is successful, whereas the *Chicago Tribune*'s "TribFax" failed because it didn't use unique information that would have value to the readers.

The *Hartford Courant*'s fax is a one-page newsletter consisting of tomorrow's headlines along with business news and local news of Connecticut. That city, of about 1 million people, has no afternoon daily, so 2,000 subscribers who pay about $500 receive their faxes at 4:30 in the afternoon.

Specialty publications target readers with news that can't wait. For $1,197, for example, *Congress Daily* delivers detailed inside information about what happened in the Congress that newspapers would generally ignore.

Service bureaus

There are startup costs to consider when going into or expanding into fax publishing. Startup cost can consist of additional phones and fax equipment, and administrative expenses such as billing, customer service, equipment troubleshooting and telecommunication technical support. Fax service bureaus can spare the publishing company these high startup costs.

Fax service bureaus started in the 1970s by leasing telephone lines and bringing in the fax equipment necessary to meet the volume demand to transmit all over the world. Some service bureaus survived when they began providing service to a particular field, such as the legal and medical professions. Today, Fax service bureaus can provide central data processing of subscribers' fax numbers, broadcast a newsletter once they receive the newsletter from the publisher electronically, or can put it in a store-and-forward to send it at a specific time, such as overnight. It also can maintain the database to archive articles.

Group 4 machines will not gain popularity rapidly, because phone lines are still analog, whereas Group 4 is digital-based. Printer makers have come out with a PostScript fax printer capable of sending better quality graphics and halftones. When using the fax option from the print box, it has the capability to send faxes either in PostScript or in Group 3 format. If the receiving fax machine is not PostScript compatible, it converts to Group 3. Fax publishers feel it doesn't affect them because they use fax service bureaus to handle their fax transmissions. There is the possibility that subscribers will buy their own PostScript fax printers, though.

Fax today

There are 13 million fax machines and modems currently in use nationwide, with 30% of those in homes. People use fax because it offers accuracy, is faster and cheaper than mail or overnight services, and in some cases, is more convenient than a telephone. The downside is that the machines are vulnerable to breakdowns and

transmission interference. Different companies, such as those in engineering, manufacturing, and law enforcement use fax transmission heavily.

Publishing industries use fax to communicate between editorial offices and printing facilities located at different places. By using the fax, printing facilities can be more productive, especially when facing a tight deadline to clarify the proofs. Periodicals that have multiple regional printing plants transmit pages from a main plant to the regional plants simultaneously. This saves time as typesetting is done only once at the main plant. Some materials that are being published using fax include *Business Week, Time,* the *Wall Street Journal,* and *The Christian Science Monitor.*

Publishers use fax publishing as another market for distributing information to their customers. Fax is faster, providing a better way to serve demanding readers who want information quickly. It also is an additional source of income and exposure. With CCITT standard, fax is an international medium that doesn't deal with regulatory issues or customs. Publishers have the ability to send items that were time-sensitive, specialized information to isolated areas. The cost of using the fax is based on telephone usage. It does not charge by the number of pages sent, but by the time incurred on the phone and the location to which the fax is being sent. In a sense, it is cheaper than mail or overnight express.

ELECTRONIC PUBLISHING

A commercial printer in Michigan "prints" automotive parts catalogs to CD-ROM. An industrial catalog firm distributes a 2,000-page catalog on disk—via its printing company. A computer manufacturer provides all technical documentation on CD-ROM. The traditional print version was converted and produced by its printer. A large printer in Chicago is now said to spend more on blank compact disks than on paper.

What's going on here? Printers are supposed to print on paper, not on digital media—or are they?

Printers do more than print on paper. They convert and distribute information. Once you get that clearly in your head, you are ready to join the majority of innovative printing firms in the United States that are deriving revenue from digital products and services. And, by the way, they still provide print-on-paper products and services.

Most of what has happened came about because of the confluence of two technologies: the very-high-density read-only disk and the portable document formats that let you create documents that can be read but not changed. Put them together and you have a digital publication—one that requires a computer to "read" it.

The problem and the solution

Documents are not all produced with the same program. To read your memo created in Microsoft Word I would also have to have the same program (and probably the same revision level and the same fonts). This is all right if everyone uses Word, but that is not the case. Documents are created and/or produced with word processing, spreadsheet, database, graphics/illustration, and desktop publishing programs.

Certainly one could release the text as simple and standard ASCII code, which just about any program could import. But ASCII would not give you or me the type, graphics and page formatting. Users demand that content and form be preserved and distributed, with some common approach to viewing and accessing the document even if you do not have the originating program or the fonts or even the same computer platform.

The solution is a portable document format and a standardized viewer.

The good, the bad, and the digital disaster

The underlying concept of document portability is that of printing to a file. As an analogy, take a sheet of paper with text and graphics on it and fax it. The sending fax converts the page images to dots and the receiving fax prints them out. If you have a fax capability from your computer, a program takes the page image, converts it to dots, and

sends it to the receiving fax for printout. Now, save the last file we created—a representation of the page as dots—and instead of printing it to paper, put it on the screen.

But there is something missing. Like any fax image, there is no underlying "intelligence" for the text. You could not search through it because it does not know an "a" from a hole in the paper. And searching is something you want.

Most portable document programs save three things: a bit map of the page as it appears on the screen, the underlying ASCII text, and the font data. That makes portable documents like some of the portable TVs of the 1950s, when you had a unit that weighed hundreds of pounds but had a handle on the top. Even with compression, most portable documents are six to ten times bigger than the original file.

By having the text as ASCII, you have the ability to search for words and phrases. This is a major advantage over print. The material in a book or catalog is not information until you find what you want. Search and retrieval lets you find what you want Another advantage of ASCII is that you can cut and paste the text from the portable document to another program. You do not get the formatting, but you do get the words.

The bitmap capture of the screen provides the print image. Usually, this is saved at 300 dpi, and that is the best you can do for printout, no matter what resolution the printer claims. Lastly, the font data may be retained.

Remote typesetting

Adobe's Acrobat is somewhat different. It is based on PostScript, the page description language that has become the mainstay of printing and publishing. Acrobat saves a PostScript representation of the page. It can then output to any PostScript printer at whatever resolution the printer has. However, for the sake of efficiency, one version uses a font substitution approach based on Adobe Type Manager and Multiple Master fonts technology. You will get type that has the same width and height but not the same style as your original document.

Another version will preserve the font data, but it increases the file size significantly. However, this latter approach provides the most important aspect of document portability—the ability to print out at any resolution.

This means that the receiver of the digital page could someday use a high-resolution color printer to print out pages as needed in a remote location. Pages could be created in one part of he world, stored electronically in another part of the world, and then sent to a printer that uses the data to make high-resolution films for printing in still another part of the world. Ads could be created at ad agencies and sent to publications. Even more, every person who accesses an on-line service could see or print that page from anywhere.

This idea is not a new one. The advent of low-cost, better quality printers could mean that, instead of printing one million pages on a press, one million presses print one page. End users will print out only what they want, whether it is the executive summary of a thick report, or the page of a technical problem that answers your question, or the legal citation that supports your position. All these examples are in current use.

Compression and viewing

Given the large file sizes that result from any of these approaches, compression is an absolute necessity. Some programs automatically compress when the file is converted and then decompress when it is viewed. Some programs do not.

The viewer is an important issue. There are usually two parts to the program: the converter and the viewer. The converter, or whatever it may be called, converts pages from virtually any program that runs in the desktop world. The viewer is the program that lets you open the file on another machine, navigate through the document, search and retrieve, and so on. There are usually two approaches to viewers. Some programs insert a mini viewer with the document file, so it carries along its own ability to open; this is free. These mini viewers do not have a full set of tools and thus a more expansive version is available—at

a price—to provide them. In some cases, there is only one kind of viewer and it is only available for a price.

This is not to say that we are not in favor of pricing viewers. However, it is safe to say that the viewers that are most commonly and easily available will make their programs popular and prolific.

At present, every supplier of these programs has or shortly will have a converter and viewer that runs on Macintosh and also Windows. Some will also run on Unix.

Too many standards . . . again

The reason that portable documents are so important is the lack of standardization in the creation and production of pages. Standardization will be imposed by establishing portable formats. Now there are four major companies with competing products. They are Adobe Acrobat, Farallon Replica, No Hands Common Ground, and WordPerfect Envoy. Soon there will be Microsoft. For the printing industry, Acrobat holds the most promise because of its ability to print to film or plate or digital press at any resolution.

How printers work with portable documents

Portable documents begin with pages that were created or produced at the desktop; that is, with programs running on the Macintosh or PC under Windows. Printers routinely receive QuarkXPress documents, for example. They usually output the pages to film and print. They can now offer their clients additional services by converting the QuarkXPress files to a portable format and mastering and duplicating CD-ROMs. Clients can have any distribution approach they want.

	Search and Retrieval	Font Support	Viewer Approach	Multiple Platforms	File Creation
Adobe Acrobat	Excellent	Excellent	Good	Excellent	Very Good
Farallon Replica	Good	Poor	Good	Good	Good
Common Ground	Excellent	Good	Excellent	Excellent	Excellent
WordPerfect Envoy	Good	Good	Good	Good	Very Good

They call it "cross-platform compatibility," but it really is incompatibility—with different "platforms," or computer system types (Mac, DOS, DOS/Windows, Windows 95, Warp OS/2, and UNIX) trying to talk to one another.

A user of nationwide newspaper advertising and the Associated Press have developed something called AP Adsend. You create a newspaper ad on a Macintosh or PC and save it as a PostScript file, distill it into an Adobe Acrobat portable document file, fill out an on-screen delivery ticket specifying which newspapers are to run it and when, then transmit it in compressed form to the AP. They will transmit it directly to the designated paper or papers.

The ad is received by the newspaper's computer looking just the way you created it. They position it into their desktop file for the issue. No film. No overnight delivery service.

Adobe Acrobat, introduced in 1992 as a pioneer product in cross-platform document distribution, uses Adobe PostScript to create a common denominator usable by most major computer systems.

PostScript is device-independent and Acrobat is plat-form-independent—the document is readable and usable by any system that has a Reader program. In AP's case, Acrobat sends the images (color and black-and-white) *and* the type *and* the page layout —as a portable document. The fonts and the document travel in a bundle called a portable document format, or PDF.

This technology goes beyond the transmission of newspaper ads—it allows access to entire electronic archives of information. The browsing, searching, and reading possibilities are extensive. It is a giant step for document independence, where software creates a giant electronic manila envelope filled with just about anything from pages to sound to video. With cross-platform inter-operability and sufficient bandwidth for video/audio/text transmission, an advertiser will be able to send ads and commercials directly to publications, broadcast media, or even directly to on-line service subscribers. Ads will appear both in print and in electronic form.

THE INTERNET

It is made up of more than 15,000 connected net-works, has more than 3 million connected computers, and has users numbering about 20 million. It is the Internet.

Started in 1969, the ARPANET was the first distributed packet-switched computer network. In 1977, the ARPANET became one of the Internet's backbone networks, and the protocol research done on the ARPANET was very influential in the development of the TCP/IP protocols currently in use on the Internet. ARPANET's technology became obsolete, however, and it was retired in 1990.

The Internet, which is the world's largest computer network, has been doubling in size (number of hosts and networks) every year since 1988. Once the exclusive do-main of research and education groups, the Internet is now gaining stature with business users.

The Internet is "owned" by approximately 20,000 or-ganizations worldwide, from large corporations to military services and government agencies. The U.S. government was very influential in the development of the Internet, but currently owns or funds only a small fraction of it.

Most of the Internet is actually privately owned and consists of local area networks inside companies. In fact, commercial connections are now growing faster than educational ones. Most wide area Internet connectivity providers are privately owned and operated and will carry any traffic users pay for. Some parts of the Internet (including the fastest parts) restrict use to research or education, but restrictions are getting few and far between.

Because the Internet had its roots in the open and information-sharing world of academia, security has typically taken a back seat. However, this is an area of concern for many business users sending mail over the network.

Password protection is the common security measure on the network today. You can also set up other defenses, including prohibiting incoming network connections, limiting incoming connections to specific services, or prohibiting incoming connections for certain hosts or networks for each service.

With the low cost of connection—often a flat monthly fee for leased line or dial-up access—business users have access to commercial and noncommercial services in the United States and 60 other countries. Electronic mail is the most popular application on the network. While on some networks an e-mail message may take hours or days to reach its destination, on the Internet it usually takes seconds to minutes. Internet mail protocols handle queue congestion and flow control automatically, as messages are divided into packets and shipped via many different routes only to come together at their destination.

An Internet message can encapsulate image, sound, video, and portable document files, as well as character sets for foreign languages such as German or Japanese. The addressee needs no special software to receive the message, although some parts of the message can't be interpreted without special software. Through Internet's e-mail, companies can exchange information with other organizations, salespeople, customers, and so on with the immediacy needed to conduct day-to-day business. And they can do so on a global basis, usually at a cheaper cost than most other e-mail offerings.

Costs came down because Internet services are carried over the Transmission Control Protocol/Internet Protocol (TCP/IP), which multiplexes mail messages (and other services) across common links. This maximizes bandwidth use, minimizing cost and allowing continuous connection.

Business users are not confined to one-on-one communications, however; group information exchange happens through the Internet's slew of mailing lists and newsgroups. Mailing lists enable a user to send a single mail message to a mail alias. Software then automatically sends the message to everyone on the list.

The Internet is the biggest carrier of USENET newsgroups. Members of newsgroups receive messages and news articles according to their specific group's profile.

With mailing lists and newsgroups, not only do customers have the option of getting information (such as problem or benefit reports) directly from individual customers, but firms can also sponsor customer mailing lists or newsgroups.

Businesses may find it useful to join mailing lists to stay on top of general issues affecting their industries. For instance, there are lists associated with topics such as technology transfer, Japanese business studies, and the oil and gas industry, (this latter includes a daily posting of oil prices companies may need to make investment decisions.)

The newsgroup approach is more efficient than mailing lists and can support more participants. The reason is that whereas a copy of a mail message is sent to each list subscriber, newsgroup messages are sent to each machine that subscribes to the newsgroup. A large number of people in a newsgroup can read the message or news article.

There are newsgroups specific to computer operating systems or programs, other groups that distribute software, and still others that discuss specific products. Help wanted newsgroups are among the most popular. For a fee, services enable users to pick and choose among traditional wire service news, sports, features, syndicated columns, business news, newsletters, and other packages.

Because the Internet is attached to the global labyrinth of networks that includes E-World, CompuServe, America

On-line, MCI Mail, and others, users and businesses sending mail have the potential to reach almost 100 million people. Internet mail, combined with interactive protocols such as TELNET and File Transfer Protocol (FTP), allow collaborative work electronically. FTP and TELNET make resources on one machine available across the net to other machines.

FTP enables users to connect to other computers and list the files in a directory, print them, and copy files back and forth. The TELNET protocol connects users to a remote machine and lets them log on as if they were on a directly connected system. The use of the Internet to collaborate on producing a publication, document, or report saves time, eliminates express mail, cuts manual transcription steps, and reduces the need to pass disks around.

Vendors are also getting in on the act, cutting down on distribution costs by placing software on the Internet. Apple has made its System 7 operating system, as well as early versions of its MacOS, available for free by anonymous FTP from apple.com.

The Internet is not about free software or mail stuff or supercomputers or any individual service it offers. The bottom line is that the Internet supports the largest and most directly connected community in the world. It might be to your advantage to become a part of that community.

There are many resources are available on the Internet with index and search services to help users.

• *Archie:* A service that indexes thousands of anonymous FTP servers worldwide—about 150 gigabytes of information. Basically, you ask Archie to locate a program or other package by name, and it responds with a list of all the hosts that have it, which directory and file it is in on each host, and when it was last updated.

• *Wide-Area Information Servers (WAIS):* WAIS can index any piece of text and report to you passages that match key words. It lets you search for information in databases located on servers. Users have access to the Bible, current weather forecasts, documents about the Internet, and so on. Users can try a WAIS terminal interface by remotely logging on to quake.think.com. Use the username "WAIS."

• *Gopher:* Gopher helps you find the right menu and keep track of the various servers and information sources. Gopher ties all these items together in a worldwide distributed menu system.

Archie, certain libraries, and many WAIS servers are available through Gopher, as are text files and software packages. You can get an idea of how Gopher works by logging on to one of the public Gopher sites.

Many companies have extensive research needs, whether it's intelligence gathering on competitors, research to help create a new product, or finding out the latest on privacy laws. The Internet lets employees check the Library of Congress, search for relevant book titles, and even retrieve information directly, all without getting out of their chairs. The Internet's various indexing and search aids can help locate these resources.

WAIS lets users search hundreds of databases located on servers. Users can access information on the sciences, recipes, zip codes, book reviews, and lots more.

At least two projects are in the works for putting books on the Internet for free: the On-line Book Initiative and Project Gutenberg. Because of copyright concerns, these services will concentrate on books whose copyrights have expired. Also available will be standard reference books and Internet material.

CD-ROM

After almost a decade, CD-ROM technology is now a standard component for desktop computers. Just as CD-ROM is becoming a mainstay, it is also nearing the end of its useful life, as a new generation of devices emerges to replace it. The ROM in CD-ROM, which stands for read-only memory, is ideal for large amounts of information that does not change. Newer CD drives and disks will be written repeatedly like high-capacity diskettes and will bring great possibilities as backup devices, as well as multimedia and other publication distribution products.

Someday there will be no difference between CD-ROM and audio CD formats, which are largely incompatible today. This upcoming enhanced CD standard will lead to

lower prices and software; audio, text, and video will be tightly integrated, permitting interactive music video disks. Most cd-rom drives in use today are double-speed, or 2X, drives that spin at twice the rate of the first generation, and thus send data to the computer more quickly, improving video and sound performance. Triple speed or 3X will soon be eclipsed by quad speed or 4X drives.

Most computers ship with quad-speed drives, and manufacturers have already stopped making double-speed drives. The next leap in storage capacity will allow CD-ROM drives to store 3.3 gigabytes of information on a single disk. Even with the best data compression, the current CD-ROM disks can hold only about an hour of video, but at 3.3 Gb, a feature film could be stored on a single high-density CD-ROM disk. As 3.3 Gb disks become widespread, new technologies may replace quad-speed drives with something even faster. The combination of higher-speed drives and higher-capacity disks opens the possibility of laser-quality movies on a single disk, which in turn could kill off VHS tapes.

CD-ROM itself could be displaced by advances in broadband networks and alternative storage technologies. Software, including video and audio, will be transmitted over networks, whether the network belongs to the phone company, the cable TV company, or the satellite company. The issue is bandwidth, or capacity of the data pipeline, and transmission time. It can take hours to download video on a 14.4-kilobit-per-second telephone line. Until the rest of the information superhighway catches up, we need storage capacity. That storage may or may not be on CD-ROM. Even in quad-speed drives, a hard disk is 100 times faster than CD-ROM, and RAM is 1,000 times faster. CD-ROM software developers are becoming adept at copying parts of their programs into computer memory. We could have three gigabytes of RAM in personal computers, and gigabyte hard disks are already common. Some sort of hybrid system involving the static storage of data on CD-ROM linked to the immediacy of an on-line service, could be an intermediate approach.

MULTIMEDIA

Multimedia is the computer integration of different forms of communication media for the presentation and dissemination of information and knowledge, for education, entertainment, simulation, and promotion.

The following societal and technological trends are leading to new approaches to information presentation and dissemination:

- The merger of telephone, television, and computer technology
- The advent of hundreds of channels of cable television
- The growth of distance learning
- The application of computers in teaching and learning
- The development of electronic publishing products, such as electronic catalogs, directories, and references
- The dissemination of information in print and nonprint
- The development of data highways, which will link academic, commercial, and governmental information users.

Each of these areas increases the access of human beings to increasingly larger bases of information and knowledge. To utilize this information and knowledge more effectively, it will have to be organized and presented in new forms that take advantage of the increased capabilities of the technology. These capabilities will have to be applied by a new breed of information developer, who will apply conceptual, aesthetic, technical, and integrative competencies to organize and design information for presentation.

Presentation

Multimedia can be used to present information in new and more interesting ways. It integrates color, graphics, video clips, animation, type, and sound. It provides new tools for conveying ideas or for making points. It appeals to multiple senses.

Simulation
Multimedia can be used to simulate control panels, gauges, and visual displays so that users can be trained in certain operational procedures before approaching an actual system. You can learn principles and concepts.

Promotion
Multimedia can bring products "alive" and allow potential buyers to learn more about them through sound and video. More importantly, potential buyers can interact with the program to get the information they want.

Education
Multimedia can be designed to be interactive and thus work with the user in the process of discovery. The program can help navigate through the information in some logical fashion while appealing to both sight and sound.

Entertainment
Multimedia is "MTV publishing" for some, in that it can be flashy, superficial, and confusing. But it can also be games, and some games, can actually be educational.

Multimedia is only the how—it is not the why. It is a technology that provides tools for information delivery, but there must also be a reliance on content.

Technical
Multimedia brings together a number of approaches to communication; it is the confluence of these five areas of technology that influence human communication, organized to present information:
- Audio
- Color
- Computer interactivity
- Photo (image)
- Text (type)
- Video.

Instructional

Multimedia will play an important role in education and must integrate the following philosophical and theoretical areas:

- Communication theory
- Instructional technology
- Learning theory.

The multimedia designer is a new breed of communications professional. He or she creates and/or produces communications media (still, motion, audio, graphic, and text images) in a computer-based environment for use in a presentation or interactive mode.

The multimedia designer is characterized by the following competencies:

- Designs programs
- Produces media elements
- Authors programs
- Implements and utilizes programs
- Conducts evaluations
- Configures and operates systems
- Utilizes networks
- Communicates effectively
- Has related knowledge of computers.

Multimedia is just another way of presenting and distributing information. Its major attribute is interactivity— the ability of someone to search and retrieve, start and stop, and jump from point to point at any pace. The animation, graphics, color, sound, video, and more are just the elements that are organized to present information in some professional, interesting, and meaningful way.

EPILOG

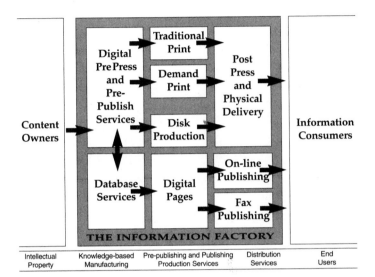

| Intellectual Property | Knowledge-based Manufacturing | Pre-publishing and Publishing Production Services | Distribution Services | End Users |

verything in this book is a part of the future. Digital prepress is a major component of the printing company of the future. Maybe the word "printing" will be in dispute and we will have to call these firms "information converters" or "information factories."

They will still use printing presses, but the steps from the document file to the press will be cut from today's manufacturing operations. Postpress technology will allow ink jet addressing and personalization. The traditional print will be supplemented with digital printing—on demand in longer and longer short runs of custom-made products. Files will be stored for reuse and "repurposed" into other products.

This company will record disks in short and long runs, publish by fax, and prepare pages for the great information superhighway. In other words, no matter how information will be converted or distributed, this innovative

organization will be the enabler—the facilitator of information dissemination in the 21st century.

Digital prepress means putting pages and documents together in electronic form in such a way that they can be reused, rerun, and repurposed into new and different products.

The printers of the future will still print, but that will be only a part of what they do. They will be the information integrators who make knowledge accessible to the masses as well as to the elite, to those with the tools of technology that access data electronically as well as to those who still require the democracy of print.

They will be the pioneers who will put libraries at our fingertips and the knowledge of the ages within our grasp. They will produce books and magazines and all the other products we know and use, but they will make them available in other forms as well.

Like Gutenberg before them, they will be the revolutionaries who change the way things are to the world that will be. We may not like all of it. We may yearn for another time and the comfort of the printed page. But we will make that decision. We will choose. They will not force society to change from paper to pixels. They will only present us with alternatives.

You didn't know that your use of digital prepress would change the world, did you?

GLOSSARY

ASCII: A file encoded in the industry-standard representation for text, ASCII (acronym for American Standard Code for Information Interchange; pronounced "ask-e"). An ASCII file contains only plain text and basic text-formatting characters such as spaces and carriage returns; it does not contain graphics or special character formatting. The ASCII character set of a microcomputer usually includes 256 characters or control codes. For example, the letter "A" is stored as ASCII 65, "B" as 66, "a" as 97, "b" as 98, etc. Some ASCII "characters" do not display as characters on the screen, but instead control the display in other ways. ASCII 8 is the backspace, 10 is the line feed, 13 is the carriage return, and 27 is escape. Other ASCII characters, consisting of letters from non-English alphabets and graphic symbols, fall in the range from ASCII 128 to 255. These "upper ASCII" characters will not always display or print in consistent ways. The most consistent ASCII characters are those that can be seen on the keyboard; they fall in the range from ASCII 32 to 127 and are called "plain ASCII." A "plain ASCII" can be read by just about any program.

Bitmap: A computerized image made up of dots. Images are "mapped" directly from corresponding bits in memory (hence the name). Also referred to as paint format.

Byte: The number of bits used to represent a character. For personal computers, a byte is usually eight bits.

Capstan design: A film/paper transport mechanism used in most imagesetters. Photographic paper or film is "pulled" off a roll.

CCD: Charge-couple-device. Common element in scanners. Measures light reflected off or transmitted from the original.

CD-ROM is an acronym for Compact Disk–Read-Only Memory.

Character generation: The production of typographic images using font master data. Generated to screens or output devices.

Color separation: The process of separating a color image into a series of single-color (cyan, yellow, magenta, and black) images that will be used as negatives. Printed on top of one another, the color separations create a full-color (or "process") image. Color separation was initially done by photographing the image three times through different color filters. However, electro-optical methods using lasers and CCDs are now employed.

CMYK: A method of representing color based on the standard printing ink colors of cyan, yellow, magenta, and black. Scanners and video monitors deal in RGB.

Compact Disk–Read-Only Memory (CD-ROM): A laser-mastered 4.72" polycarbonate disk capable of storing approximately 600 megabytes of information. The information can consist of audio, visual, and alphanumeric (textual) files interspersed on the disk. A CD-ROM drive uses the CD format as a computer storage medium. One compact disk can store 550 Mb to more than 1 Gb of data on a disk about the size of a traditional 5-inch floppy disk.

Compression: The shrinking or flattening of computer files so that the same information is stored in less memory. On CD-ROM, image files are routinely compressed, and text files can be compressed if necessary. Compression and decompression schemes are mathematical.

Digitizer: A computer peripheral device that converts an analog signal (images or sound) into a digital signal. With an image, the digitizer sends position information to the computer, either on command from the user (point digitizing) or at regular intervals (continuous digitizing). Digitizers are available in various sizes, ranging from tabletop models (digitizer pads) to large stand-alone units.

Dingbats: Typographical ornaments such as bullets, arrows, and check marks, usually used for design emphasis within text.

Display file: The text as it appears on the screen or in printout, with field tags and file markers invisible. Hypertext links are visible, because they are used to "jump" between related sections of the text.

Dithering: A technique for alternating the values of adjacent dots or pixels to create the effect of intermediate values. In printing color images or displaying color on a computer screen, dithering refers to the technique of making different colors of adjacent dots or pixels give the illusion of a third color; for example, a printed field of alternating cyan and yellow dots appears to be green. Dithering can give the effect of shades of gray on a black-and-white display or the effect of more colors on a color display.

Dots per inch (dpi): A measure of the resolution of a screen image or printed page. Dots are also known as pixels. The Macintosh screen displays 72 dpi, the LaserWriter printer prints 300 dpi, and a photo imagesetter can print 2,540 dpi or more.

Draw program: A type of graphics program that creates images using vectors (line and curve segments) rather than a mass of individual dots. See Paint program.

Dynamic range: A scanner's ability to capture an image's gradations from the lightest highlight to the darkest shadow.

EPSF *(Encapsulated PostScript File):* An alternative picture file format supported by Adobe Systems and third-party developers. It allows PostScript data to be stored and edited and is easy to transfer between Macintosh, MS-DOS and other systems. Will output only to PostScript devices, not to a display screen. Also referred to as EPS files.

Erasable optical disk: (Also called rewritable optical disk). Optical disk that can be rewritten a large number of times at the user's workstation.

Flatbed scanner: A device that works in a manner similar to a photocopy machine; the original art is positioned face down on a glass plate. This design can accommodate thick objects such as books, and allows for exact alignment of the original page. The scanner enables you to import graphics and images into a variety of software programs. With sheet-fed scanners, the original is fed directly through rollers—a faster process for multiple pages.

Font: A complete set of characters and symbols in one typographic design.

Grid pattern: The shape of halftone screen dots. Some common shapes are linear, elliptical, and round. Different shapes cause different effects in the final output. Adobe Photoshop allows you to specify a diamond dot, which is supported on some of the newer imagesetters. Contact your vendor to find out whether your imagesetter supports the diamond dot function.

Halftone: Because laser printers and printing presses cannot produce gray, the reproduction of a continuous tone image, such as a photograph, is processed through a screen that converts the image into dots of various sizes to provide the illusion of gray.

Hit: A matching of a search request.

HSV: Abbreviation for hue, saturation, and value—a color model used in some graphics programs. HSV must be translated to another model for color printing or for forming screen colors.

Hypertext: Direct searching based on term occurrences in the text; the retrieval system will find other text units containing the same term(s). A second form is based on hyper-

text links that have been inserted in the text. These links can draw the user's attention to related sections even if the sections do not share the same terms and would not be found on the basis of term occurrences.

Imagesetter: An output device, usually high-resolution, that produces pages of text, graphics, and images on paper or film, using electrostatic or photographic techniques.

Jaggies: A colloquial term for the jagged edges formed on raster-scan displays when displaying diagonal lines.

Kerning: In typesetting, the process of subtracting space between specific pairs of characters so that the overall letterspacing appears to be even.

Lands: The reflective portions of a CD-ROM track, opposite of pits.

Light valve imaging: A process in which red, green, and blue halogen beams image photo film.

Local Area Network (LAN): Interconnected computers that can share programs and data files as well as the use of peripheral devices such as printers or CD-ROM drives. Each microcomputer connected to a LAN will typically require a network circuit board and software. A LAN allows many computers to access the same information files.

Mark-up: The procedure of inserting file markers, field tags, and/or hypertext links in the text. Mark-up can be based on a standard markup language, such as the Automated Composition System of the Government Printing Office or the Standard Generalized Markup Language (SGML). A useful markup language can also be unique to one organization or even to one file. The particular file marker and field tags used with a file are declared when in setting up a text indexer. Hypertext links do not have to be declared, because they are automatically indexed as searchable terms.

Mask: A technique used in graphics programs that makes use of an opaque image to block out an area of an illustration.

Mastering: Etching the original CD-ROM disk using information from the premastering data.

Megabyte (MB): A unit of measurement equal to 1024 kilobytes, or 1,048,576 bytes.

Moiré: An undesirable effect that results when halftone screen patterns become visible. This pattern is often caused by misaligned screens.

Object-oriented: An approach in drawing and layout programs that treats graphics as line and arc segments rather than individual dots.

OCR: Acronym, for optical character reader; a device that allows a computer to read printed information.

Offloading: Relieving the intensive amount of data processing associated with a specific application (e.g., graphics) from the CPU, by performing those calculations in a dedicated or specialized processor.

Output resolution: The dots per inch (dpi) of the output device (high-end imagesetters can support various resolutions). The higher the screen frequency, the higher is the output resolution required to maintain 256 shades of gray.

Page buffering: The ability to spool an entire image to disk and print in a continuous motion.

Paint program: A type of graphics program that treats images as a collection of individual dots or picture elements (pixels) rather than as a collection of shapes (or objects). See Draw program.

Palette: The collection of colors or shades available to a graphics system or program.

PICT: A standard data format in which most Macintosh il-lustrations are encoded. PICT data can be created, displayed on the screen, and printed by routines incorporated in the Macintosh system, so a program need contain no graphics-processing routines in order to incorporate PICT data gener-ated by other software.

Pits: Laser-etched holes in the CD-ROM tract that do not re-flect light. Opposite of Lands.

Pixel: Stands for picture element; the smallest dot you can draw on the screen. A pixel is also a location in video memory that corresponds to a point on the graphics screen when the viewing window includes that location. In a monochrome display, each pixel can be either black or white, so it can be represented by a bit; thus, the dis-play is said to be a bit map. In color or grayscale displays, several bits in RAM may represent the image. In a high-res-olution display, each pixel is represented by either two or four bits. Thus, the display is a pixel map instead of a bit map.

PostScript: A computer language created by Adobe Sys-tems. PostScript allows a programmer to create complex pages using a series of commands. Text and graphics can be controlled with mathematical precision.

PostScript-compatible: Any software program that trans-lates statements written in the PostScript page description language. Sometimes called a "PostScript clone."
Premastering: Creating a recorded file that contains the exact "image" or file layout of a CD-ROM, with error correc-tion and timing information, ready for mastering.

Proximity searching: Finding search terms that occur within a specified number of words in the text. Proximity search-ing is not as stringent as phrase searching, which requires

that the terms occur in the text exactly as entered for the search.

Raster image processor (RIP): A device or program that translates the instructions for a page in a page description or graphics output language to the actual pattern of dots (bit map) supplied to a printing or display system.

Repeatability: The ability to keep photo film and the images thereon in proper register.

Record: In a database, one complete entry consisting of one or more fields of data.

Resolution: The degree of clarity of a display or printer image. Resolution is usually specified in dots per inch (dpi). The higher the resolution, or the greater the number of dpi, the sharper the image. For film recorders, resolution usually refers to the number of lines that make up the entire screen on a display or on film. The resolution of film recorders ranges from the low PC standard (200 lines for CGA to 350 lines for EGA) up to 10,000 lines.

Retrofit: Backward integration of advanced capability into a device or program that was not originally intended for that purpose.

RGB: Abbreviation for red-green-blue; a method of displaying color video by transmitting the three primary colors as three separate signals. There are two ways of using RGB with computers: TTL RGB, which allows the color signals to take on only a few discrete values; and analog RGB, which allows the color signals to take on any values between their upper and lower limits, for a wide range of colors. Also, RGB refers to a method of specifying color by its component proportions of red, green, and blue.

Rosette: The pattern created when all four CMYK color halftone screens are printed at traditional angles, shown to

produce the best results in printed color output. The rosette pattern is noticeable only under magnification.

Scanner: Any graphic input device that converts printed matter into bit (digital) data; also a device that reads an optical image such as a photograph and creates an electronic rendition for storage or imaging onto a printing plate.

Scanning: Converting an image to a digital file that can be stored, retrieved, displayed, and printed by a computer. The process is also known as "digitizing" and the digital file is also known as a "bitmapped image."

Screen angle: The angle at which a screen is rotated for printing. The angle affects the way the halftone dots are laid down on each separation film. If the dots do not align correctly, moiré patterns appear when the films are placed on top of one another.

Screen frequency: The number of halftone cells per unit of measurement in a screen; the higher the frequency, the finer the screen. A screen of 30 lines per inch is made up of dots that are one-third the size of the dots in a screen of 10 lines per inch.

SCSI: Abbreviation for Small Computer System Interface. SCSI is an industry-standard interface between computers and peripheral device controllers, used by the Macintosh as well as other computers. SCSI interfaces provide high-speed access to peripheral devices.

Segmented file: A record in a record-oriented database is often stored in as many segmented files as there are fields. For example, if a record consists of company information, the company name, street address, city, zip code, officers, products, and many other fields may be stored in segmented files and keyed to each other by the record number. This file structure allows more flexible searching and output, but requires more time to prepare and verify.

Slide scanner: A scanner that can only utilize transmission or transparent images, as opposed to reflective or opaque images.

Spooler: A utility that manages printers on a network. It intercepts print files until the printer is ready to print them.

Standard Generalized Markup Language (SGML): A language for marking text for typesetting and disk publishing to allow sophisticated searching. SGML enables the publisher to mark text just once for multiple uses.

Stopwords: Words that are common in a full-text file but have little value in searching. Words in a stopword file will be excluded from the indexes, considerably reducing the size of the indexes and improving search performance.

Tag Image File Format (TIFF): A file format for graphics developed by Aldus, Adobe, and Apple that is particularly suited for representing scanned images and other large bitmaps. The original TIFF saved only black-and-white images in uncompressed forms. Newer versions support color and compression. TIFF is a neutral format designed for compatibility with both Macintosh and MS-DOS applications.

Tape backup: File storage and transfer medium. Both nine-track tape and smaller format tape cartridges are commonly used. Tape backup is used for protecting and transferring files, because tape has a high density of data storage.

Thermal dye sublimation: Like thermal transfer, except that pigments are vaporized and float to desired proofing stock. These inks are highly translucent and produce very high quality. Also called thermal dye diffusion transfer, or D2T2.

Thermal printers: operate by placing a "transfer" sheet that carries ink in contact with the paper or transparency. A heated printhead then touches the transfer sheet to transfer

images to the right points on the page. Used for comps and dummies.

Tolerance: The distance registration marks are off.

Wildcard: A search term that ends with a "?" or some other symbol. The characters preceding the symbol are often a stem or truncation that can have multiple endings. All terms beginning with that stem will be found in the same search.

Write-Once Read-Many (WORM): An optical disk on which the publisher or user can write files directly, without mastering, but which cannot be erased or rewritten.

WYSIWYG: Pronounced "wizzy-wig;" stands for "What You See Is What You Get," an expression characterizing page processing and typesetting programs or systems that show on screen what you will get as the output from a printer or imagesetter, complete with correct line breaks, pagination, and other formatting, as well as graphics, images, and color.

SOURCES

Michael H. Bruno, "Printing in a Digital World," GAMA, Salem, NH, April, 1995.

Robin McAllister, "Trapping," QuarkXPress Users International, April, 1995.

Professor Frank Cost, RIT School of Printing Management & Sciences. Seminar and class materials.

Selected course materials from the RIT Technical & Education Center of the Graphic Arts.

David Cohn, Senior Technical Staff, RIT Technical & Education Center of the Graphic Arts.

Professor William Fisher, School of Photographic Arts and Sciences technical paper on trapping.

Jack Klasnic, international authority on reprographics.

Michael Mell, interactive training program on stochastic printing.

Some of the material in this book has appeared in *American Printer, Color Publishing,* or *Electronic Publishing* magazines.

Pocket Guide to Digital Prepress

Available directly from your local
bookseller or Delmar Publishers

For more information, contact Delmar Publishers
By mail: 3 Columbia Circle
 Box 150015
 Albany, NY 12212-5015

By Telephone (518) 464-3500
 (800) 347-7707

By Fax (518) 464-0301

Via Internet http://www.delmar.com/
 delmar.html